HEBREW ILLUMINATED MANUSCRIPTS IN THE BRITISH ISLES

A Catalogue Raisonné

by

BEZALEL NARKISS

Preface by

SIR JOHN POPE-HENNESSY

PUBLISHED BY THE OXFORD UNIVERSITY PRESS
FOR THE ISRAEL ACADEMY OF SCIENCES AND HUMANITIES
AND THE BRITISH ACADEMY
1982

Oxford University Press, Walton Street, Oxford OX2 6DP
London Glasgow New York Toronto
Delhi Bombay Calcutta Madras Karachi
Kuala Lumpur Singapore Hong Kong Tokyo
Nairobi Dar es Salam Cape Town
Melbourne Auckland
and associate companies in
Beirut Berlin Ibadan Mexico City

Published in the United States by Oxford University Press, New York

Israel Academy of Sciences and Humanities, Jerusalem

British Library Cataloguing in Publication Data

Narkiss, Bezalel
Hebrew Illuminated Manuscripts in the British Isles.
Vol. 1: The Spanish and Portuguese Manuscripts
 1. Manuscripts, Jewish—Great Britain
 2. Illumination of Books and Manuscripts, Jewish
 I. Title II. British Academy III. Israel Academy
 of Sciences and Humanities
745.6'74924 ND2935

ISBN 0 19 725977 4

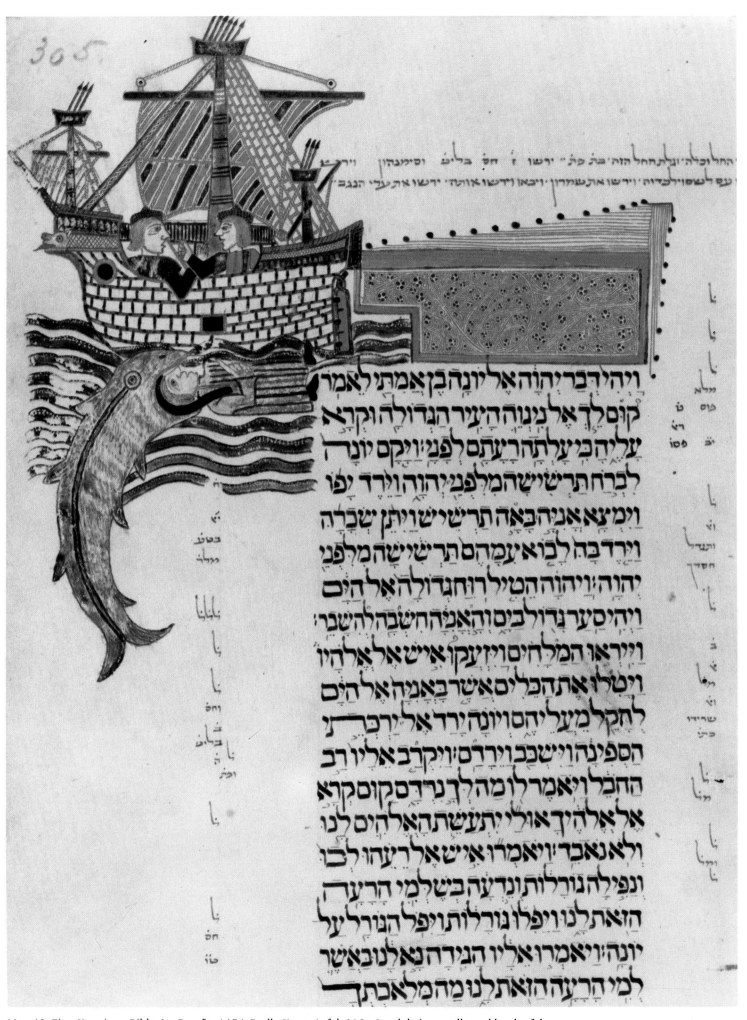

No. 48. First Kennicott Bible, La Coruña, 1476, Bodl., Kenn. 1, fol. 305r: Jonah being swallowed by the fish.

ויהי דבר יהוה אל יונה בן אמתי לאמר

קום לך אל נינוה העיר הגדולה וקרא

עליה כי עלתה רעתם לפני ויקם יונה

לברח תרשישה מלפני יהוה וירד יפו

וימצא אניה באה תרשיש ויתן שכרה

וירד בה לבוא עמהם תרשישה מלפני

יהוה ויהוה הטיל רוח גדולה אל הים

ויהי סער גדול בים והאניה חשבה להשבר

וייראו המלחים ויזעקו איש אל אלהיו

ויטלו את הכלים אשר באניה אל הים

להקל מעליהם ויונה ירד אל ירכתי

הספינה וישכב וירדם ויקרב אליו רב

החבל ויאמר לו מה לך נרדם קום קרא

אל אלהיך אולי יתעשת האלהים לנו

ולא נאבד ויאמרו איש אל רעהו לכו

ונפילה גורלות ונדעה בשלמי הרעה

הזאת לנו ויפלו גורלות ויפל הגורל על

יונה ויאמרו אליו הגידה נא לנו באשר

למי הרעה הזאת לנו מה מלאכתך

HEBREW
ILLUMINATED MANUSCRIPTS
IN THE BRITISH ISLES

by

Bezalel Narkiss

Volume One

The Spanish and Portuguese Manuscripts

Part One: Text

In collaboration with

Aliza Cohen-Mushlin *and* Anat Tcherikover

Jerusalem and London 1982

Preparation and publication of this volume
was made possible by a grant from the
Memorial Foundation for Jewish Culture

Printed in Israel
at Ben-Zvi Printing Enterprises Ltd., Jerusalem

*Rosy Schilling
in memoriam*

PREFACE

THE IMPORTANCE of Hebrew illuminated manuscripts for the study of mediaeval art was established over eighty years ago with the publication of the first facsimile of the Sarajevo *Haggadah* and the accompanying studies by H. Miller, J. von Schlosser and D. Kaufmann (Vienna 1898). It is, however, only since the Second World War that many more facsimiles and studies have appeared to elucidate the development of Hebrew illumination in particular, as well as its relationship to the history of mediaeval art in general.

It has become obvious in recent years that no study of European or Near Eastern art can be complete without a knowledge of Jewish illumination; the interrelationships and the cross-influences in style and iconography become apparent only when both components are known and studied. It is, therefore, encouraging to observe the growing number of projects concerning Hebrew illuminated manuscripts, and to be able to support an enterprise like this Catalogue, which will enlarge the knowledge and appreciation of both scholars and laymen. Its importance lies in its comprehensiveness, as well as in its systematic handling of the different schools of Jewish illumination. The restriction to manuscripts in libraries in the British Isles is, regrettably, unavoidable, but it is to be hoped that this Catalogue will be complemented by similar ones covering libraries in other countries. Nonetheless, the collections in the British Isles are so extensive that, even by studying only these manuscripts, one can follow, to some extent, the history of Hebrew illumination throughout the Middle Ages.

The original plan for this Catalogue Raisonné was initiated by the late Dr Rosy Schilling, in collaboration with Professor Bezalel Narkiss, who worked on it from 1963 to 1967 with the aid of the David Salomons Fund. The encouragement of the bookman Dr Moshe Spitzer, and the support of the former Israel Ambassador to Great Britain Dr Eliahu Elath, were invaluable at that time. The systematic research in the different libraries at that initial stage proved that there was not just a handful of famous Hebrew illuminated manuscripts to be studied, but a wealth of hundreds which needed systematic investigation. However, the illness and death of Dr Schilling put an end to this first stage. The compilers of this Catalogue, like all students in the field, owe much to her invaluable work. Thanks are due to Professor J.B. Trapp and Miss Christine Evans, who helped in the preparation of the Catalogue in that stage.

It was the energetic encouragement of Professor Joshua Prawer of the Israel Academy of Sciences and Humanities, and of the late Mr Derek Allen, Secretary of the British Academy, which made possible the stage which led to publication of the Catalogue. The late Dr Neville Williams and Mr John Carswell, Secretaries of the British Academy, as well as Dr Yehezkel Cohen and Dr Shimeon Amir, the successive Directors of the Israel Academy, took a great interest in the furthering and completion of the task. The special committee set up by the British Academy, which I had the honour to chair, did much to help with the structure of the Catalogue, and benefited from the contributions of its members. They include: The late Professor Otto Kurz,

Mr N.C. Sainsbury, the late Dr J. Rosenwasser, Professors J.B. Segal and T.J. Brown, Mr R.A. May and Professor J. Barr. Special thanks are due to Professor C.R. Dodwell, who has chaired the committee since 1978, to Mr Peter Brown, the Deputy Secretary of the British Academy, Miss J.C. Saies of the British Academy and Mrs A. Haiam of the Israel Academy, who closely followed the work of the committee and the progress of the Catalogue.

Since 1975 Professor Narkiss has been engaged in completing the work, using new, more concise methods of description, studying each manuscript and placing it in a group or school. Short codicological and historical data introduce each Catalogue entry. The Decoration section of each entry starts with a résumé of the Decoration Programme, which gives the reader an immediate impression of what the illumination of the manuscript is like. The detailed Description following the Decoration Programme makes it possible to shorten the page-by-page descriptions common in other catalogues. The Conclusion of each entry discusses the style and iconography, and relates it to other manuscripts, whether Hebrew, Latin, Greek or Arabic, as well as to European or Eastern schools of illumination.

In this new method of cataloguing and describing the manuscripts afresh, Professor Narkiss has had the keen and valuable assistance of Dr Aliza Cohen-Mushlin, Christine Evans, Hava Lazar, Dr Gabrielle Sed-Rajna, Anat Tcherikover and Nedira Yakir, who have devoted endless hours of work, energy and thought to the preparation of these volumes. At this stage the use of the questionnaires of Dated Hebrew Manuscripts, prepared by *The Hebrew Palaeography Project*, under the direction of Professor M. Beit-Arié and Professor Colette Sirat, was of great value. Our gratitude is extended to them all.

The catalogue is planned to include four different areas of Hebrew illumination: (1) The Oriental schools of Egypt, Persia, Palestine, Yemen and North Africa; (2) The Sephardi schools of the Iberian Peninsula; (3) The Ashkenazi schools of France and Germany; and (4) The Italian schools, which include the Ashkenazi manuscripts from the north of Italy. For reasons of convenience, the publication, which is about to appear in three volumes, does not follow this logical sequence of schools.

At the Israel Academy thanks are due to Mr Reuven Eshel, Miss Norma Schneider, Mr Shmuel Reem, Mr Gideon Stern and Ms Isabelle Black for editing and seeing this volume through the press. Dr Moshe Spitzer is thanked for his invaluable advice on typography, planning and layout of this book. Thanks are also due to Mr Amiel Wardi for setting the text, and to the team of Ben-Zvi Printing Enterprises in Jerusalem, for printing it.

It is a pleasant duty for me to thank, in the name of the two Academies, the author and his assistants, the members of the committee, and the staff of both Academies for their help in carrying out the project. Special thanks are owed to Mr Ben Pollard, as well as to the Valmadona Trust and its trustee Mr Jack Lunzer, for their generous financial help. Hearty thanks are due to the librarians and keepers of the British Library in London; the Bodleian Library in Oxford; Cambridge University Library, Trinity College and Emmanuel College, Cambridge; the John Rylands Library, Manchester; the Chester Beatty Collection and the Library of Trinity College, Dublin; the Mocatta Library at University College, and Jews' College, London; and the Library of the University of Aberdeen.

John Pope-Hennessy

The Metropolitan Museum of Art,
New York

CONTENTS

List of Libraries

AUL	Aberdeen, University Library
BL	London, British Library
Bodl.	Oxford, Bodleian Library
CUL	Cambridge, University Library
JRL	Manchester, John Rylands Library
LUL	Leeds, University Library
ML	London, University College, Mocatta Library
TCLC	Cambridge, Trinity College Library
TCLD	Dublin, Trinity College Library

Note on the Entries

The entries in this catalogue follow a self-explanatory sequence. Most of the descriptive details follow the system used in other catalogues of manuscripts.

In the section dealing with *Codicology*, the number of vellum leaves is denoted in Arabic numerals and the number of paper fly leaves in Roman, e.g. II + 112 + III.

The Jewish dating from the Creation is given with the equivalent general Gregorian date in parentheses; e.g. 5 Ab 5234 (19 July 1474).

The following abbreviations are used: A.V. for the English Authorized Version of the Bible; T.B. for the *Babylonian Talmud*; b. for *ben* or *bar* (son); 'n for Ibn (son), r. for Rabbi.

Transliteration Rules

1. The transliteration follows the modern Hebrew spelling and pronunciation.
2. The *dagesh ḥazaq* is not indicated. Consonants are doubled only to avoid mispronunciation.
3. Biblical names are given according to the Authorized Version. Post-biblical names and terms are transliterated according to the following chart:

'	א	k	כ	r	ר
b	בּ	kh	כ,ך	sh	שׁ
v	ב	l	ל	s	שׂ
g	ג	m	מ,ם	t	ת
d	ד	n	נ,ן		
h	ה	ṣ	ס	a	אַ אָ אֲ
w	ו	'	ע	e	אֶ אֵ אֱ [na'] אְ
z	ז	p	פ	ei	אֵי
ḥ	ח	f	פ,ף	i	אִי אִ
ṭ	ט	ẓ	צ,ץ	o	אֳ אָ אֹ אוֹ
y, i	י	q	ק	u	אֻ אוּ

INTRODUCTION

THE SEPHARDI SCHOOLS OF ILLUMINATION

The fact that "The captivity of Jerusalem in *Sepharad*" mentioned by the Prophet Obadiah (1:20) was identified as Spain in the Jonathan and Syriac translations of the Bible was later considered by the Jews as proof of their early settlement in Spain, which they called *Sepharad*. In any event, there is evidence that Jews lived in Spain from the Roman period up until their expulsion from united Christian Spain in 1492.

The Sephardi culture was highly developed under the Romans, the Visigoths, the Moslems and the reconquering Christians, as the Jews had to readjust to different types of society, religion and culture with each change of rule in order to preserve their own community, religion and culture. Not only did the Jews support the establishment of each rule, they also absorbed part of the new culture, assimilating it to the best of their ability into their own.

Adjusting to the environmental life style while adhering to their religion, communal laws, customs and language – sometimes at a high cost – gave the Jews the special kind of national existence characteristic of them up to the present time. While this consistent existence became more difficult with each change of rule in Spain, to the point where Jews were often regarded as traitors, culturally these changes resulted in a flexible and manifold Spanish Judaism. This combination of immanent Jewish traditions and recurrent changes of general life style is visually expressed in the various stylistic trends of manuscript illumination.

Hebrew books were continuously copied, in manuscript form, throughout all periods, but no illumination survives from Visigothic and Moslem Spain. Although the earliest extant Hebrew illuminated manuscript dates from the period of the Christian Reconquest in the thirteenth century, the importance of Jewish schools of illumination in the Iberian Peninsula lies in their being the transmitters of Jewish art from the Moslem East to Western Europe.

Moslem rule in Spain, which lasted more than five hundred years, was tolerant of both Jewish and Christian religious and communal life during most of this period. It was then that Jewish Hebrew culture, imbued with Arabic style, attained its highest degree of excellence in literature. There can be no doubt that Jewish illumination existed in Moslem Spain, at least up to the rule of the Almoravides in the twelfth century when both Jews and Christians were forced to embrace Islam or flee the country. It was only the Christian Reconquest that put an end to forced conversion, thereby at least partially preserving the Christian Hispano-Moresque culture, including Latin illuminated manuscripts. With no extant Hebrew manuscripts from this period, it is only through the survival of Hispano-Moresque archaistic elements in later manuscripts that the existence of such Hebrew illumination can be assumed.

Hebrew illumination is known to have existed continuously in the Iberian Peninsula up to the final expulsion of the Jews from Spain and Portugal in 1492 and 1496, respectively. The destruction of most Jewish communities in 1395, and the pressure to convert to Christianity during the fifteenth century, had little effect on this kind of artistic activity.

During the period in question different schools of illumination developed within the borders of the various Spanish kingdoms, mainly those in the north of the peninsula; although cultural mobility across political

borders was simple and frequent, local traits can be distinguished between the schools of Castile and Aragon, Navarra and Portugal.

That our knowledge of the various schools of illumination is limited is due to the scarcity of modern studies having been devoted to specific schools and little documentation on them having been published. The few studies carried out to date have brought to light two main components characteristic of Jewish art in Spain: (1) the perpetuation of Jewish tradition from earlier periods, and (2) the direct stylistic relation to general contemporary schools of art. It is therefore not surprising that, while the iconography of the Hebrew manuscripts depends mainly on Jewish tradition, they are predominantly Spanish in style. Therefore, a comparison of Hebrew and Latin manuscripts has often made it possible to attribute the style of the former to local Latin schools or regions. And, conversely, Hebrew manuscripts have also been used to date Latin and Spanish illumination. A case in point is the *Copenhagen Maimonides Guide* of 1348 from Barcelona (Copenhagen, Kongelige Bibl., Cod. Heb. 37), which the late Millard Meiss used in order to date and even place a school related to the "Master of St. Mark", after the triptych of St. Mark now in the Pierpont Morgan Library in New York (see Meiss, Catalonia; Wormald, Copenhagen; Narkiss, *HIM*, pp. 18, 27, Pl. 18, and the Bibliography on p. 76).

The numerous affinities between Jewish and Christian illumination derive from the similar working methods of the scribes and artists of both communities from the thirteenth century on. Jewish workshops producing illuminated manuscripts were centred, like those of their Christian compatriots, round the figure of the scribe rather than the artist. Personal workshops, established during the thirteenth century in the cities of Western Europe, reinforced the long-established Jewish tradition of families of scribes, in contrast to the monastic scriptoria of the Catholic West in the early Middle Ages. Within such a Jewish tradition, the scribe determined the layout of the book and the areas of decoration for the artist to follow. For instance, in copying a Bible, the scribe laid stress on the traditional text, vocalization and massorah. A well vocalized and massorated text, one with no errors, was sought, and the use of such a model was specified with pride by scribes in their colophons. Bible decoration developed gradually in the Near and Middle East in the early Middle Ages, by the massorators who wrote the traditional text of the massorah in micrography, using it to outline decorative shapes and objects. In many cases the scribe was also the massorator, a practice which continued in Spain and strengthened the scribe's influence in planning the decoration of a codex.

Undoubtedly most of the illuminators of Hebrew manuscripts were Jewish. A few of their names are known from their colophons, such as Joshua Ibn Gaon (Nos. 3–6), Joseph Hazarfati, the artist of the *Cervera Bible* (see Narkiss, *HIM*, Pl. 6), and Joseph Ibn Hayyim, the artist of the *First Kennicott Bible* (No. 48). There is also a contract of 1335 from Palma de Mallorca, in which Asher Bonnim Maimo undertakes to copy and illuminate a Bible and two books of Maimonides for David Isaac Cohen (see Hillgarth & Narkiss, Contract).

The two main components found in Sephardi illumination, namely the traditional Jewish iconography and the contemporary Christian style, are best exemplified in Spanish Hebrew Bibles of the thirteenth and fourteenth centuries. The decoration plan of these Bibles was based on eastern Hebrew antecedents in four respects: (1) carpet-page frontispieces; (2) decoration at the end of books; (3) decorative signs of sections; and (4) the micrographic massorah. The contemporary Christian Spanish influence can be detected in three elements: (1) the development of initial-word panels at the beginning of books to replace the Latin initial letters which do not exist in the Hebrew script; (2) text illustrations, disguised as *parashah* signs or at the beginning and end of books, next to their texts, outlined in micrographic massorah or painted; and, above all (3) in the style of the decoration.

The use of models for illumination was a common habit of scribes and artists throughout the centuries. For example, the illumination of the *First Kennicott Bible* of 1476 (No. 48) follows the plan of decoration and some of the iconography, as well as some of the decorative motifs, of the 1300 *Cervera Bible* (Lisbon, Biblioteca Nacional, MS. 72; see Narkiss, *HIM*, pp. 23, 25, 52, 74, Pls. 6, 17). However, some peculiar decorative motifs in the *Kennicott Bible* (see Edmonds, Ibn Hayyim), and the very different styles of these two manuscripts, show how closely the artists of the two manuscripts were integrated into their immediate artistic environment. Archaistic elements in both manuscripts have their sources in the Latin Castilian schools of their respective periods, or depend on much earlier Jewish tradition.

Practically nothing is known of Sephardi schools of illumination from the Moslem period and early part of the Christian Reconquest, since the very few manuscripts from these periods that have survived have almost no decoration. The earliest decorated Bibles, from Castile, are the *Bibliothèque nationale Castilian Bible* of 1232 from Toledo (Paris, Bibliothèque nationale, hébr. 25, Fig. 4); the *Damascus Keter* of 1260 from Burgos (Jerusalem, JNUL, MS. 4° 790; see Narkiss, *HIM*, pp. 23, 80, Pl. 5); and the *First* and *Second Cambridge Castilian Bibles* (Nos. 1, 52). These manuscripts, all from the second and third quarters of the thirteenth century, have decorative motifs of a Hispano-Moresque type (see Sed-Rajna, Toledo), although their soft Gothic style is clearly influenced by contemporary Northern French illumination. This combination of Hispano-Moresque and Spanish Gothic style is evident in the Castilian schools of Toledo, Tudela, Burgos and Soria at the end of the thirteenth and beginning of the fourteenth centuries. Scribe-artists like Ibn Merwas, the two Ibn Gaon brothers, and others who probably headed workshops, developed their own personal Gothic style and motifs although they adhered to the traditional decoration plans for the Bible.

Castilian *haggadot* of the same period similarly use traditional motifs and decoration plans. The decorated *mazzah* and *maror*, as well as the decorative architectural form in which the *piyyuṭ Dayenu* is copied, derive from earlier eastern *haggadot*. On the other hand, the addition of a full-page biblical picture cycle no doubt results from the influence of Franco-Spanish illuminated Latin Psalters and picture Bibles. This innovation was made possible by the extraction of the *haggadah* from the general prayer book, giving it a separate entity.

Catalan schools of Hebrew illumination concentrated round the royal court in Barcelona throughout the fourteenth century, where Jewish dignitaries served as administrators, scientists, physicians, translators and financiers. A rich Jewish class could afford to support many workshops producing sumptuous illuminated works of art such as the *Golden Haggadah* (No. 11), the *Barcelona Haggadah* (No. 13) and the *Duke of Sussex Catalan Bible* (No. 19). While the Catalan *haggadot* have decoration programmes similar to those of the Castilian schools, they developed to the utmost an extensive plan of text decoration, as well as a larger cycle of biblical pictures in full-page panels. Unlike Bibles, the Spanish *haggadah* manuscripts are hardly ever dated or located, since none bears a colophon. It is therefore only through stylistic comparison that one can establish their relation to an artistic school. Some of these early fourteenth century *haggadot* betray the first influences of Italian style on Spanish illumination.

The oriental iconographical tradition seems to be more pronounced in the late fourteenth-century Hebrew Bibles of Catalonia. This becomes apparent in decorated carpet pages which include a display of Sanctuary implements, and in the decorated massoretic notes at the end of the books, as well as in the marginal decoration outlined in micrography found on almost every text page.

Besides *haggadot* and Bibles, many other types of manuscripts were illuminated in the Catalan schools of the fourteenth century. Most of them are related to Barcelona, although some are from other provincial centres. Production of illuminated manuscripts must have stopped or at least slowed down following the massacre of Jews and the destruction of many Spanish Jewish communities during the 1395 uprising. However, many of these communities soon revived, and artistic centres developed again at the beginning of the fifteenth century. Lack of comprehensive studies prevents us from establishing to which schools most groups of fifteenth-century manuscripts belong. One of the few groups which can be distinguished is the Portuguese school, which has been studied at length (see G. Sed-Rajna, *Manuscrits hébreux de Lisbonne*, Paris 1970, and a review by T. Metzger, *Lisbonne*, Paris 1977), and other groups from the late fifteenth century, some of which are Spanish although they depend at times on the Portuguese school. We have tentatively arranged these manuscripts into coherent groups wherever possible, although we have been unable to localize them. The existence of one dated manuscript from Cordoba of 1479 (New York, Jewish Theological Seminary Library, MS. L5) does not permit us to assume that all the rest are of the same origin.

The influence of Italian and Flemish illumination on these groups can perhaps be explained by the close connections between Jewish merchants of these countries and Spain.

To sum up, one can say that the style of Jewish illumination in Spain was directly related to the major schools of Christian illumination, although it maintained its own special Jewish tradition in the decoration programme, in certain motifs and in its iconographical repertoire.

I. Castilian Schools of the Thirteenth and Fourteenth Centuries
[Nos. 1–10]

Few illuminated Hebrew manuscripts of the thirteenth and early fourteenth centuries survived the hazards of the Christian Reconquest of Spain and the subsequent period of transition from Moslem to Christian rule. Most of the extant manuscripts are of Castilian origin, from Toledo and Cervera, or from further northeast, from Tudela, Soria and Burgos. Their style combines Hispano-Moresque elements – a survival from the Moslem period – with the more contemporary fashionable Franco-Gothic style.

The Hispano-Moresque elements are mainly expressed in the flat rendering of human figures and the stylized and geometric interlaces. The Franco-Gothic influence is manifested in the soft rendering of the figures and decoration, as well as in the abundance of grotesque motifs and the use of blue and magenta. There is an additional Italian influence noticeable in the illumination of Castilian manuscripts. Noteworthy are some similar iconographic features in the *Hispano-Moresque Haggadah* (No. 9) and the *Italian Schocken Haggadah* of *c.* 1400 (Jerusalem, Schocken Library, MS. 14940; cf. Narkiss, M., Schocken Haggadah). These may be attributed to an earlier common model, an Italian prototype of the *Hispano-Moresque Haggadah*, or *vice versa*. There are however differences within each of the centres which can be attributed to different workshops. Some of the scribes or artists of these workshops are known to us from their colophons, for example, Ibn Merwas and Ibn Gaon, who copied and illuminated several extant manuscripts. Other scribes, whose names appear in the colophon of a single manuscript, have no doubt produced additional books which did not survive.

Besides two undated *haggadot*, all the other manuscripts of this school are Bibles which scribes were proud to furnish with their colophons. It is possible to attribute the two *haggadot* to the Castilian school, and to date them approximately, by comparing their style with that of the dated Bibles.

The decoration programmes of Bibles and *haggadot* are detailed in the introductions below (pp. 16–18, 42–44).

Castilian Bibles: Decoration Programme
[Nos. 1–8]

The decoration programmes of thirteenth- and fourteenth-century Bibles follow the Oriental traditions known to us from Moslem Palestine and Egypt in the ninth to twelfth centuries (see Stassof & Gunzburg, Pls. I–XIX; Narkiss, *HIM*, pp. 18–20, 42, Pl. 1).

The decoration of the Bibles can be divided into four categories: (1) decorative carpet pages preceding or succeeding the main divisions of the Bible into Pentateuch, Prophets and Hagiographa; (2) decorated panels at the end of books framing the listing of the number of verses in the book and their mnemonic sign; (3) ornamental motifs designating the *parashot*, *haftarot* and sometimes the chapters of Psalms; (4) ornamental shapes in the margins, outlined by Massorah Magna written in micrography.

Of special interest to the development of decoration in the Castilian Bibles are the *parashah* sign motifs and the carpet pages. The *parashah* motifs in some of these Bibles developed from the middle of the thirteenth century onwards as text illustrations, a marked deviation from the Oriental Bibles. In later Bibles of the Castilian schools these helped fashion marginal text illustrations, either outlined in micrography or as painted illumination detached from the *parashah* sign.

The carpet pages of the Castilian Bibles, like those in the Oriental Bibles, incorporate massoretic and grammatic material. In texts, such as the Massorah Magna, the differences between Ben Asher and Ben Naftali, or the grammatic treatise by R. David Kimḥi, are used at random as prefaces to different Bibles. As in the Oriental manuscripts, the massorah in micrography is mainly used to outline decorative shapes, thereby rendering it useless for its content. The geometric and floral shapes are sometimes framed by biblical verses written in display script, or as painted borders, as in the *Cervera Bible* of 1300 (Lisbon, Biblioteca Nacional, MS. 72; see Santos, *Portugal*, p. 11, Pl. XI; Narkiss, *HIM*, pp. 23–25, 52, Pl. 6 and bibliography on p. 170).

Other carpet pages display the Jerusalem Temple or the wilderness Tabernacle and their various implements in a decorative style that follows earlier traditions. During this period the Bible was regarded as a replacement for the destroyed Temple, and the depiction of an array of mixed Sanctuary implements from both temples and the Tabernacle was a symbol for the yearning for Messianic times and the wish to rebuild Jerusalem and its Temple.

Three ways to depict Sanctuary implements crystallized in the thirteenth century. One trend, an extensive plan of the Temple of Jerusalem based on the texts of the Mishnah and its exegesis by Maimonides, at times incorporates representations based on the biblical description of each implement of the Tabernacle in the wilderness together with Rashi's Commentary. Joshua Ibn Gaon's plan of the Temple in the *Second Kennicott Bible* (No. 3, Figs. 9–10) is an example of this trend, and the single leaf from the *First Ibn Merwas Bible* (No. 2, Fig. 5) may represent a similar, though debased, plan (see below, third trend). These plans of the Tabernacle in the wilderness appear in mediaeval manuscripts of Rashi's Commentary on the Bible, as well as in Maimonides' commentaries on the Mishnah (cf. Wischnitzer, Maimonides). They may all depend on earlier models developed when Herod's Temple was still standing (cf. Narkiss, Sanctuary).

The second trend, the most popular one in fourteenth-century Catalonia, represents a haphazard array of implements from the Temples of Jerusalem as well as from the Tabernacle in the wilderness (see Metzger, T., Objets du culte). To these is sometimes added a picture of the cleft Mount of Olives with a tree on top, alluding to Zechariah's prophecy on the Coming of the Messiah (14:4; cf. Gutmann, Kingdom, p. 172). Arrays of Sanctuary implements were also common in the mosaic floors of early Palestinian synagogues, in Roman-Jewish catacombs, on gold-glass bases, coins and on clay, metal and stone objects which may have been the prototype of the later arrays in carpet pages of the Bibles. (For detailed descriptions of the Temple and Sanctuary implements see Introduction to Catalan Bibles (pp. 101–104).

The third trend combines a well-defined ground-plan of the Temple with a haphazard array of Sanctuary implements. This is no doubt the case in the two full-page panels in the Oriental *First Leningrad Bible* of 929 (Leningrad Public Library, Ms. II, 17; cf. Stassof & Gunzburg, Pls. 1, 3; Narkiss, *HIM* p. 42, Pl. 1A), where there are two different arrangements of the ground-plan and the implements. However, this plan is a mixture of the Solomonic and Herodian Temples with the Tabernacle in the wilderness. The façade of the Herodian Temple and its court appears with the Ark of Covenant, stylized cherubim, a jar of manna and other implements from the Tabernacle and Solomon's Temple. Moreover, among the haphazardly placed implements of the Sanctuary are such elements from Herod's Temple as the golden vine (Metzger, M., Caractères).

The fragmentary single leaf of implements from the *First Ibn Merwas Bible* (No. 2, Fig. 5) seems to follow the tradition of the *First Leningrad Bible*. It is close enough to representing a partial plan of the Temple, depicting more than the customary implements in their correct relation to each other, for example, the tables for slaughtering animals and hooks next to the Altar of Sacrifice. However, the additional pots and pans are placed above the Altar as an array of objects, rather than in their correct position. This trend of mixing the Sanctuary plan with a decorative array may also depend on earlier prototypes such as the famous Vatican gold

glass from the catacomb of SS. Pietro e Marcellino (cf. Narkiss, Sanctuary, Fig. 7), where a symbolic Roman Temple is flanked by the two Solomonic pillars of Yakhin and Boaz (I Kings 7:20), surrounded by the Tabernacle court hangings (Ex. 27:9–18), with an array of implements in front of the Temple.

All three trends of depicting the Jerusalem Temples, the Tabernacle in the wilderness and their implements may have had a definite plan as their prototype, perhaps one dating as early as the Herodian period. Their depiction as frontispieces to the Bible is not merely text illustration, it conveys the special Jewish attitude towards the Bible in the Orient and Spain, as a replacement for the destroyed Temple. The title *Miqdashiah*, i.e., "God's Temple", given to some of the mediaeval Hebrew Bibles, is another expression of this attitude (cf. Weider, Sanctuary).

The Oriental origins of the Castilian Bibles' decoration programme may point to the existence of no longer extant illuminated Jewish Bibles of antiquity and the early Middle Ages. This is made more likely by the close relation of these Bibles to the decoration programme of eighth- and ninth-century Christian sacred books and Moslem Korans, which also contain carpet pages and decorative book divisions (cf. Narkiss, *HIM*, p. 19).

Thirteenth-Century Bibles
[Nos. 1, 52]

The earliest extant Castilian Bibles in the British Isles date from the second half of the thirteenth century. These are the *First* and *Second Cambridge Castilian Bibles* (Nos. 1 and 52), which have stylistic similarities to the *Bibliothèque Nationale Castilian Bible* of 1232 (Bibliothèque nationale, hébr. 25, Fig. 4). Their decoration programme consists of full-page carpets, panels at the end of books and decorated *parashah* indicators. The floral arabesque motifs are archaistic elements, survivors of Hispano-Moresque illumination.

1. FIRST CAMBRIDGE CASTILIAN BIBLE

Castile, mid-thirteenth century

CUL, Add. 465

Figs. 1–4

Bible and table of the Christian division of chapters.

General Data

Codicology

Vellum; I+246+I leaves; 330×285 mm. Text space (231–324)×(210–215) mm; height of the text space with Massorah 280–283 mm. Written in square Sephardi script, in brown ink, 32 lines (Massorah, 2+3 lines) in 3 columns. Ruling by stylus, 2+37+3 horizontal and 1+3+3+2 vertical lines. Pricking in inner, upper and lower margins. 31 quires of 8 leaves each except for Quire XXXI⁶. Catchwords at the bottom of the last page of each quire; those on fols. 176v, 184v and 192v are in a later hand, in dark brown ink. Quires are numbered with Hebrew letters at the top of the first page and at the bottom of the last one, except for Quires XXII–XXX.

The names of the books and the chapters in the upper margins are in a fourteenth-century Sephardi hand. The Christian chapter division is in a sixteenth-century Sephardi hand. The division of Psalms into seven parts is in sixteenth-century Sephardi cursive.

Colophon
fol. 168r End of Latter Prophets (according to Schiller-Szinessy, p. 16; one folio before the second hand begins): An erased inscription of 12 lines, starting with the traditional repetition of the last two verses of Malachi. The rest, which may have been a colophon, is illegible even under ultra-violet light.

fols. 245r–246v A table of the Christian chapter divisions of the Hebrew Bible and the Spanish names for the different books. The table, copied by R. Solomon b. Ishmael, was designed for quick reference in the recurrent controversies between Jews and Christians. It is written in neat thirteenth–fourteenth century Sephardi cursive.

History
Paper-leaf before fol. 1r Eighteenth-century decorated title page in a Polish hand, stating the merits of the manuscript.
Purchased by Cambridge University from M. Lipschütz of Cracow in 1869.

Decoration

Programme
A. Small panels.
B. Decorative micrography to the Songs of Moses.
C. Decorated *parashah* signs.
D. Decorated chapter divisions.
E. Decorated title page.

Description
A. *Small Panels.*
The two small panels at the ends of the main divisions are decorated with geometrical and stylized foliage ornaments in red, blue and gold.
fol. 59r End of Pentateuch: A U-shaped frame (65 × 55 mm) with circles, lines and squares on a brush gold ground, a gold fillet frame and a pen-drawn zigzag at the top.
fol. 111v (Fig. 1) End of Former Prophets: Pen-drawn, schematized interlacing scrolls form a symmetrical arabesque motif, resembling a gate and flanked by two banners. The main ground is red, but the spaces enclosed by the scrolls are filled with blue, gold and some magenta.

B. *Decorative Micrography to the Songs of Moses.*
fol. 20r (Fig. 2) First Song of Moses: The middle text column is framed by a micrography band, coiling round the plain Massorah lines at the top and bottom while at the sides it is interrupted by micrography circles, lozenges, jar-like and stylized foliage motifs, mostly enclosing similar motifs in red or brush gold.
fol. 58r–v (Fig. 3) Last Song of Moses: The text is written in two columns; between them is an elongated candelabrum-like tree in micrography and pen-drawing, with some red, blue and magenta tinting and additional line motifs. The design of the trees includes circles, palmettes and

other stylized foliage. The shapes on fol. 58v are more angular than on fol. 58r, and there are large brush gold dots between the branches of the tree.

C. *Decorated* Parashah *Signs.*
Some *parashah* signs have small, fillet-framed panels, mostly semi-circular and with a stylized foliage motif above. This motif often resembles a tree or a candelabrum. Most *parashah* decorations are crudely executed in brush gold, outlined in red (e.g., fols. 4r, 11v, 19v, 26r and 58v – Fig. 3), except for the one on fol. 2v, which has a very fine palmette motif coloured in red, blue and brush gold.

D. *Decorated Chapter Divisions.*
Sixteenth-century chapter divisions are decorated with small pen scroll motifs in red (e.g., fol. 58v – Fig. 3).

E. *Decorated Title Page.*
The eighteenth-century title page on the paper leaf before fol. 1r is framed with a band of symmetrically arranged foliage and conventional flowers coloured red, green, yellow and brown, with black outlines.

Conclusions

The manuscript is a representative of the large thirteenth-century Spanish Bibles written in three columns, with micrographic Massorah forms decorating the Songs of Moses only. The gold and colouring of the candelabrum-like tree form of the Massorah and the *parashah* signs were probably added later in the thirteenth century by another artist; Schiller-Szinessy (p. 18) ascribes them to the fifteenth century. The decoration should be compared with that of the *Damascus Keter*, a Spanish Hebrew Bible of 1260 from Burgos, now in Jerusalem (National and University Library, MS 4° 790; Narkiss, *HIM*, p. 50, Pl. 5), where the *parashah* signs are of a somewhat later date. The interlacing scrolls of Moslem type at the ends of the main divisions (fols. 59r and 111v), should be compared with the decorated Bible of 1232 from Toledo, in Paris (Bibliothèque nationale, hébr. 25, e.g., fols. 8v and 39r – Fig. 4). The manuscript and its decoration are probably from Castile, about the middle of the thirteenth century.

Bibliography

Schiller-Szinessy, No. 13, pp. 16–19.
Loewe, *Hand List*, No. 22.
Sotheby Sale, 11.12.1961, Lot 114, p. 24, Pl. 2. ?.
Joel, *Damascus Keter.*
Narkiss, *HIM*, p. 50, Pl. 5.

1A = 52. SECOND CAMBRIDGE CASTILIAN BIBLE

Castile, c. 1279 and mid-fifteenth century

CUL, Add. 3203

Figs. 500–511

Bible with massoretic lists and computistic tables.

This manuscript was decorated in two stages: at the time of its copying around 1279, and at the time of its binding in the middle of the fifteenth century. The entry was placed with its second stage as No. 52.

Ibn Merwas Group, Toledo, 1300–1334
[No. 2]

Joseph Ibn Merwas is known to have copied three Bibles in Toledo in the first half of the fourteenth century. The *First Ibn Merwas Bible* in London (No. 2), dating from 1300, is his earliest; the other two are in the S.D. Sassoon Collection (MS. 508, dating from 1307, and MS. 1208, dating from 1334). These three Bibles can represent only a fraction of what Ibn Merwas copied over thirty-four years; however, no other manuscript bearing his colophon is known. Other manuscripts from the thirteenth century are known from Toledo, but these are not illuminated. It is possible that Joseph Ibn Merwas was following a tradition when he decorated his manuscripts without figural illustrations, unlike his contemporaries Ibn Gaon and the illuminators of the Soria-Burgos schools (see Introduction to the Ibn Gaon group, pp. 22f.). The fragmentary plan of the Sanctuary appears only in the *First Ibn Merwas Bible* (No. 2, Fig. 5). However, some of the implements in this stylized array are similar to those in Ibn Gaon's Temple plan in the *Second Kennicott Bible* (No. 3, Figs. 9, 10), and may be of similar origin (see Decoration Programme of Castilian Bibles, pp. 16f.).

2. FIRST IBN MERWAS BIBLE

Toledo, 1300

BL, Or. 2201

Figs. 5–8

Bible.

General Data

Codicology

Vellum; 368 leaves; 240×210 mm. Text space (177–185)×(158–170) mm; height of the text space with Massorah 214–220 mm. Written in square Sephardi script, in dark or light brown ink, 32 lines in 3 columns, except for fols. 265r–307v (Psalms, Job and Proverbs), which are written in two columns. Ruling by stylus, 2+32+3 horizontal and 2+3+3+2 vertical lines.

The quires were originally of 6 leaves each, but a later binder, who rearranged the order of the books, rendered the quires indeterminate. Quire I⁴ (fol. 1 is a stub conjoined with fol. 4; both are later additions, replacing the missing Gen. 1:1 to 2:2 on thicker parchment; fols. 1r–v and 4r are blank; fols. 2–3 are of the same vellum as the original manuscript), Quire II¹ (fol. 5). Most of the catchwords are cut off or very faded (e.g., fols. 39v and 45v).

The original foliation is found in the lower left-hand corner of all the rectos, starting on fol. 5r which is

foliated ב (2). The same hand added the book and *parashah* titles in the upper margins and the numbering of the chapters. This enables us to determine the original order of the books: the Sanctuary implements and massoretic list (fols. 2r–3v; no original foliation), Pentateuch (fols. 4r–101v; originally 1r–98v), Chronicles (fols. 338r–368v; originally 99r–130v), Psalms, Job, Proverbs, Five Megillot, Daniel, Ezra, Nehemiah (fols. 265r–337v; originally 131r–211v), Former Prophets (fols. 102r–183v; originally 212r–294v), Latter Prophets (fols. 187r–264v; originally 295r–378v), colophon and massoretic list (fols. 184r–186r; no original foliation). Several leaves are missing after fol. 210 (Jer. 6:6 to 20:18).

Binding
Seventeenth-century white parchment binding, with black tooling of frames and foliage corner decoration.

Colophon
fol. 184r Now bound at the end of II Kings, before massoretic lists: Joseph b. Judah b. Merwas (מרואס) has completed the whole Bible in Tulitola (=Toledo) in the month of Iyyar 5060 (21 April to 19 May 1300). The name of the original patron has been erased. The original date, 60 (ששים), still visible under ultra-violet light, was erased and altered to 6 (ששה) by a later hand. This caused Margoliouth to date it to 1246 wrongly (I, pp. 21–23; Leveen, p. 183). The date was corrected by Sassoon (I, pp. LI, 1–2).

History
Sale and Owners' Inscriptions.
fol. 99v Sale inscription in Arabic: R. Suleyman the Physician b. Samuel (?) b. R. Joseph sold the manuscript on the 6th of Ramadan 854 A.H. (13 October 1450).

fol. 368v Obliterated inscription in eastern round script of the fifteenth or sixteenth century, after the rebinding of the manuscript.

fol. 184r Owners' inscriptions: (1) Shalom b. Joseph Ḥayyim Luẓia Levi. (2) Muṣi 'n Ṣalem al-Gamal.

fol. 4r An erased owner's inscription, including the name …h b. Shalom.

fol. 186v Unclear sale inscription, including the name Judah 'n Muṣi.

fol. 5r "Judah Kamal inherited the Bible" ("24 books").

fols. 1r, 189r Unclear sale inscription.

Purchased by the British Museum in 1879.

Decoration
Programme
A. Full-page panel with plan of the Temple.
B. Full-page panels of Massorah Magna.
C. Painted borders to the Songs of Moses.
D. Decorative micrography of Massorah Magna.
E. Decorative massoretic notes.
F. Indicators of *parashot* and *sedarim*.

Description
A. *Full-Page Panel with Plan of the Temple.*
fol. 2r (Fig. 5) The schematic plan of part of the Temple is divided by fillet borders into three horizontal compartments. The implements within the compartments, as well as the fillet borders, are formed by faded gold bands outlined in black ink, surrounded by thin pen flourishes, some with blue fillings. Some bands are filled with a scroll design in dark ink, or with small gold circles, which also fill some spaces within and around the implements. The entire panel is framed by a faded acanthus scroll border in blue, yellow and gold.

In the top compartment on the right is an object formed by two rectangles, one smaller than the other, decorated with roundels, which may represent the musical instrument called *magrefah* (Mishnah *Tamid* 3:8; 5:6; TB 'Arakhin 10b–11a), which had ten holes, producing many different melodies. To the left is an object which may represent the laver on its stand (or a pot?), and then three censer-like fire-pans.

In the middle compartment is the altar of sacrifice with three steps; a grate (?), rendered as circles; two horns on top and, on the left, the ramp with a window beneath it called *revuvah* (Mishnah *Middot* 3:3; *Mishneh Torah* VIII:1:2:14). On the right are two flesh-hooks, a basin, a fire-pan (or the laver on its foot, or Aaron's flowering rod) and an effaced shovel (or a stave, or Moses' rod; Num. 20:9).

In the lower compartment are the twenty-four rings (*ṭabba'ot*) of the slaughterhouse within blue rectangles formed by gold fillets. Four rectangular gold frames represent the slaughtering tables (*shulḥanot*) (Mishnah *Middot* 3:5; 5:2). If the interpretation of these implements is correct, this page represents the main implements of the Court of Israel in the Second Temple (Mishnah *Middot* 2:6).

For further references to the plan of the Temple, see the description of the *Second Kennicott Bible* (below, No. 3) and the general description of the Sanctuary implements (pp. 101–104).

B. *Full-Page Panels of Massorah Magna.*
There are six full-page panels of micrographic Massorah, framed by inscriptions.

fols. 187r, 188v The panels outline forms consisting of intersecting circles.

fols. 187v, 189r These two panels consist of a variation of the former two, forming horizontal rows of three pointed ovals and two lozenges each.

fols. 188r, 338r (Fig. 6) A trellis pattern including lozenges.

C. *Painted Borders to the Songs of Moses.*
fols. 34v (Fig. 7), *35r* First Song of Moses:

Both pages are framed by similar wide, green borders with a running pattern of alternating green and magenta squares formed by spared ground plaits enclosing red and blue dots that run along both sides of the border. Each square has a gold, star-shaped centre and is separated from the other squares by similar plaits and straight fillets on alternating green, magenta and ochre grounds. Inside the upper and lower borders is a fillet with a spared ground, running acanthus scroll pattern outlined in red, green, violet and ochre. Outside the borders there is another fillet of a similarly coloured angular plait.

fols. 97v–98v (Fig. 8) Last Song of Moses: These three pages are framed by thin borders of spared ground acanthus scrolls (fols. 97v–98r) and dense geometrical interlacing (fol. 98v) on a green and red ground, with gold squares at the corners and in the middle of each border.

D. *Decorative Micrography of Massorah Magna.*
The decoration outlines geometrical shapes in the lower margins of some pages.

E. *Decorative Massoretic Notes.*
These notes appear at the end of books in various forms, e.g., a six-pointed star (fol. 99v).

F. *Indicators of* Parashot *and* Sedarim.
The indicators of the *parashot* in the Pentateuch and the *sedarim* throughout the manuscript are surrounded by simple floral and geometrical pen decorations.

Conclusions

The manuscript was written in Toledo in 1300, and not in 1246. This was proved by Sassoon (I,

pp. LI, 1–2), when he described two other manuscripts in his collection (MSS 508 and 1208), which were written by the same scribe, Joseph Ibn Merwas, at Toledo in 1307 and 1334. Our manuscript is a rare example of an early Sephardi Bible illustrated with the plan of the Temple. The implements are stylized, geometrical objects arranged compactly over the page. The density of composition is emphasized by the filling of discs within and around the implements. This decorative array resembles that in the early Hebrew Bibles from the East, such as the *First Leningrad Bible* of 929 (Leningrad, Public Library, MS II.17; Narkiss, *HIM*, Pl. 1). However, they differ in style.

The leaf (fol. 2r) with the Temple implements, which belongs to the incomplete first quire, does not differ in style from the remaining illuminations. The ornamental borders of the implement page are similar in style to the acanthus borders of the Song of Moses (fols. 34v–35r and 97v–98r) and are related to the other two Ibn Merwas Bibles in the Sassoon Collection. They are similar to the borders of other early fourteenth-century Toledo manuscripts, such as the *First Ibn Gaon Bible* of 1301 (Paris, Bibliothèque nationale, hébr. 30; cf. hébr. 1314).

Bibliography
Ginsburg, *Introduction*, No. 37, pp. 667–674.
Stassof & Gunzburg, Pls. II–III.
Margoliouth, No. 52, I, pp. 21–23.
Leveen, p. 183.
Sassoon, *Ohel David*, I, pp. LI, 1–2; Pl. 26.
Nordström, *Bibles*, pp. 101–105, Fig. 25.
Narkiss, *HIM*, Pl. 1.
Metzger, T., Objets du Culte.
Sed-Rajna, Toledo.

Ibn Gaon Group, Soria and Tudela, c. 1300
[Nos. 3–6]

The brothers Joshua and Shem-Tov Ibn Gaon were active in Soria, in the northeastern part of Castile, during the first two decades of the thirteenth century. Joshua, the massorator, decorator and illuminator, is the more prominent of the two. His brother Shem-Tov is known to us only from one Bible (Sassoon, MS. 82), which he copied and signed in 1312.

Of the four manuscripts signed by Joshua Ibn Gaon, two are dated. The *First Ibn Gaon Bible* (Paris, Bibliothèque nationale, hébr. 20), which Joshua signed in the decorative Massorah Magna, was written in Tudela (Navarra) in 1300 (see Narkiss & Sed-Rajna, Ibn Gaon). In the *Second Kennicott Bible* (No. 3), which

he copied in Soria in 1306, he signed his name in the colophon of the plan of the Temple which precedes the text. In a third Bible (Paris, Bibliothèque nationale, hébr. 21) Joshua states that he executed the first quire; in the fourth, the undated *Dublin Ibn Gaon Prophets* (No. 4), he signed his name within the micrography in a way similar to that in his first Bible.

Although they are not signed, at least two other manuscripts may be attributed to the hand of Joshua Ibn Gaon: the *Oxford Ibn Gaon Bible* (No. 5), a manuscript of the Former Prophets with Aramaic Targum, and a Pentateuch in Parma (Biblioteca Palatina, MS. 2938); both may form parts of the same manuscript.

As the decoration in the Ibn Gaon Bibles is connected with the massorah, this suggests that Joshua should be regarded basically as a massorator artist. In both manuscripts where he signed his name in the decorated micrography of the Massorah Magna, he uses elaborate textual formulae invoking God to give him strength, and in one case (Paris, Bibliothèque nationale, hébr. 20, fol. 69r) he states explicitly that he is the scribe of the massorah.

All six manuscripts mentioned above show similar characteristics in motif and style. As a massorator, Joshua Ibn Gaon decorated the lower and upper margins with geometrical and foliage scrolls, grotesque dragons and text illustrations, using the micrographic Massorah Magna to outline the forms (see Metzger, T., Masora, pp. 103–105). In his decoration not related to the massorah, he fills some empty spaces in the spandrels of arches and in the corners of the Calendar circles, with designs in brown, red, blue and green inks and burnished gold. His typical motifs can be found in all his signed Bibles as well as in those attributed to him. Dragons, scrolls, fish and some animals are sometimes identical in the different manuscripts, pointing to the use of stencils as patterns. Moreover, the same type of dragon appears as painted decorations in full-page arcades as well as in the micrography. Pen-drawn dragons and animals, in spared-ground technique or in micrography with burnished gold fillings, appear in the *Second Kennicott Bible* (No. 3, fols. 5r–6r), as well as in the two Paris manuscripts (hébr. 20, fol. 8r, and hébr. 21, fol. 7v). These were drawn by Joshua Ibn Gaon, but they may have been coloured by an assistant since the painted and gilt decoration seems somewhat heavier than the pen drawing and micrography. The same applies to the painted animals illustrating the text in the *First Ibn Gaon Bible* (hébr. 20, e.g. fols. 13r, 49v, 54r, 72r, 114v) and the *Dublin Prophets* (No. 4, fol. 143r). In fact, only those illustrations which seem to have had stencil patterns are of fine draughtsmanship; the micrography is also outlined in plummet. The less accurately painted text illustrations, such as Noah's Ark (hébr. 20, fol. 13r) and the camel and an unclean bird (*ibid.*, fol. 114v), were probably drawn freehand.

The full-page panels in the signed Bibles comprise: (1) Decorated carpet pages (e.g. Kenn. 2, fols. 14r–15r, 117v; hébr. 20, fols. 1v, 9r, 9v; hébr. 21, fols. 1v–8r). (2) Decorated arcaded pages framing the list of precepts, massoretic notes and calendars (e.g. Kenn. 2, fols. 3r–13r; hébr. 20, fols. 3v–6v; hébr. 21, fols. 2r–7v; Oxford, Opp. Add. 4° 75, fols. 2v, 158v). (3) Rotating circular calendars (e.g. hébr. 20, fols. 2r, 7r–8v; hébr. 21, fol. 20r).

The spandrels of the arcaded pages and circular calendars are decorated with painted and spared-ground dragons and animals, as well as ornamental penwork.

Among the penwork motifs typical of Ibn Gaon's style is a rather spacious palmette scroll, sometimes incorporating a human head. A head of this type appears as a *parashah* sign in hébr. 20, fol. 103r. The only full-page illustration, a plan of the Temple, appears in the *Second Kennicott Bible* (No. 3). Isolated elements of the Sanctuary implements, similar in form to those depicted in the plan, appear as marginal text illustrations in the *First Ibn Gaon Bible* (hébr. 20, fols. 43r, 49v, 54r, 57r, 58r, 88v).

3. SECOND KENNICOTT BIBLE

Bodl., Kenn. 2

Bible, plan of the Temple and list of the 613 precepts.

General Data

Codicology

Vellum; II + 428 leaves; *c.* 308 × 235 mm. Text space (195–200) × (146–140) mm; height of the text space with Massorah 237–258 mm. Written in square Sephardi script, in brown ink, mostly 34 lines in two columns. The Massorah is in micrography, 2 lines in the upper and 3 in the lower margins. Ruling by stylus, 2 + 34 + 3 horizontal and 3 + 3 + 3 vertical lines. Pricking is noticeable in all margins. The book of Ruth (fol. 300r) precedes Psalms. The titles have been added in the left-hand corner of every recto, except for the Pentateuch. 39 quires of 12 leaves each, except for Quires I² (2 single leaves, fragments from a large folio, with the plan of the Temple, later bound as at present), II⁸, III³, XII⁸, XIX¹⁶, XXI¹⁰, XXXII¹⁰, XXXV¹⁰, XXXVIII⁹ and XXXIX⁴. The quires are marked with catchwords at their ends. Fol. 299v is blank.

Binding

Sixteenth- or seventeenth-century Turkish brown calf binding with a sunken central medallion, corners and frame. All the sunken areas are decorated with red floral scrolls on a gold ground, on applied pieces of leather (Pope, V, Pl. 978; van Regemorter, Pl. 42).

Colophon

fols. 1r, 2v (Figs. 11–12) On the back of the plan of the Temple, in a hand similar to that of the text of the Bible, and at the end of a long descriptive text relating "the planning and erection of the Temple of our God in its place... and I wrote and painted (כתבתי וציירתי) this, I... Joshua b. Abraham Ibn Gaon of Soria, as I have learnt from... R. Isaac b. Gershon... (and I did it) for the dear and noble... R. Moses 'n Haviv... and that love to me should always be in his mind I painted for him and his sons... the structure of the Temple... Completed in Adar תתרסו" (5066; 16 February to 16 March 1306). The name of Moses 'n Haviv and the date of completion were added after the completion of the colophon, in a fainter ink, though in the same hand.

Scribe's notes

fols. 38r, 44r, 110r (Fig. 24), *118r and in many other folios* "Blessed be God for ever and ever. Amen and amen." A conventional invocation of Joshua Ibn Gaon is found within the Massorah on many pages, mostly in the lower margin in the middle and at the end of quires. Nowhere is the scribe's name mentioned.

History

fol. 427v Sale inscription: R. Shamuel Parzant (פארזנט) bought the manuscript from R. Nissim b. Aaron ha-Kohen for 2,500 Damascene coins on Monday, the 8th of Marheshvan 5279 (2 October 1519).

Decoration

The entire decoration of the manuscript is painted in similar shades of red, green and some blue; many burnished gold shapes are outlined in red or black. The plan of the Temple has some additional purplish brown and light ochre, which also occurs in the last panel (fol. 427r). All the frames, objects and grotesques have pen underdrawings.

Programme

A. Fragments of Temple plan.
B. Full-page frames for the colophon of the Temple plan.
C. Framed and arcaded pages for the list of 613 precepts.
D. Full-page carpet panels and frames.
E. Half-page carpet panels.
F. Gold frames for massoretic notes.
G. Decorative *parashah* signs.
H. Decorative micrography of Massorah Magna.
I. Traditional "large letters".

Description

A. *Fragments of Temple Plan.*
fols. 1v–2r (Figs. 9–10) These two folios are two fragmentary quarters of a large sheet of vellum, depicting the plan of the Temple. They are bound wrongly: the top part of fol. 2r was originally connected upside-down to the top of fol. 1v. Together they formed the right-hand side of the plan, which was twice as large and the left-hand side of which is missing. The original ground plan portrays vertical architectural elements — such as gates, chambers and ramps — as if laid on the ground. The same applies to the Temple implements and other furniture.
The plan is outlined in ink, and some of the walls and most of the arched gates are filled in with red, green, blue, brown and yellow; a few of the implements are in burnished gold. The description follows the original form of the plan, starting from the bottom (east) of fol. 1v upward. Although the inscriptions on fol. 1v are almost invisible now, they are still discernable under ultra-violet light. The different components of the plan are

numbered here (in parenthesis) to facilitate their identification on the transparent pages laid on Figs. 9, 10. The Temple is surrounded by a wall (1), of which only the battlements, shaped like arrow-heads, survive. Within the outer walls are the words (2): רוח דרומית, "south wind", inscribed twice, once at the bottom right of fol. 1v and once at the top right of fol. 2r. However, according to the actual layout of the Temple it should be north. This mistaken inscription led the artist to misplace some of the implements and edifices in the plan (see following description and conclusions). At the top of fol. 2r is inscribed (3): רוח מערבית, "west wind" (in its right place on the plan).

fol. 1v (Fig. 10) At the bottom of the page, between the battlements on the right, is the red outline of a domed house, inscribed (4): לשכת בית אבן (על פני הבית) צפונית מזרחית ובה מפרישין כהן שורף, "A chamber called the House of Stone in the northeastern corner of the Temple, and there was set apart the priest who burns (the red heifer)" (Mishnah *Parah* 3:1). To the left of it is the inscription (5): הר הבית חמש מאות אמה על חמש מאות אמה, "The Mount of the Temple (measured) 500 cubits by 500 cubits" (Mishnah *Middot* 2:1). Further to the left, under a green and red canopy, the letter *shin* is still visible (6), probably the beginning of the word שער, "Gate", to denote the Gate of *Shoushan*, the main eastern gate to the Temple mount (*Middot* 1:3). Under it is inscribed (7): מקום, "Place", probably to denote the place where the High Priest burned the heifer (*Middot* 1:3). To the right of the gate is a recess in the inner wall, inscribed twice (8): פירצה, "Breach"; according to *Middot* 2:3, there were thirteen breaches, made by the Hasmonaean kings, in the *soreg* (9), a latticed railing which surrounded the Temple. The twelve red steps connecting the *soreg* and the Temple, in a space called *ḥel*, חל, "Rampart" (11) (*Middot* 2:3), are inscribed (10): שתים עשרה המעלות, "The twelve steps". These lead up to a small green arch, inscribed (12): פשפש, "Wicket" (*Middot* 2:6). On the right of this wicket is the eastern gate of the Women's Court (13), called Nicanor Gate, a large, red and green trefoil horse-shoe arch; actually this gate connected the Court of the Women with the Court of the Israelites. To the right of a second wicket — also inscribed (14): פשפש — is another arch, inscribed (15): לשכת פנחס המלביש, "Chamber of Phinehas, the Keeper of the Vestments" (*Middot* 1:4). To the right, the wall of the Temple is inscribed (16): כותל עזרה, "Wall of the *Azarah*" (the Temple court). Under it, in the *ḥel*, is inscribed (17): מחנה לויה, "Camp of the Levites". At the corner of the Temple wall is a green edifice, inscribed (18): מקום השומרי׳, "Place of the watchmen" (*Middot* 1:1). Under the Nicanor Gate, within the *ḥel*, is a red gate, inscribed (19): לשכת הפר[גוד] והלוים

שומרי׳ מתוכה, "Chamber of the Screen, and the Levites keep watch from inside" (Mishnah *Kelim* 29:1). At the right top of the page, in the wall of the Temple Mount, was another gate, which has been cut off: the Tadi Gate (20) (*Middot* 1:3), and near it an inscription (21): מקום השומרים, "Place of the watchmen". In the *soreg* (9) on the north side are four recesses, inscribed (8): פירצה, "Breach". On fol. 1v, only seven of the nine red and green arches in the northern wall (according to the Mishnah) of the Temple are inscribed. The first arch from the bottom has a circle of dots like a courtyard around it, inscribed (23): לשכת העצים אינה מקורה, "Chamber of the Woodshed, not roofed" (*Middot* 2:5). Next to it is (24): שער הנשי׳, "Gate of the Women", and (25): שער השיר, "Gate of Singing" (according to Mishnah *Middot* 2:6 these two gates should have opened to the Court of the Israelites, and not to the Women's Court). Next to this is the arch to (26): לשכת מצורע אינה מקורה, "Unroofed Chamber of Lepers", surrounded by dots, like the previous chamber. All the gates and chambers mentioned so far open on to the Court of the Women (27). The next, larger arch, which opens on to the Court of the Israelites (28), is called (29): שער הניצוץ, "Gate of the Flame" (*Middot* 1:5); a horizontal green band in the plan (30) might indicate that this gate was on two levels. Between the Court of the Israelites and the Court of the Women is a horizontal brown band with three arches, inscribed (31): ולשכות היו תחת עזרת ישראל, "And there were chambers beneath the Court of the Israelites" (open to the Women's Court). There the Levites stored (32): כנורות ונבלים, "Fiddles and Harps", and (33): מצילתים, "Cymbals" and other musical instruments (*Middot* 2:6). To the left of these chambers are semi-circular bands in red, brown and green (34), indicating the fifteen steps that led from the Court of the Women to the Court of the Israelites, where the "Songs of the Grades" (Psalms 120–134) were sung (*Middot* 2:5). The horizontal blue strip (35) above the Gate of the Flame indicates the partition between the Court of the Priests (the Holy Place) and the rest of the Temple (*Middot* 2:6). To the right of it are two uninscribed gates, one smaller (36) than the other (37), with arches towards the *ḥel*. These may indicate the openings in the Gate of the Flame to the *ḥel* (*Middot* 1:5). Above them are the last two gates (38): שער הקרבן שבו מכניסין קרבן למטבחי׳, "Gate of the Offering, where the offerings were brought in to the slaughter-house", and (39): שער המוקד, "Gate of (the House of) the Hearth" (*Middot* 1:5). This last gate is separate from the House of the Hearth (40), which is a round, elongated edifice within the *ḥel*, outlined in green with red arches. According to *Middot* 1:6–9, the House of the Hearth had two gates and four

appended chambers; here, there are two gates (44) and five chambers (41). Two of the chambers are on its "holy side", and two on its "secular side", the fifth is divided between them. The border-line between the "holy" and the "secular" sections within the House of the Hearth is indicated by a dotted line, inscribed (42): ראשי פספסין, "Ends of flagstones". On a hook within the holy section hang two large keys of the court (43) which were used by the Elders of the priestly families, who slept in the House. Two gates (44) open from the House of the Hearth, one to the *hel* and the other to the Court. Inside the Temple Court, behind the Gate of the Offering and the Gate of the Hearth, is a green triangle, inscribed (45): מקום השומרים, "Place of the watchmen". To the left is the slaughtering area of the porch. Each of the eight red pillars (46), called *nannaṣim*, has three iron hooks (like a fleur-de-lis) at its top, on which the slaughtered animals were hung. Between the pillars is a herring-bone decoration. The inscription under the pillars is (22): בית המטבחים לצפונו של מזבח, "The slaughter-house to the north of the altar" (*Middot* 3:5). To the left are four double-framed squares (47), indicating the marble tables, on which the animals were skinned. Nearby are six rows of four compartments each (48); 22 contain the rings to which the animals to be slaughtered were bound (*Middot* 3:5). To the left of the rings can be seen two steps of the sacrificial altar (49), a section of an implement inscribed: בזך לק..., "bowl for..." collecting the blood (50), and smaller steps to the Holy Place (51) with part of its green and red double doors (52) (*Middot* 4:1).

On top of one of the columns is an inscription (55) שמר "watchman" (*Middot* 1:1). Above the row of rings and the tables is a guitar-shaped musical instrument (53), called *magrefah*, with a short, wide neck, ending in a double-faced eagle. It has four strings, ten round holes and is studded around the borders with dots. The inscription above and below it says (54): מגריפה אחת ועשרה נקבים היו / לה כל אחד מוציא מאה מיני זמר נמצאת כולה אלף מיני זמר, "A *magrefah* (was in the Temple) and it had ten holes, each of which produced a hundred kinds of song, amounting for the whole to one thousand kinds of song" (TB *'Arakhin* 11a). According to Mishnah *Tamid* 5:5, it used to utter these sounds when it was thrown "between the porch and the altar". Above the *magrefah* to the right of the double doors are a gold scroll and clusters of grapes bordered by two vertical green lines (56), which are continued on fol. 2r, and inscribed there: גפן זהב, "Golden vine" (*Middot* 3:8). In the next section to the right (on fol. 2r) is the golden chain (57), which was fixed to the roof-beam of the porch and on which the young priests climbed to see the crowns in the ceiling (*Middot* 3:8). In the same compartment (on fols. 1v and 2r) are three knives (58) above brown, deep bowls, probably indicating the place where they were kept, the Chamber of the Slaughter-Knives (*Middot* 4:7). A double red band across the last two sections, running in a curve, continued on fol. 2r, may indicate the tunnel (59), which, according to *Middot* 1:6, 9, was called *meṣibbah*. This tunnel ran under the porch to the place of immersion and led to the Tadi Gate (20). The rectangular red band on the top right of fol. 1v is the eastern wall of the Chamber of Hewn Stone, the *Lishkat ha-Gazit*, the seat of the Great Sanhedrin (60), which is continued on fol. 2r as an elongated, rectangular ground-plan of a building. In its lower part (fol. 1v) is a roundel with a dotted circle inside, and an illegible, round inscription outside (61). On the right wall are four recesses, inscribed (62): חלון, "Window".

fol. 2r (Fig. 9) The two large gates in *Lishkat ha-Gazit* — one inscribed (63): פתח פתוח לקדש, "Entrance to the Holy", and the other (64): פתח פתוח לחל, "Entrance to the secular" — were used by priests, who were either accepted to serve or disqualified from serving in the Temple by examination of the Great Sanhedrin, which sat as shown in the plan by a semi-circular golden band, inscribed (65): סנהדרין יושבין, "Sanhedrin seated", (*Middot* 5:4). The president of the Sanhedrin was seated on a large, golden chair decorated with interlacing geometrical patterns and inscribed (66): קתדרה, "*Qatedrah*". Above, within the Temple wall, are three domed chambers. The first, with a draw-well inside, is inscribed (67): לשכת הגולה, "Chamber of the Diaspora", where the *golah* cistern was, with a wheel above it to draw water for the Holy Place (*Middot* 5:4). Next to it — somewhat overlaping, to show that it is on a second storey — is (68): לשכת בית אבטינס, "Chamber of *Bet Avtinas*" (*Middot* 1:1); according to the Talmud this chamber was next to the Gate of the Court (28, see TB *Yoma* 19b). The third chamber is (69): לשכת העץ היא לשכת כהן גדול אחורי שתיהן וגג שלשתן שוה, "Chamber of Wood, the chamber of the High Priest (which was) behind the other two (Chamber of the Diaspora and Chamber of Hewn Stone), and the roof of the three (was on the) same level" (*Middot* 5:4. According to the Mishnah all four chambers should be on the south side of the Temple and not here). An arch in the top right-hand side of the Court is inscribed (70): שער יכניה שבו יצא בגלותו, "Gate of Yekhoniah, where he went into exile" (*Middot* 2:6). In the corner of the Holy Place is a green arch, inscribed (71): מקום השומרים, "Place of the watchmen" (*Middot* 1:1). Outside the Holy Place, in the *hel*, are four red arches, inscribed (72): לשכות לשמוש הכהנים והלויים, "Chambers for the use of the priests and the Levites".

Round the Holy Place, within the thick walls to the right and top, are five and one "cells", תאים (73 and 74), separated by fleur-de-lis partitions. According to the Mishnah (*Middot* 4:3) there were 15 cells, in three stories in the north and three stories in the south; but only 8 cells in three stories in the west. Each cell had 3 entrances, depicted here as recesses and arches, each inscribed (75): פתח, "Entrance". In the top right-hand corner is a diagonal red band surrounded by a yellow spiral, the passage-way (*meṣibbah*), inscribed (76): מסיבה זו היתה עולה מקרן צפונית ומערבית שבה היו עולין לגגות התאים היה עולה למסיבה..., "This *meṣibbah* went up from the north-west corner (*Middot* 4:5 mentions this *meṣibbah* as being in the north-east corner of the Holy Place), by which they could go up to the roofs of the cells; (the priest) went up the passage-way". To the right is an aperture inscribed (77): לול, "Passage"; this is one of the "small passages in the loft leading into the Holy of Holies, through which workmen were lowered in boxes" (*Middot* 4:5).

In the Holy Place itself, only three angular branches of the seven branched golden *Menorah* are extant (78), with bowls, knops, flowers and red flames, inscribed between the first and the second branch (79): וזה משפטיה, "And this is its mode". Under the branches is a golden bowl, inscribed (80): כן זהב, "Golden stand". On top are a golden vessel (81), a square fire-pan (82), two bowls and two brown utensils, inscribed (83): בזיכי לבונה, "Incense censers". Near the north wall of the Holy Place — which is filled with circles to indicate the cedar logs (84) of which it was built — is a long, green, hooked pole, resting on one side on a split, brown log; it is inscribed (85): מקום הַטְרַקְשִׁין, "Place of the *traksin*". The *traksin* is supposed to have been the cedar-covered partition between the Holy Place and the Holy of Holies (*Middot* 4:7). Nothing of the Holy of Holies is shown in these fragments of the plan.

B. *Full-Page Frames for the Colophon of the Temple Plan.*

Two full-page frames surround the colophon of the Temple plan and the preceding eulogy (fols. 1r and 2v; *c.* 192 × 142 mm). They consist of dense, multiple, interlacing, spared ground frets on a red ground (fol. 1r – Fig. 11) and two intersecting guilloches on red and green grounds, forming a diamond shape filled with red, green and ochre (fol. 2v – Fig. 12).

C. *Framed and Arcaded Pages for the List of the 613 Precepts.*

There are twenty-one framed pages for the lists of the 613 precepts, in their order of sequence in the Pentateuch, written in two columns, 36 lines per page (fols. 3r–13v; the last one unframed). The frames measure (205–215) × (156–160) mm. They are angular fillets, in different colours and gold, framing each column separately. Most of the pages have two horse-shoe arches within the frames (e.g., fols. 3r–4v, 5r – Fig. 13, 8v–9r and 12v–13r); others are trefoil pointed (fols. 5v – Fig. 14 and 10r – Fig. 16), ogee (fol. 6r – Fig. 15) or cinquefoil (fol. 9v) arches. The spandrels of the arches are decorated with dragon and bird grotesques (e.g., fols. 3r, 5r, 6r, 8v, 9v–10r and 12r–v), penwork (e.g., fols. 3v–4v, 5v and 9r) and foliage scrolls (fol. 13r). Fols. 6v–7r have a gold scroll on a red ground between the columns. The dragons and birds are either in gold (e.g., fols. 3r, 6r and 9v–10r), or in spared ground (e.g., fols. 5r and 12r–13r) on red or green grounds. The penwork, in red and violet, consists of large, spacious scrolls on the vellum ground, with palmette, club or floral motifs. The horse-shoe arches on fols. 3r–5r rest on fillet columns with half-capitals and bases and no bottom frame.

D. *Full-Page Carpet Panels and Frames.*

The four full-page, rectangular, decorative carpet panels at the beginning (fols. 14r–15r) and at the end of the Pentateuch (fol. 117v), each measuring (192–200) × 145 mm, are decorated with interlacing geometrical patterns, framed by gold bands on the vellum ground (fols. 14r, 15r and 117v), or by spared ground bands with coloured ground fillings, some decorated with brushwork (fol. 14v). On fol. 15r (Fig. 17) there is a star in the centre, enclosing a three-towered castle — the arms of Castile.

The panels are framed by wide bands, carrying inscriptions in gold on a red ground (fol. 14r), inscriptions in red on the vellum ground, either bordered by green fillets (fol. 14v), or outlined in ink and red on the vellum ground (fol. 117v). The frame on fol. 15r has a stylized acanthus scroll in gold on a red ground.

Similar borders with gold script on the vellum ground, bordered by coloured fillets, frame the list of *ṣedarim* at the beginning of the Latter Prophets (fols. 204v and 205r; 194 × 147 mm), with inner frames of coloured fillets for the two text columns.

E. *Half-Page Carpet Panels.*

There are two single-column decorative panels, one at the end of the Latter Prophets (fol. 299r; 195 × 65 mm) and another at the end of the Hagiographa (fol. 427r; 193 × 60 mm). Each is decorated with a double, stylized acanthus scroll; on fol. 299r (Fig. 18) it is in gold with red, green and blue ground fillings, and on fol. 427r, pen-drawn and tinted light ochre and red on the vellum ground. The scrolls have large curls set in pairs, the curls of each pair intersecting and enclosing similar mirror-image motifs issuing from the curls. The

motifs on fol. 299r are grotesque heads, palmettes and stylized acanthus. On fol. 427r they are three-lobed, stylized flowers, with symmetrical red foliage motifs interlacing with the ochre curls of the main scroll. In both panels the scrolls terminate in dragons' heads at the bottom.

F. *Gold Frames for Massoretic Notes.*
The massoretic notes at the ends of many books have gold frames within the width of one text column (59–54×57–63 mm). The gold fillets are outlined mainly in red (e.g., fol. 299r – Fig. 18).

G. *Decorative* Parashah *Signs.*
The decorated *parashah* signs are mainly in gold, with a coloured outline and coloured ground fillings above the abbreviation פרש (*parash*), written in ink on the vellum ground within a small rectangular frame. The frames are mostly rectangular, sometimes with interlacing bands at the corners forming small squares (e.g., fols. 30v, 49v, 76r – Fig. 22 and 90r). Other frames form eight-pointed stars (e.g., fols. 20r, 56r and 66r).
The large (height 27–67 mm) decorative motifs on top are:
1. Often supported by single or double bars (e.g., fols. 30v, 34v, 69r and 88v), thus resembling a tree. The motifs consist of a symmetrical palmette, mostly of an inverted heart shape enriched by additional interlacing bands (e.g., fols. 28r, 30v, 34v, 45r, 51r, 53r and 88v), some with additional curls (e.g., fol. 49v) extending to the sides. Other motifs are more foliated and have a fleur-de-lis in the centre (e.g., fols. 17v, 76r – Fig. 22, 86v and 115v).
2. Stylized trees, consisting of fleurs-de-lis, alternating with small circles, and often supported by a small triangle (e.g., fols. 20r, 22r, 24v, 32v, 56r, 58v, 85r, 91v and 102v). Some have additional framing bands (e.g., fols. 47r and 66r) or richer foliage and supporting bars as in Type 1.
3. Elongated, reversed gold pearls flanked by gold, coloured or pen-drawn foliage motifs (e.g., fols. 79v, 82v, 90r and 105r), or placed on top of a bar and flanked by two pen-drawn (coloured on fol. 73r) grotesque heads (e.g., fols. 37r, 52v and 100r), some motifs with additional gold (e.g., fols. 70v – Fig. 21, and 73r) or pen-drawn (e.g., fol. 64v) foliage shapes.

H. *Decorative Micrography of Massorah Magna.*
The micrography in the upper and lower margins is written in decorative forms, mostly on the first, last and two middle pages of each quire. The patterns on opposite pages are often similar or identical. They generally enclose gold penwork or coloured motifs (some in silver, e.g., fols. 86r, 88r, 95v and 97v), which, since they mostly follow the micrography pattern, consist of small lozenges,

squares, triangles, circles, roundels, short bars, stars, small stylized foliage and other motifs described below. The main patterns of the micrography are:
1. Different variations of intersecting lozenges (e.g., fols. 15v, 16r, 67v and 85v), quatrefoils (e.g., fols. 15v, 74r, 257v, 275v and 276r), semi-circles (e.g., fols. 16r, 73v and 239v–240r – Fig. 25), circles and sections of circles (e.g., fols. 159v–160r and 257v–258r), ovals (e.g., fols. 37v – Fig. 20, and 62r), stars (e.g., fol. 86r), or different combinations of lozenges, X- and V-shapes and zigzags (e.g., fols. 43v–44r, 49v, 79v–80r, 135v–136r, 147v–148r, 206r and 381v–282r).
2. Angular plait patterns of two bands (e.g., fols. 20r, 37v – Fig. 20, 73v, 79v–80r, 103v–104r and 147v–148r), three (e.g., fols. 62r and 91v – Fig. 23) or four bands (e.g., fols. 38r, 49v, 67v, 104r, 110r – Fig. 24, and 113v); some consist of single interlacing Massorah lines rather than bands (e.g., fols. 129v–130r, 141v–142r, 171v–172r, 183v–184r, 222v–223r, 293v–294r and many others) which also form rounded patterns of knots (e.g., fols. 25v–26r, 43v, 92r, 118r, 212r and 329v–330r). The motifs formed by single lines are generally more richly decorated with the small gold and coloured shapes (e.g., fol. 76r – Fig. 22).
3. An angular meander (e.g., fols. 26r and 58r).
4. Stylized acanthus scrolls (e.g., fol. 31v – Fig. 19) or interlacing foliated scrolls (e.g., fol. 37v – Fig. 20).
5. Different motifs in the centre of the top or bottom Massorah lines, mostly triangles, V-shapes, ovals, circles, semi-circles, lozenges, pear shapes and also many different interlaces, mainly heart-shaped (e.g., fols. 47v, 55v–60r, 86r, 114r, 154r and many others), some with a fleur-de-lis at the top or bottom (e.g., fols. 39v–40r, 76r – Fig. 22, 178r, 181v–182r, 363v–364r and others), fleurs-de-lis (e.g., fols. 38r, 55v, 68r, 190r and 227v–228r) and a star-shaped interlace with one lozenge on top and another below (e.g., fols. 31v–32r, 153v, 166r, 177v, 257v, 287v and 341v–342r).
6. Massorah lines decorated with circles (e.g., fol. 110r – Fig. 24) — or sometimes lozenges (e.g., fol. 67v), knots (e.g., fol. 91v – Fig. 23) or other shapes — at their ends, middles or both, some of the plait patterns of single lines forming three knot motifs along the margin. The single motifs mostly enclose gold circles, lozenges, squares, stars and other shapes, with additional penwork decoration. Among the gold and coloured motifs enclosed in the micrography shapes of most types are also many *lions rampant* (arms of Leon), three-towered castles (arms of Castile), and fleurs-de-lis (arms of Aragon) (e.g., fols. 72v, 76r – Fig. 22, 87v, 94r, 98r, the lion is in colour; 102r, 120r, 156v–157r, 193v–194r, 285v–286r and many others), alternating with eight-pointed stars which fill

micrography knots on fol. 142r. There are also crescents and stars or rosettes on fols. 265v and 266r; a *lion passant* on fol. 93v; gold bars, mostly flanking other motifs (e.g., fols. 305v–306r, 329v–330r, 335v–336r, 341v–342r and 381v); and bands with penwork (e.g., fols. 154r, 165v and 206r), or with a spared ground plait (e.g., fols. 166r, 177v and 239v–240r).

7. Gold and painted motifs, which sometimes form the main decoration of the upper and lower margins, consisting of different combinations of X- and V-shapes, with other angular motifs and small lozenges (e.g., fols. 19v–20r, 25v, 104r, 130r, 141v, 154r, 171v–172r, 197v–198r, 272r – Fig. 26, 374v, 381v – Fig. 27 and others), or a row of stars alternating with small lozenges (e.g., fol. 48r). The micrography lines form general outlines for the decoration of each margin as a whole.

I. *Traditional "Large Letters"*.

The traditional "large letters" of the Bible are written in gold outlined in red (e.g., fol. 299r – Fig. 18).

Conclusions

This is one of the most important manuscripts of Joshua Ibn Gaon from Soria. Although its colophon on fols. 1r and 2v (Figs. 11–12) pertains only to the two fragments of the Temple plan, there are other elements which help to attribute the entire manuscript to Ibn Gaon's *atelier*. The medium size of the book and its decoration programme, with carpet pages, arcaded pages, golden *parashah* signs, ends of books and decorated Massorah in micrography with added gold, silver and coloured motifs are some of the features common to most of his Bibles. Joshua Ibn Gaon's small, somewhat angular script can be found in the colophon of the Temple plan and in the lists of precepts under the arcades, as well as in the main text of our Bible. The formula "Blessed be God for ever and ever. Amen and amen", which is commonly found in the Massorah at the end of quires in other Bibles by Joshua Ibn Gaon, is also found here, though here it does not contain the name of the scribe (e.g., fol. 110r – Fig. 24). The decorative motifs in the spandrels of the arches — such as grotesque dragons in spared ground or colours on a gold ground or *vice versa* — and the spacious penwork framed by heavy gold fillets are typical of Joshua Ibn Gaon's *atelier*. The arms of Castile (a three-turretted castle), Leon (*lion rampant*) and Aragon (fleur-de-lis), which appear together or separately in the decoration, are favoured by our scribe-massorator-artist as decorative motifs. The lightly coloured fret motif framing the colophon and the heavy, painted scrolls framing the large emblem of Castile (fol. 15r – Fig. 17) are quite often found in other Ibn Gaon manuscripts.

The plan of the Temple is mainly dependant on the Mishnah, Tractate *Middot*, though it contains some peculiarities, e.g., the *Menorah* (78) appears on the right (south) of the Holy Place and has square branches. This may be explained by noting Ibn Gaon's mistake in calling the north side of the Temple, which is on the right-hand side of the plan, "south wind" (2). Nevertheless, most of the edifices, gates, chambers and courts are placed correctly, as though the right-hand side of the plan was north, disregarding the inscription "south wind". The other major mistake is that three chambers — those of the Hewn Stone (60), the Diaspora (67) and the Wood (69) — are depicted on the top right of fol. 2r (according to the Mishnah *Middot* 5:4 they should have been on the south side of the plan). Another misplaced edifice is the *meṣibbah* (76) going up the roof of the Holy Place, which is in the northwestern corner (even the inscription indicates it), while according to *Middot* 4:5 it should have been in the northeastern corner. These mistakes could not have been made on purpose, and could not in any case represent a tradition different from the Mishnah, which was no doubt known to Joshua Ibn Gaon and to his teacher Rabbi Isaac b. Gershon. If not an artist's copying error, this may represent a visual tradition, which although erroneous, was faithfully copied. There is no other knowledge of this teacher, Rabbi Isaac b. Gershon, nor of his writings, which might have explained these peculiarities. This type of Temple plan is quite unique in Hebrew biblical manuscripts of the Sephardi School, in which a haphazard array of Temple and Tabernacle implements is usually found. This haphazard arrangement may hark back to synagogue floor mosaics in the East in the fourth to sixth centuries. The idea of a plan, rather than their arrangement is known from earlier Hebrew illuminated manuscripts such as the plan of the Tabernacle in the *First Leningrad Bible* of 929 from Fustat, now in Leningrad (Public Library, MS II.17; see Narkiss, *HIM*, Pl. 1), although there, too, the arrangement of the different implements is not exactly according to the Bible. A plaster grafitto found in the Jewish Quarter of Jerusalem with a *Menorah*, segments of the shew-bread table and incense altar, may have been a Temple plan from the time of Herod's Temple, since these implements are placed correctly in relation to one another (Narkiss, Sanctuary). The array of implements in the *First Ibn Merwas Bible* (above, No. 2), which resembles a fragment of a plan, is also full of incorrect placements and has many unidentified objects. Most of the Temple plans in mediaeval Hebrew manuscripts appear in Maimonides' *Mishneh Torah*, Book VIII: 4 and in his commentary on the Mishnah, *Middot* (Wischnitzer, Maimonides, and relevant literature). Other such plans appear in

Rashi's commentary on the Pentateuch (Narkiss, Sanctuary, pp. 14–15), and subsequently in the Latin Bible commentaries written by Peter Comestor (Nordström) and Nicolaus de Lyra (Rosenau). Most of these plans are diagrammatic and scanty, and not as painterly and detailed as that of Ibn Gaon's, in which every architectural detail is identified and every implement clearly outlined. While Joshua Ibn Gaon may have had models from which to fashion his plan, it is also possible that he invented the shape of some objects and even their placement.

This illuminated Bible and Temple plan is second in a series of manuscripts, all of which have similar elements and were copied, massorated and painted by Joshua Ibn Gaon (see introduction on pp. 22–23).

Bibliography

Neubauer, No. 2323.
Zotenberg, No. 30, p. 3.
Stassof & Gunzburg, Pls. II–III.
Roth, Kennicott, *Sefarad*, 1952.
Roth, Antecedents, p. 37, n. 1.
Schirmann, *Hebrew Poetry*, II, Pl. 11 (two pages from the First Ibn Gaon Bible).
Nordström, Peter Comestor.
Rosenau, Nicolaus de Lyra.
Metzger, T., Objets du Culte (with extensive bibliography on the Sanctuary implements).
Narkiss, *HIM*, Pl. 1.
Narkiss, Sanctuary.
Narkiss & Sed-Rajna, *Ibn Gaon*.
Beit-Arié, Date.
Van Regemorter, *Some Oriental Bindings in the Chester Beatty Library*, Dublin 1961, Pl. 42.

4. DUBLIN IBN GAON

Tudela, c. 1300

TCLD, MS. 16

Figs. 28–42

Latter Prophets and Hagiographa.

General Data

Codicology

Vellum; III + 186 + I leaves; *c.* 287 × 232 mm. Text space 215 × 160 mm; width of single column 70 mm; height of the text space with Massorah 258 mm. Written in square Sephardi script, in dark and light brown ink, 35 lines in two columns, except for Psalms, Job and Proverbs, which are written in one column. Massorah Magna in smaller square script, 2 lines in the top and 3 in the bottom margins; Massorah Parva in a single column in the outer and inner margins and between text columns. Ruling by stylus, 2 + 35 + 3 horizontal and 2 + 3 + 2 vertical lines. Pricking is noticeable in the inner margin, mainly for horizontal lines. 20 quires of 12 leaves each, except for Quires I^4 and II8, both forming one original quire of 12 leaves (the second quire is wrongly bound and should be inserted in the middle of the first; no text is missing); V^{10-1}, of which the last folio (Ezek. 1:12–4:4) is missing after fol. 45v; VII8; VIII10; IX^{8-1}, of which the last folio is cut off, although no text is missing; XIX2; XX6, of which two folios were originally blank. Many catchwords in the lower left-hand margin of the last folio in the quires. Decorated Massorah at the beginning and end of quires.

Strange original order of books in the Hagiographa: Ruth, Psalms, Job, Proverbs, Ecclesiastes, Song of Songs, Lamentations, Daniel, Esther, Ezra, Nehemiah and Chronicles.

Binding

Brown morocco binding on wooden boards, decorated with blind tooling, with metal corners and the remains of two metal clasps. The decoration on each cover consists of a large central oval, deeply tooled, with foliage scrolls and a smaller raised oval in the centre. Framed by a rectangular linear border decorated with vases and papyrus flowers in the corners and at all four angles. Binding not later than the seventeenth century, as evidenced by an owner's signature of this date found on the inner wooden board of the front cover.

Unidentified watermarks on fol. II: three circles topped by a Maltese cross. In the lower circle, the initials $_A^S$; in the central circle, 00; and in the top circle, an inverted crescent.

Colophon

None.

Scribe's Note

fol. 13r (Fig. 28) Joshua Ibn Gaon, the massorator, wrote his name in micrography in the lower margin of the Massorah, in a formula he used often in other manuscripts: "Blessed be God, who gave strength to his

servant, son of his maidservant Joshua 'n Gaon (עבדיה בן אמתיה יהושע ו' גאון). Blessed be God for ever. Blessed be He who gives strength to the weary. Amen and Amen."

Other invocations typical of Joshua Ibn Gaon are to be found in the Massorah in the bottom margins of fols. 37r (Fig. 29), 58r, 76r, 156r and 166v (see below, Conclusions).

History

fol. 185r Birth of a son on the 7th of Kislev 5308 (19 November 1547).

fol. 186r Birth of a son, Benvenisti, on Tuesday, the 1st of Adar.

fol. 184r Seventeenth-century owner: "Bought it with my money for the worship of my Lord... Solomon Ibn Daulan (דאולן) b. Samuel." This signature is also on the inner front cover paper stuck to the wooden board.

fol. 184v Seventeenth-century owner: "Since I received this book as a present from my father and mother, I wrote my name here to proclaim that it is mine, Abraham." Possibly written by Abraham Ibn Isaac Garibi (גריבי), who signed his name twice: on fol. 185v, as well as on the inner front cover where he also signed "Abran Haribi" in Latin characters.

fol. 184r Eighteenth-century owner: "Bought it with my own money for the worship of my Lord... for the sum of fifty clears (נקויות?), Jacob Shalit (שליט)."

fols. 185v, 186r Eighteenth-century owner: "This book belongs to Jonah Navaro (נבארו)..."

fol. IIv "The Gift of Major Clanaghan (of Gibraltar) in 1748." Former shelf-mark: M.2.6.

Decoration

Programme

A. Decorative micrography of the Massorah Magna.
B. Framing panels to massoretic notes.
C. Fantastic animals, birds and grotesques.
D. Text illustrations.
E. Traditional "large letters".
F. Decorative signs for the middle of the books.

Description

A. *Decorative Micrography of the Massorah Magna.*

At the beginning and end of most quires, and sometimes in their middle, the lower (and at times also the upper) margins are decorated with massoretic micrography in different shapes. Most of the decoration consists of geometrical forms, floral forms or animals. The motifs are: interlacing frets (e.g., fols. 1r, 36v, 75v–76r, 83r, 119r, 131r and 143r); geometrical bands (e.g., fols. 9r, 24v, 37r – Fig. 29, 46r, 51v, 58r, 65r, 94v, 118v and 130v); geometrical forms within the Massorah lines, such as circles, semi-circles, triangles and lozenges (e.g., fols. 19r, 21r, 107r, 142v, 148v–149r and 155r); interlaced arcades (fol. 25r); star of David (fol. 30r); open flowers (e.g., fols. 31r and 95r); interlacing foliage scrolls (e.g., fols. 13r – Fig. 28, and 154v); fleurs-de-lis (e.g., fols. 66r,

106v and 179r); dragons and other fantastic animals (e.g., fols. 101r – Fig. 30, 166v – Fig. 31, 167r – Fig. 32, and 178v); confronting fish (fol. 167r – Fig. 32). The micrography outlines the forms and is embellished with additional gold leaf, burnished silver and colours. The gold is outlined in red; the colours are red and violet ink. The foliage scrolls are devoid of colour. In two of the geometrical bands (fols. 24v and 37r – Fig. 29) there is additional penwork – scrolls and palmette motifs in red and violet. On fol. 37r (Fig. 29) there is a small drawing in red of a *lion rampant*, possibly an escutcheon of Leon.

B. *Framing Panels to Massoretic Notes.*

The massoretic notes at the end of each book are usually framed by a wide rectangular gold band outlined in red, the width of one text column. These are similar to the bands and geometrical gold shapes of the micrography (§A). The frames on fols. 72v (Fig. 33) and 74v have a gold guilloche interlace on a red ground; that on fol. 132v has a blue foliage scroll painted on gold, in the manner described in § C.

At the end of Psalms (fol. 109r – Fig. 34), Job (fol. 118v – Fig. 35) and Proverbs (fol. 126r) the panel, with its extension decoration, is across two text columns. The panels at the end of Ezekiel (fol. 65v), Ruth (fol. 84r) and Ecclesiastes (fol. 129v – Fig. 40) do not contain massoretic notes.

C. *Fantastic Animals, Birds and Grotesques.*

1. Most panels at the end of a book (§B) have painted fantastic animals, birds and grotesques, connected by foliage scrolls which partly frame the text column by extending on either side of it. One panel, at the end of Job (fol. 118v – Fig. 35), has extensions of geometrical and floral decoration, but no animals.

2. Fantastic animals, birds and grotesques appear at the beginning of some books when the text begins at the top of the column (e.g., fols. 1r, 73v, 83r, 133r, 140r and 154v – Fig. 36).

3. In the outer margins of the Book of Psalms the same fantastic animals surround, with geometrical interlacings, the Hebrew numbers of chapters, which are in gold (fols. 84v–109r – Fig. 34).

The fantastic animals, grotesques, foliage and the geometrical scrolls issuing from them, as well as the additional floral and geometrical motifs, are painted in different shades of blue, magenta, vermilion, red, brown, green and yellow, with some burnished gold and silver. White is used to highlight most colours; yellow is used to highlight the green. Most of the animals and foliage scrolls are elongated, thin forms, undulating elegantly.

Among the fantastic creatures can be discerned: little dragons with lions' heads and two claws, some with wings and some with extended tails (e.g., fols. 69v – Fig. 38, 72v – Fig. 33, 73r – Fig. 39, 75r–v, 77v, 78r, 81v, 83r, 85r–109r –

Fig. 34, 140r and 143v); small, draped dragons with scroll-like tails (e.g., fols. 65v, 68v – Fig. 37 and 154v – Fig. 36); hooded dragons (e.g., fols. 75v and 77v); double-faced dragons (e.g., fols. 75r and 126r); a winged dragon blowing a horn (fol. 72r); dragons' masks (e.g., fols. 81v, 84v, 86v, 87v, 133r and 154v – Fig. 36); lions' masks (e.g., fols. 45v, 65v – Fig. 37, 72r, 73r, 77v, 78r, 89r and 109r – Fig. 34); dragons' bodies with birds' neck, head and beak (e.g., fols. 20r, 72r–v, 75r–v, 84v, 88r–v, 89r, 92v, 93r, 95r–v, 98r–v, 100r, 101r – Fig. 30, 103v, 104r, 105v, 108r, 109r – Fig. 34, 143v and 154v – Fig. 36); a hooded, human-faced dragon with a vine leaf issuing from its mouth (e.g., fol. 87v).

Among the animals there are: two striding lions with foliage tails (fol. 69v – Fig. 38), leopards (e.g., fols. 76v and 78r), a stag (fol. 91r), does (fol. 73r – Fig. 39), some snakes (e.g., fols. 75r and 76v) and a lizard (fol. 129v – Fig. 42).

Among the birds there are: many herons (e.g., fols. 1r, 20r, 72v – Fig. 33, 78r, 84v, 85r–v, 88r, 89r, 91v, 92r, 94r, 98r, 100v and 143v), ducks (e.g., fols. 20r, 94v, 106r, 108v and 109r – Fig. 34), an eagle (fol. 94r) and a fish-bird (fol. 45v).

The vegetation that can be discerned is mainly of thin, intertwined scrolls, ending in elongated, single leaves (acanthus profile) or triple acanthus leaves. Some have extensions of clusters of triple leaves, fig and vine leaves and clusters of grapes. Roundels and palmettes decorated with gold foliage on blue and magenta grounds with white flourishes appear in the corners of two massoretic note panels (fols. 109r – Fig. 34, and 118v – Fig. 35).

D. *Text Illustrations.*

Some of the painted animals illustrate the text of the next book:

fol. 68v (Fig. 37) A locust standing near a tree and a vine scroll illustrate the text of Joel 1:4, which appears in the next column.

fol. 69v (Fig. 38) Two facing lions illustrate Amos 1:2.

fol. 73r (Fig. 39) Two does grazing illustrate the end of Jonah 4:11.

fol. 76v (Fig. 40) A horde of animals, partly effaced — including: a camel, an elephant, a leopard, a doe, a lion, a snake, a horse, birds, a giraffe, a dragon, a bird-headed dragon and the bust of a monkey and a monkey's mask — which illustrates Zephaniah 1:3.

E. *Traditional "Large Letters".*

All the traditional "large letters" of the Bible are written in gold (e.g., fols. 82v, 118v – Fig. 35, 129v – Fig. 42, 140r and 143r).

F. *Decorative Signs for the Middle of Books.*

The middle of most books is framed in gold (e.g., fols. 106r and 122r).

Conclusions

This manuscript, another of Joshua Ibn Gaon's Bibles, bears his signature not only in the micrographic Massorah on fol. 13r (Fig. 28) and in other invocations typical of his work, but is also carried out in his specific style. Some of the motifs used by him in other manuscripts, which also appear here, are the guilloche, the scroll, the fleur-de-lis, and especially the dragons and fantastic animals shaped in micrography. Some found here are so similar to those in other manuscripts that they may have been stencil-copied into the various manuscripts. This is the case with the confronting dragons on fol. 166v (Fig. 31; cf. Bibliothèque nationale, hébr. 20, fol. 12v; Metzger, Pl. CVII, Fig. 56); the confronting fish on fol. 167r (Fig. 32; cf. Bibliothèque nationale, hébr. 20, fol. 33r; Metzger, Pl. CVI, Fig. 49; Lisbon, Biblioteca Nacional, MS 72, fol. 83r, Metzger, Fig. 50; Parma, Biblioteca Palatina, MS 2938, fol. 233v; Metzger, Fig. 59); and also the foliage scroll in which he writes his name (cf. Bibliothèque nationale, hébr. 20, fol. 10v; Metzger, Fig. 36; Lisbon, Biblioteca Nacional, MS 72, fol. 19r, Metzger, Fig. 35; the *Second Kennicott Bible*, above, No. 3, fol. 37v; cf. Metzger, Fig. 37). However, such constant use of similar representations and techniques is by no means limited to Ibn Gaon's workshop. It is also found in other manuscripts from Toledo, Cervera (cf. Lisbon, Biblioteca Nacional, MS 72) and other centres in Castile. Nevertheless, the use of red and violet ink with gold and silver geometric motifs to embellish the micrographic shapes is typical of his work. The technique which develops later in Ibn Gaon's work is that of penwork scrolls and palmette motifs. As this technique appears only in two places in our manuscript (fols. 24v and 37r – Fig. 29), it is possible that this manuscript is earlier than the others, although one should bear in mind that it has no apparent date.

Joshua Ibn Gaon used both outlined Massorah and painted illustrations in the manuscripts which he signed, for example in his *First Bible* of 1300 (Paris, Bibliothèque nationale, hébr. 20). There the drawn and painted animals seem to have been done from the same model, e.g., the deer on fols. 20v and 114v in the *First Bible* (Narkiss and Sed-Rajna, Pls. V, X) and the cow on fols. 114v and 254r (Narkiss and Sed-Rajna, Pls. X, XII). There are many motifs similar to both our Dublin and Paris manuscripts, such as the short-winged stubby dragons on fol. 166v (Fig. 31) of our Dublin manuscript, and those on fols. 8r, 8v of hébr. 20 (Narkiss and Sed-Rajna, frontispiece), or the confronting fish in our manuscript on fol. 167r (Fig. 32), and hébr. 20, fol. 13r (Narkiss and Sed-Rajna, Pl. IV).

Joshua Ibn Gaon was responsible as massorator for the entire decoration of the manuscript. He no doubt planned and executed the framing panels at

the end of books, the "large letters" in gold and the mid-book signs.

It is, however, not certain that Joshua was responsible for the additional decoration of fantastic animals and scrolls. This type of motif does not appear in any of his other manuscripts nor does it seem to be typical of his style. The elegant rendering of the dragons, with highlights in white and yellow, points to a different origin. The contemporary manuscript which is close in style to our manuscript is the *Cervera Bible* of 1300, now in Lisbon (Bibliotheca Nacional, MS 72). Besides similar micrographic shapes, it has many fantastic animals rendered in the same technique, especially dragons and beasts painted over foliage scrolls. Compare, e.g., our fol. 79v with colophon fol. 434r

of the *Cervera Bible*. However, the density of composition in the *Cervera Bible* points at least to a different artist, if not to a different school. Another slight similarity is the highlighting of green leaves with yellow veins, e.g., the tree on our fol. 68v (Fig. 37) and that on fol. 316v of the *Cervera Bible* (*HIM*, Pl. 6); note, however, the dissimilarity in compositional density: the tree in the *Cervera Bible* is less dense.

Bibliography

Narkiss, *HIM*, Pl. 6.
Narkiss & Sed-Rajna, Ibn Gaon.
Metzger, T., Masora.
Narkiss, Relation.

5. OXFORD IBN GAON

Soria, c. 1300

Bodl., Opp. Add. 4°75

Figs. 43–51

Former Prophets with Targum and Massorah.

General Data

Codicology

Vellum; I + 158 + I leaves; *c.* 285 × 230 mm. Text space (213–220) × (158–162) mm; height of the text space with Massorah 250–255 mm. Written in square Sephardi script, in dark and light brown ink, 37 lines in two columns. The text is written throughout in alternating verses of Hebrew and Targum. The names of the books were added at the top of every recto by a later hand. The margins were trimmed later. Ruling by stylus and pencil, 2 + 37 + 3 horizontal and 3 + 3 + 3 vertical lines. Pricking is noticeable in the inner margins. 14 quires of 12 leaves each, except for Quire I² (two leaves cut off after fol. 2r; no text missing), marked with catchwords. The quires are gathered so that outward hair side faces hair.

Binding

Modern.

Colophon

None.

Scribe's Note

At the end of some quires, within the decorated Massorah at the bottom margins, there are invocations typical of Joshua Ibn Gaon (e.g., fols. 8v – Fig. 46, 33r – Fig. 48, 38v – Fig. 49).

History

fol. 2r Don Abraham b. Don Isaac ha-Levi of Almukasm(?) sold this manuscript, together with a manuscript of the Latter Prophets, to Don Todros b. Don David Ibn Shoshan of Sali on the 7th of Elul 5242 (22 August 1482).

fol. 1v Don Todros b. Don David Ibn Shoshan sold it to Don Abraham b. Ban Banesht of Soria on the 26th of Nisan 5252 (7 April 1491).

fol. 1r Owners' inscriptions: (1) Joseph ben Judah; (2) Abraham Qoronil (קורוניל) bought the manuscript in Egypt on Tuesday, the 18th of Tishri 5351 (16 October 1590). Birth inscriptions of 1716 and 1717. Purchased by the Oxford University, together with the Oppenheim Collection, in 1829.

Decoration

Programme

A. Decorated frames enclosing tables of massoretic notes.
B. Blank frames of gold fillets.
C. Decorative micrography of Massorah Magna.

Description

Most of the decoration is in burnished gold, mainly outlined in red or black, with some red fillings and penwork.

A. *Decorated Frames Enclosing Tables of Massoretic Notes.*

fol. 2v (Fig. 43) The full-page frame which encloses the beginning of the list of differences between Ben Asher and Ben Naphtali, consists of a double arcade in gold within an outer rectangular line frame that measures 205 × 158 mm. The pointed arches rest on columns with capitals shaped as stylized foliage above rings, with a fillet segment forming an impost capital. The bases of the columns are of similar shape, although inverted. The spandrels are decorated with red penwork scrolls, with symmetrical palmettes and floral variations. Compare, e.g., the *Second Kennicott Bible* (above, No. 3), fols. 4r, 5v (Fig. 14).

fol. 158v (Fig. 44) A frame formed of gold fillets occupies most of the page (142 × 160 mm). It surrounds the beginning of the massoretic differences regarding Isaiah, which are written in two columns separated by a border (compare, again, the *Second Kennicott Bible*, fols. 6v–7r), decorated with a pattern of spared ground, multiple plaits densely interlaced with red ground fillings (cf. the above-mentioned Bible, fols. 1r – Fig. 11, 2v – Fig. 12).

B. *Blank Frames of Gold Fillets.*

The frames appear across one text column at the end of the books (fols. 24v, 47v, 101v and 158v – Fig. 44; (15–53) × *c.* 70 mm; cf. the *Second Kennicott Bible*, fol. 229r – Fig. 18).

C. *Decorative Micrography of Massorah Magna.*

The Massorah in the upper and lower margins is written in decorative shapes, with more elaborate patterns mostly on the first, last and middle two pages of each quire. The micrography shapes often enclose small gold or coloured shapes fitted to them, such as small lozenges, triangles, bars, stars, sometimes with additional penwork. The micrography patterns are:

1. At the middle of the lines, mostly V-shapes enclosing a gold triangle, or a heart-shaped interlace with three angular gold fillings (e.g., fols. 14v–15r, 20v–21r, 38v – Fig. 49, 39r – Fig. 50, 56v–57r, 81r and 87r); ovals (e.g., fols. 26v – Fig. 47, and 27r); roundels intersecting the Massorah lines (e.g., fols. 33r – Fig. 48, and 75r); various interlaces (e.g., fols. 62v and 92v–93r); circles (e.g., fols. 4v, 5r – Fig. 45, 18v–19r, 46v–47r, 114v–115r and 119r), which also appear at the end of some Massorah lines (e.g., fols. 82v–83r and 118v) or at both the middle and the end (e.g., fols. 122v–123r and 129r) and lozenges (e.g., fols. 110v, 117r and 129r).

2. The Massorah lines, written in running patterns across the margins, form intersecting ovals (e.g., fols. 3r and 86v), lozenges (e.g., fol. 50v), semi-circles (e.g., fols. 8v – Fig. 46, 9r and 87r) or circles and sections of circles (e.g., fols. 44v–45r). There are also stylized, interlacing acanthus scrolls (e.g., fol. 38v – Fig. 49); angular interlaces of two bands (e.g., fols. 8v – Fig. 46, 9r and 80v) or three bands (e.g., fol. 3r); rounded or angular interlaces of two lines (e.g., fols. 26v – Fig. 47, 27r, 68v–69r and 80v–81r) or four lines (e.g., fols. 14v–15r, 20v–21r, 39r – Fig. 50, 51r, 62v–63r and 98v), sometimes forming three knots along the margin (e.g., fols. 32v–33r and 86v); those on fol. 75r enclose eight-pointed gold stars.

Among the gold motifs enclosed by the micrography shapes are also a three-towered castle — the arms of Castile (e.g., fols. 5r – Fig. 45, 47r, 51r, 105r – Fig. 51, 118v, 124v, 129r, 133r, 135r and 147r), a three-towered castle together with a *lion rampant* — the arms of Leon (e.g., fols. 4v, 5r – Fig. 45, and 77r) or a fleur-de-lis — the arms of Aragon (e.g., fols. 105r – Fig. 51, 111r and 134v). A fleur-de-lis by itself appears on fol. 10v. There are also eight-pointed stars flanked by gold bars (fols. 44v–45r) and six-petalled rosettes or stars (fols. 92v–93r).

Conclusions

The size of the manuscript, the script, all the types of decoration, as well as other codicological details, occur in a very similar manner in the *Second Kennicott Bible* (above, No. 3) from Soria, which was completed by Joshua Ibn Gaon in 1306. Although our Bible is not signed, the use of certain formulae in the Massorah indicate that he himself or someone in his workshop may have been responsible for the decoration of the manuscript. All the micrography patterns and the accompanying gold shapes also occur in the *Second Kennicott Bible*; compare, e.g., our fols. 3r, 15r and 33r – Fig. 48 with the *Second Kennicott* fols. 37v, 62r, 211v and 124r, respectively. The penwork, gold bars and micrographic drawings are also similar to the *First Ibn Gaon Bible* of 1300 (Paris, Bibliothèque nationale, hébr. 20, e.g., fols. 4v, 45r; cf. Narkiss and Sed-Rajna, Pls. I–II). In light of the above, the manuscript can be attributed to the Ibn Gaon School of Soria, early in the fourteenth century.

Bibliography

Neubauer, No. 68.
Narkiss & Sed-Rajna, Ibn Gaon.

6. CAMBRIDGE CASTILIAN PENTATEUCH AND HAGIOGRAPHA

Castile, early fourteenth century

CUL, Add. 652

Figs. 52–57

Pentateuch and Hagiographa.

General Data

Codicology

Vellum; 1 + 335 leaves; 270 × 215 mm. Text space (172–176) × (140–145) mm; height of the text space with Massorah 217 mm. Written in square Sephardi script, in brown ink, 26 lines in 2 columns. Ruling mostly by stylus, some in pencil, 2 + 26 + 3 horizontal and 2 + 3 + 2 vertical lines. Pricking in all margins. 42 quires of 8 leaves each, except for Quire XLII[7]. Numbering of the quires in Hebrew letters on the last page of some quires, and some catchwords; many other numbers were cut off by a binder. Fols. 1r (before Genesis), 146v (end of the Pentateuch) and 265r (before Proverbs) are blank. Half of fol. 146 was cut off.

Colophon

None.

History

Owners' Inscriptions

fol. 335r In Hebrew-Italian cursive: Isaac Samuel(?) Hai (חי).

fol. 1r In a square, nineteenth-century Italian hand: (1) David Abraham Hai; (2) Judah Hayyim Fabri. In Latin cursive characters: (1) J.V. 1837; (2) Leone Vivanti; (3) Felice Vivanti.

fol. 334v Leon.

Verso of the front paper fly-leaf Zevi Liphshitz.

Purchased by the Cambridge University from Samuel Schönblum of Lemberg in 1870.

Decoration

Programme

A. Decorative micrography.
B. Micrographic text illustrations.
C. Decorated *parashah* signs.
D. Other decorative signs.

Description

A. *Decorative Micrography.*

The micrographic shapes in the margins and at the end of books mostly enclose small segments of burnished gold or small pen motifs in red. Other massoretic notes at the ends of some books are shaped as six-pointed stars (e.g., fols. 36v, 67v, 89v – Fig. 54, 119v and 303r). The Massorah lines in the upper and lower margins are sometimes adorned with geometrical shapes, mostly sections of circles, zigzags and Y-shapes between the text

columns (e.g., fols. 13v – Fig. 53, 14r–15r, 47r, 85r, 86v, 88v and 107r), and sometimes with interlacing motifs in the middle of the lower Massorah lines (e.g., fols. 8r, 23r, 24v, 113r and 113v) or quatrefoils extending to the side margins (e.g., fols. 8r and 20r).

B. *Micrographic Text Illustrations.*

The most elaborate decorations are three small text illustrations:

fol. 2v (Fig. 52) The temptation (Gen. 3): A coiled snake between the text columns.

fol. 13v (Fig. 53) The binding of Isaac (Gen. 22:9–13): A ram caught by its horns in a thicket in the outer margin.

fol. 315v (Fig. 57) End of Daniel: The massoretic note is shaped as a lion, its mane is pen-drawn.

C. *Decorated Parashah Signs.*

The *parashah* signs are enclosed within small motifs in burnished gold, mostly various palmettes and other symmetrical foliage combinations (e.g., fols. 4v, 7v, 16r, 22r, 43r, 51r, 58v, 62r, 83r, 129r and many others). The shapes are formed by undulating, foliate gold bands. The decoration of some *parashah* signs is in brown pen-drawing, mostly filled with red penwork. These mainly consist of a round, lobed or heart-shaped compartment, with extensions of plaited bars, resembling flasks (e.g., fols. 105v – Fig. 55, 110r, 114r, 116v and 141v). Other signs are framed by six- or eight-pointed stars in pen-drawing (e.g., fols. 97r, 100v and 138r).

fol. 269v (Fig. 56) Prov. 8:22: An arabesque motif formed of foliate gold bands — similar to the *parashah* signs, though larger and more elaborate — decorates the middle of the outer margin.

D. *Other Decorative Signs.*

The marginal indications for the *sedarot*, as well as the large initial for Genesis (fol. 1v), are in burnished gold. These and other signs in the margin, like those for the middle of a book, are sometimes surrounded by small penwork or gold motifs that resemble the *parashah* signs (e.g., fols. 18r, 34v, 45v, 89v – Fig. 54 and 104r).

Conclusions

The size of this two-part Bible was common in the first half of the fourteenth century in Castile and

Navarre, in the centres at Toledo, Tudela and Soria, as well as in Burgos. The manuscript lacks the decorated, carpet-like frontispiece and perhaps a plan of the Temple, but there are blank folios at some main divisions of the books (e.g., fols. 1r, 146v and 265r), which may have been allocated for such decorations. The decorated arabesque *parashah* signs, and especially the delicately shaped Massorah in micrography, were common in Castilian Bibles such as those of the Ibn Merwas and Ibn Gaon groups (above, Nos. 2–6, and

others), in the late thirteenth century and the early fourteenth century. The delicate text illustrations in micrography with added gold and colours (e.g., fols. 2v, 13v and 315v) render our manuscript especially close to those of Ibn Gaon's workshop, even though it lacks other characteristics of this school.

Bibliography

Schiller-Szinessy, No. 16, pp. 24–25.
Loewe, *Hand List*, No. 30.

Other Bibles of Various Schools
[Nos. 7, 8]

Motifs and some elements of style similar to those of the Ibn Gaon group are known in Bibles from other contemporary Castilian schools; for example, the *Cervera Bible* of 1300 (Lisbon, Biblioteca Nacional, MS. 72, e.g. fols. 19r, 83r; see Metzger, T., Masora, Figs. 35, 50), the *Serugiel Bible* (No. 7) and the *Oxford Castilian Bible* (No. 8). They are, however, from different workshops not directly related to the Ibn Gaon group.

7. SERUGIEL BIBLE

Soria, 1304

Bodl., Arch. Selden A. 47

Figs. 58–69

Bible with Rashi commentary.

General Data

Codicology

Vellum; I + 400 (fols. IV–VII, 1–396) + 2 (fols. 397–398 — a biblical fragment from another manuscript) + I leaves; 214 × (168–174) mm. Text space (145–150) × (113–116) mm; height of the text space with commentary 185 mm. Written in small, square Sephardi script, in light brown ink, 37 lines in two columns. The Rashi commentary — in 2 lines at

the top and 3 lines at the bottom of each page, as well as on fols. IVr–VIIv (Rashi on Ex. 20:1 to 21:12) — is written in smaller square script. Ruling by stylus on the recto of folios, sometimes accentuated in pencil, (1–2) + 37 + (2–3) horizontal and 2 + 3 + 2 vertical lines. Pricking is noticeable in the inner margins. 36 quires of 12 leaves each, except for Quires I[4], II[9], VII[10], XVII[4] (two leaves cut off after fol. 178r; no text missing), XVIII[4], XXVI[8], XXXV[10], XXXVI[13] (one leaf cut off at the beginning; no text missing and two fly-

leaves at the end). The quires are gathered so that outward flesh side faces flesh. In the margins there are two catchwords for the main text (fols. 151v and 381v) and four for the Rashi commentary (fols. 103v, 127v, 151v and 163v). The titles of the *parashot* and of the books are written in the upper margins.

Binding
Mottled calf binding with blind-tooled lace border.

Colophon
fol. 394v (Fig. 58) "I, Samuel b. Jacob Serugiel (סרוגיאל)... wrote Daniel and Ezra, the books which conclude the twenty-four books (of the Bible) for [], the son of [], completed in the town of Soria in the year תתרסד" = 5064 (1304). The date has been altered to 4864 (1104) after 1628, when Leon de Modena still read it correctly as 5064 (see below, History).

History
fol. 395r (fly-leaf) Leon de Modena's entry in Italian: "La presente Bibia manoscritta é stata veduta da me diligentem e trovato translato fidelissimus scritta con ogni accuratezza cosi de punti come di accenti l'anno 5064 alla creatione del mondo (1304) con il massored piccolo e l'esposicion di Rabbi Salomone sopra il questa del'antichità é realtà é venissima é bona. Io Leon Modena, Rabi Eb. in Venetia, il di 8 octobre 1628 de Christ. Se è 5388 alla creatione del mondo secondo il computo de gli Eb."
fol. 394v (Fig. 58) Some grammatical rules by a fifteenth-century hand.

Decoration

Programme
A. Text in geometrical shapes.
B. Small decorative motifs within micrographical script.
C. Decorative panel.
D. Decorated *parashah* signs.
E. Decorative frame for the colophon.
F. Decorative script for the word *ḥazaq*.

Description
All decorations are in pen-drawing, in ink similar to that of the text.

A. *Text in Geometrical Shapes.*
There are eight fully decorated pages (fols. IVr–VIIv), the text of which is written in two columns of geometrical shapes forming roundels, lozenges, rectangles, etc. The spared spaces around and between the text columns, as well as some motifs within the text, are filled with pen-drawn decorations. The drawing is free and somewhat crude, and the shapes are decorated with dots and short pen strokes.
Among the motifs are: very dense, mostly irregular interlaces of bands, including a basket pattern and various knots and plaits; symmetrical foliage motifs resembling palmettes and consisting of clusters of various leaves (on fol. IVr – Fig. 59, where the motif is large and occupies the space between the text columns, it incorporates a large fleur-de-lis, two confronting birds and other motifs); S-scrolls with large palmettes in the curls (e.g., fols. VIr – Fig. 60 and VIIv); small dragons, mostly with foliated tails, on almost every page, pairs of which appear among the foliage with intertwined necks (fols. VIr and VIIr – Fig. 62) or confront each other (fol. IVr). There are also small birds and grotesque birds on most pages, and small grotesque lions (e.g., fols. Vr and VIr). Between the text columns at the top of fol. VIv (Fig. 61) is a stylized, open curtain, with a hanging lamp in the centre. On fol. 275v the commentary is written in roundels, but is unframed. The biblical texts before the First and Second Songs of Moses (fols. 28v and 93r – Fig. 65, respectively) are also written in geometrical shapes, triangles and lozenges, but they have a different appearance.

B. *Small Decorative Motifs Within Micrographical Script.*
The Rashi text in the upper and lower margins is written in geometrical forms in the centre of the lines on almost every page between fols. 232r and 248r (e.g., fols. 245v – Fig. 66, 247v – Fig. 67), as well as on a few other pages, in particular fols. 255v–256r, 261v–262r, 267v – Fig. 68, 268r and 275v–276r, which are the first, last or middle pages of their quires. Within these geometrical forms, in the centre of the lines, there are decorative motifs consisting of lozenges, triangles, V-shapes, hexagons, pear-shapes and circles. These are filled with small pen-drawn interlaces, knots and foliage, of the same type as those described in §A and by the same hand. There are also a spread eagle (fol. 247v – Fig. 67) and some grotesques (e.g., fols. 248r, 276r and 312r).

C. *Decorative Panel.*
One small rectangular panel (12 × 40 mm) at the end of the list of differences between Ben Asher and Ben Naphtali (fol. 97r) is decorated with an interlace of lozenges and plaits on an ink ground.

D. *Decorated Parashah Signs.*
Some of the *parashah* signs are decorated. The sign is surrounded by small palmettes (e.g., fol. 9r – Fig. 64) with additional scrolls or small knots; on fol. 5r, which lacks a panel, they flank the sign. The panel on fol. 3r (Fig. 63) is topped by a short bar decorated with vine scrolls. These motifs are neatly drawn on the vellum ground; the ground around them is filled with ink. Other *parashah* signs, as well as some notes in the margins, are indicated by very small pen motifs.

E. *Decorative Frame for the Colophon.*

An inverted U-shaped frame for the colophon (fol. 394v – Fig. 58), measuring 44×50 mm, is decorated with a wave on the left, a guilloche pattern on the right and stylized scrolls on the top. Also on top are three small fleurs-de-lis.

F. *Decorative Script for the Word Ḥazaq.*

The word *ḥazaq* is written at the end of the Bible, above the colophon (fol. 394v – Fig. 58). Its letters are filled with pen-drawn dragons, mostly with foliated tails, on a brown ink ground.

Conclusions

The text of this manuscript was written by several scribes, all of whom decorated the sections they wrote with pen-drawings in ink. The scribe, Samuel b. Jacob Serugiel, was probably responsible only for copying Daniel (from Chapter 2 on) and Ezra (fols. 376v–394v, e.g., fol. 377r – Fig. 69), starting in the middle of a quire on the verso of a folio, as he states in the colophon, although he may also have copied fol. 374r (part of Esther). The alteration of the date in the colophon, to make it seem earlier (1104), cannot apply to this manuscript, and this was no doubt done after it was in the hands of Leon de Modena in 1628. The original date is written in an unusual form ($400 + 400 + 200 + 64 = $ תתרסד), known from other manuscripts from Soria, as Beit-Arié has shown. Serugiel certainly wrote and decorated the colophon and the word *ḥazaq* above it (§§ E–F). The unknown scribe who wrote most of the text seems to be contemporary with Serugiel, in his style of script and type of decoration of the *parashah* signs (§D).

The scribe of the Rashi commentary on fols. IVr–VIIv and in the upper and lower margins was also responsible for its decoration. Though crude in their execution, these pen-drawn decorations are similar in motifs and density of composition to the *parashah* signs and the colophon frame.

The motifs of both scribes resemble to some extent the decorations of Joshua Ibn Gaon of Soria from the beginning of the fourteenth century, mainly in the dragons in the word *ḥazaq* and in the scalloped acanthus scrolls framing the colophon. However, our manuscript is smaller in size than the large Ibn Gaon Bibles, it has a Rashi commentary where the large Bibles have a Massorah and it has an entirely different decoration programme. The odd, angular script of our manuscript, which seems at times more northern or Italian in character, can be compared to the large-format *Oxford Ibn Gaon* (above, No. 5).

The pen-drawn *parashah* signs in our Bible are similar to the few decorated signs in a *Mishneh Torah* manuscript of 1285, now in Oxford (Bodl., Can. Or. 78, fol. 10v), which is marked in the way most manuscripts from Soria are dated: תתרמ"ה= $400 + 400 + 200 + 45$ (see Beit-Arié, Date).

The crude type of decorations in our Bible should be compared to the *Oxford Castilian Bible* (below, No. 8), which probably dates from the beginning of the fourteenth century; it has similar motifs of palmettes, scalloped acanthus leaves, geometrical interlacings, and, in particular, similar birds and dragons in the spandrels of its arcades (fols. 3r–10v). However, that Bible is large and has a different decoration programme. Moreover, the decoration of its arcades is executed in bright colours, and not pen-drawn as in our Bible.

The few elements of style and motif in our manuscript that do correspond with other contemporary manuscripts from Soria may suggest that this odd manuscript belongs to the group.

Bibliography

Neubauer, No. 1.
Beit-Arié, Date.

8. OXFORD CASTILIAN BIBLE

Castile, early fourteenth century

Bodl., Can. Or. 94

Figs. 70–78

Bible with haftarot.

General Data

Codicology

Vellum; I + 486 + I (and two more paper fly-leaves stuck to the binding); *c.* 303 × 245 mm. Text space (209–217) × (180–182) mm; height of the text space with Massorah 257–249 mm. Written in square Sephardi script, mostly in light brown ink, 29 lines in three columns. Ruling by stylus, 2 + 29 + 3 horizontal and 2 + 2 + 2 + 1 vertical lines. Pricking is noticeable in the lower margins. 62 quires of 8 leaves each, except for Quires I², XVI¹⁰, XX⁶, XXI⁶ and LXI⁶, gathered so that outward hair side faces hair. Most catchwords have been partly or wholly cut off. Fols. 11r and 486v are blank.

Binding

Blind-tooled, brown calf binding, decorated with two concentric rectangular frames with flower scrolls. The inner frame has eight acanthus leaves in the corners, four facing inwards and four outwards. Italy, seventeenth century.
The three crescent watermarks in the first and last paper fly-leaves resemble those from Venice of 1610 (Heawood, Nos. 863–864).

Colophon

None.

History

Owners' Inscriptions

fol. 1r In a seventeenth-century Italian hand: Abba b. Judah Delmedigo.
fol. 117r In a seventeenth-century Italian hand in the outer margin: Shemaryah Delmedigo.
fol. 11r A long, faded inscription, almost invisible.
fol. 486v "On 11 December 5544 (1783) I made a loan to Samuel Almasis on this book…" Above this, an illegible inscription, partly faded.

Death and Birth Entries

fol. 1v (1) Death of the father of Shemaryah Delmedigo on the 9th of Sivan 5425 (23 May 1665); (2) death of his mother on the 16th of Iyyar 5451 (15 May 1691).
fol. 2r (Fig. 70) (1) Birth of a son, Moses, on Friday, the 27th of Ḥeshvan 5442 (8 November 1681), and his death on the 3rd of Sivan 5442 (9 July 1682); (2) death of Zipporah Delmedigo on the 12th of Shevat 5453 (19 January 1693); (3) death of Joshua Kotolo(?) on the 12th of Shevat 5475 (18 January 1715); (4) birth of a daughter, Signorina, on the 26th of Sivan 5443 (21 June 1683); (5) death of Shemaryah Delmedigo on Monday, the 4th of Tevet 5473 (2 January 1713); (6) death of Bono Delmedigo on Thursday, the 2nd of Shevat 5484 (27 January 1724).

fol. 2v (1) Death of the child Simḥa bat R. Isaac Michael Ḥai ha-Levi, aged 12 years and 11 months, on Sunday, the 24th of Elul 5495 (11 September 1735); (2) death of a girl, Bella Riamanta Brakhah bat R. Isaac ha-Levi, on Tuesday, the 9th of Iyyar 5498 (29 April 1738); (3) death of the youth Abraham Ḥayyim Levi on Friday, the 23rd of Tishri 5524 (30 September 1763). Purchased by the Oxford University, together with the Canonici Collection, in 1817.

Decoration

Programme

A. Full-page panel illustration of Sanctuary implements.
B. Full-page frames.
C. Arcades framing massoretic notes.
D. Decoration at the divisions of books.
E. Decorative *parashah* signs and mid-book indications.
F. Decorative micrography of the Massorah.

Description

A. *Full-Page Panel Illustration of Sanctuary Implements.*
fol. 1r (Fig. 71) The panel depicts some of the Sanctuary implements in pen-drawing of tinted ochre, with traces of painted gold, on the vellum ground. In the centre is the *Menorah*, with rounded branches. Each of the branches and the upper part of the shaft are decorated with three goblet-like bowls, one round knop, a fleur-de-lis-like flower and a lamp, in that order, one above another. The first lamp on the right has traces of a flame, bending towards the centre, in brown ink. In addition, the shaft is decorated with three knops at the three branching points. The lower part of the shaft has another bowl, above which are another knop and a flower consisting of two symmetrical petals. The base is rounded and rests on three tripod legs. To the right of the shaft is a round covered object, inscribed: כיור, "laver" in gold, and two gold instruments, inscribed: (חצוצרו(ת, "trumpets"; and two flesh-hooks(?). To the left is another vessel similar to the laver and three other elongated objects with erased inscriptions. The elongated object above the two horizontal ones may be read under infra-red light as כפות, "spoons". The panel is framed by a band of pen-drawn palmettes in scrolls.

[39]

B. *Full-Page Frames.*

fols. 1v–2v (Fig. 70) Three full-page frames, measuring (222–225) × (175–177) mm, enclose the birth and death inscriptions of the manuscript's owners. Each frame consists of two tiers of triple arcades, which are shaped as gables with a trefoil top. They are executed in red, though the frames and spandrels are filled with brown, pen-drawn, stylized acanthus scrolls and some small interlaces, both with a few ground fillings in ink.

C. *Arcades Framing Massoretic Notes.*

fols. 3r–10v These full-page frames, measuring (228–235) × (200–205) mm, are executed in pen-drawing with careless fillings of red, dark blue, dark green and very bright yellow. Opposite pages have similar decorations. Each frame consists of a triple arcade for the three columns of text, each one cinquefoil-shaped at top and bottom. The decoration is confined to the frames, spandrels and columns of the arcades. The headings and other rubrics are written in colour.

The cusped spandrels of the cinquefoils on the top and bottom are decorated with different coloured motifs on a coloured ground, surrounded by inscriptions in blue and red. The motifs, many of which are within roundels, are: eagles (fols. 3v, 5v, 7r, 7v – Fig. 73, and 9v – Fig. 75), some with two heads and intertwined necks (fols. 8r – Fig. 74, 8v); other birds (e.g., fols. 7r and 10v); a bull (fol. 7v – Fig. 73); and many lions. There are also pairs of birds (e.g., fols. 4r, 7v – Fig. 73, 9r, 9v – Fig. 75) or lions (e.g., fols. 8r – Fig. 74, 8v), flanking foliage motifs. A three-towered castle (fol. 4v – Fig. 72) represents the arms of Castile, and *lions passant* and fleurs-de-lis may represent the arms of Leon and Aragon (e.g., fols. 4r, 4v – Fig. 72, 5r, 6r, 8r – Fig. 74, 9r, 9v – Fig. 75, 10v). Among the foliage and geometrical motifs are various rosettes (e.g., fols. 4v – Fig. 72, 5v, 6v and 7r) and many symmetrical floral motifs, as well as several variations of small, centralized interlaces, including eight-pointed stars. The columns and framing bands have various plait patterns (e.g., fols. 3v–5r, 7v – Fig. 73, 8r, 9v – Fig. 75, 10r–v), a running pattern of heart-shaped palmettes (e.g., fols. 4v – Fig. 72, 5r–7r), foliated zigzags (e.g., fols. 3v–4r and 6v–7r), stylized acanthus scrolls (e.g., fols. 5v–6r and 8v–10v), painted chevrons (e.g., fols. 5v–6r) and all-over pelta patterns (e.g., fols. 7v – Fig. 73, 8r–9r).

Most of the decoration on fol. 3r (Fig. 78) was repainted in the fourteenth century with magenta, blue, red and gold, with some elaboration of thin-brush motifs. The frame has interlacing bands, framing ovals separated by knots on a gold or blue ground. The heads of a man and a woman are in the bottom corners, and a mask and a dog in the upper corners. In the spandrels, within roundels, are a monkey, a dog, a rabbit and a human-faced grotesque. Rectangular patches of tendrils with flowers and gold dots issue from both lower corners into the lower margin.

D. *Decorations at the Divisions of Books.*

The frames at the ends of the books are mostly the width of one text column (42–53 mm). The decorations at the main divisions — the end of the Pentateuch (fol. 124v), of the Former Prophets (fol. 259v) and of the Latter Prophets (fol. 362r – Fig. 77) — are larger and more elaborate. Many frame the massoretic notes and the mnemonic signs for the books; others are blank. They are of several types, all formed by bands similar in motif and colours to the decorated bands of the frames described in § C. Those at the main divisions comprise one or two compartments and a U-shaped top (fols. 124v, 259v and 362r – Fig. 77; height 85, 165 and 178 mm, respectively). Within the compartments, on the vellum ground, are an eight-pointed star enclosing a *lion rampant* (fol. 124v) and a similar star in one compartment, and a lion in the other (fols. 259v and 362r – Fig. 77). The decorations at the ends of the other books are either H-shaped with the horizontal bar resting on brackets (e.g., fols. 39v, 104r, 189v, 223v, 283r, 313v, 341r and 344v; height 52–64 mm) or an inverted M-shape with a stylized foliage motif on top of the central gable (e.g., fols. 80v, 346r, 349r, 349v, 352v, 353r, 354r, 355v, 356r, 361r, 394r, 417v, 421r, 427v and 436r; height 42–56 mm). The lower parts of both kinds frame the beginnings of the books, which mostly appear in triangular form. The massoretic notes of the previous book are sometimes framed by the upper part of the motif (e.g., fols. 80v, 417r, 421r and 436r). Where a book ends at the bottom of a text column, the motif is U-shaped (e.g., fols. 160v, 175r – Fig. 76, 350r, 405v, 450r and 486r; cf. fol. 423r; height 17–49 mm); that above the beginning of Psalms (fol. 364r) runs across the text space. These frames are sometimes accompanied by two birds flanking the beginning of the next book (e.g., fols. 63v, 161r and 175r – Fig. 76) or by small foliage motifs (e.g., fol. 415r), once, within another U-shaped frame (fol. 405v). The beginning of Isaiah (fol. 260r) is flanked by two confronting *lions passant.*

E. *Decorative Parashah Signs and Mid-Book Indications.*

The signs for the *parashot* of the Pentateuch are written in ink, mostly with stylized symmetrical foliage motifs, including palmettes and fleurs-de-lis above and a heart-shaped palmette below. These motifs are similar in style and colour to those in the decorated frames described in § C.

F. *Decorative Micrography of the Massorah.*

Two similar foliage motifs appear on every page, at

the bottom of the spaces between the text columns. They rise from the lower Massorah lines, which are shaped as angular plaits, zigzags or simplified arcades, or as angular interlaces, knots, lozenges and V-shapes distributed along the straight lines (e.g., fols. 175r – Fig. 76, 362r – Fig. 77).

The small, painted motifs of §§ E–F include: heraldic lions (e.g., fols. 17v, 31v, 38r, 42r, 45v, 54r, 100r and 353v), heraldic eagles (e.g., fols. 14r, 31r and 75v) and other birds (e.g., fols. 17r, 28r, 32r and 341v), or a foliage variation consisting mainly of two or three superimposed, heart-shaped palmettes (e.g., the *parashah* signs on fols. 62r, 83v, 89r, 91v, 97r and 111v) and fleurs-de-lis (fols. 175r – Fig. 76, 362r – Fig. 77). Other signs in the margins are sometimes decorated with similar small motifs.

Conclusions

The decorations of this undated manuscript are similar to those of other fourteenth-century Bibles; they include Temple implements, arcaded massoretic lists, decorated motifs at the beginning and end of the books, *parashah* signs, as well as decorative micrography of the Massorah. Of these decorations, the full-page depiction of implements and the arcades that frame the family entries seem to be a later addition. The decorated frames painted on a separate, conjoint leaf of a different kind of vellum (Quire I) differ in style as well as in size from those of the massoretic lists. The script identifying a few implements also differs. The other decorations — the full-page frames of the massoretic lists, the book-indication devices and the massoretic micrography — are original. The frames of the tabulated massoretic lists and their coloration recall the canon tables of tenth- and eleventh-century Spanish Bibles, identified by symbols of evangelists; in our manuscript the eagle, the ox and the lion are decorative motifs in the spandrels of arcades (e.g., fol. 7v – Fig. 73).

Though different in style, the decorations of our manuscript can be compared with those of the *Serugiel Bible* (above, No. 7). Similar motifs appear in both manuscripts, e.g., confronting birds (fol. 7v – Fig. 73, as against fol. Iv); the interlaced necks of two birds (fol. 8r – Fig. 74) or dragons (fol. VIr – Fig. 60), respectively; and single birds and *lions passant* (fols. 4r, 5v, 6r and 7r; cf. fols. Vr and VIr). Even the scrolls of fols. 5v–6r in our manuscript can be compared in their fleshiness and roundness to some acanthus leaves in the *Serugiel Bible* (fol. VIIv). Our manuscript was, therefore, written and partly decorated at the beginning of the fourteenth century. The decorative heraldic devices of Castile, Aragon and Leon may point to the dominant Castilian School of the time. At some later stage, during the fourteenth century, the conjoint leaf depicting the Temple implements was added, possibly under Catalan influence, when the frame and spandrels on fol. 3r (Fig. 78) were repainted.

Bibliography
Neubauer, No. 7.
Heawood, *Watermarks*, Nos. 863–864.

Castilian and Catalan Haggadot of the Thirteenth and Fourteenth Centuries: Decoration Programme

[Nos. 9–18; relating to Chapters I and II]

Half of the approximately twenty extant fourteenth-century Spanish illuminated *haggadot* are in libraries in the British Isles. These represent almost the whole range of *haggadah* illustration in its various phases and schools and include some of the most important *haggadot* for understanding the development of *haggadah* illumination, e.g. the *Golden Haggadah* (No. 11), the *Hispano-Moresque Haggadah* (No. 9) and the *Rylands Sephardi Haggadah* (No. 15).

The text of the Sephardi *haggadot* consists of the main Passover service (*Seder Haggadah shel-Pesah*), preceded by directions and benedictions for Passover Eve, and sometimes preceded and followed by *piyyutim* and scriptural readings for the Great Sabbath before Passover and the Passover week. Often written by different scribes on separate quires, these may have been executed in the same workshop and were at times bound separately (e.g. *Catalan Passover Parashot and Piyyutim*, No. 14).

The decoration programme of the most elaborate Sephardi *haggadah* manuscripts contains: (1) full-page biblical and ritual illustrations; (2) text illustrations, mostly ritual, but sometimes biblical; and (3) painted initial words, some in panels, with decorations extending from them.

(1) The biblical and ritual illustrations are executed in full-page panels, usually in separate quires preceding the *haggadah* (for an exception, see the *Barcelona Haggadah*, No. 13); these are similar to Latin Psalter illuminations of the twelfth to fourteenth centuries. Since Passover is a ritual celebrated privately at home, the small *haggadah* manuscript was indeed best suitable for adornment and illustration. There are two types of full-page biblical illustrations in the Sephardi *haggadot*. The most common type depicts only the story of the Exodus from Egypt, which is related in the *haggadah* text. Examples are the *Hispano-Moresque, Rylands* and *Brother Haggadot* (Nos. 9, 15, 16), the *Parma* (Biblioteca Palatina, Parms. 2411), *Bologna* (U.L. 2559), and *Kaufmann* (Budapest, A.422) *Haggadot*. It can be assumed that the second type, with full-page Genesis episodes preceding the Exodus cycle, were added to the Exodus cycle in the thirteenth century under the influence of French Bible and Psalter illustrations. Examples of the Genesis and Exodus type are the *Golden* and *Sister Haggadot* (Nos. 11, 12), the *Prato Haggadah* in the Jewish Theological Seminary in New York, and the *Sarajevo Haggadah*. Of the *haggadot* with Genesis and Exodus cycles, only the *Sarajevo* and *Prato Haggadot* begin with the creation of the world. The *Golden Haggadah* (No. 11) opens with Adam naming the animals, and the *Sister Haggadah* (No. 12) with the creation of Adam by the angels.

The fact that two types of cycles exist side by side, a combined Exodus and Genesis cycle and an Exodus-only cycle, does not mean that they derive from different prototypes. Iconographical and stylistic comparisons show that they may have had common origins, and that the artists, who chose the episodes they wanted to depict, used the same models for both types (see Narkiss, *Golden Haggadah*, pp. 43–61). However, the choice of episodes depicted is not identical, even in manuscripts like the *Golden* and *Sister Haggadot*, which are otherwise closely related to each other. Each contains scenes not depicted in the other, which points to a model with a cycle more extensive than either.

The textual sources of the full-page biblical illustrations are neither exclusively biblical nor directly dependent on the midrashic text of the *haggadah*. The illustrations sometimes derive from known midrashic texts, such as *Genesis Rabbah* and *Exodus Rabbah*. For example, Adam created by angels (cf. Schubert, U., Adam); Abraham saved from the fire of the Chaldeans (cf. Gutmann, Haggadah, note 43; Narkiss, *Golden Haggadah*, pp. 64–65); Joseph meeting an angel on the way to his brothers (cf. Nordström, Jewish Legends, p. 489); the Israelites despoiling the Egyptians in the Plague of Darkness (cf. Narkiss, *Golden Haggadah*, pp. 54–55). Other illustrations derive from unidentified legendary origins, such as Potiphar hurrying home with his friends to find his wife with Joseph (cf. Paecht, Ephraimillustration, p. 217).

The iconographical sources of these *haggadot* cycles vary from one picture to another. Most episodes depend on Gothic illuminated picture Bibles or on French, Spanish or Italian biblical cycles preceding Psalters. Others depend on Byzantine illumination as well as on early Christian and early Jewish biblical representations (see Narkiss, *Golden Haggadah*, pp. 43–61; and Gutmann, Antiquity).

The biblical cycles preceding the Sephardi *haggadot* fall into two recensions, which differ in iconography and style, and which are not identical with either of the two types mentioned. The *Hispano-Moresque* (No. 9), and the *Parma, Bologna, Prato* and *Sarajevo Haggadot*, belong to the first recension, which is typified by spacious compositions, usually comprising one episode within a full- or half-page panel. This kind of composition has bearings on the iconography of the scenes as well, in that it depicts only the most essential details; for example, the many scenes of Moses and Aaron meeting with Pharaoh and his council, where only the protagonists are depicted as gesturing in a similar way on either side of the panel. The only representative of this recension in the British Isles is the *Hispano-Moresque Haggadah* (No. 9), which shows many archaistic elements in compositional style, such as the architectural framework, the stylized human figures, and their bright colourings. Whereas these might be characteristic of the Castilian schools, their archaistic iconography may also be related to Italian origins. The ritual scenes in the *Hispano-Moresque Haggadah* depict the various preparations for Passover Eve, each on a separate page.

The second recension is more dense in composition, and the scenes are more varied. Most pages are divided into two or four compartments, some of them containing two or three episodes each. The iconography of some scenes is peculiar to this recension, e.g. the three naked maidens in the scene depicting the finding of Moses; as in the first recension, the iconography of similar episodes is repeated.

The very few ritual scenes in the second recension are appended to the last full-page panel of the biblical cycle. They represent cleaning the house and preparation of the Passover meal (e.g. baking the *mazzot*, slaughtering the lamb, preparing *ḥaroṣet* and laying the Passover table).

The *Golden* and *Sister Haggadot* (Nos. 11–12), and the *Rylands* and *Brother Haggadot* (Nos. 15–16), all of Catalan schools, belong to the second recension. They expose mainly French iconography, and their Italian and Byzantine stylistic motifs are contemporary.

(2) The text illustrations in both types and recensions are usually placed in the margins, although some of the more common ones are found within the text space, sometimes attached to the initial-word panels (most text illustrations appear in Metzger, M., *Haggada*).

The most common and more traditional illustrations, which appear in almost all manuscripts, are the *mazzah* and the *maror*, two of the three basic objects which, according to Rabban Gamaliel, must be referred to during the ceremony; the third object is the Paschal lamb. The *mazzah* is usually depicted as a large, decorated roundel, sometimes occupying an entire page, and the *maror* is usually represented as a large green lettuce, sometimes resembling an artichoke. Less common are illustrations of some of the rabbis mentioned in the *haggadah* text. The most prominent of these – Rabban Gamaliel and his pupils – sometimes occupy an entire page, while the Rabbis Akiva, Yosse, Tarfon, Eliezer and Elazar are each depicted where mentioned in the text. Illustrations of the four sons sometimes appear in relation to the midrashic text mentioning them. The wise son is represented as an elderly man reading a book; the wicked son as a soldier with a sword; the innocent son as a child; and the son who does not know how to ask – as a boy or a fool.

There are also additional ritual and biblical illustrations in the margins of some Sephardi *haggadot*. The most common among these are the family round the *seder* table; pouring out and raising the four cups of wine; and preparations for the Passover meal. The biblical illustrations include the bondage of the Israelites in Egypt; the Exodus from Egypt; and the death of the first-born. Some midrashic illustrations, such as Abraham being cast into the fire by Nimrod, also appear in the margins. The *Sassoon Sephardi Haggadah* (Jerusalem, Israel Museum, MS. 181/41) and the *Barcelona Haggadah* (No. 13) are unique among Sephardi *haggadot* in that they incorporate ritual, biblical and midrashic illustrations both within the text and in the margins. The latter has only two full-page panels, showing a procession of men performing the different stages of the *haggadah* ritual, as a sort of visual mnemonic.

(3) The initial-word panels are the most common type of decoration in the *haggadah* text, as well as in the Passover *piyyuṭim* and scriptural readings. In the Catalan schools these are either painted in the Spanish Gothic colours of magenta, blue and burnished gold, or they are highly decorative penwork panels in red, violet, blue, brown and green. Some of the *haggadot*, like the *Sassoon Haggadah* now in the Israel Museum, contain text illustrations within the panels. Other panels have floral and geometrical extensions which sometimes surround the text or connect the panels, forming a column of panels on either side of the page. This device, the most traditional textual decoration, is commonly used in the *piyyuṭ Dayenu* within the *haggadah* text. Along the extensions are found animals, birds, fantastic creatures, grotesques and some text illustrations.

The style of the different *haggadot* depends to some extent on the models on which they were based. Together with the iconography, the artists adopted stylistic elements as well as motifs. One of the most characteristic elements common to Sephardi *haggadot* is their eclecticism. The combination of dense French Gothic composition with the rather dramatic gestures and crude expressionism of the Spanish Gothic, together with the italianizing edifices and clothing and byzantinizing landscapes and colourings, produces a style peculiar to the Catalan schools of illuminated *haggadot*. On the other hand, the archaizing Hispano-Moresque style and old italianate iconography is typical of Castilian *haggadot*.

Nonetheless, each *haggadah* preserves its individual style, as well as its quality. The fact that the skill of the artists who produced the Sephardi *haggadot* ranges from art of a very high quality to folk art proves that there was an abundance of illuminated *haggadot* and that the available models were used by many craftsmen. Comparing *haggadot* from the same recension but of different quality and date may point to the origin of *haggadah* illumination. A good way to trace the origins of stylistic motifs is to compare the *Golden* and *Sister Haggadot*, both of the same iconographical recension. The early fourteenth-century italianizing architectural elements in the *Golden Haggadah* (*c.* 1320) can be found half a century later in the *Sister Haggadah*. In fact, these elements are more pronounced in the *Sister Haggadah*, possibly because its less competent artist followed the model more closely. It is obvious that Italian biblical illuminations influenced Catalan illumination afresh in the early fourteenth century.

Castilian Haggadot
[Nos. 9, 10]

Of the two Castilian *haggadot* in the British Isles, only the *Hispano-Moresque* (No. 9) preserves full-page biblical illustrations. The extensive cycle is mainly comprised of Exodus episodes and numerous ritual scenes, but also includes some episodes of the Binding of Isaac. The iconography of the biblical and ritual cycle is connected to Italian tradition exemplified in later manuscripts such as the *Schocken Italian Haggadah*. The style of the *Hispano-Moresque Haggadah* is archaistic, and may also depend on Italian origin.

The *Mocatta Haggadah* (No. 10) has no biblical illustrations, but only text decorations, including initial-word panels and micrographic outlines. The *Casanatense Haggadah* (Rome, Bibl. Casanata, Cod. 2761) and the *Parma Haggadah* (Parma, Biblioteca Palatina, Parms. 2411; see Metzger, M., *Haggada*, pp. 407–408), neither of which have been studied properly, seem to belong to the Castilian School. The use of zoomorphic letters, decorated penwork and micrography in these two *haggadot* is similar to that in the *Golden Haggadah* (No. 11) of the Catalan school, which proves that stylistic motifs were common to different schools over a certain period.

The dating of these Castilian *haggadot* can be deduced by comparing their style with that of dated Bible manuscripts such as those of the Soria-Tudela Ibn Gaon group, with their micrography, motifs and light colours.

9. HISPANO-MORESQUE HAGGADAH

Castile, late thirteenth or early fourteenth century

BL, Or. 2737

Figs. 79–104; Pl. XXVIII:88, 95

Haggadah, Passover readings and biblical picture cycle.

General Data

Codicology
Vellum; 1 + 94 (1 unfoliated blank after fol. 3) + 1 + I leaves; *c.* 160 × 120 mm. Text space (92–94) × (60–63) mm. Written in square Sephardi script, in dark brown ink, 13 (*Haggadah*) or 14 (readings) horizontal lines; *haftarot* for Passover written in smaller script: 2 lines above and 3 lines below the text of the *Haggadah*. Height of the text space with the *haftarot* (127–129) mm. Ruling by stylus on hair side only, 2 + (13–14) + 3 horizontal and 2 vertical lines. Pricking is noticeable in the lower and outer margins. 13 quires of 8 leaves each, except for Quires I⁴, II⁷, IV⁶, (IX–X)⁶ (leaves reassembled), XII⁷ (stump at the end) and XIII⁹ (stump at the end). Each quire is gathered so that hair side faces hair and flesh side faces flesh, starting with an outward hair side. Most text quires are marked with catchwords at the end. Fols. 1v, 3v, 3a recto and verso, 4r and 62r are blank.

Binding
Modern binding, preserving one paper leaf and two parchment leaves from before 1884. Fol. 63 is wrongly bound; its correct place is after fol. 68.

Colophon
None.

History
fol. 3a recto Effaced owners' inscriptions.
Paper fly-leaf of the back binding Purchased by the British Museum from Ḥayyim Horowitz on 26 January 1884.

Decoration

Programme
A. Full- and part-page panels.
 1. Frontispiece.
 2. Full- and part-page text illustrations.
 3. Cycle of Exodus.
 4. Passover ritual scenes.
 5. The binding of Isaac.
B. Painted initial-word panels.

Description

A. *Full- and Part-Page Panels.*

All sixty-six full-page and four half-page panels, except fol. 1r are accompanied by contemporary captions in the upper margins which describe the scenes. These captions mostly consist of the relevant biblical verses. The name of God is always השם, "the Name", translated here as "the Lord".

The panels are executed in coloured pen-drawings with light brownish outlines on the vellum ground on both sides of the leaves. They consist of spacious compositions, with elaborate frames of architectural foliage and abstract motifs and are coloured with inks and washes (partly gouache) of olive green, vermilion, several shades of blue, magenta, pink, yellow, yellow ochre, red ochre, violet and red ink, with some dusky gold. The proportions of the human figures range from squatness to mild elongation. The figures occupy from one-third to one-half of the height of the panel, except for some very small ones (e.g., fols. 84v and 85r). They are mostly shown from the side, some with their faces turned to the front. Occasionally a head in profile or in three-quarters profile is set on a body shown frontally. The faces are not coloured. Moses is usually beardless, whereas Aaron is mostly shown bearded. Both sometimes wear small, round caps, as Pharaoh's attendants do sometimes (e.g., fols. 63r and 63v – Fig. 85). Pharaoh wears a crown and a gown, both in dusky gold heightened in green. The repeated scene of Moses and Aaron before Pharaoh in most cases shows Pharaoh seated on a stone bench on the left, with one, two or three attendants behind him, and Moses and Aaron on the right. Egyptian soldiers and their horses wear unspecified mediaeval knights' armour (e.g., fols. 84v and 85r). Each panel is framed by a rectangular border of spared ground, variations of a palmette scroll with three-lobed leaves — the most common ornamental motif in the manuscript — and a square interlace in each corner, in red or violet ink on the verso or recto of each folio, respectively. The lower part of the frame usually forms the ground line on which the figures stand. Most panels have an inner, arcaded frame, either single, triple or trefoil, mostly decorated with the spared ground foliage scroll and resting on two thin columns surmounted by capitals. Some arches are decorated with grotesque heads; others are composed of or surmounted by human figures, birds or animals, some of which are related to the scene in the panel. Most arcades are surmounted by architectural structures — some of which occupy a third of the panel — consisting of different combinations, mostly symmetrical, of coloured walls, edifices with many windows, doors, arcades, towers and turrets, some extending above the frame of the panel. Almost all arches and windows are round; only a few are ogival. Some of them include the three-towered castle resembling the arms of Castile (e.g., fols. 65v, 66r, 66v and especially that on fol. 69r – Fig. 89). Many architectural shapes and pieces of furniture in the frames and within the panels are decorated with coloured rings. The inner frames on fols. 91v–93v consist of single arches, with large yellow leaves in the spandrels. These leaves occasionally appear in other places (e.g., fol. 73r – Fig. 94).

The text illustration on fol. 20v is framed similarly to the other full-page panels, though the ground is painted magenta and blue, as it is in the initial-word panels (see § B); the illustration on fol. 35v is unframed on the vellum ground.

1. *Frontispiece.*

fol. 1r (Fig. 79) (1) This panel, measuring 93 × 61 mm, is framed by a thin line only and encloses a green vine with leaves, sprigs and clusters of grapes. The trunk is decorated with an interlace.

2. *Full- and Part-Page Text Illustrations.*

fol. 9v (Fig. 80) (2) Part-page illustration: "And afterward shall they come (out of Egypt) with a large property" (Gen. 15:14): In a trefoil arch (35 × 17 mm), attached to the left of the initial-word panel, a man is holding a long-necked flask and raising a goblet; this may illustrate the custom of raising the cup when reading the next passage: (ו)היא שעמדה לאבותינו, "(And) this (promise) it is which has stood by our forefathers".

fol. 20v (Fig. 81) (3) "Rabban Gamaliel" — as written on the initial-word panel on the opposite page — is seated on a stool in front of an inscribed open book that rests on a lectern. He is pointing at four students to the left. An oriental lamp hangs from the arch of the architectural frame.

fol. 21r (Fig. 82) (4) Part-page illustration: The Paschal lamb, represented as a ram within the text, is eating a leaf from the frame of the page-long extension of the initial-word panel.

fol. 22r (Fig. 83) (5) Part-page illustration: The *mazzah*, depicted as a roundel 60 mm in diameter, is formed by the interlacing gold and silver fillet frames of two crosses, one Greek and the other similar to a Maltese cross. At the four ends of the Greek cross are blue and magenta ground fillings, decorated with four grotesque animals (lions?) in dusky gold. In the centre is a circle, with a spared ground scroll drawn in silver, enclosing a blue and magenta rosette. Four silver-framed triangles emerge from beneath the four sides of the roundel.

fol. 22v (Fig. 84) (6) Part-page illustration: The "*maror*" is represented under the initial-word panel as a cluster of green lettuce leaves, held together by a handle. It is closely framed on three sides by an arch measuring 50 × 60 mm. The arch

is decorated with a pen-drawn foliage scroll and bordered by red and blue fillets.

fol. 35v (Fig. 85) (7) שמשון הגבור, "The brave Samson", wearing a short orange robe, is rending a magenta lion while riding it.

3. *Cycle of Exodus.*

fol. 62v (8) "The Egyptians made the sons of Israel serve in rigour" (Ex. 1:13): An Egyptian taskmaster, standing on the right, is holding a stick and pointing at two Israelites who are working on the left. One of the Israelites, atop an unfinished building, is taking a brick from the other, who carries it on his head as he climbs a ladder. Another building is on the right. There is no architectural frame.

fol. 63r (wrongly bound) (9) Moses and Aaron before Pharaoh (inscribed with Ex. 5:1): Aaron, on the right, with Moses behind him, are arguing with Pharaoh, who is seated on the left. With him are three attendants.

fol. 63v (wrongly bound) (Fig. 86) (10) "...Moses and Aaron went in unto Pharaoh... and Aaron cast down his rod... and it became a serpent" (Ex. 7:10): A beardless Aaron is standing behind Moses, who is also beardless. Aaron holds a spotted green serpent, which is swallowing three small serpents — the magicians' rods (Ex. 7:12). Pharaoh and two of his attendants are on the left.

fol. 64r (11) זאת האשה ילדה בן ובא זה מעבדי פרעה ולקחו להשליכו היאורה כמו שתראו, "This woman has given birth to a son, and this servant of Pharaoh's came and took him to throw him into the Nile, as you can see": A naked woman, sitting up in bed, holds the naked child round the waist. On the right, a man dressed in vermilion is seizing the baby by its arms. The trefoil arch is decorated with dragons' heads.

fol. 64v (Fig. 87) (12) "...Pharaoh charged all his people, saying: Every son that is born ye shall cast into the river" (Ex. 1:22): Two men, each holding an infant by the legs, are casting them into a segment of a violet river. The legs of a third infant can be seen in the river. The trefoil arch is decorated with the confronting busts of two men flanked by two grotesque birds.

fol. 65r (13) Moses being given back to his mother to be nursed: Pharaoh's daughter, standing behind the river, hands over the infant Moses in swaddling clothes to his mother. Moses' sister, Miriam, is behind Jochebed. Pharaoh's daughter and Jochebed are both kerchiefed. The inscription "And the daughter of Pharaoh came down to wash herself at the river" (Ex. 2:5) does not describe this scene. The trefoil arch is formed by dragons and birds, with lions resting on the capitals.

fol. 65v (14) זה משה שהכה את המצרי ויטמנהו בחול, "This is Moses, who struck the Egyptian and hid him in the sand" (based on Ex. 2:11–12): Moses is pushing the Egyptian, whose legs alone

are visible, into a mound of sand. The trefoil arch is formed by a two-bodied lion devouring two men.

fol. 66r (15) "And when he went out the second day, behold, two men of the Hebrews strove together" (Ex. 2:13): Moses, on the right, chastizes a man on the left, who is trampling on another man and holding him by his hair while looking back at Moses. Two fighting birds form the arch.

fol. 66v (16) "Moses fled from... Pharaoh, and dwelt in the land·of Midian, and he sat down by a well" (Ex. 2:15): Moses, sitting on a square well on the right and raising his right hand to his eyes, watches the two daughters of Jethro, who are leading a sheep and a goat. Above the trefoil arch are two hounds seizing two confronting hares.

fol. 67r (Pl. XXVIII, Fig. 88) (17) Moses and the burning bush: The bearded Moses, holding a staff and wearing a sheepskin coat and one shoe, is standing on the right. He is raising his right hand towards the hand and wing of a cherub that emerges out of a green bush, surrounded by red flames, on the top of a magenta mountain. Two green sheep and a green goat are on the mountain, together with Moses' other shoe. There is a segment of blue sky above the bush. There is no architectural frame. Inscribed: "And Moses was a shepherd" (Ex. 3:1).

fol. 67v (18) Moses' return to Egypt: "And Moses took his wife and his sons, and set them upon an ass" (Ex. 4:20). Moses, beardless and wearing a hood, is walking on the right behind an ass.

fol. 68r (19) "And the Lord said to Aaron: Go into the wilderness to meet Moses" (Ex. 4:27): Moses and Aaron embracing each other under two trees. There is no architectural frame.

fol. 68v (20) "And Moses and Aaron went and gathered together all the elders of the children of Israel" (Ex. 4:29): Aaron, holding a staff with a fleur-de-lis at its end, and Moses behind him, confront six elders on the left.

fol. 69r (Fig. 89) (21) "And the Lord said unto Moses... get thee unto Pharaoh in the morning, lo, he goeth out unto the water" (Ex. 7:14–15). A crowned Pharaoh is riding a green horse into a segment of water. On his gloved left hand is perched a bird (falcon?). A beardless Moses behind him is lifting a warning finger. On the top of the trefoil arch is a gable decorated with a red clover-leaf and flanked by two triple towers – the arms of Castille.

fol. 69v (22) The plague of "blood" (Ex. 7:19–25): The panel is divided horizontally into two. At the bottom on the right, with Moses behind him, is Aaron, effecting the plague of blood by striking with his rod a patch of red water in which are three dead green fish. A yellow pitcher, with red liquid spilling from it, stands on a red shelf on the left. At the top, two confronting

Egyptians use hoes to dig for water into a small red-ochre hill. On the hill, and on the point of one hoe, are drops of blood. The scene is in accordance with certain midrashic texts, such as Targum, Pseudo Jonathan and *Exodus Rabbah* 9:11.

fol. 70r (23) Aaron and Moses negotiating with Pharaoh: Aaron and Moses, on the right, speak to Pharaoh, who is accompanied by two attendants (inscribed with Ex. 7:26; A.V. 8:1).

fol. 70v (Fig. 90) (24) The plague of frogs (inscribed with Ex. 8:1; A.V. 8:5): Moses, on the right, is striking the water with a budding staff. There are three frogs in the water, another in the opening of an oven and one in mid-air under a trough in which there are four other frogs (Ex. 8:3). Still another frog is enclosed in the middle of the trefoil arch framing the panel. Aaron is standing behind Moses, contrary to the biblical and midrashic texts.

fol. 71r (25) Pharaoh begging Moses and Aaron to remove the frogs (inscribed with Ex. 8:4; A.V. 8:8): In the middle, a kneeling Pharaoh pleads with Moses and Aaron, who are on the right. Two attendants stand behind Pharaoh. There is a trapeze-shaped middle arch in the architectural frame.

fol. 71v (Fig. 91) (26) The plague of "lice" (Ex. 8:12–14; A.V. 16–18): Aaron to the right, followed by Moses, is holding his budding staff horizontally. Under the staff four small people, two sheep and a goat, are all covered with small brown gnats. The lice are also jumping into the air and on to two confronting deer, each of which is being seized by two hounds placed above the trefoil arch.

fol. 72r (Fig. 92) (27) Moses meeting Pharaoh, who is going out to the water (inscribed with Ex. 8:16; A.V. 8:20): This is similar to the scene on fol. 69r, but here Moses is bearded and there is no bird perched on the hand of Pharaoh, who is looking back at Moses.

fol. 72v (Fig. 93) (28) The plague of "'arov" (Ex. 8:17–20; A.V. 8:21–28), i.e., beasts (*Exodus Rabbah* 11:2): Moses, his right hand raised, stands on the right amongst four lions, one biting a man and the others devouring a head or an arm or a leg. The arch framing this panel is formed by a two-headed lion, flanked by two men whose heads are in the lion's mouths; their legs are being bitten by smaller, crouching lions, on which they are standing. The lions' paws resemble the lobed foliage of the frame.

fol. 73r (Fig. 94) (29) "And I will sever in this day the land of Goshen" (Ex. 8:18; A.V. 8:22): The land of Goshen is represented herein as a building, incorporated into the architectural frame. At the bottom, a sheep, a goat and two rams are under a low arch. Above is a triple arcade containing a courtly scene. A man on the right, holding a fleur-de-lis and a ring, is turned to the left towards a woman holding a ring. There is another man on the left. Above is a triple tower with windows, arcades and battlements, with a frontal face in the middle window and two men blowing horns at the top.

fol. 73v (30) "And Pharaoh called for Moses and for Aaron and said: Go ye, sacrifice to your God in the land" (Ex. 8:21; A.V. 8:25): Pharaoh, standing on the left with three attendants, talks to Moses and Aaron. There are dogs seizing foxes on both sides above the trefoil arch.

fol. 74r (Pl. XXVIII:Fig. 95) (31) Moses and Aaron before Pharaoh (inscribed with Ex. 9:1); cf. fol. 70r. There is only one attendant.

fol. 74v (Fig. 96) (32) The plague of "murrain" (Ex. 9:3): Dead cattle lie on the ground in front of Moses and Aaron, who are on the right. Additional penwork decorates the trefoil arch and the capitals.

fol. 75r (33) "And Pharaoh sent, and behold, there was not one of the cattle of the Israelites dead" (Ex. 9:7): To the right are two men talking to each other and pointing to three sheep and a goat on the left. The architectural frame here has two unequal arches.

fol. 75v (34) The plague of "boils" (Ex. 9:8–12): On the right are Aaron and Moses, throwing red dots of ashes towards heaven. The falling ashes cover three small men at Moses' feet, as well as Pharaoh and his attendant, who are on the left.

fol. 76r (35) Moses and Aaron before Pharaoh (inscribed with Ex. 9:13); cf. fol. 74r.

fol. 76v (36) The plague of "hail" (Ex. 9:22–25): On the right a bearded Moses raises his right hand. On the left, large round hailstones are falling on a large tree, two small men and one sheep.

fol. 77r (37) Moses and Aaron before Pharaoh (inscribed with parts of Ex. 9:27); cf. fol. 74r.

fol. 77v (38) "And Moses went out of the city from Pharaoh, and he spread his hands to the Lord" (Ex. 9:33): A bearded Moses is accompanied by Aaron, who is beardless.

fol. 78r (39) Aaron and Moses before Pharaoh (inscribed with parts of Ex. 10:3); cf. fol. 74r.

fol. 78v (40) Pharaoh's wise men advising him to send the Israelites away: On the right, Pharaoh, accompanied by one attendant, is seated and holding a sceptre. On the left are three wise men (inscribed with Ex. 10:7).

fol. 79r (41) Moses and Aaron being brought back to Pharaoh. On the left, Pharaoh is seated, accompanied by one attendant. Aaron is looking back at a servant, who is pushing him forwards towards Pharaoh (inscribed with parts of Ex. 10:8–9).

fol. 79v (42) The plague of "locusts" (Ex. 10:12–15): On the right, a beardless Moses raises his right arm towards a tree on the left, on which three insects are feeding; another insect eats grass, and still another is in the middle of the triple arch.

fol. 80r (43) Pharaoh begging Moses and Aaron to pray for him (inscribed with Ex. 10:16–17); similar to fol. 74r, but here Pharaoh is standing.

fol. 80v (44) The plague of "darkness" (Ex. 10:21–22): A column divides the triple arcade into two compartments. Moses, standing under the right-hand arch, raises his hand into the dark brown area of the other compartment, where there are four people feeling their way in the darkness.

fol. 81r (45) Pharaoh negotiating with Moses: The king is standing with two attendants on the left (inscribed with Ex. 10:24–25). Gold stars in a blue sky can be seen through a large window above.

fol. 81v (46) On the right, Moses and Aaron give instructions to the Elders of Israel. On the left are seven Elders (inscribed with Ex. 12:21).

fol. 82r (47) Eating the Paschal lamb: Four men are marching from right to left. The first one on the left holds a lamb fastened to a long spit, the second holds a staff, the next is putting on a shoe while standing and the last is tying his girdle (according to Ex. 12:11, which forms the inscription). The arches of the triple arcade enclose smears of red to indicate the blood on the houses (Ex. 12:13).

fol. 82v (48) מכת בכרים, "The plague of the first-born" (Ex. 12:29–30): There are two symmetrically placed groups, each one including a bearded man lying dead in a high bed, two kerchiefed, mourning women behind the bed, their feet visible beneath it, and the winged arm of an angel holding a short sword which emerges from the arch above.

fol. 83r (49) On the right, Pharaoh, with two attendants, tells Moses and Aaron, to the left, that the Israelites should leave Egypt (inscribed with Ex. 12:30–31).

fol. 83v (50) A procession of ten people who "...took their dough before it was leavened" (Ex. 12:34): The dough is in two yellow sacks, one of them carried by the leader, on the left, who leans on a stick with his other hand. One of the men is carrying a stick with a magenta bag over his shoulder.

fol. 84r (51) אלו נושאים ארונו של יוסף, "These are carrying Joseph's coffin" (based on Ex. 13:19): A procession of eight men is headed by Moses, who is taller than the rest and holding up his decorated staff. Behind him are two men carrying a yellow coffin with a pink lid.

fol. 84v (Fig. 97) (52) The Egyptians catching up with the Israelites in "Baal Ẓephon" (Ex. 14:9): Baal Ẓaphon is depicted in the middle as a high tower with coloured steps surmounting an arcade. Ascending the steps on the right are a horse — half-hidden by the tower — and three armed soldiers carrying shields, a banner, an axe and a lance. Descending on the left are four Israelites,

with their right arms lifted (an allusion to Ex. 14:8).

fol. 85r (Fig. 98) (53) "But the Egyptians pursued after them" (Ex. 14:9): Four armed green soldiers, riding charging horses, are led by the crowned Pharaoh. They are all helmeted and carry shields, lances and a blue banner.

fol. 85v (54) The Israelites complaining to Moses (inscribed with Ex. 14:11, 13): On the left is Moses, holding his staff which extends beyond the frame. He is turning back towards seven Israelites. The head and forelegs of a horse and two lances emerge from behind the column on the right.

fol. 86r (55) The crossing of the Red "Sea" (Ex. 14:21–28): Between two sections of wavy blue water above and below are twelve Israelites — including two women — headed by Moses, who is holding up his staff, as on fol. 85v. In the upper section of the water there are pen-drawings of two dead horses and three soldiers and a king with green armour. There is no architectural frame.

fol. 86v (56) ותצא מרים הנביאה [בתפים וב־ מחולות], "...Miriam the prophetess came out [with timbrels and with dances]" (based on Ex. 15:20): Miriam, standing in the middle, is dressed in an ochre-gold gown and holding a round timbrel decorated with a red fleur-de-lis. She is flanked by two wreathed dancing women.

4. Passover Ritual Scenes.

fol. 87r (57) הגעלה — cleaning the dishes for the Passover by boiling them: Two men are holding large tongs above a cauldron, which hangs by a chain over a fire between them. The chain is fastened to a pole between the two capitals of the coloured arch, which is shaped like an oven with a chimney. To the left, a woman with a fancy head-dress hands dishes to one of the men.

fol. 87v (58) אלו לשות, "These are kneading" (The dough for the *mazzot*): Two tall women are working at troughs that have a single leg each. Between them are two men, one shaping a round *mazzah* and the other, seated at a table with three *mazzot*, combing lines on one of them.

fol. 88r (Fig. 99) (59) נחתום, "Baker", putting two *mazzot* into his coloured oven with the aid of a long shovel. Behind him are two women, each carrying a tray of *mazzot*, one on her head, the other in her hands.

fol. 88v (60) אלו עושין חרסת, "These are preparing the *ḥaroṣet*": Two men are sitting on the ground, pounding *ḥaroṣet* with pestles in a large, cauldron-like mortar.

fol. 89r (61) וזה נותן מהם, "And this one is giving of (to) them": A man standing on the right, behind a large pot placed on a tripod, is ladling *ḥaroṣet* onto the plate of another man, who is tasting it. To the left is a third man, walking while holding up his plate.

fol. 89v (62) וזה נותן מצות שמורות, "And this

one is distributing 'guarded' *mazzot*": On the right, a man holding a wicker basket of *mazzot* gives one to another man in front of him. A third man, proceeding towards the left, holds up his *mazzah*. The pen-drawn *mazzot* are round, each with a criss-cross pattern of lines and with four triangles extending from it, similar to the roundel on fol. 22r (see below, § B).

fol. 90r (63) Cleaning dishes in the מקוה, "ritual bath": Two men on top of an arch on the right and one on top of an arch on the left are holding various vessels. One of the men on the right is bending down to lower a long-necked flask into the blue water below, which covers the columns of the arches. The scene is framed by a single arch.

fol. 90v (64) אופה, "Baker", probably meaning the cook, ladling something from a large cauldron on a tripod onto a plate which he holds in his left hand. In front of him is a youth, arms stretching out to take the plate. To the left, a third man carries bread (or meat) in a shallow dish and is covering it with a lid. The dish extends into the rectangular frame. There is a chimney-like cylinder in the middle of the arcade at the top.

fol. 91r (65) זה השלחן, "This is the table (of the Passover)": On the table are a jar, a *mazzah*, a chalice, a flask, a knife and a wicker basket containing vegetables and another *mazzah*. Behind the table are a man on the right and a woman on the left, holding up their goblets. Between them is a man holding a flask and pointing to an open book, inscribed: הא לחמא, "this bread", and ספר גאלה, "book of redemption".

fol. 91v (Fig. 100) (66) זה עושה הפסח, "This one is preparing the Paschal (lamb)": On the right is a boy turning a long spit on which a lamb is roasting over a fire. On the left, a man seated on a three-legged stool is working a large pair of bellows. The scene is framed by a single arch, with a cone-like chimney as though for an oven.

5. The Binding of Isaac.

fol. 92r (67) Abraham and Isaac are riding on an ass, on the left, and two boys follow them (inscribed with Gen. 22:3).

fol. 92v (68) On the right, two boys are standing behind a large mule eating out of a sack hanging from a hook fixed to a large, two-branched tree on the left (inscribed with Gen. 22:5).

fol. 93r (69) "And he saw the place afar off" (Gen. 22:4): Abraham is pointing to the left. Isaac carries the wood, tied to a stick, over his shoulder.

fol. 93v (Fig. 101) (70) The binding of Isaac (inscribed with Gen. 22:9): On the left is Isaac, with his hands tied together, lying on his back on an altar built of stones. Abraham is holding back Isaac's head, with a knife in his outstretched right hand. A winged hand pointing to Abraham appears out of a blue segment of sky. A ram is caught in a bush behind Abraham.

B. *Painted Initial-Word Panels.*

There are many painted initial-word panels $(16-32) \times (29-65)$ mm — mostly within the text, particularly in the *Haggadah*, but also at the main divisions of the other readings — which form the main decoration of the text pages. These are occasionally accompanied by text illustrations within the text space (fols. 21r – Fig. 82, 22r – Fig. 83, and 22v – Fig. 84) or in a special compartment attached to the side of a panel (fol. 9v – Fig. 80). The decoration is enriched by ascenders and descenders of some letters, with related extensions of the panel cutting through the text space, some along the entire page. On some pages these extensions are dominant (e.g., fols. 12v, 21r, 23v, 24r, 26v and 31v).

Special combinations of panels form full-page panels (e.g., fol. 16v – Fig. 103, R. Judah's mnemonic signs for the ten plagues) or almost full-page panels (e.g., fol. 29v). The repeated words of the poem *"Dayyenu"* (fols. 18v, 19r – Fig. 104) are written in two columns within vertically elongated panels that flank the text. The undecorated repeated words in other poems are similarly written (e.g., fols. 32v–35r). On fol. 16r a blank space has been left for illustration.

The initial words are written in dusky gold or silver. The larger letters are often lobed, with pointed ends (e.g., fols. 4v, 6v, 7r, 16v, 21v, 23v and many others), similar to those of the *Mocatta Haggadah* (below, No. 10). The panels are mostly divided into four fields, coloured blue and magenta alternately, and decorated with thin white or yellow flowers and foliage scrolls. The panels are framed by thin borders, mostly yellow, and by pen-drawn foliage scrolls in light brown or red ink, with extended, pointed leaves. The ascenders and descenders are often foliated and strung with beads; sometimes they terminate in a gold foliage motif (e.g., fols. 7r and 21r). In other places the frame terminates in large yellow-tinted pen-drawn foliage motifs (e.g., fols. 12r, 12v, 16v and 23v).

fol. 4v (Fig. 102) The beginning of the *Haggadah*: הא לחמא עניא, "This is (the bread of affliction)". Here a full-page eight-pointed star surrounds an octagonal initial-word panel, which is framed by a spared-ground foliage scroll with gold ground fillings. The points of the star are, alternately, blue and magenta; the four magenta fields enclose grotesque animals or birds, and the blue ones are decorated with thin foliage motifs. The star is framed similarly to the other initial-word panels.

fol. 5r The initial-word panel has a penwork ground in red, consisting of curly scrolls with palmette variations and other small foliage motifs.

fol. 27v A contraction of the name of God is written within a panel, shaped as a trefoil arcade.

Conclusions

This manuscript belongs to the class of Spanish *Haggadot* to which are appended a cycle of full-page panels illustrating biblical and liturgical episodes (see introduction to Castilian and Catalan *Haggadot*, above, pp. 42–44). The fact that the full-page miniatures in this *Haggadah* are found at the end of the codex does not necessarily mean that this was their original position, as they may have been moved by a later binder. Within this class, this manuscript belongs to the group of primitive-looking *Haggadot*, such as the *Parma Haggadah* (Biblioteca Palatina, Parma 2411) and the *Casanatense Haggadah* (Rome, Biblioteca Casanata, cod. 2761), all of which share the outline pen-drawing, the wash colouring and the pronounced, single, contrasting bright colours — such as the bright vermilion, red, green and yellow — on the vellum ground. There is a complete disregard of natural colouring, the cattle and other animals being green or yellow, and water mauve.

The composition and figure style of the full-page illustrations resemble manuscripts executed in Castile under Alfonso the Wise in the last quarter of the thirteenth century. The flat, decorative framework which encloses the spacious compositions is somewhat similar to that of the *Libro del Ajedrez* of 1283 (Escorial, Royal Library, MS T.I.6; see Domínguez-Bordona, *Ars Hispaniae*, XVIII, Figs. 147–149).

The thin, flat figures, outlined in light brown ink with few shading lines, and the colourless, bold, round-chinned faces with a pronounced squint, mainly in profile, can be compared to a miniature of Adam and Eve in Paradise in *Fuero Juzgo* by Alfonso the Wise (Madrid, Biblioteca Nacional, MS Hb. 56, fol. 1r; see Domínguez-Bordona, *Catalogo*, Pl. 44).

These elements, together with the bright colours framed by single outlines, hark back to earlier Hispano-Moresque manuscripts, such as the León Bible of 1162 (Colegiata de San Isidoro, MS 3; *ibid.*, Pls. 43 and 45), and to twelfth-century Beatus manuscripts, such as that from San Pedro de Cardeña (Madrid, Museo Arqueológico Nacional; *ibid.*, Pl. 56). This archaistic tradition continued until the fourteenth century, e.g., in the *Libro de Apolonio* in the Escorial (MS K. III. 4; see Domínguez-Bordona, *Manuscritos*, Fig. 502).

The provincial style of our *Haggadah* was no doubt influenced by the illumination of the Castilian Schools of Alfonso the Wise and may have been executed at the end of the thirteenth or at the beginning of the fourteenth century. The three-towered castle resembling the arms of the kingdom of Castile may support this assumption. Some decorative motifs in our manuscript appear in other Hebrew illuminated manuscripts from the Castilian School of around 1300. In the Bibles of Joshua Ibn Gaon of Soria and Tudela from 1300 onwards there are similar red and violet conch shells, fleshy acanthus scrolls and intricate penwork in the frames of the full-page panels, and human figures, animals, birds and dragons appear on the capitals and in the spandrels of the arches. The many towers on top of the framing arches also resemble those of the *Cervera Bible* of 1300 (Lisbon, Biblioteca Nacional, MS 72), which also point to the Castilian School.

The illumination of the manuscript was probably executed by at least three hands from the same workshop. The main artist was the draftsman of the full-page panels on fols. 70r–93v (Figs. 90–101), which have heavier lines but better proportioned figures than the work of the artist who drew the full-page panels on fols. 62v–69v (Figs. 86–89), with larger faces and shorter bodies. The main artist uses fewer outlines, smaller heads, with bulging noses, heavier chins and stringy, formal hair. The second artist (fols. 62v–69v) is somewhat softer in his figure style. There is, however, a unifying element in the drawings and formal gestures, as well as in the tempera colours of the garments, which are shaded by streaks of darker tones and heightened by some white. The illustrations within the text on fols. 1r (Fig. 79) and 35v (Fig. 85) were probably executed by the main artist. An apprentice may have been responsible for the colouring of the decorated initial-word panels in the text, as well as for the background in the one full-page panel in the text (fol. 20v – Fig. 81). The strong blue and magenta colours used by this apprentice are more common in Spanish illumination than in the French manner of colouring.

Bibliography

Margoliouth, III, No. 609, p. 203.

Domínguez-Bordona, *Catalogo*, No. LXVII, pp. 193f, Pls. 43–45, 56.

Idem, *Ars Hispaniae*, XVIII, Fig. 133, 147–149.

Idem, *Manuscritos*, II, No. 1628, Fig. 502.

Narkiss, *Golden Haggadah*, pp. 43–73, Figs. 23, 25, 26, 30.

10. MOCATTA HAGGADAH

Castile, c. 1300

ML, MS. 1

Figs. 105–122

Haggadah, piyyuṭim and Passover laws with midrashim, the Five Megillot and parts of the Mishnah in the margins.

General Data

Codicology

Vellum; 58 leaves; *c.* 242 × 188 mm. Text space (157–178) × (110–118) mm; height of the text space — including the marginal material, written in small script in two lines above the main text and in three lines below it — 210–215 mm. Written in square Sephardi script in several sizes, in brown ink, 21 lines (fols. 2v–12r — *piyyuṭim*), 17 lines (fols. 12v–19r — Passover laws) or 11 lines (fols. 20v–57v — *Haggadah*). Ruling by stylus, 2 + 21 (or 17 or 11) + 3 horizontal and mostly 1 + 1 vertical lines; many folios between 2v–11r have 1 + 2 + 1 vertical lines. Pricking is noticeable in a few lower margins and in the inner margins of fols. 2r–11r (Quire I). 7 quires, mostly of 8 leaves each, starting on fol. 2r, except for Quires I[10] and VI[6], of which the outer sheet is missing, i.e., a leaf after fols. 43 and 49. Therefore, the text is not complete. At least one quire is missing at the end. Fols. 1 and 58 are two fragments from a three-columned Sephardi Bible, which form new fly-leaves and may have originally been used as part of the binding. Fols. 2r, 19v and 20r are blank, although the last two carry the continuation of the marginal texts.

Binding

A red morocco binding of the first half of the nineteenth century, decorated with gold lace, was replaced by a modern, blind-tooled leather binding in 1964. Fols. 2–11 were then correctly rebound, following former foliation of fols. 2, 10, 4–9, 11 and 3.

Colophon

None.

History

fols. 2r, 20r, 20v Faded owner's inscription.
On the paper inside the former front cover "126".
On the paper inside the former back cover "2a, 51, Cat. p. 424, Liturgies, Jews' Service books, *Haggadah* for Passover (Mediaeval). M. MS. 1."

Decoration

Programme

A. Painted initial words and panels with added decoration and one text illustration.
B. Decorative micrography.

Description

A. *Painted Initial Words and Panels with Added Decoration and One Text Illustration.*

The initial-word panels are above, across or within the text, with the additional decoration extending from their sides into the margins (e.g., fols. 20v, 21v–23r, 23v – Fig. 107, 24r–v, 25r – Fig. 108, 27r, 30v and 31r; see below). The panels and their extensions sometimes form a complete frame (fol. 20v — the beginning of the *Haggadah*) or an inverted U-shaped frame to the text (e.g., fols. 22v and 25r).

Several panels are often grouped to form larger, rectangular panels of various sizes, some full-page (e.g., fols. 35v – Fig. 110, and 36r – Fig. 111) or almost full-page (e.g., fol. 43r – Fig. 118). A variation of this scheme consists of columns of initial words forming decorative vertical bars, which, in their most elaborate form, flank the text and are connected by decorative horizontal bands which separate the individual verses of the poem "*Dayyenu*" (fols. 39r, 39v – Fig. 112, 40r – Fig. 113, 40v – Fig. 114, and a variation on fol. 41r – Fig. 115). On other pages there is only one such column, on one side of the text, e.g., fols. 50r (Fig. 119: כי לעולם חסדו), 51v (אודך), 52r (אנא), 54r–56r, 56v (Fig. 122: פסח מצרים) and 57v (מבית און). Other panels are grouped in stepped shapes (e.g., fols. 41v and 50v – Fig. 120).

The decorative writing on fol. 19r (Fig. 106), which occupies most of the text space, is in coloured zoomorphic letters on the vellum ground. The decorations throughout the *Haggadah* are painted in bright shades of ultramarine blue, greyish blue, several shades of magenta, bright red and green, with some yellow, ochre, orange and brown, and with burnished gold and some silver (e.g., fol. 38v). Most shapes are painted in distinct contrasting fields of colour, clearly outlined in black, and mostly decorated with various brush motifs. Abstract shapes are covered with dense, thin brush scrolls and other motifs, mainly in black or white. The brushwork forms the sole elaboration of the painted surfaces. This, together with the colour contrasts, results in a highly

ornamental patchwork effect, which is particularly striking in some of the grotesques and zoomorphic letters (e.g., fols. 19r – Fig. 106, 22r, 23r and 36r – Fig. 111).

The initial words within the panels are mostly in burnished gold. Their shapes are rounded and bulging, with curved, pointed ends and small lobes at many of the angles. Many terminate at the top in grotesque heads, mostly with foliage issuing from their mouths (e.g., fols. 22r, 26v, 35v – Fig. 110, 39r, 39v – Fig. 112, 40v – Fig. 114, 41r, 44v, and 47v). Some of the facial features are pen-drawn on the painted white or pink faces, which are partly surrounded by the gold of the letter, forming hoods (e.g., fols. 39r, 39v – Fig. 112, 40r – Fig. 113, and 52v). In many places various stylized foliage motifs are also incorporated into the design, forming tails for the dragons' heads (e.g., fols. 39r, 39v – Fig. 112, 40r – Fig. 113, 40v – Fig. 114, 41r – Fig. 115: "*Dayyenu*"). Some vertical strokes, especially the descenders of some letters, are particularly decorated, sometimes partly in colour (e.g., fols. 44v and 52v). Some consist of patterns of interlacing bands with coloured fillings (e.g., fols. 35v – Fig. 110, 50v – Fig. 120, and 52v) or a gold ground (e.g., fol. 53r – Fig. 121); others are shaped as chains of superimposed heart shapes, mostly connected with straight bars or other motifs (e.g., fols. 17r, 29v and 44v; cf. fols. 41r – Fig. 115, 47v and 52v). The majority of these descenders terminate in large foliage or floral motifs, and many belong to letters that incorporate grotesque heads as well.

The zoomorphic letters on the vellum ground on fol. 19r (Fig. 106), which are pen-drawn with red, blue, magenta and some yellow fillings, have very similar grotesque heads, foliage motifs and decorated descenders. The strokes of the letters are divided by thin bands into differently coloured sections which are decorated with figures-of-eight and a few foliage motifs. Every letter is topped by a small penwork lozenge in red. The bulging shapes of the gold letters seem to be a variation of the coloured zoomorphic ones. In the latter, the complete shape of a dragon or a band can be identified, whereas only the outlines can be seen in the gold letters. These are especially noticeable when comparing the gold letters with the painted example in fol. 22v, the drawings over gold on fols. 39r and 41r (Fig. 115), or the exposed under-drawing on, for example, fol. 36r (Fig. 111).

The initial words in the panels on fols. 46v and 47r are drawn in a more angular and rigid manner. They are painted brown, with spared-ground small rosettes, outlines and dividing bands and with additional white brush scrolls.

The panels, mostly measuring (32–58) × (60–150) mm, are divided into separate fields painted in the above-mentioned colours, with magenta and blue predominating. The division into fields is mostly irregular and often forms many small patches of one colour set in irregular patterns on a ground of the other colour (many between fols. 25r and 57v). These patches sometimes take the form of bands that make up partial frames (e.g., fols. 29r, 32r, 37r, 39r, 39v – Fig. 112, 40r – Fig. 113, 40v – Fig. 114), flowers or leaves (e.g., fols. 34v, 39v – Fig. 112, 43r – Fig. 118, 44v and 47v), or highly stylized, almost abstract foliage shapes (e.g., fols. 31r, 31v, 34v and 50r – Fig. 119); in other places they are surrounded by interlacing bands (e.g., fols. 40v – Fig. 114, 50v – Fig. 120). Some panels take the form of multi-coloured patchwork (e.g., fols. 47v, 50r – Fig. 119, 54v and 55r), whereas others are divided into a central compartment and framing bands (e.g., fols. 17r, 20v, 21v and 26r). Most panels have a partial fillet frame and short extensions from the corners, shaped as small foliage motifs or as cusps, mostly enclosing similar foliage (e.g., fols. 46v and 47r). Cuspings also decorate the sides of some panels (e.g., fols. 23r, 24v, 25v, 26r, 32v, 37v, and 42r – Fig. 116). Among the motifs extending from the corners are small, horned grotesque heads (e.g., fols. 23v – Fig. 107 and 27r); a small grotesque and a rabbit are at the upper corners of the panel on fol. 25r (Fig. 108). The painted fields of the panels consist of fine scrolls or bold designs of diapers, chequers and zigzags, as well as of stylized foliage motifs and scrolls, executed in brushwork. There are also a few gold shapes on the ground of the panels (e.g., fol. 22v).

Most of the panels on fols. 51v–52v, 53r (Fig. 121), 53v–56r, 56v (Fig. 122), 57r–v incorporate areas of penwork forming the main ground (e.g., fols. 51v, 52v, 53r – Fig. 121, 53v, 54r, 55v and 56r) or a few insertions (e.g., fols. 54v, 55r and 56v – Fig. 122). These panels are also surrounded by penwork. The penwork consists of very dense red scrolls, with narrow lobes filled with flourishes, some of the larger and more rounded curls filled with scrolls, dotted pearls and palmette variations in violet. Some of the violet insertions are triangular or rectangular (e.g., fols. 52v, 53r – Fig. 121, and 54v); on fol. 56v they form a chequered pattern with the red penwork. The penwork round the panels consists of similar motifs in small fields of different shapes, surrounded by lines with sections of dotted pearls and extended tendrils, which also surround many of the painted sides of the panels.

The decorations accompanying initial words consist of elongated extensions from the panels, one of which is a text illustration. They are decorated and painted in a way very similar to that of the panels from which they extend, with lobes, cusps, sections of coloured bands and stylized foliage or cusps at the bottom.

In many places the extended decoration is combined with ascenders and descenders of the final *kaf* (e.g., fols. 35v – Fig. 110, 44v, 46v, 47r, 52v and 53r – Fig. 121), *lamed* (e.g., fols. 41v, 44v, 45r and 47v), the final *nun* (e.g., fols. 17r, 42r – Fig. 116, and 50v – Fig. 120) or *qof* (e.g., fols. 29v and 38r). These ascenders and descenders sometimes fall within the text, dividing it arbitrarily (e.g., fols. 38r, 44v, 46v, 47v and 52v; cf. fol. 19r – Fig. 106).

Some extensions have additional lobed foliage issuing from their sides (e.g., fols. 20v and 23r). In other places the motifs of the marginal decorations are attached to the sides of the panels. These incorporate various motifs on ᵗhe vellum ground or on a coloured ground, including dragons with foliated tails (e.g., fols. 22r, 23v and 24r), grotesque heads and a grotesque bird (fol. 31r), a dead peacock whose legs are stretched upwards and whose neck descends along the margin (fol. 23r), as well as stylized acanthus scrolls (e.g., fols. 31r and 45r).

fol. 17r The right-hand compartment of the panel encloses a motif resembling Latin initial decoration, painted in blue with two gold dots on a magenta ground. Compare with fol. 30v, where similar decoration, in a compartment with rounded sides, also fills the extension into the margin (see also fol. 31r).

fol. 20r The framing fillets on the sides are interrupted by roundels enclosing gold dots; cf. the micrographic tree on the opposite page.

fol. 33v The panel is supported by a large corbel with stepped sides, decorated with coloured brickwork.

fols. 35v (Fig. 110), *36r* (Fig. 111) דצ״ך עד״ש באח״ב — Mnemonic words for the ten plagues. The full-page panels, measuring 173 × 128 mm and 185 × 128 mm, are decorated with various coloured patches and are sub-divided by various coloured bands. The panel on fol. 35v is also bisected vertically by the decorative tail of the letter *kaf*, which protrudes from the panel and terminates in a large, stylized foliage motif. The lower part of this tail is flanked by two small, decorative panels framed in gold, with a large gold cinquefoil attached to the bottom of each and partly protruding from the bottom of the panel. The panel on fol. 36r is shaped as a double arcade. The arches rest on a corbel in the centre and on columns at the sides. Each column has a stepped base decorated with brickwork, and is decorated with a boss from which a double acanthus motif emerges. All the points from which the arches rise are surmounted by pinnacles. Each arch encloses two coloured lozenges with gold centres. A horizontal band separating the two initial words is decorated with a large, stylized scroll. The lower compartment encloses a very large winged dragon.

fols. 39r, 39v (Fig. 112), *40r* (Fig. 113), *40v* (Fig. 114), *41r* (Fig. 115) Of the two composite panels which flank the main text ("*Dayyenu*") on each page, that on the left includes, in addition to the various coloured patches, different motifs above each of the three initial words in the composite panel. On fol. 39r are, within compartments, from top to bottom: a chalice between two flasks; a bear(?) and a grotesque; a hound(?) chasing a hare(?), which is to the side of a small gold tree (damaged). On fol. 39v are, from top to bottom: a stylized gold tree (palmette) and two grotesques with gold, foliated tails, the lower with a bearded human head. Both columns of initial words on fol. 40r are decorated with interlacing coloured bands: those in the right-hand column form an all-over pattern, whereas those in the left-hand column form three separate motifs, the upper and middle ones being six-pointed stars enclosing a crescent with a small star and a small rosette, respectively. On fol. 40v are, within compartments, from top to bottom: a grotesque with a hooded human head; a standing lion, lifting one paw; and two confronting peacocks, their beaks crossed (faded).

fol. 43r (Fig. 118) Text illustration: The roundel of the *mazzah*, within an almost square panel (115 × 118 mm), together with the initial-word panel on top forms an almost full-page panel, 162 mm in height. The roundel is formed by interlacing geometrical shapes in gold, with coloured ground fillings. The panel and roundel are framed by coloured fillets. A lobed gold leaf within a blue frame extends into the margins from each corner.

B. *Decorative·Micrography.*

Portions of the Mishnah (*Sanhedrin* 10 and *Avot*) are written in different shapes of micrography in the outer margins of almost all pages, except for fols. 54v, 55v, 56v and 57v, where they are in the inner margins, and fols. 2v, 12v and 13r, where they are in both side margins. The micrography shapes enclose matching coloured shapes in blue, red, green, violet, magenta and lustre magenta (e.g., fol. 56v – Fig. 122). Most frequent is the candelabrum motif, which appears in a great variety of large and small forms, with two to eight branches, incorporating various combinations of lozenges, triangles, heart shapes, roundels, other geometrical shapes and some lobed foliage. The tops of the flames are in blue or red; some are decorated with fleurs-de-lis. Many of the trees are plaited (e.g., fols. 17v, 18r, 23r – Fig. 107, 24v, 29v, 33v–35r – Fig. 109, 37v, 38r, 41v, 42r – Fig. 116, 44r, 46v, 47r, 48v, 53v and 57r). There are also bands with foliage scrolls (e.g., fols. 25r – Fig. 108, 35v and 36r – Fig. 111) and various geometrical shapes (e.g., fols. 16v, 17r, 26r, 42v – Fig. 117, 45v, 46r, 49r, 52v and 53r), interlacing bands (e.g., fols. 27r, 42r – Fig. 116, and 32r) and a

column of motifs which include fleurs-de-lis in different colours enclosed in medallions (e.g., fols. 25r, 28v and 29r) or executed in micrography (e.g., fols. 14r – Fig. 105, 14v, 15r and 22r).

Conclusions

The illumination of this manuscript, with its many titles and initial words, is highly decorative, even though it has only one full-page text illustration of the *mazzah*. The zoomorphic shapes of the letters in the mnemonic sign for Passover (fols. 19r – Fig. 106) and others (e.g., fols. 26v, 52v) might point to an earlier model of either Hispano-Moresque, Merovingian or Mid-Eastern origin. These letters became fashionable in Hispano-Hebrew illumination at the end of the thirteenth century, as can be seen from the **Hamilton Şiddur** (Berlin, Staatsbibliothek, Ham. MS. 288; see Narkiss, *HIM*, Pl. 7) and the *Casanatense Haggadah* (Rome, Biblioteca Casanata, Cod. 2761). They are executed in the dark Hispano-Gothic magenta, blue, brown and gold found in early fourteenth-century Sephardi manuscripts such as the *Golden Haggadah* of *c.* 1320 (below, No. 11) or the *Barcelona Haggadah* (below, No. 13). However, the shape of the arcaded page in our *Haggadah* (fol. 36r), with the triple turrets on top and stepped bases of the columns, should be compared with the arcadings of the *Hispano-Moresque Haggadah* (above, No. 9, e.g., fols. 65v, 66v, 69r – Fig. 89), as well as with those of the *Casanatense Haggadah*, e.g., fol. 35r. This may point to the dependence of the *Mocatta Haggadah* on an early Castilian model of the thirteenth or early fourteenth century. The marginal decorations, shaped in micrography with some additional coloured elements, are known from decorated Massorah shapes in Bibles of the fourteenth century. Castilian Bibles, such as those of the Ibn Gaon group from Soria of around 1300 (Cat. Nos. 3–6 above), contain micrographic decorations similar to those on, e.g., fols. 35v and 42r, though some of the motifs, such as the candelabrum-like tree on fol. 18r, became fashionable in a more elaborate form in Catalonia during the second half of the fourteenth century. The elaborate combination of micrographic shapes with added colour motifs is similarly found in a Catalan Hebrew Bible of 1301 (Copenhagen, Kongelige Bibliotek, Cod. Hebr. II). This may suggest a date of *c.* 1300 to our *Haggadah*.

Bibliography

Rye, *Mocatta*, MS. 1, pp. 424.

II. Catalan Schools of the Fourteenth Century
[Nos. 11–32]

The Catalan schools of Hebrew illumination were centred round Barcelona, the capital of the Kingdom of Aragon and seat of a strong Jewish community. The wealthy aristocratic Jewish families of Barcelona were probably proud of their connection with the royal court, and their patronage of illuminated manuscripts must have resulted in part from their exposure to the rich Spanish culture. Manuscripts like the *Golden Haggadah* (No. 11), at the beginning of the century, and the *Duke of Sussex Catalan Bible* (No. 19), at its end, are good examples of the quality of the illumination produced. They make use of the latest stylistic innovations in contemporary Latin illumination, which brought together the French and Italian Gothic components known in Barcelona; however, their decoration plan and iconography conserve the Jewish traditions. Side by side with these high-quality manuscripts are those decorated by less accomplished or even popular artists, e.g. the *Sister Haggadah* (No. 12) or the *Oxford Catalan Levi ben Gershom* (No. 31). The rather crude workmanship of the manuscripts posits artists attached to models; they therefore preserve the specifically Jewish iconography more accurately than the high-quality manuscripts of the period.

During the fourteenth century the Catalan schools produced a great number of illuminated *haggadot* and Bibles, as well as other kinds of books. Of about ten sumptuously decorated Catalan *haggadot*, five of the most important ones are in collections in the British Isles. And, although they possess no colophon, their attributed dates range throughout the fourteenth century. The production of Bibles, however, was concentrated in the second half of the century. It must be mere coincidence that the British Isles collections do not possess Bibles of earlier date, the existence of which is well attested by the *Parma Catalan Bible* of 1277 (Parma, Biblioteca Palatina, Parms. 2668; see *Manoscritti biblici ebraici*, No. 32, pp. 77–78, Pls. 24, 25); the *Perpignan Bible* of 1299 (Paris, Bibliothèque nationale, hébr. 7; see Gutmann, *Manuscript*, Pls. 6–7); and the *Copenhagen Catalan Bible* of 1301 (Copenhagen, Kongelige Bibl., Cod. Heb. II; see *Synagoga Cat. Exhib.*, Recklinghausen, 1960–1961, No. B. 8).

It is interesting to note that books of a religious nature, like the *London Catalan Naḥmanides* (No. 30) or the *Oxford Midrash Tanḥuma* (No. 27), were not the only manuscripts illuminated. Books of philosophy and polemics (Nos. 29, 31, 32), and even *Maimonides' Aphorisms in Arabic* (No. 28), were decorated as well. However, with no tradition of illumination, one can hardly point to a consistent decoration programme. These manuscripts were mostly decorated at the discretion of the artist, and their decoration is concentrated in their main text division.

For the decoration programme of Catalan *haggadot* and Bibles, see the Introductions on pages 57, 101–104. The destruction of the Jewish communities in 1395 had little effect on the artistic creation of illuminated manuscripts. Two Catalan manuscripts in our collections (Nos. 24, 32) were copied and decorated in 1396. There are, however, very few Hebrew illuminated Catalan manuscripts from the fifteenth century.

Catalan Haggadot of the Fourteenth Century
[Nos. 11–18]

The decoration programme, its relation to the text and the iconography of the Catalan *haggadot* are discussed in the Introduction to the Castilian and Catalan *haggadot* (pp. 42–44). The style of most Catalan *haggadot* from the fourteenth century is directly related to illumination of the highest quality, and is comparable to manuscripts executed for the royal court at Barcelona and elsewhere. For instance, the *Golden Haggadah* (No. 11) of the early fourteenth century depends in part on Spanish Latin illumination such as the Catalan Laws of 1321 (Paris, Bibliothèque nationale, Lat. MS. 4670A, Parts 7 and 9; see Narkiss, *Golden Haggadah*, pp. 38–39), which is one of the earliest known manuscripts containing moderate italianizing influences mingled with late-thirteenth-century Franco-Spanish Gothic style.

The more pronounced italianizing style of the *Rylands Sephardi Haggadah* (No. 15) of the second half of the fourteenth century is clearly dependent on that found in the *Chronicles of Jaime el Conquistador* of 1343 (Barcelona University, MS. 1; see Domínguez-Bordona, in *Ars Hispaniae*, Vol. XVIII, 1962, Fig. 186). This style is also evident in the *Copenhagen Maimonides' Guide* of 1348 (Kongelige Bibl., Cod. Heb. 37; see Narkiss, *HIM*, Pl. 18). The Italian style reached Majorca and Catalonia through their direct connection with southern Italy.

While Italian influence was very noticeable in Catalonia, especially in Barcelona, its stylistic elements and motifs reached Castile and Portugal much later, only in the fifteenth century.

The Franco-Spanish Gothic style, in evidence from the beginning of the fourteenth century, is an archaizing element which survives in most *haggadot* throughout the fourteenth century. This is particularly noticeable in the decoration of text pages, mainly in initial-word panels and their decorative scroll extensions. Decorative motifs such as these can still be found in late fourteenth-century *haggadot* like the *Sarajevo* and *Kaufmann* manuscripts. Being secondary in importance, this kind of decoration was probably perpetuated by apprentices who closely followed the more traditional patterns. By contrast, the master artists, the illustrators of manuscripts, were constantly looking for innovations in iconography and style.

Other early-fourteenth-century *haggadot* can also be attributed to the Catalan school, for example the *Catalan Haggadah Genizah Fragment* (No. 17) and the *Barcelona Haggadah* (No. 13), as well as the *Catalan Passover Parashot and Piyyuṭim* (No. 14). Their dating can be deduced by comparing their figural and decorative style with that of the *Golden Haggadah* (No. 11) and contemporary Catalan Latin manuscripts. In the same way, the late-fourteenth-century Catalan *haggadot* are mainly related to contemporary Catalan Bibles through the stylistic rendering of their scrolls and leaves. The *Sister Haggadah* (No. 12), the *Rylands* and the *Brother Haggadot* (Nos. 15–16) belong to the second half of the century.

11. GOLDEN HAGGADAH

BL, Add. 27210

Biblical picture cycle, Haggadah and piyyuṭim.

General Data

Codicology

Vellum; 1 + 100 (fols. 2 – 101) + I leaves (fols. 1 and I are paper fly-leaves); *c.* 247 × 198 mm. Text space (168–172) × (133–135) mm (fols. 24v–55v — *Haggadah*) or (157–163) × (127–132) mm (fols. 6v–23v and 56v–101v — *piyyuṭim*). Written in square Sephardi script in several sizes, in brown ink, 10 (*Haggadah*) or mostly 26 (*piyyuṭim*) horizontal lines, in one or two columns or in verse form. Ruling by stylus, 10 or 26 horizontal lines, and 1 + 1 vertical lines, except for *piyyuṭim* and *parashot*, which are written in two columns and have 1 + 2 + 1 vertical lines. Pricking is noticeable in the upper and lower margins of some pages of the *piyyuṭim*. 13 quires of 8 leaves each, except for Quires I⁹ (8 + 1; the last joined from Quire II), II⁵ (one leaf joined to Quire I and two leaves cut off) and XIII⁶, which are gathered so that outward hair side faces hair. Fols. 2r, 3v–4r, 5v–6r, 7v–8r, 9v–10r, 11v–12r, 13v–14r, 15v–16r, 24r and 56r were originally blank; all but the last one have seventeenth-century additional texts and decorations.

Binding

Seventeenth-century North-Italian dark-brown morocco binding on wooden boards, with elaborate, delicate, blind-tooled borders on each cover. At the centre of each cover there is a circular, fan-shaped pattern with a small, crowned and winged heraldic eagle tooled into the leather. The outer borders are composed of fleurons, circles, scrolls and a row of the same heraldic eagles. Fragments of metal clasps.

Colophon

None.

History

fol. 2r (Fig. 123) Decorated title page: The manuscript was given by R. Joab Gallico of Asti (near Turin) to his daughter Rosa, on the occasion of her marriage to Elijah ben Menahem Rava in Carpi (near Modena), on the 10th of Ḥeshvan 5363 (25 October 1602).
fol. 16r (Fig. 124) A heraldic device of the Gallico family.
fol. 2r In the top margin, inscription of acquisition by legacy: "[with the help of the Almighty] / Amongst your brothers you inherited a legacy on the 6th of Kislev (5)365 (28 November 1604) / and this is my part and luck / the young Arieh."
fol. 1r Birth entry: Azariah Zedekiah Ḥayyim Ashkenazi, on 22 January 1689.

fol. 101v Censors' signatures: (1) Fra Luigi da Bologna, February 1599 (probably in Carpi); (2) Camillo Jaghel, 1613; (3) Renato da Modena, 1626.
fols. 3v–15v On the reverse side of the full-page miniatures: A mnemonic rhymed poem on the laws of Passover and a cabbalistic commentary on the "signs" of the Passover *Seder*, written in a seventeenth-century Italian hand.
Up to 1863 in Joseph Almanzi's Collection in Padua; No. 328 in his catalogue.
Purchased by the British Museum from A. Asher & Co. of Berlin, together with the Almanzi Collection, in 1864.

Decoration

Programme

A. Full-page panels:
1. Biblical scenes.
2. Ritual scenes.
B. Decorative titles and initial words with accompanying decorations:
1. Decorative titles and initial words.
2. Accompanying decorations.
C. Seventeenth-century decorations:
1. Frontispiece.
2. Full-page armorial device.
3. Full-page frames for added texts.

Description

A. *Full-page Panels.*

The fourteen full-page panels painted on one side of confronting leaves depict 71 scenes from Genesis (fols. 2v–3r, 4v–5r, 6v–7r and 8v) and Exodus (fols. 8v–9r, 10v–11r, 12v–13r and 14v–15r) and 5 ritual scenes (fol. 15r). Their measurements vary: those on fols. 2v–9r (original Quire I) measure 178 × 156 mm, and those on fols. 10v–15r (original Quire II) measure 180 × 152 mm. Each panel is divided into four compartments (80 × 70 mm), formed by bands coloured blue with vermilion fillet borders (fols. 2v–9r, 11r, 13r and 15r) or light brown bordered by green fillets (fols. 10v, 12v and 14v). The bands are decorated with white pen scrolls or zigzag patterns. Small gold squares are stamped in the corners of each compartment. Fols. 2v and 9r–15r have additional penwork foliage scrolls extending from the four corners.

Each compartment has a decorated, diapered, stamped gold-leaf ground, with architecture, landscape and figures standing out against the golden ground. The shapes of the figures, objects and landscapes are outlined in black and painted in several shades of blue, wine red, vermilion, olive green, grey, violet-grey, pink, magenta, brown and dusky gold, all heightened with lighter shades. The landscape consists of step-like rock shapes of brown and violet-grey, with some tufts of dark green grass and flowers. Water is depicted by wavy stripes of two shades of blue. Trees have violet-grey trunks and dark bottle-green, round tops, and leaves outlined in black, with some white flowers. Segments of sky are in violet-grey.

Buildings, with doors, windows and dome-like interiors, in green, brown, magenta and blue, are seen mainly from the exterior; many look like domed baldachins; two have coffered ceilings (fol. 15r). Domatomorphic furniture is in colours similar to the buildings.

The human figures, proportionally balanced but large compared to the landscape and other objects, are gothic in style and expressive in movement and gesture. Faces and naked skin are white, heightened with pink; facial features are in black. Drapery of clothes, curtains, sheets and table-cloths is in soft folds, with shadows and highlights in different shades of the same colour and black and white lines. Where groups of people appear, only those in front are shown fully; of the rest, parts of heads, or even only one eye (Scene 18), are shown. Animals are in their natural colours; sheep are white with linear wool.

The panels depict a consecutive cycle from Gen. 2:19 to Ex. 15:20. In some cases more than one episode is represented in a single compartment, so that the cycle of 71 episodes is arranged in 53 compartments. The sequence of episodes and compartments is usually from right to left, first on top (a – right and b – left), and then at the bottom (c – right and d – left).

The captions to the panels, written in a small, square script, are probably contemporary with those in the *Haggadah* and the *piyyuṭim*, although they were written by another hand. In most cases they are biblical verses that describe the episodes correctly; they are therefore cited in our descriptions below as titles (in inverted commas). In other cases, mainly where the captions are not biblical, they are cited in Hebrew and translated.

1. *Biblical Scenes.*
Fig. 125
fol. 2v, a (1) אדם קורא שמות לחיות ולבהמות, "Adam gives names to the beasts and the cattle" (based on Gen. 2:19–20): To the left, Adam is seated naked on the ground, pointing with his left hand to the birds on top of a tree in the middle of the compartment, and with his right hand to the

animals approaching him from the right. Among the animals are a reptile, a goat nibbling at a second tree, two sheep, a red bull, two donkeys and a rabbit.

fol. 2v, b, right (2) The creation of Eve (Gen. 2:21–22): Eve's naked bust emerges from Adam's right side as he lies naked and asleep on the ground.

fol. 2v, b, left (3) The temptation (Gen. 3:1–8): On either side of the Tree of Knowledge, on which the serpent is coiled, are Adam and Eve, covering their nakedness with fig leaves. From a segment of sky in the top right-hand corner a winged angel is pointing at them. Inscribed: אדם ואשתו ערומים, "Adam and his wife naked".

fol. 2v, c, right (4) קין והבל מגישים מנחה, "Cain and Abel offer a sacrifice" (based on Gen. 4:3–5): Abel, carrying a lamb in his covered hands, is standing to the right of a column altar with fire on the top. It bends towards Cain, who is standing on the left holding a sheaf of corn in his bare hands and looking away from the altar.

fol. 2v, c, left (5) "And Cain rose up [against Abel his brother and slew him]" (Gen. 4:8): Cain holds a long-handled axe in his left hand and looks up at the winged angel, who is emerging from a segment of sky to reproach him. Under Cain's feet and partly buried in the ground are the bloody head and arm of Abel (Gen. 4:9–10). The human figures are damaged.

fol. 2v, d (6) נח ואשתו ובניו יוצאים מן התיבה, "Noah and his wife and his sons come out of the ark" (based on Gen. 8:18–19): In the middle, a bearded Noah helps two sheep exit from the arched door of a box-like ark. Behind him are his wife and four children. In front of him are the animals: two more sheep, a donkey, a red bull and a goat. Below him is a pig. On top of the left-hand side of the ark is a dove holding a branch in its beak.

Fig. 126
fol. 3r, a, right (7) "And he planted a vineyard" (Gen. 9:20): Noah, wearing a white apron, is cutting off the red clusters of grapes with a knife. A basket full of red grapes is near him (not recorded in the Bible).

fol. 3r, a, left (8) "And he drank of the wine, and was drunken; and he was uncovered" (Gen. 9:21): Noah is lying naked on the ground, asleep. Behind him are two youths, Shem and Japhet, holding a blue and vermilion cloth to cover Noah; inscribed: "and their faces were backward" (Gen. 9:23).

fol. 3r, b (9) The builders of the tower of Babel kill each other (Gen. 11:1–9; *Genesis Rabbah* 38:10): To the right of a white stone tower is a man stabbing in the back another man who is drawing up a bucket with a pulley. Below, a man hoeing is being stoned by another man who is looking out of a low window in the tower. In front of the tower are two men stabbing each other. The

architect, standing on the left in a long green robe, is being stoned by a man from a higher window. On top of the tower is a man stabbing another in the back. Inscribed: דור הפלגה, "The divided generation" (Mishnah *Bava Meẓi'a* 4:2; *Sanhedrin* 10:3, based on Gen. 10:25).

fol. 3r, c (10) נמרוד וחכמיו משליכין את אברהם בכבשן האש, "Nimrod and his wise men throw Abraham into the fiery furnace" (*Genesis Rabbah* 38:13; *TB Peṣaḥim* 118a; *Tana D'vei Eliyahu* 6): To the right is the crowned Nimrod, seated under a green canopy, pointing at Abraham, who is being thrown by two attendants into the hands of two winged angels who appear from the fire in a barrel-like furnace in the left-hand corner. Below the king sit two of his counsellors.

fol. 3r, d (11) Abraham's hospitality and the prophecy to Sarah; inscribed "[And he] stands by them [under the tree and they did eat]" (Gen. 18:8): Three winged angels sitting under a tree behind a set table point to Abraham on the left, who is waiting on them holding a flask and pointing to Sarah, who stands within an open edifice; inscribed: "[and he said:] Behold, in the tent" (Gen. 18:9).

Fig. 127

fol. 4v, a (12) לוט ובנותיו בורחים, "Lot and his daughters flee": To the right is Lot, pushing four children in front of him. In the middle, on top of a stepped rock, is the white figure of Lot's wife; inscribed: "And she became a pillar of salt" (Gen. 19:26). To the left are four bleeding heads among the ruins of tumbling houses and parts of walls; inscribed: הפיכת סדום, "The overthrow of Sodom".

fol. 4v, b, right (13) The binding of Isaac; inscribed: "Abide ye here with the ass" (Gen. 22:5): Abraham's two young attendants are standing behind the ass.

fol. 4v, b, left (14) "And he bound Isaac his son" (Gen. 22:9): Isaac is lying on the ground with hands bound. Kneeling over him is Abraham, holding a knife and looking backwards at a winged angel, who is appearing from a segment of sky and pointing to a ram that is hanging vertically from a tree in the middle of the panel; inscribed: "And behold, a ram" (Gen. 22:13).

fol. 4v, c, left (15) Isaac blessing Jacob; inscribed: "Come near, I pray thee, that I may feel thee" (Gen. 27:21): Isaac, sitting on the left, behind a table laid with a lamb on a plate, is touching Jacob's hands and neck. Behind Jacob is Rebecca.

fol. 4v, c, right (16) "and Esau [his brother came in from his hunting]" (Gen. 27:30): Approaching from the right is Esau, carrying a hare hanging from a club over his shoulder and armed with bow and arrows.

The two scenes in this compartment (15–16) should be read from left to right, as described

above. A large green building serves as background for both.

fol. 4v, d (17) Jacob's dream; inscribed: "A ladder set up on earth... the angels of god ascending and descending" (Gen. 28:12): To the left is "Jacob", lying on the ground asleep. One angel is ascending the ladder, which is placed diagonally, and another is descending it. The head and wing of an angel appear from a rectangular aperture in the segment of sky in the top right-hand corner. Two other angels are walking on the ground, one touching Jacob's head.

Fig. 128

fol. 5r, a, left (18) "and he passed over the ford Jabboq" (Gen. 32:22–23): Jacob and seven other people are walking on the left side of the Jabboq, painted diagonally from about the middle of the panel to the bottom left-hand corner.

fol. 5r, a, right (19) Jacob wrestling with the angel; inscribed: "And a man wrestled with him" (Gen. 32:24–25).

Secnes 18–19 should be read from left to right, as described above.

fol. 5r, b (20) "Joseph's dream" (Gen. 37:5–9): Joseph, asleep on a large bed, is covered with a green and pink blanket. Above him are twelve sheaves bowing to a large sheaf in the middle. On top is a human-faced, blazing red sun and a blue crescent moon. The stars are not represented.

fol. 5r, c (21) Joseph relating his dreams to his father and brothers: On a background of a large green building, the small figure of Joseph on the left tells his dreams to Jacob, who is seated in the middle; inscribed: "And his father rebuked him" (Gen. 37:10). On the right are the figures of seven brothers; inscribed: "Joseph's brothers".

fol. 5r, d, right (22) Joseph meets an angel on the way to his brothers (*Genesis Rabbah* 84:14): A winged angel shows the way to Joseph, who is carrying his dusky gold and vermilion garment on a stick over his shoulder; inscribed: "And a certain man found him" (Gen. 37:15).

fol. 5r, d, left (23) [אחיו] רועים הצאן, "[His brethren] pasture the flock" (based on Gen. 37:12, 18): Six brothers are sitting, some of them pointing towards the approaching Joseph. Behind them is a dog, and in front of them are three sheep and a ram. The scene is separated from scene 22 by a tree.

Fig. 129

fol. 6v, a, right (24) The second council of the brothers (Gen. 37:26–27): Five people are conversing behind the top of a hill, one of them pointing at Scene 25.

fol. 6v, a, left (25) Joseph is being pulled up from a round well by two of his brothers (Gen. 37:28); wrongly inscribed: "And they cast him into a pit"

(Gen. 37:24). The scene is separated from Scene 24 by a tree.

fol. 6v, a, below left (26) Smearing Joseph's coat with blood: One brother kneeling, holds a bleeding kid over Joseph's dusky gold garment, which is held by another brother. On the right two sheep and a ram graze; inscribed on the right: "And they killed a kid of goats" (Gen. 37:31).

The three scenes in this compartment (24–26) are misplaced: the smearing of Joseph's coat should come after Joseph is sold to the Ishmaelites (27).

fol. 6v, b (27) "A company of Ishmaelites came... and they sold Joseph" (Gen. 37:25, 28): On the right is Joseph, being passed over by one of his brothers to a Saracen dressed in white, while another Saracen puts handfuls of coins into the outer garment of another brother. To the left are two loaded mules.

fol. 6v, c (28) "And they brought the coat of many colours to their father... and he rent his clothes" (based on Gen. 37:32, 34): To the left is Jacob, seated on a wide chair under a green canopy, tearing his clothes; his face is averted from Joseph's bloody, dusky gold coat, which is held by one of the four brothers on the right. To the left of Jacob stands a mourning woman.

fol. 6v, d, top right (29) Joseph and Potiphar's wife: In a low-beamed room, a crowned woman wearing underclothes is sitting up in bed and seizing the fleeing Joseph by his coat; inscribed below to the right: "And she caught him by his garment" (Gen. 39:12).

fol. 6v, d, top left (30) Potiphar and two of his friends hurry home through the open gate (not recorded in the Bible). No inscription.

fol. 6v, d, below (31) חלום המשקה והאופה, "The dream of the butler and the baker" (Gen. 40:9–19): To the right is the butler, seated under a bent tree with clusters of grapes on it, squeezing one of the clusters into a cup. In the middle is the baker, a raven pecking at the loaves in a basket on his head. Seated on the left is a bearded Joseph, pointing at them with both hands; inscribed: יוסף פותר, "Joseph interprets".

Fig. 130

fol. 7r, a (32) "Pharaoh's dreams" of the cows and the ears of corn (Gen. 41:2–7): A crowned and bearded Pharaoh is asleep in a large bed. Above him are seven fat and seven lean red and brown cows and ears of corn.

fol. 7r, b (33) Joseph interpreting Pharaoh's dream in front of his counsellors: To the left, under a green canopy, the crowned and bearded Pharaoh is sitting on the same bench with a bearded Joseph and conversing with him; inscribed: "And he shaved himself and changed his raiment" (Gen. 41:14). To the right stand three counsellors, also conversing; inscribed: חרטמי פרעה, "Pharaoh's magicians"

fol. 7r, c (34) "Joseph speaks roughly to his brothers" (based on Gen. 42:7) and orders the arrest of Simeon (Gen. 42:24): To the right is Joseph, seated before a hanging curtain and pointing at four brothers, who are standing on the left. One of the brothers' hands are raised in astonishment. At their feet are a sack and the kneeling, bare-footed Simeon, his hands being bound by a servant; inscribed: "And he bound him before their eyes" (Gen. 42:24).

fol. 7r, d (35) Joseph makes himself known to his brethren: To the right is Joseph, seated before a hanging curtain and kissing the tiny Benjamin, who stands on Joseph's knees; inscribed: "And he fell upon his brother Benjamin's neck" (Gen. 45:14). Five brothers are approaching from the left.

Fig. 136 — PL. XXXIX

fol. 8v, a (36) Jacob meets Pharaoh: Pharaoh, Jacob and Joseph are seated in front, to the left of a green baldachin. To the right, behind a mountain, are three of "Joseph's brothers". In the bottom right-hand corner is a river with fishes. Inscribed: "And Jacob blessed Pharaoh" (Gen. 47:7, 10).

fol. 8v, b (37) שכל את ידיו, "He crossed his hands" to bless Ephraim and Manasseh (Gen. 48:1, 14): יעקב חולה, "Jacob is sick", sitting up in bed on the left, propped up by a dusky gold, decorated cushion. Behind him, from the top of the panel, a curtain is hanging. Jacob's hands are crossed over the kneeling children, behind whom are Joseph and three other men.

fol. 8v, c (38) Mourning over Jacob's bier: Jacob's coffin, covered by a purple cloth, stands under a tree. To the right kneel six mourners dressed in brown and blue monk's habits with capuchin hoods. One of the mourners is bearded. To the left sit the mourners: a crowned king and four men with bare heads; inscribed: "And they came to the threshing floor of Atad" (Gen. 50:10; cf. "Pharaoh and his servants" in the *Sister Haggadah* [below, No. 12], Scene 57).

fol. 8v, d, left (39) "And Pharaoh said unto the midwives" that they should kill the male babies of the Hebrews (based on Ex. 1:15): The enthroned Pharaoh gives orders to two standing midwives. A counsellor is seated at his feet.

fol. 8v, d, right (40) "Every son that is born ye shall cast into the river" (Ex. 1:22): In the bottom right-hand corner a bearded man is throwing a naked child into the river where another child is drowning.

Scenes 39–40 should be read from left to right, as described above.

Fig. 131

fol. 9r, a (41) The finding of Moses: On top of a hillock to the right, Miriam is seated; inscribed: "And his sister stood" (Ex. 2:4). In the lower part of the panel, in the water, three naked maidens

approach from the left; inscribed: "And her maidens walked" (Ex. 2:5). The maiden in front is opening the lid of a box in which the infant Moses lies in swaddling clothes.

fol. 9r, b (42) בתיה מביאה משה לפני פרעה, "Bitiah brings Moses before Pharaoh" (not recorded in the Bible; see *Leviticus Rabbah* 1:3). On the right is Pharaoh's daughter escorted by two maidens and carrying the swaddled infant Moses to show him to the enthroned king on the left, who is listening to the advice of three counsellors (alluding to *Exodus Rabbah* 1:26).

fol. 9r, c, right (43) "An Egyptian smites a Hebrew" (Ex. 2:11), using a club. Both are standing.

fol. 9r, c, left (44) "He slew the Egyptian and hid him in the sand" (Ex. 2:12): The kneeling, beardless Moses is holding an axe dripping with blood over a dead Egyptian, who is lying on the ground. The scene is separated from Scene 43 by a tree.

fol. 9r, d (45) Moses saves the daughters of the priest of Midian: A beardless Moses, standing in the middle, is flanked by two trees. Behind him to the left are three women, one of them carrying a distaff. Moses prevents two male shepherds from interfering with the sheep drinking water from a spring below. Inscribed: "But Moses stood up and helped them" (Ex. 2:17).

Fig. 132

fol. 10v, a, left (46) "Put off thy shoes" (Ex. 3:5): In the middle of the panel is Moses, sitting and taking off his shoes; below him are many sheep, a dog and a goat.

fol. 10v, a, top right (47) "And Moses hid his face" (Ex. 3:6): On the right stands Moses, with his shoes on, lifting a covered hand to hide his face from a winged and nimbed angel, who appears above a burning bush on a mountain to the left (Ex. 3:2); inscribed: מלאך הסנה, "The angel of the bush". The first may be an erroneous inscription, instead of Moses seeing the burning bush (Ex. 3:2). Otherwise scenes 46–47 should be read from left to right, as described above.

fol. 10v, b, right (48) Moses takes his family back to Egypt: Zipporah, approaching on horseback from the right, is carrying two babies in her arms; a dog walks alongside the horse; inscribed: "And set them upon an ass" (Ex. 4:20).

fol. 10v, b, left (49) ויפגשהו אהרן, "And Aaron met him" (based on Ex. 4:27): A bearded Aaron, appearing from the left, embraces a beardless Moses, who is carrying a lance and pointing at his wife on the horse.

fol. 10v, c (50) Moses and Aaron perform miracles before the Elders of Israel: On the right is a bearded Aaron holding a snake in his left hand; near him, a beardless Moses points to the snake and expounds the miracle; inscribed: "And he did the signs in the sight of the people" (Ex. 4:30). To the left are nine Elders, stretching out their hands, two of them kneeling; inscribed: "Then they bowed their heads and worshipped" (Ex. 4:31). A blood-red spring separates the Elders from Moses and Aaron.

fol. 10v, d (51) משה ואהרן באים לפני פרעה וחכמיו, "Moses and Aaron come before Pharaoh and his wise men" (Ex. 5:1–5): Aaron, with a long beard, and Moses, with a short beard and carrying a staff, appear before the enthroned Pharaoh, who is seated cross-legged beneath a canopy and holding a long sceptre with a fleur-de-lis at its end. Two counsellors are seated, and another is standing in front of the king.

Fig. 133

fol. 11r, a (52) The bondage of the Israelites (Ex. 5:6–13): To the right, at the top of a tower, is נוגש העם, "the taskmaster of the people", holding a stick. Below him are a barefooted old man carrying a bundle of straw, and a barefooted מגבל הטיט, "the mixer of the clay", holding a stick. To the left are מלבן לבנים, "the maker of bricks", a woman carrying a baby to be put into the brick (*Exodus Rabbah* 5:22) and another woman.

fol. 11r, b (53) "And they built for Pharaoh treasure cities" (Ex. 1:11): On the right is the taskmaster, holding a stick and giving instructions to two barefooted men on a scaffolding who are building a wall. Another barefooted man is raising a bucket by a pulley.

fol. 11r, c (54) "But Aaron's rod swallowed up their rods" (Ex. 7:12): On the right is Aaron, holding a snake that is swallowing two other snakes held by two magicians. The magicians are seated at the feet of the enthroned, cross-legged Pharaoh on the left. Another attendant stands to his right. Moses, who is standing in the middle, is arguing with them.

fol. 11r, d (55) The plague of blood: to the right are "Moses and Aaron", the latter touching with his staff the red water of the river in which three dead fish are floating. On the left is the enthroned Pharaoh. Behind him, towards the centre, are two men digging for water with hoes and finding blood; inscribed: ["And all the Egyptians digged round about the river for water to drink"] (Ex. 7:24).

Fig. 134

fol. 12v, a (56) The plague of frogs: On the right, "Moses" (not Aaron, as in the Bible) with a short beard, touches the water with his staff. A row of green frogs leap out of the water into vessels in a cabinet, into windows — in one of which there is a figure — and on to Pharaoh, who is seated on his throne on the left before a hanging curtain; inscribed: "And the frogs came up" (Ex. 8:2; A.V. 8:6).

fol. 12v, b (57) The plague of lice: "Aaron", touching the ground with his staff, and "Moses", on the right, appear before the enthroned Pharaoh and two of his wise men, who are all covered with lice. To the right are a donkey scratching its muzzle and two bulls. To the left, at windows above Pharaoh and the magicians, are three women scratching themselves, two of them with double ivory combs. Inscribed: "And it became lice in man and in beast" (Ex. 8:13; A.V. 8:17).

fol. 12v, c (58) "A grievous 'arov" (Ex. 8:20; A.V. 8:24), i.e., beasts (*Exodus Rabbah* 11:4; *Midrash Tanḥuma, Parashat Bo*): "Moses", holding a staff, stands on the right before Pharaoh, who is standing in front of a baldachin accompanied by an attendant. A squirrel, a dog, a lion, a wolf and a griffon are stepping over each other and attacking the astonished Pharaoh.

fol. 12v, d (59) "A very grievous murrain" (Ex. 9:3): In the middle, from the top of a buttressed tower, one youth is lowering a dead sheep, and another, a dead goat. On the ground, surrounding the tower, are dead horses and cattle. To the right, a man is wiping away a tear. To the left is another man; inscribed: קורע בגדיו, "rending his garments".

Fig. 135

fol. 13r, a (60) The plague of boils: To the right is משה זרק פיח הכבשן, "Moses throwed the ashes of the furnace" (based on Ex. 9:10) out of a bowl. The ashes are depicted as red dots. Behind Moses is Aaron, holding a staff. To the left is רופא שבא לפני פרעה, "a physician who comes before Pharaoh", who is enthroned, barefooted and covered with spots. Below are two seated counsellors, a shepherd, sheep and a donkey, all of them covered with spots.

fol. 13r, b, left (61) The plague of "hail and flaming fire" (Ex. 9:24): From a segment of blue sky, above, fall white and red dots breaking the branches of a tree under which are a hooded shepherd, sheep and a goat. To the left is Pharaoh on his throne.

fol. 13r, b, right (62) Moses begs God to stop the plague of hail: The standing Moses "spreads abroad his hands unto the Lord" (Ex. 9:33). Scenes 61–62 should be read from left to right, as described above.

fol. 13r, c (63) The plague of "locusts" (Ex. 10:13–15): To the right are "Moses and Aaron", the former touching the ground with his staff, from which locusts are creeping up on two trees.

fol. 13r, d, top (64) The plague of "thick darkness" (Ex. 10:22): On the left, on a background of dark brown, are the king and three seated men. To the right are a boy and two men feeling their way in the darkness. A bird is perched on a stick.

fol. 13r, d, below (65) "And they spoiled the Egyptians" (Ex. 12:36): Four Israelites, three of them barefooted, are taking three gold chalices from an open cupboard. One is carrying a case on his back and supporting it with raised hands.
For the relation between the last two scenes, see *Exodus Rabbah* 14:3 (cf. *ibid.*, 1:12).

Fig. 138

fol. 14v, a, top (66) (!) מכת בכורים, "The plague of the first-born" (Ex. 12:29–30): On the right, in a domed room, is a winged angel swinging his sword and smiting a man in bed. A mourning woman stands at the side. To the left sits the crowned queen, mourning her son who lies in a nurse's lap.

fol. 14v, a, below (67) The funeral of the first-born (not recorded in the Bible); or: The Israelites take Joseph's bier out of Egypt (Ex. 13:19): Six men are carrying a covered coffin. In front are three mourners wearing brown monk's habits.

fol. 14v, b (68) Pharaoh commands the Israelites to leave Egypt: To the right, on top of a battlemented wall, is the king, with two counsellors, pointing outwards with his hand; inscribed: "Rise up and get you forth" (Ex. 12:31). Walking towards the left are the Israelites, their right hands raised. Some of them hold lumps of dough, and a woman is carrying a baby. Moses follows behind, holding his staff. Inscribed: "And the Children of Israel went out with a high hand" (Ex. 14:8).

fol. 14v, c (69) The pursuit by the Egyptians: An army of equestrian knights, headed by the crowned king, is riding towards the left. All of them carry lances. The king's banner, shield and the housing of his horse are *azure* and *lion rampant or* (Leon). Other escutcheons are: *gules*, a ring and a blazing sun *or* and *azure*; a wing *or*; and *gules* and a *lion rampant or*. Inscribed: "And Pharaoh drew nigh" (Ex. 14:10).

fol. 14v, d (70) The passage of the Red Sea: The Israelites are on the left, surrounded by water. One of them carries a child over his shoulder, and a woman carries a baby in her arms. Moses follows behind them, holding a staff and turning round to look at the drowning king, horses and soldiers, who are surrounded by fish. Inscribed: "And the Lord overthrew the Egyptians in the midst of the sea" (Ex. 14:27).

Fig. 137 — PL. XL

fol. 15r, a (71) "And Miriam the prophetess, the sister of Aaron, took the timbrel in her hand" (Ex. 15:20): Five girls are playing musical instruments: a lute, a square and a round timbrel, cymbals and sticks. Two girls are dancing.

2. Ritual Scenes.

fol. 15r, b (72) בעל הבית מצוה לתת מצות וחרוסת לתינוקות, "The master of the house

orders *maẓẓot* and *ḥaroṣet* (sweetmeat) to be given to the children": On the left is the master of the house, seated under a canopy and pointing with his hand. On a bridge on the right are a group of five children and a woman carrying a baby, some holding round *maẓẓot*. Two other children serve them, one carrying a basket over his shoulder, the other holding plates of *ḥaroṣet* which is being served from a pot by a man sitting on the left, below the master of the house.

fol. 15r, c, right (73) בודק את החמץ לאור הנר, "He searcheth out the leaven by the light of a candle": A bearded man holding a lighted yellow candle is reaching into a niche with a stick to clear out the leaven into a bowl being held by a youth.

fol. 15r, c, left (74) [מטאטאת הבית ומטהרתו], "[She sweeps the house and cleans it]": A woman is cleaning the coffered ceiling with a long-handled brush. In the middle is a girl sweeping the floor with a small brush.

Scenes 73–74 are depicted inside one room, with many niches and a coffered ceiling.

fol. 15r, d, right (75) עושין צרכי הפסח, "Making preparations for Passover": In a house with a coffered ceiling is a man slaughtering a sheep on the ground, while another man skins a ram that is hanging with a skinned sheep from a rod below the ceiling.

fol. 15r, d, left (76) Cleansing dishes: Beneath a baldachin is a man putting dishes into a large black cauldron over the fire.

B. *Decorative Titles and Initial Words with Accompanying Decorations.*

The decorations of the text pages consist of decorative titles or initial words, mostly written on the vellum ground or in panels within the text space. The panels often have marginal decorations extending from them, some as ascenders and descenders of letters — which at times divide the text space in the middle — decorated with foliage or abstract motifs and some grotesques. The most elaborate decorations appear at the most important parts of the *Haggadah* (e.g., fols. 24v, 26v – Fig. 141, 32v, 41r, 41v – Fig. 145, 42v, 50r – Fig. 147 and 55r – Fig. 148) and of the *piyyuṭim* (e.g., fols. 16v – Fig. 139, 22v – Fig. 140, 23r, 56v – Fig. 149, 66v – Fig. 150, 68v, 70v – Fig. 151, 78v – Fig. 152 and 83r), including two almost full-page text illustrations of the *maẓẓah* (fol. 44v – Fig. 153) and the *maror* (fol. 45v – Fig. 154).

The scheme of decoration varies between pages written in one text column (*Haggadah*) and pages written in two text columns (*piyyuṭim*).

Pages with one text column — mainly in the *Haggadah* — have large initial words or initial-word panels within the text space, sometimes several panels on one page (e.g., fols. 26v – Fig. 141, and 50r – Fig. 147). Their extended

decorations often spread along the outer margin, within the text space, and into the lower or upper margins (e.g., fols. 16v – Fig. 139, 22v – Fig. 140, 23r, 26v – Fig. 141, 27r – Fig. 142, 43v, 46r, 47r, 50r – Fig. 147, 53r and 55r – Fig. 148). The repeated words of the *piyyuṭ* "*Dayyenu*" (fols. 41v – Fig. 145, 42r – Fig. 146, 42v) form two decorative columns, flanking the text.

The pages written in two columns — in the *piyyuṭim* — mostly have small title panels. Those in the main divisions and in the more important parts of the prayers are incorporated within a decorated band which runs between the text columns. The more elaborate pages have extensions that partly frame the text (e.g., fols. 56v – Fig. 149, 61r, 62r, 66r, 66v – Fig. 150, 68v, 70v – Fig. 151, 73r, 78v – Fig. 152, 83r and 85r) and also have additional decorative panels (e.g., fols. 56v, 70v, 78v and 83r). The colours of the text-page decorations are similar to those of the full-page panels (see above, § A). However, since the grounds are mostly magenta or blue, the colour effect is different from that of the full-page panels with gold grounds. The colours of the zoomorphic letters are somewhat lighter and appear to have been done by wash.

1. *Decorative Titles and Initial Words.*

Most of the initial words for the *Haggadah* and the main divisions of the *piyyuṭim* are written in gold, silver or coloured zoomorphic letters, mostly on the vellum ground. Four different types can be distinguished:

(a) Many of those written in gold are enclosed by painted panels $(23–48) \times (32–144)$ mm with magenta or blue grounds (e.g., fols. 22v – Fig. 140, 26v – Fig. 141, 28r, 30v, 55v and 56v – Fig. 149), or are divided into alternating magenta and blue compartments (e.g., fols. 16v – Fig. 139, 24v, 27r – Fig. 142, 47r and 82r). The coloured grounds are decorated with thin brush patterns in lighter shades and white, or diapers, chequers or scrolls, framed by coloured, modelled fillets, some in gold. Two panels (Fols. 32v, 41v – Fig. 145) are decorated with violet or red penwork of scrolls with lobed foliage on the vellum ground. That on fol. 41v is also framed by penwork.

fol. 51r A contraction of the name of God (three *yods*) is written in foliated gold letters within a blue panel shaped as a paisley motif, with a pink framing fillet and extending leaves as a stem.

fol. 70v (Fig. 151) The two small title panels flanking the large panel — "for the Second" and "Day" — are shaped like eight-pointed stars.

fol. 78v (Fig. 152) Sabbath of Passover: An almost square, gold-framed title panel (55×60 mm) within the second text column is attached to the side of the central decorative band. The word is written in gold within an eight-pointed gold star enclosed in a circle with coloured ground fillings decorated with gold scrolls.

(b) Most titles for the *piyyuṭim* are written in gold or colour within much smaller panels (6–14) × (17–57) mm with coloured or gold grounds and frames (e.g., fol. 16v – Fig. 139 and many others between fols. 56v – Fig. 149 and 86r). Some are grouped together to extend across the text (e.g., fol. 87r), whereas others are connected to a central band which extends at times into the upper and lower margins, forming an I-like shape.

(c) The zoomorphic letters are pen-drawn and tinted red, purplish magenta, green, violet-grey and two shades of blue. The strokes of the letters are divided by pen-drawn hands — which are sometimes decorated with dots — into coloured sections heightened with white lines. They terminate at the top in grotesque animal and human heads, mostly pen-drawn, some with coloured hoods and others with foliage in their mouths (e.g., fols. 31v, 34v – Fig. 144, 36v, 38r and 40v, the latter in gold). One of the heads on fol. 31v wears a cap and is accompanied by an outstretched arm. Other initial words are similarly written, though without the heads (e.g., fols. 34r, 55v and 41v – Fig. 145, 42r – Fig. 146, 42v — "Dayyenu", with one head on each page from which the marginal decoration issues).

(d) Many small titles and initial words are written in colour on the vellum ground.

2. *Accompanying Decorations.*

The decorations accompanying the initial words or panels include three text illustrations (fols. 27r – Fig. 142, 44v – Fig. 153 and 45v – Fig. 153), the last two nearly full-page.

The motifs of the marginal decorations set vertically in the margins or within the text, differ from those set horizontally. Both types issue from each other, from panels or from elongations of letters by means of cusped shapes in gold and colours, mostly enclosing a small section — even a single curl — of ivy scroll, with the enclosed space mostly in a different colour. Cusps enclose other motifs, such as: multi-coloured dragons (e.g., fols. 16v – Fig. 139 and 26v – Fig. 141) or dragon heads (e.g., fols. 42v and 61r; cf. fol. 42r); palmettes (e.g., fols. 56v – Fig. 149, 68r, 78v – Fig. 152 and 83r), some of which extend upwards from the centre top of a panel (e.g., fols. 62r and 66r; cf. fols. 16v – Fig. 139, 24v, 28r and 56v – Fig. 149); a larger section of ivy scroll (fol. 32v); and pairs of acanthus leaves (e.g., fols. 22v – Fig. 140 and 78v – Fig. 152).

(a) *Vertical Decorations:* (1) Bands of alternating blue and magenta sections decorated with scrolls or geometrical motifs in white brushwork (e.g., fols. 16v – Fig. 139, 26v – Fig. 141, 27r – Fig. 142, 32v, 50r, 61r, 66v, 68r, 73r and 78v – Fig. 152) or gold (e.g., fols. 66v, 68r and 85r). The sections are separated from each other by gold shapes, and the whole bar is accompanied by modelled, coloured fillets on one or both sides.

(2) A wider band decorated with a vine or ivy scroll, often with coloured or gold buds and beads, mostly on a magenta or blue ground decorated with thin white brush motifs (e.g., fols. 67v and 68v). The foliage sometimes incorporates multi-coloured grotesques (e.g., fols. 22v – Fig. 140, 23r, 67r — on a gold ground — and 68r) or a grotesque head (fol. 23r). Other bands are decorated with a palmette scroll, mainly between two ascending serifs of *lamed* (e.g., fols. 47r and 55r – Fig. 148), or flanked by two dragons (e.g. fol. 66v – Fig. 150, 67v). On fol. 67r, a section of such a band is decorated with a geometrical interlace, forming an eight-pointed star.

(b) *Horizontal Decorations:* These are mainly extensions from the vertical ones, as well as from ascenders and descenders. They consist of coloured branches shaped like trumpets, heightened by lines and small roundels and curling at the ends, where they are mostly strung with beads and carry coloured ivy leaves; they are often accompanied by small gold roundels. Those attached to a vertical motif or a letter are mostly in pairs in the upper or lower margins, hanging symmetrically on both sides or in reversed curls (e.g., many pages between fols. 24v and 85r). Different hybrids, mostly in pairs, are connected with this type of decoration, some on top of a panel with symmetrical foliage spreading from them (e.g., fols. 56v – Fig. 149 and 68v), others flanking the decoration between the text columns (e.g., fol. 66v – Fig. 150). On fol. 23r, a single dragon is incorporated into the foliage; on fol. 68r, another dragon is on top of a panel.

(c) *Decorative Panels:* Two decorative panels flanking an initial-word panel (fol. 56v – Fig. 149) and a roundel (fol. 66v – Fig. 150) are decorated with interlacing patterns of gold or coloured bands with gold and coloured ground fillings, forming star and rosette patterns.

(d) *Grotesques:* Some grotesques are more elaborate. One of them is a text illustration (fol. 27r, below).

fol. 16v (Fig. 139) A grotesque dog is running along the foliated branch.

fol. 22v (Fig. 140) In the lower margin, below the foliage decoration, is a human-headed hybrid wearing a pointed hat and playing the bagpipe.

(e) *Text Illustrations:* Three text illustrations are added in the style and colouring of the painted decoration.

fol. 27r (Fig. 142) Benediction of the first cup of wine: On top of an initial-word panel is a draped hybrid with hooded human head and human arms, holding one long-necked jar and drinking from another.

fol. 44v (Fig. 153) מצה זו, "This *mazzah*": Below the painted initial-word panel is a large

roundel 124 mm in diameter, which occupies most of the text space. It is decorated with an all-over pattern of a rosette composed of interlacing gold fillets, squares, circles and ogival shapes. The ground is alternately blue and magenta. In the centre is an ochre gate in a white brick wall.

fol. 45v (Fig. 154) מרור זה, "This bitter herb": Below the gold initial word, in the middle of the text, is a large, dark, bottle-green lettuce (height 120 mm), painted with lighter green leaves and a vermilion stalk.

C. Seventeenth-Century Decorations.

All are painted on originally blank pages. The first two relate to the wedding of Rosa Gallico to Elijah Rava at Carpi in 1602.

1. Frontispiece.

A full-page arcade (fol. 2r – Fig. 123), resting on mermaid caryatids and on columns decorated with conventional brush gold flowers. In the arch is an angel's head with wings. Coloured in dark brown and purple.

2. Full-Page Armorial Device.

The device of the Gallico family on fol. 16r (Fig. 124) has a motto inscribed on a scroll above: "He stooped down, he crouched as a lion, and as an old lion, who shall rouse him up?" (Gen. 49:9). The oval cartouche of the device itself is supported by naked mermaids which are seen in profile. The crest is a sun in splendour. The field of the device is divided vertically into two (*pale*). On the left (*dexter*) is a *lion couchant gardant* before a mountain cave, on top of which is an eight-pointed star. On the right (*sinister*) is a *cock vigilant*, facing a stalk of corn, and above them a crescent (*increscent*) and a six-pointed star (*mullet*).

3. Full-Page Frames for Added Text.

On the reverse sides of the full-page panels is a mnemonic poem on the laws of Passover (fols. 3v – 15v). Each page is framed by a gold fillet surrounded on the inner and outer sides by dark red and vermilion lines and by a pattern of single green trefoils and red berries. On the inner and outer sides, in the four corners and in the middle of the frame, are blue trefoil motifs. On fol. 24r there is an additional empty frame.

Conclusions

The two types of decoration in the *Golden Haggadah* (§§A and B) were carried out in the same workshop, though several artists can be distinguished. The full-page panels depicting biblical episodes from Genesis and Exodus represent one of the earliest consecutive biblical cycles in Hebrew illuminated manuscripts from Spain. Their iconography, which includes many non-biblical, midrashic episodes, may point to an earlier, lost model which was ultimately dependent on a late classical Jewish archetype (Narkiss, *Golden Haggadah*, pp. 52–61). Comparing the iconography with other *Haggadot* that contain a biblical cycle, it is apparent that the *Golden Haggadah* belongs to the second iconographical recension (Narkiss, *op. cit.*, pp. 43–73; see above, pp. 42–44).

Although each full-page panel is divided into four compartments, the composition within each compartment is quite spacious. It is, however, not as spacious as in the manuscripts of the first recension — e.g., the *Hispano-Moresque Haggadah* (above, No. 9) — which have a single panel to a page.

Two artists can be distinguished in the painting of the full-page panels. The first painted the original first quire, illustrating the episodes from Genesis and five compartments with Exodus scenes (fols. 2v, 9r – Figs. 125–131, 136). His compositions, which expose large gold ground spaces next to crowded areas, are not well balanced, but his human gestures and faces are rendered expressively. The second artist, who painted the second quire which comprises the rest of the Exodus scenes, and the six ritual scenes (fols. 10v, 15r – Figs. 132–137), is by far the better trained, though not as expressive as the first. His compositions are well balanced, and his human figures have a distinct, elegant, French-Gothic sway. In spite of the differences between the two, it is quite obvious that both artists belong to the same atelier and that both had a single, common model to copy from. Their art is Catalan of the beginning of the fourteenth century, influenced mainly by contemporary Parisian style, with a few Italo-Byzantine elements. The Parisian elements, distinguished in the proportions of the human bodies, the expressive gestures, the stereotyped faces and the hair styles, are dependent on Maître Honoré's *Decretum Gratiani* in Tours (Bibliothèque municipale, MS 558; see Millar, *Honoré*, Pl. 1). The Italo-Byzantine elements are the cleft ground with tufts of grass and box-like architectural backgrounds, both creating spatial illusion. These derive mainly from Bolognese and Neapolitan illuminations of the period (see Salmi, *Miniatures*, pp. 18–20, 34–36). The coffered ceilings of the canopied throne and the three ritual pictures are also of Italian origin.

Only the second artist has a dated stylistic parallel. His style should be compared with that of one of the artists who illustrated a manuscript of *Catalan Laws* written in Barcelona in 1321 (Paris, Bibliothèque nationale, Lat. 4670 a, Parts 7 and 9; see Narkiss, *op. cit.*, pp. 38–39). Our manuscript could therefore be dated to the third decade of the fourteenth century.

As opposed to the style of the two artists of the full-page panels, the initial-word panels are

decorated in an archaistic Gothic style very common in Europe around 1300. The foliage scrolls, flowers and grotesques resemble the style of northern France in the second half of the thirteenth century. The zoomorphic letters are typical of Sephardi illumination in the late thirteenth and early fourteenth centuries, such as those in the *Cervera Bible* of 1300 (Lisbon, Biblioteca Nacional, MS 72), the *Mocatta Haggadah* (above, No. 10) and the *Hamilton Siddur* (Berlin, Staatsbibliothek, Ham. 288, see Narkiss, *HIM*, Pl. 7). The Eastern elements in the decorations are mainly the geometrical forms resembling arabesques in the panels of the *piyyuṭim* and also in the miniatures themselves, as, for instance, on Jacob's pillow in Scene 37 and on Miriam's musical instrument in Scene 71.

Bibliography

Margoliouth, No. 607, 2, pp. 200–202.

Leveen, p 190.

Luzzatto, *Almanzi*, p. 39, No. 328.

Müller & Schlosser, *Sarajevo*, I, pp. 103 f., 106 f.; Pl. IV:1.

Frauberger, *Buchschmuck*, p. 47; Fig. 46.

Wischnitzer, Haggadahs, pp. 199, 201, 206–207, 215–216.

Leveen, *Bible*, pp. 99–104; Pls. XXI–XXXII.

Salmi, *Miniatures*, pp. 18–20, 34–36.

Domínguez-Bordona, *Ars Hispaniae*, XVIII, pp. 107, 143; Figs. 172–174.

Millar, *Honoré*, Pl. 1.

Roth, Rylands, 1960, pp. 136, 140, 143–146, 148–150, 156.

Narkiss, *Golden Haggadah*, pp. 38–39, 52–61.

Narkiss, *HIM*, Pls. 7, 8, pp. 21, 25, 56, 58, 80.

Gutmann, *Manuscript*, Pls. 11, 12, 25, Figs. III, IV.

12. SISTER HAGGADAH

Barcelona, mid-fourteenth century

BL, Or. 2884

Figs. 155–208; Pl. LI: Figs. 173, 188

Biblical picture cycle, Passover Eve prayers and Haggadah.

General Data

Codicology

Parchment; I + 64 + I leaves; 230 × 190 mm. Text space (147–152) × (113–118) mm. Written in a square Sephardi script, in light brown ink, 10 lines (fols. 27v–63v — *Haggadah*) and 14 or 18–19 lines (fols. 19v–26v and fols. 27r and 64r–v, respectively — prayers). Ruling by stylus, 10 (*Haggadah*) or 15 (prayers) horizontal lines (19 on fols. 64r and 64v) and 2 vertical lines. Pricking is noticeable in the inner and lower margins. 9 quires of 8 leaves each, except for Quires III² and IX⁶. All are gathered so that outward hair side faces hair. Fols. 1r, 18v and 19r are blank.

Binding

Pig-skin binding. End – papers with unidentified watermark.

Colophon

None.

History

A handwritten note on paper, stuck on the inner back binding: "Le pitture rappresentareo i fatti principali delle *Genesi* e dell'*Esudo* fino al passaggio del Mar Rosso compito; li ultimi tre se riferiscono ni riti Pasquali Ebraici, e il tuto alla fine del MS. contiene il Rituale della Pasqua degli Ebrei."

fol. 1r In pencil: "Vergane Pietro".

Fly-leaf of the back binding: Purchased by the British Museum from Eugen von Miller on 13 June 1885.

Decoration

Programme

A. Full-page panels:
 1. Biblical scenes.
 2. Ritual scenes.
B. Initial-word panels and accompanying decorations:
 1. Painted decorations.
 2. Penwork.
C. Marginal text illustrations.

Description

A. Full-Page Panels

The thirty-four full-page panels, measuring (155–160) × (132–137) mm, depict eighty-six

(155–160) × (132–137) mm, depict eighty-six scenes of a consecutive cycle from Gen. 1:26 to Ex. 15 (fols. 1v–16v) and five ritual scenes (fols. 17r–18r). They are painted on both sides of the leaves, ruled by stylus with double lines for the frames. They are mostly divided into two horizontal compartments, but in a few cases more than one episode is in a single compartment; so that the cycle of 86 episodes is arranged in 62 compartments. Each compartment is framed by a thin coloured fillet, in some places heightened in white. The last two panels (fols. 17v and 18r) are not divided and have additional penwork foliage scrolls in the corners. The full-page panels are painted in light, shiny gouache colours in orange, vermilion red, manganese blue, pink, magenta, yellow-ochre, green, greyish white and black, with a very little silver or gold. Most of the colours are applied in distinct fields and heightened in a crude, linear way. They are also outlined with darker and lighter shades and with white or black lines, in which the drapery is also modelled. This linear treatment constitutes the only modelling.

The illustrations on fols. 1v–8r and 17v are painted on the vellum ground. Other grounds are painted blue, brown, red, grey, magenta or pink. The illustrations on fols. 8v–12r are painted plain, while those on fols. 12v–17r and 18r are diapered or chequered. In some panels the paint has partly flaked off or faded (e.g., fols. 1v–2r, 3v–5r and 7v–8r).

The composition of each panel is dense, with figures and architectural and landscape elements filling the space.

Landscapes are scarce and are confined to coloured heaps of earth, green blades of grass, rounded trees and wavy blue and white patterns to represent water. Architectural elements, human figures filling them, are predominant in some panels. The architecture consists of some exteriors, many domed or gabled baldachins and some interiors. The structures are fourteenth-century Italian in style, but they are rendered in a strange way, in which the perspective is misunderstood though good models are used.

Most of the human figures occupy the entire height of the compartments, their size usually being dictated by their relation to the landscape, architecture and other objects in the panel. In the first quire (fols. 1v–8v) the faces and hands are greenish yellow, heightened with white and pink. In the rest of the full-page panels, as well as in the text illustrations, they are white and pink only. Some of the faces are outlined and have facial features added in black lines over the paint. The figures wear long or short gowns, over which some have cloaks of various shapes. They wear black shoes and coloured stockings. Headgear is varied: the most remarkable is a turban-like hat with a

piece of cloth sticking out behind; others are hoods, caps and pointed or high hats. Women are shown bareheaded or kerchiefed. Pharaoh is crowned.

The panels depict a consecutive cycle from Gen. 2:7 to Ex. 15:20, representing in some cases more than one episode in one compartment.

The sequence of the 86 episodes and of the 62 compartments is usually from right to left, first on top (a), and then at the bottom (b).

Some of the subjects in the cycle, as well as part of the iconography, are similar to those in the *Golden Haggadah* (above, No. 11), though they often differ in details. The detailed descriptions here will refer to that manuscript when necessary.

The faded captions to the panels were written in the upper and lower margins in a contemporary round script; a later hand copied them in a square script below the older ones. In most cases they are biblical verses which describe the episodes correctly, and are therefore used in our description below as titles (in inverted commas). In other cases, mainly where the captions are not biblical, they are cited in Hebrew and translated. Some of the captions are similar to those in the *Golden Haggadah*, and are so mentioned in the detailed description below.

1. Biblical Scenes.

Fig. 155

fol. 1v, a (1) The creation of Adam by angels (*Genesis Rabbah* 8:1, 5; 15:3, 8): The naked Adam is standing in the middle, in front of an orange hillock, his hands being held by two kneeling angels. Six more angels, standing three on each side, are pointing at him. Inscribed: "And He breathed into his nostrils the breath of life" (Gen. 2:7).

fol. 1v, b (2) Adam names the animals (Gen. 2:19–20): The naked Adam is seated on a hillock to the right (reversed from the *Golden Haggadah*, Scene 1), pointing with his right hand to the animals between two trees in front of him. Among the animals are a dragon, a lion, a fox, a bear, dogs, a bull and goats. Inscribed: ויקרא להם שמות, "And he gave them names".

Fig. 156

fol. 2r, a, right (3) The creation of Eve (Gen. 2:21–23): As in the *Golden Haggadah* (Scene 2), i.e., Eve issuing from Adam's side, but spreading out her arms under a triangular tree. Inscribed: "And He took one of his ribs and shut in flesh instead thereof" (Gen. 2:21).

fol. 2r, a, middle (4) The temptation of Eve (Gen. 3:1–6): To the right the naked Eve is standing in front of the Tree of Knowledge, around which is coiled a blue serpant.

fol. 2r, a, left (5) חוה שנותנת לאכול לאדם מפרי עץ הדעת, "Eve, who gives Adam to eat from the

[68]

fruit of the Tree of Knowledge" (based on Gen. 3:6): Eve, on the left, puts the fruit into Adam's mouth. Both are naked.

Scenes 4–5 are combined in the *Golden Haggadah* (Scene 3).

fol. 2r, b, right (6) Cain and Abel bringing sacrifice (Gen. 4:3–4): The two, standing on either side of an altar, are holding their offerings. Similar to the *Golden Haggadah* (Scene 4), but here both men have their hands uncovered and are looking at the vertical flame on the altar, and Cain is wearing a shorter robe. The faded inscription reads: "And Abel, he also brought of the first-born of his flock" (Gen. 4:4).

fol. 2r, b, left (7) "And Cain rose up against Abel his brother and slew him" (Gen. 4:8): Cain lifts a long-handled axe above Abel, who is seated on the ground with his right arm raised to ward off Cain, a spurt of orange blood gushing out of his head (almost entirely effaced).

Fig. 157

fol. 2v, a (8) "Make thee an ark of gopher-wood" (Gen. 6:14): On the left, נח מצוה לאומנים שיעשו התיבה, "Noah orders the craftsmen to make the ark". Three of the craftsmen hold axes, two have hammers, and one is lifting wood with a pulley. There is another inside the half-built ark and two more seated on the roof frame.

fol. 2v, b (9) נח מוציא החיות והבהמות מהתיבה, "Noah takes the animals and cattle out of the ark" (based on Gen. 8:19). Similar to the *Golden Haggadah* (Scene 6), but the green dove is sitting on the right of the ark's gabled roof, and Noah is kneeling while he helps the sheep exit. Only his wife is behind him; his three sons are to the left of the ark. Among the animals, which are in the foreground, are a pink goat, a green bird and three that are unidentifiable.

Fig. 158

fol. 3r, a, middle (10) נח בוצר ענבים, "Noah cuts grapes" (based on Gen. 9:20) with a knife and puts them into a magenta coloured basket.

fol. 3r, a, right (11) וישותה מן היין, "and he drinks of the wine" (based on Gen. 9:21) from a large blue chalice, while leaning against the hill on which the vine is growing.

fol. 3r, a, left (12) "And he drank of the wine… and he was uncovered in his tent" (Gen. 9:21): Inside a building, on a dark magenta ground, the drunken and partly undressed Noah, holds his penis in his left hand. Behind him are two of his sons, holding a blue garment to cover him with and looking away, as in the *Golden Haggadah*, Scene 8. Inscribed: "And their faces backwards, and they saw not their father's nakedness" (Gen. 9:23).

fol. 3r, b (13) נמרוד שמשליך אברהם לתוך כבשן האש, "Nimrod, who throws Abraham into the fiery furnace" (*Genesis Rabbah* 38:13; *TB Peṣaḥim*

118a; *Tana D'vei Eliyahu* 6): As in the *Golden Haggadah* (Scene 10), but with no counsellors or furnace. A single attendant pushes the kneeling Abraham into the open flames, in which המלאך שמציל אברהם מהאש, "the angel, who is saving Abraham from the fire", is kneeling.

Chronologically, this scene should have followed the next one.

Fig. 159

fol. 3v, a (14) דור הפלגה שהורגין זה את זה, "The divided generation [of the Tower of Babel] who are killing each other" (*Genesis Rabbah* 38:10; based on Gen. 11:7). The composition and iconography are similar to those of the *Golden Haggadah* (Scene 9), though the details differ. The tower is in the centre, and on top are two men fighting, one with a trowel and one with a hammer. A man on the right of the panel, drawing a rope through a pulley, is being pushed from behind by another, while a third man holds the nose of the first man, raising a heavy sword to chop off his head. Below him is a man lifting his arm and head towards the bucket at the top of the tower. To the left a crouching man is being stoned by two men, one at his side and the other leaning out of a window in the tower. At the bottom of the tower there is a gate.

fol. 3v, b (15) Abraham's hospitality and the prophecy to Sarah: "And he stood by them under the tree and they did eat" (Gen. 18:8): As in the *Golden Haggadah* (Scene 11), i.e., the three angels (*Genesis Rabbah* 48:9) are seated behind a table, but there is a tree on either side, and Abraham serves them from the right of the table. Sarah is inside an edifice on the left; inscribed: "And he said: Behold, in the tent" (Gen. 18:9).

Fig. 160

fol. 4r, a (16) "The destruction of Sodom" (Gen. 19:24–29): The representation and inscriptions are identical to those of the *Golden Haggadah* (Scene 12), but with the sequence of scenes reversed, from right to left: a heap of geometrically shaped destroyed buildings, and Lot's wife standing in the middle; inscribed: "and she became a pillar of salt" (Gen. 19:26). To the left: לוט ובנותיו בורחין, "Lot and his daughters flee".

fol. 4r, b, right (17) בנות לוט משקות לאביהן יין, "The daughters of Lot make their father drink wine" (based on Gen. 19:33): One daughter is pouring out wine into a cup held by Lot, who is seated on the right in front of an arched edifice; the other is walking towards the left carrying a flask and a cup.

fol. 4r, b, left (18) בנות לוט ששוכבות עם אביהן, "Lot's daughters, who are lying with their father" (based on Gen. 19:33–35): One of them is lying with Lot on a mattress, covered by a blanket. In front is another arched edifice.

[69]

Scenes 17–18 are not represented in the *Golden Haggadah*; they have flaked off.

Fig. 161

fol. 4v, a, right (19) Isaac blesses Jacob (Gen. 27:18–19): Isaac sits on a stool, in front of a gabled arch which forms part of a roofed edifice, his right hand resting on Jacob's head and his left hand touching his son's arm; inscribed: "Come near, I pray thee, that I may feel thee" (Gen. 27:21). Jacob is guided by Rebecca's hand from behind. The scene is separated by a tree from Scene 20.

fol. 4v, a, left (20) "And Esau his brother came in from his hunting" (Gen. 27:30): Esau, armed with sword and dagger (instead of the bow and arrows in the *Golden Haggadah*), is carrying a rabbit on his shoulder.

Scenes 19–20 are inscribed and represented similarly to Scenes 15–16 in the *Golden Haggadah*, although the sequence is reversed and the architectural background of both scenes in the *Golden Haggadah* is confined here to only the first one.

fol. 4v, b (21) Jacob's dream: "And he dreamt that God's angels were ascending and descending it" (based on Gen. 28:12); represented similarly to the *Golden Haggadah* (Scene 17): Beside Jacob, who is lying on the ground, stand two angels; one angel is climbing the ladder. Unlike the *Golden Haggadah*, there are two heads of angels within the segment of cloud above (the *Golden Haggadah* has one angel, with a single wing); another angel is seated on the right in front of a tree and a rounded stone.

Fig. 162

fol. 5r, a (22) Jacob comes to the land of Ḥaran (Gen. 29:1–6): On the right, on either side of a well, יעקב שואל לרועים הידעתם את לבן, "Jacob asks the shepherds: Know ye Laban?" One of the two shepherds is pointing to the left; inscribed: והנה רחל בתו באה מן הצאן, "and behold, Rachel his daughter is coming from (!) the flock" (distortion of Gen. 29:6). Rachel carries a distaff. In the middle are three sheep and a tree. Not in the *Golden Haggadah*.

fol. 5r, b, right (23) יעקב מנשק לרחל, "Jacob kisses Rachel" (based on Gen. 29:11), actually embracing her. He is carrying a sword and a dagger.

fol. 5r, b, left (24) יעקב שאוכל עם לבן ועם רחל, "Jacob, who eats with Laban and with Rachel": They are all seated round a legless table suspended in mid-air with a cat underneath. Rachel wears a crown and Laban holds a flask above a bowl which stands on the table. Also on the table are a goblet, knives and bread.

Neither of Scenes 23–24 are in the *Golden Haggadah*.

Fig. 163

fol. 5v, a (25) Jacob increasing his flocks (Gen. 30:37–43): To the left is יעקב שמציג את המקלות ברהטים בשקתות המים, "Jacob, who sets the sticks in the gutters in the watering troughs" (based on Gen. 30:38). To the right, under a tree, are six sheep, one of them climbing on another, drinking from the trough; inscribed: הכבשים באים על הצאן, "The sheep come on the flocks". Below the trough are a well and two dogs. Not in the *Golden Haggadah*.

fol. 5v, b, left (26) Jacob's passage of the Jabboq (Gen. 32:22–23) and meeting with Esau? (Gen. 33:4): On the left side of the diagonal river are Jacob's family and a dog. The man at the head of the family (Jacob?) is confronting a male figure on the extreme left (Esau?). The figures are badly damaged. Not shown in the *Golden Haggadah*.

fol. 5v, b, right (27) Jacob wrestling with the angel (Gen. 32:24–25): Below are three ewers (part of Jacob's riches?).

Scenes 26–27 are represented and inscribed as in the *Golden Haggadah* (Scenes 18–19), except for the diagonal band representing the river, which is painted in the reverse direction, from top left to bottom right. Neither the dog nor the ewers are in the *Golden Haggadah*.

Fig. 164

fol. 6r, a (28) Joseph's dreams (Gen. 37:5–9): On the left, Joseph in bed is depicted once for both dreams, in a position reversed from that in the *Golden Haggadah*. To the right are twelve sheaves of corn bowing to a larger sheaf in the middle; inscribed: "And lo, my sheaf arose and also stood upright" (Gen. 37:7). Almost identical with the *Golden Haggadah* (Scene 20), but with a background of hills and a tree. On the left, "Joseph dreams a dream, and behold, the sun and the moon and eleven stars prostrated themselves before me" (Gen. 37:9). Above Joseph are a vermilion sun, eleven black stars and a moon outlined in ink.

fol. 6r, b (29) ויספר החלום לאביו, "And he related the dream to his father" (based on Gen. 37:10): To the right is Joseph, standing before the seated Jacob. On the left, separated from Joseph and Jacob by a tree, are seated four of אחי יוסף שנוטרין לו איבה, "the brothers of Joseph, who nurse their hatred of him". The placement of the two groups is a reversal of that in the *Golden Haggadah* (Scene 21), and the architectural ground therein is missing here.

Fig. 165

fol. 6v, a, right (30) Joseph meets an angel on the way to his brothers (*Genesis Rabbah* 84:14): Inscribed: "And a certain man found him, as he was wandering in the field" (Gen. 37:15).

fol. 6v, a, left (31) The council of the brothers:

Four brothers are seated, and one is standing with his sword raised. Inscribed: "And they conspired against him to kill him" (Gen. 37:18).
Scenes 30–31 are as in the *Golden Haggadah* (Scenes 22–23), except that the sheep shown in the *Golden Haggadah* are missing here.
fol. 6v, b, top right (32) "And they cast him into a pit" (Gen. 37:24): One brother is on either side of Joseph, who is being lowered into a round pit. The scene is separated by a tree from Scene 33.
fol. 6v, b, left (33) The second council of the brothers: Round a legless table (not shown in the *Golden Haggadah*) are five of the brothers; inscribed: "And they sat down to eat bread... and behold, a travelling company of Ishmaelites come from Gilead" (Gen. 37:25). One brother points upwards, as if to the next panel on the opposite page (cf. one brother pointing at the next scene in the same panel, Scene 24 of the *Golden Haggadah*).
fol. 6v, b, bottom right (34) "And they killed a kid of goats and dipped the garment in the blood" (Gen. 37:31): The brother who is kneeling and holding the bleeding lamb is shown as in the *Golden Haggadah* (Scene 26), but here there is no second brother holding the garment.
Scene 34 should follow scene 36, a misplacement similarly found in the *Golden Haggadah* (Scenes 26–27); and the composition of Scenes 32–34 is reversed.

Fig. 166
fol. 7r, a, right (35) "And they drew and brought up Joseph out of the pit" (Gen. 37:28): Two brothers lift Joseph out of the round pit with ropes. Not in the *Golden Haggadah*.
fol. 7r, a, left (36) The selling of Joseph: In front of four camels is a group of three Ishmaelites, וקונין את יוסף, "buying Joseph" from one of the brothers. Inscribed as on Scene 33, with the addition of "with their camels bearing". Differs from the *Golden Haggadah* in details.
fol. 7r, b, right (37) Joseph and Potiphar's wife: The latter is sitting up in bed, holding Joseph's vermilion garment while Joseph is fleeing from her, his blue-stockinged legs visible behind the bed. Inscribed: ותנח בגדו אצלה וינס ויצא החוצה, "And she laid up his garment by her, and he fled and got out" (based on Gen. 39:16 and 12). No architectural background, unlike Scene 29 in the *Golden Haggadah*.
fol. 7r, b, left (38) פוטיפר וחבירו שנכנסין בבית, "Potiphar and his friend, who enter the house" (not in the Bible, nor in any recorded *midrash*). The two enter through an open door with a double-arcaded background. This scene is similarly rendered in the *Golden Haggadah* (Scene 30).

Fig. 167
fol. 7v, a, right (39) המשקה והאופה חולמים חלום, "The butler and the baker dream a dream"

(Gen. 40:5): Both are lying in the same bed, with a triple arcade and a hanging oil lamp as background. Not in the *Golden Haggadah*.
fol. 7v, a, left (40) יוסף פותר החלום לשר המשקים ולשר האופים, "Joseph interprets the dream to the butler and the baker" (Gen. 40:9–19): All three are placed as in the *Golden Haggadah* (Scene 31). The butler, seated on a wicker chair to the right, is pressing grapes into a goblet. The kneeling baker in the centre is carrying a basket of loaves on his head, and a raven is pecking at the bread. Joseph is seated on a bench to the left.
fol. 7v, b (41) "Pharaoh dreams a dream" of the cows and of the "seven ears of corn coming up after them" (Gen. 41:2–7); as in the *Golden Haggadah* (Scene 32), i.e., Pharaoh lying in bed, with the cows and corn filling the rest of the panel space. However, the distribution of the cows and the ears of corn is different from that in the *Golden Haggadah*: only five cows of each sort ותרעינה באחו, "are grazing in the field" (Gen. 41:2) under a tree to the right of the bed.

Fig. 168
fol. 8r, a (42) יוסף פותר החלום לפרעה, "Joseph interprets the dream to Pharaoh": To the right are Pharaoh and Joseph, seated on a bench within a double arcade. To the left are three conversing counsellors. The placement of the two groups as well as that of the figures in them is reversed from that in Scene 33 of the *Golden Haggadah*.
fol. 8r, b (43) A crowned Joseph rides the royal horse in the midst of six other people, the first of whom plays a flute while the others point at Joseph. Inscribed: "And they cried before him, bow the knee" (Gen. 41:43). Not in the *Golden Haggadah*.

Fig. 169
8v, a (44) ויצברו בר אוכל בערים ושמר(ו), "And they gathered corn for food in the cities and they stored it" (based on Gen. 41:35, though the scene illustrates verses 47–49): Two men are bringing corn on the backs of two horses. On the left three other men are emptying corn from sacks on their shoulders into seven pyramid-like storehouses of various colours decorated with a brick pattern. Not in the *Golden Haggadah*.
fol. 8v, b (45) Jacob's sons come to Egypt (Gen. 42:3–5): On the right are nine armed men and one laden donkey; inscribed: אחי יוסף שמדברים עם הסופר, "Joseph's brothers, who talk to the scribe" (not in the Bible). To the left, within a battle-mented archway and accompanied by an armed guard, is הסופר שכותב בשער העיר הנכנסין והיוצאין, "the scribe, who writes within the town gate all those who go in and out" (not in the Bible). He is sitting and writing on a scroll. Not in the *Golden Haggadah*.

Fig. 170

fol. 9r, a (46) The arrest of Simeon: On the left is the bearded Joseph, crowned and enthroned, and accompanied by an attendant. He is talking to four brothers, who are standing on the right, with Simeon, his hands being bound by another man, kneeling among them; inscribed: "And he bound them before their eyes" (Gen. 42:24). As in the *Golden Haggadah* (Scene 34), although the composition is reversed.

fol. 9r, b (47) אחי יוסף שמחלים פני אביהם שימסור להם בנימין, "Joseph's brothers, who beg their father that he should give them Benjamin": Three armed brothers kneel before Jacob, who is sitting in a canopied chair with Benjamin seated at his feet. Between the brothers is a loaded donkey. Not in the *Golden Haggadah*.

Fig. 171

fol. 9v, a (48) אחי יוסף שמביאין בנימין ליוסף והוא מחבקו ומנשקו, "Joseph's brothers, who bring Benjamin to Joseph, and he embraces and kisses him" (Gen. 43:29 conflated with Gen. 45:14). Four brothers stand on the right, with a crowned Joseph sitting on the left, behind a door (not shown in the *Golden Haggadah*) and holding the small Benjamin on his knees. A pink curtain hangs behind him. Reversed from the *Golden Haggadah* (Scene 35) and also inscribed differently.

fol. 9v, b (49) The feast of Joseph and his brothers (Gen. 43:32–33): On the right, behind a legless table, sit six of the brothers, "the first-born according to his birthright, and the youngest according to his youth" (Gen. 43:33). Within an arcade on the left and sitting at a separate, round table set with a goblet, a flask and two plates is יוסף שאוכל עם בנימין ומתנבא בגביע, "Joseph, who is eating with Benjamin and prophesying (*sic*) with the goblet". Placing the brothers with the aid of a silver (here golden) goblet is according to *Genesis Rabbah* 92:5, but Benjamin sitting at the same table as Joseph must be from another source. Not in the *Golden Haggadah*.

Fig. 172

fol. 10r, a (50) "And the goblet was found in Benjamin's bag" (Gen. 44:12): On the right, behind a tree, wearing armour and carrying swords, spears and shields, are עבדי יוסף שרודפין אחרי אחיו, "Joseph's servants who pursue his brothers". The golden (!) goblet is found in the bag of Benjamin, who is being held by an armed man. Behind him stand three astonished brothers and a donkey. Not in the *Golden Haggadah*.

fol. 10r, b (51) ויגש אליו יהודה ומשתחוה לפניו, "And Judah approached him, and he kneels (!) in front of him" (based on Gen. 44:18–34): On the right, behind Judah, are five other brothers, some kneeling and some standing, one of them armed. To the left, under a canopy, בנימין עומד תחת רגלי יוסף, "Benjamin stands (although in the picture he

is sitting) at the feet of Joseph", who is crowned. Not in the *Golden Haggadah*.

Pl. LI: Fig. 173

fol. 10v, a (52) Joseph makes himself known to his brethren (Gen. 45:1–14): On the left, within an arcade, is יוסף שמחבק בנימין ובוכה עליו, "Joseph, who embraces Benjamin and weeps over him". To the right are six of אחי יוסף שעומדים מפוחדים על שיוסף תפש בנימין, "Joseph's brothers, who stand frightened because Joseph has seized Benjamin". Cf. Scene 35 in the *Golden Haggadah*, which represents this scene in the manner in which it is depicted in Scene 48 above.

fol. 10v, b (53) יעקב שיורד למצרים בעגלות, "Jacob, who goes down to Egypt in chariots", is accompanied by seven men, all sitting in a chariot pulled by two horses from the right. Beneath the chariot are two running dogs. At either end is a green tree with a blue trunk. To the left is יוסף שיוצא לדרך לראות את אביו, "Joseph, who goes out on the way to see his father" on horseback, accompanied by an attendant (based on Gen. 46:5–7, 29). Not in the *Golden Haggadah*.

Fig. 174

fol. 11r, a, right (54) Joseph presents five of his brothers to Pharaoh: To the right five of אחי יוסף ויוסף עמהם, "Joseph's brothers and Joseph with them", are conversing. In the *Golden Haggadah* (Scene 36) this and the following scene (55) are joined in one composition, depicting only three brothers.

fol. 11r, a, left (55) יעקב עומד עם פרעה בחדר/ ושואל כמה שני ימי חייך, "Jacob stands with Pharaoh in the room / And he asks: How old art thou?" (Gen. 47:7–10). Both Jacob and Pharaoh are seated (!) here, under a canopy similar to that in the *Golden Haggadah* (Scene 36).

fol. 11r, b (56) The blessing of Ephraim and Manasseh (Gen. 48:1–15): To the left is Jacob, sitting up in bed and leaning against a green cushion, a pink curtain behind him; his hands are crossed while blessing the two children, as in the *Golden Haggadah*, Scene 37. At the foot of the bed stands Joseph. To the right, entering through a door in the wall, is השמש שמביא לאכול ליעקב שהוא חולה, "the servitor, who brings food to Jacob, who is ill", carrying a towel and a dish and followed by another man; not in the *Golden Haggadah*. The bottom outer corner of the leaf is torn off.

Fig. 175

fol. 11v, a (57) Mourning over Jacob's bier (Gen. 50:10); represented and inscribed as in the *Golden Haggadah* (Scene 38): In the middle, between two trees, is Jacob's coffin. On the right are twelve mourners all dressed in blue monk's habits. On the left, "Pharaoh and his servants" are seated, mourning.

fol. 11v, b, left (58) פרעה שאומר למילדות העבריות, "Pharaoh, who says to the Hebrew midwives" (based on Ex. 1:15): On the left, a crowned Pharaoh sits under a canopy. Behind him, in front of a trefoil arch, are two attendants, and in front of him, the midwives. The scene is divided by a tree from Scene 59.

fol. 11v, b, right (59) "Every son that is born ye shall cast into the river" (Ex. 1:22): A man is throwing a baby into the river. The bottom outer corner is torn off.

Scenes 58–59 should be read from left to right, as described above and as in the *Golden Haggadah* (Scenes 39–40).

Fig. 176
fol. 12r, a (60) The finding of Moses (Ex. 2:4–5); the representation and first inscription are similar to those in the *Golden Haggadah* (Scene 41): "And his sister stood afar off" (Ex. 2:4), watching the infant Moses who is depicted on the box-like ark. Three naked maidens wading in the wavy river approach the ark from the left. In the water are four dead infants (not in the *Golden Haggadah*). Inscribed on the left: "And the daughter of Pharaoh went down to wash herself at the river" (Ex. 2:5).

fol. 12r, b (61) בת פרעה שמראה משה לפרעה והחרטומים אומרים שהוא עתיד להחריב מצרים, "Pharaoh's daughter, who shows Moses to Pharaoh, and the magicians say that he will destroy Egypt in the future" (*Exodus Rabbah* 1:26); similar to the *Golden Haggadah* (Scene 42): On the left, in front of a pink curtain, is an enthroned Pharaoh flanked by two counsellors. His daughter, approaching from the right and followed by one old and one young maid, carries the infant Moses. The counsellor to the left of Pharaoh's daughter stands in front of another figure of uncertain identity, who is touching Moses' head (not in the *Golden Haggadah*).

Fig. 177
fol. 12v, a, left (62) An Egyptian "smites a Hebrew of his brothers" (Ex. 2:11) with a stick. Reversed from the *Golden Haggadah* (Scene 43), and with the addition of Moses, who is standing on the left and wearing a cloak with a decorative collar, his right hand on the head of the kneeling (?) Hebrew and holding the Egyptian's hand (? damaged) with the other (not in the *Golden Haggadah*). The scene is separated by a tree from Scene 63.

fol. 12v, a, right (63) "And he slew the Egyptian and hid him in the sand" (Ex. 2:12): The Egyptian is lying at the feet of Moses, who is carrying a blood-stained axe over his shoulder. Similar to the *Golden Haggadah* (Scene 44).

fol. 12v, b (64) Moses saves the daughters of the priest of Midian: "Moses stood up and helped them" (Ex. 2:17); represented and inscribed similarly to the *Golden Haggadah* (Scene 45), though different in details. Moses, wearing a hat with a feather and flanked by many sheep, mediates between two shepherds on the left and three women on the right. One of the women is carrying a large distaff.

Fig. 178
fol. 13r, a, left (65) מלאך הסנה, "The angel of the bush" (based on Ex. 3:2): The winged angel emerges from a leafy bush, which is burning on top of a hill. Unlike the representation in the *Golden Haggadah*, the angel is not nimbed.

fol. 13r, a, middle (66) "Put off thy shoes" (Ex. 3:5): Moses, seated on the hillside surrounded by sheep, is taking off his shoe.

fol. 13r, a, right (67) Moses hides his face (Ex. 3:6): Moses leaning on his staff, raises his hand to his face. To his right is a lamb. Inscribed: "Moses kept the flock" (Ex. 3:1). The inscription in the *Golden Haggadah* (Scene 47) — "and Moses hid his face" (Ex. 3:6) — is more appropriate.

The placement and depiction of Scenes 65–67 is similar to those in the *Golden Haggadah* (Scenes 46–47). Moses is depicted twice in the panel.

fol. 13r, b (68) Moses and Aaron perform miracles before the Elders of Israel; similar to the *Golden Haggadah* (Scene 50). On the right: "and he did the signs in the sight of the people" (Ex. 4:30). Moses and Aaron stand facing left, their hands in gestures of speech, with Aaron holding a snake by its tail. On the left: "Then they bowed their heads and worshipped" (Ex. 4:31). Four Elders are kneeling within a roofed interior.

Fig. 179
fol. 13v, a (69) "But Aaron's rod swallowed up their rods" (Ex. 7:12); similar to the *Golden Haggadah* (Scene 54). On the left: פרעה וחרטומיו יושבים, "Pharaoh and his magicians are seated". Pharaoh sits cross-legged on his throne, one magician standing to his right and another seated at his feet and holding two snakes. Both snakes are being swallowed by the snake held by Aaron, standing with Moses on the right. Moses argues with the standing magician. The gate of a town forms the background to the scene.

fol. 13v, b (70) The plague of blood (Ex. 7:19–24); similar to the *Golden Haggadah* (Scene 55): On the right are Moses and אהרן שמכה את היאור, "Aaron, who strikes the river". The river is depicted as a red rectangle with three fish in it. On the left is the enthroned Pharaoh, and above the river are two men, hoeing, who represent "all the Egyptians digged round about the river" (Ex. 7:24), finding only blood.

Fig. 180

fol. 14r, a (71) "The plague of frogs" (Ex. 8:1–3; A.V. 8:5–7); similar to the *Golden Haggadah* (Scene 56): משה שמכה בנהר והצפרדעים עולים בבתים, "Moses, who strikes the river, and the frogs come up to the houses". On the right is Moses, touching the water with his staff. Green frogs leap out of the water into vessels in wall niches and on to the enthroned Pharaoh, on the left.

fol. 14r, b (72) The plague of lice (Ex. 8:12–14; A.V 8:16–18): On the right are Moses and Aaron, Aaron touching the ground with his staff. In the centre the enthroned Pharaoh turns to the left towards the scene of "lice in man and beast" (Ex. 8:13; A.V. 8:17). The representation resembles that in the *Golden Haggadah* (Scene 57) only in some iconographical details, such as a woman appearing at a double-arched window. This woman and two others are scratching themselves with double combs. There are two other figures, and, below, a donkey turning its head backwards, and another donkey's head. The lice, however, are not depicted.

Fig. 181

fol. 14v, a (73) The plague of "'arov" (Ex. 8:20; A.V. 8:24), i.e., beasts (*Exodus Rabbah* 11:2). On the right are "Aaron and Moses", their hands in gestures of speech. To the left, separated from Aaron and Moses by a tree and against the background of a triple arcade, is פרעה שבורח מפני החיות, "Pharaoh, who escapes from the beasts". Among the beasts surrounding Pharaoh are two fantastic birds and three quadrupeds.

fol. 14v, b (74) דבר כבד בבקר ובצאן בסוסים (ו)בחמורים, "A very grievous murrain upon the herds and the flocks, the horses (and) the asses" (based on Ex. 9:3); different from the *Golden Haggadah* (Scene 59): Two men are carrying a sheep and a foal out through a gateway in the middle. Other sheep and horses are lying on the ground. To the right is a man in mourning, and to the left is another one, rending his clothes, as in the *Golden Haggadah*.

Fig. 182

fol. 15r, a, right (75) The plague of boils (Ex. 9:8–11): Moses is throwing the ashes of the furnace out of a bowl. The ashes are depicted as red dots. Behind Moses is Aaron, holding his staff, and in front of him are two kneeling figures and a tree. Inscribed: "Take to you handfuls of ashes of the furnace, and let Moses sprinkle it towards the heaven..." (Ex. 9:8).

fol. 15r, a, left (76) פרעה מוכה בשחין, "Pharaoh afflicted by boils", which are depicted as black dots. He is seated on a bench, surrounded by three attendants, one of whom, perhaps a doctor, is examining Pharaoh's hands (cf. the *Golden Haggadah*, Scene 60: "a physician...").

Scenes 75–76 are similar to Scene 60 in the *Golden Haggadah*, although different in details.

fol. 15r, b, left (77) The plague of "hail" and flaming fire (Ex. 9:22–25); similar to the *Golden Haggadah* (Scene 61): White and red dots fall on a tree, under which are a hooded shepherd and his sheep. To the left is the enthroned Pharaoh.

fol. 15r, b, right (78) Moses begs God to stop the plague of hail; Moses, genuflecting, lifts his hands and head towards a segment of blue sky at the top. Aaron is standing behind him. Inscribed: "As soon as I will go out of the city, I will spread my hands unto the Lord" (Ex. 9:29).

Fig. 183

fol. 15v, a (79) The plague of "locusts" (Ex. 10:13–15): Moses and Aaron to the right and an enthroned Pharaoh to the left are all pointing to a tree on which bird-like locusts are landing. In the background are hillocks with grass and two more trees. Pharaoh does not appear in the *Golden Haggadah* (Scene 63).

fol. 15v, b, left (80) The plague of "darkness" (Ex. 10:21–23): On the left is the enthroned Pharaoh touching the wall, as in the *Golden Haggadah* (Scene 64). In front of him are four people seated under a battlemented arch on a black ground.

fol. 15v, b, right (81) "And they spoiled the Egyptians" (Ex. 12:36): Four people, one carrying a case on his back (as in the *Golden Haggadah*, Scene 65) and with a silver goblet at his feet. Two others, each holding three silver goblets.

For the relation between the last two scenes, see *Exodus Rabbah* 14:3.

Fig. 184

fol. 16r, a (82) "The plague of the first-born" (Ex. 12:29–30): To the right are four mourners at the bed of a dead man. To the left, within a double arcade, is בכור פרעה מת, "The deceased first-born of Pharaoh", lying in a woman's lap. The king and two counsellors surround them, the king stroking the boy's head. The two mourning scenes are similarly combined in the *Golden Haggadah* (Scenes 66–67).

fol. 16r, b (83) "Pharaoh says: Rise up and get you forth" (Ex. 12:31): On the right is Pharaoh, on top of a battlemented edifice with a double window, similar to that in the *Golden Haggadah*, (Scene 68). Walking towards the left are "Israel goes out with a high hand" (Ex. 14:8), lifting their hands — "and the people carry their dough before it was leavened" (Ex. 12:34); two of the Israelites carrying it on sticks over their shoulders, and another, holding a piece of dough in his hand, are preceded by a banner-bearer with sword. The banner has yellow and red horizontal stripes.

Fig. 185

fol. 16v, a, right (84) The pursuit of the Egyptians: The crowned Pharaoh and two other knights on horseback, all wearing armour and carrying shields, ride in from the right. Inscribed: "And Pharaoh drew nigh" (Ex. 14:10).

fol. 16v, a, left (85) The passage of the Red Sea: "And the waters were a wall unto them on their right and on their left" (Ex. 14:22): A group of Israelites led by a banner-bearer (the banner similar to that in Scene 83 above) are framed by water, shaped as a turretted wall in front of and behind them.

Scenes 84–85 are in separate compartments in the *Golden Haggadah* (Scenes 69–70), where the drowning Egyptians are also represented.

fol. 16v, b (86) "And Miriam the prophetess... took a timbrel in her hand, and all the women went out after her with timbrels and with dances" (Ex. 15:20): To the right, behind a tree, is Miriam, holding a square timbrel (as in the *Golden Haggadah*, Scene 71) and escorted by a woman. To the left are eight women, some crossing hands in a dance, and one playing the cymbals.

2. *Ritual Scenes.*

Fig. 186

fol. 17r, a (87) The master of the house, seated under a canopy on the left, is distributing *mazzot* from a heaped trough. In the middle, a man stands ladling out *ḥaroset* (sweetmeat) from a pot. Behind him are three men holding *mazzot* and bowls (as in the *Golden Haggadah*, Scene 72); inscribed: "And ye shall watch the unleavened bread" (Ex. 12:17).

fol. 17r, b, right (88) The search for the leaven: In a room with a coffered ceiling, the father is holding a candle and putting his hand into a niche in the wall. To his right is a boy holding a white bowl. Inscribed: "Ye shall put away leaven out of your houses" (Ex. 12:15).

fol. 17r, b, left (89) Spring-cleaning the house: Two women are holding brushes; one sweeps the floor and the other brushes the coffered ceiling.

In the *Golden Haggadah* (Scenes 73–74), the above two scenes are joined in one compartment.

fol. 17v (Fig. 187) (90) The synagogue: In the middle of the interior of a synagogue, within a *bima*, stands a bearded *ḥazzan* reading from a book or scroll. Gathered below are a group of men, two of them holding books, and a child. The elevated *bima* is attached to one of the four twisted, vermilion columns of the building. The columns carry three arches, the one on the left slanting and trefoil shaped. The blue tiled roof and part of the red brick outer wall can be seen on top. The decorated wooden *bima* is supported by three small, blue columns and has wooden stairs. Four poles, rising from the corners and connected by

four horizontal bars at the top, are decorated with skittle-like gold finials. On the *bima* are two green candlesticks. On each side of the *bima* three oriental glass lamps hang from pulleys on beams between the side columns; another lamp hangs from the middle arch. In the lower left-hand corner of the panel is a small-scale gabled façade of the synagogue, with one doorway. Inscribed by the later hand: בעל הבית ובני ביתו שאומרים ההגדה, "The master of the house and his household, who are saying the *Haggadah*". This may be an error, or it may have been a local custom to read the *Haggadah* in the synagogue (see Freehof, pp. 222–226; Gutmann, p. 18, No. 46).

fol. 18r (Pl. LI: Fig. 188) (91) בעל הבית ובני ביתו שעושים הסדר בליל פסח, "The master of the house and his household, who are performing the *Seder* on the Passover Eve" (inscribed by the later hand). On the left, at the head of a long table, sits the master of the house. The first two initial words of the Haggadah — הא לחמא, "This is the bread" — are inscribed in an open book in front of him. Also seated at the table are a child, two women and two men. On the table, covered with a white cloth and chequered stripes, are three silver goblets, a bowl, a vermilion flask and another open book, also inscribed with the beginning of the Haggadah: הא לחמא עניא די אכלו, "This is the bread of affliction which (our forefathers) ate". Under the table are two cats. The room is made of a triple arcade with trefoil arches, the two side arches slanting downwards towards the frame and lighted gold lamps suspended from the middle arch. The intended allusion to an interior perspective is more noticeable here than anywhere else in this manuscript. The arcades are battlemented and enclose blue or ochre grounds with a brick pattern.

B. *Initial-Word Panels and Accompanying Decorations.*

Within the text space there are painted or penwork initial-word panels, often with marginal decorations extending from them, some as ascenders and descenders of letters which at times divide the text space in the middle. The most elaborate decorations are: (a) a large panel at the beginning of the *Seder* ceremony (fol. 19v – Fig. 189) with the extension in the outer and lower margins; (b) a fully framed page at the beginning of the Haggadah text (fol. 27v – Fig. 191) with a panel across the text and an extension and a descender on either side of the text that join in the lower margin to frame the text and the additional illustration; (c) decorations where a repeated word of a *piyyut* forms a continuous, elongated panel (e.g., fols. 20v – Fig. 190, 21r–22r, 48v – Fig. 200, 49r–v and 60v – Fig. 206). Two of the text illustrations occupy a large part of the text space (fols. 51v–52r – Figs. 202, 203).

1. *Painted Decorations.*

The painted accompanying decorations include two text illustrations (fols. 51v–52r – Figs. 202, 203). The initial words are almost always written alternately in burnished gold or silver outlined in black or red, within painted or penwork panels measuring $(25-35) \times (70-90)$ mm. The painted panels and the extending decorations are painted in several shades of magenta and blue, as well as vermilion, light green and burnished gold. The motifs and colours, as well as stylistic features, are close to that type of decoration in the *Golden Haggadah* (No. 11, § B). The panels have coloured grounds, mostly blue and magenta, decorated with thin brush scrolls in white, a few in colours, and one in gold (fol. 27v – Fig. 191). The grounds of some panels are diapered or chequered (e.g., fols. 28r, 32v – Fig. 192, 33v and 53v). Some of the larger panels are divided into alternating blue and magenta compartments. The frames consist of thin coloured fillets.

fol. 58r (Fig. 204) A contraction of the name of God (three *yods*) is written in gold within a panel shaped as a paisley leaf on a blue ground and framed in silver.

fol. 60v (Fig. 206) This large panel, measuring 130×80 mm, comprises three joined panels separated from each other by bands. Each band is decorated with a foliage scroll and a large gold roundel.

Most of the extensions consist of coloured branches and scrolls, often shaped as trumpets, heightened by lines and small roundels. They curl at the ends, where they bear coloured leaves, mostly variations of ivy. Often they are also strung with a few beads; some are accompanied by small gold roundels (e.g., fol. 27v – Fig. 191). These branches are frequently in roughly symmetrical pairs in the upper or lower margins (e.g., fols. 29r, 34r – Fig. 194, 37r, 47v, 50r, 52v, 53r and 60v – Fig. 206, with a dragon below; cf. fols. 19v – Fig. 189, and 33r – Fig. 193). Other variations of ivy scrolls are within wide, coloured bands alongside *lamed* ascenders (e.g., fols. 45v with a human grotesque on top, 57r and 63r – Fig. 208). Different sizes of ivy and other foliage scrolls are within coloured, cusped shapes (e.g., fol. 46v), which connect the marginal motifs to each other, to the side of a panel or to the ascender of a letter (e.g., fols. 19v – Fig. 189, 27v – Fig. 191, 29r, 33r – Fig. 193, 34r – Fig. 194, 37r and 47v).

Some panels are surmounted by symmetrical palmettes, with a pair of leaves extending sideways (e.g., fols. 27v – Fig. 191, and 38v), or are accompanied by small gold roundels (e.g., fol. 32v – Fig. 192).

Various painted grotesques are attached to the ends of the descenders of several letters, some of them with foliated tails, biting the end of a descender (e.g., fols. 35r and 55r). On fol. 28r, two such dragons are combined to form a large motif which spreads into the text and the lower margin. Other grotesques, also appended to prolongations of letters, are half-human hybrids (e.g., fols. 41r and 45v), the one on fol. 57r holding a shield and brandishing a silver hammer — perhaps a text illustration to "Pour out thy wrath". Some descenders are interrupted by symmetrical foliage or bead motifs.

The two text illustrations on fols. 51v and 52r belong to this type of decoration in colouring, style and general type of Haggadah decoration (cf. the *Golden Haggadah*, fols. 44v – Fig. 152, and 45v – Fig. 153).

fol. 51v (Fig. 202) מצה זו, "This *mazzah*": A roundel 77 mm in diameter is decorated by interlacing gold fillets which form a star pattern surrounded by foliage motifs. There are coloured ground fillings. The roundel is framed by a green circle, with four additional extending corners.

fol. 52r (Fig. 203) מרור זה, "This bitter herb": A large stylized green cluster of lettuce, measuring 110×60 mm (partly flaked off) gathered together by a vermilion holder.

2. *Penwork.*

Some of the penwork panels are similar in size to the painted panels, and their writing is also in gold or silver. Others are smaller, with the initial words written in ink (e.g., for the *piyyuṭim* between fol. 20v – Fig. 190 and fol. 26v). The penwork is in red and violet ink and mostly consists of curly scrolls and heart-shaped palmettes enclosing lobed foliage, some dotted. There are also narrow S-scrolls filled with flourishes and stylized variations of scrolls, as well as a few other foliage and floral motifs (e.g., fols. 26v and 48r).

The frames consist of lines with single beads and pearled sections. Similar lines clustered together with plain lines, ending in long flourishes and often issuing from different ornamental foliage motifs, form the extensions into the margins.

Similar framing, with or without extensions, is applied to some painted panels and prolongations of letters (e.g., fols. 20r, 42v, 43r, 44r, 45r and 48r).

Beside some panels there is an additional pen-drawing:

fol. 60r (Fig. 205) Below the panel: a hand pointing at a human grotesque.

fol. 63r (Fig. 208) Between the two penwork panels: two human grotesques and a dog.

C. *Marginal Text Illustrations.*

The eleven additional text illustrations are painted in the margins (fols. 27v, 32v, 34v, 35v, 36r, 36v, 41v, 50v, 51v, 52r and 61r), five of them within a small architectural frame, three attached to the

ends of descenders of the type described in B (fols. 41v, 50v and 61r), one framed within the text space (fol. 27v), and one in the outer margin (fol. 51v). They mostly consist of single figures directly related to the text they illustrate. They are painted by a hand different from that of the text decorations and differ somewhat from the full-page panels. The outline drawings and the facial features, as well as some of the large heads, resemble the full-page panels, but the colours are darker and there are additional shades of brown, green and grey with burnished gold, made up of thicker ground paste which is cracking in places. The unframed illustrations are painted on the vellum ground in the outer margin (fols. 32v, 34v, 35v, 36r and 36v); those within small architectural frames (50–85) × (35–40) mm in a multifoil arch are on a coloured ground criss-crossed with diagonal gold lines (fols. 41v, 50v and 61r).

fol. 27v (Fig. 191) The benediction of the first cup of wine, (מפירקא) אתאן, "Returning (from the Synagogue)" — the beginning of the *Seder*: A man seated on a bench, holding a silver goblet. Flanking the frame of the illustration are two shields with *gules* and five vertical bars *or*, resembling the arms of Barcelona.

fol. 32v (Fig. 192) (לחמא עניא) הא, "This is (the bread of affliction)" — the beginning of the Haggadah: A man stands holding a *mazzah* in his left hand.

fol. 34v (Fig. 195) "R. Eleazar ben Azariah said...": A bearded rabbi seated on a bench points to an open book on a stand.

The Four Sons.

fol. 35v (Fig. 196) "The wise one" is seated, reading a book. Below is "the wicked one", brandishing a gold (flaked) sword and wearing a turban and a short gown decorated with a scroll pattern in gold. The lower right-hand corner has been torn off, and his legs are missing.

fol. 36r (Fig. 197) "The innocent one" is seated, pointing at the text.

fol. 36v (Fig. 198) "The one who does not know how to ask" is depicted as a child, walking and sticking his tongue out.

fol. 41v (Fig. 199) "And we have cried out": A man kneels in prayer.

fol. 50v (Fig. 201) "Rabban Gamaliel", seated and holding a sceptre and a book, is flanked by two students (slightly faded).

fols. 51v–52r These two pages have illustrations both within the text space and in the margins, and both illustrate the same text. However, they are not the same type of decoration.

fol. 51v (Fig. 202) מצה זו, "This *mazzah*": A seated man holds a round white *mazzah* with four extending pointed corners.

fol. 52r (Fig. 203) מרור זה, "This bitter herb": A man dressed in a long red gown with a grey outer robe stands holding a cluster of leaves.

fol. 61r (Fig. 207) "In my distress"(Ps. 118:5): A man stands in prayer.

Conclusions

The biblical cycle in the full-page panels of this *Haggadah* (§A) is of the second recension, and is so very similar in choice of subjects and in iconography to the cycle in the *Golden Haggadah* (above, No. 11) as to justify calling it the *Sister Haggadah*. However, a detailed comparison of the scenes proves that they could not have been copied from one another, but must have had a common model encompassing a wider cycle than either of them, since both *Haggadot* have scenes that do not appear in the other.

The iconography of this manuscript is probably closer to that of the common model, being executed by an artist less skilled than the artists of the *Golden Haggadah*. In style, however, this artist was more eclectic as evidenced by the full-page panels, as well as the text decorations. The archaizing French elements are mainly noticeable in the text pages. The initial-word panels with their extending foliage decoration, the soft, undulating scrolls, the buds, the cusps and the decorative grotesques, as well as the illustrations of the *mazzah* and *maror*, are painted in the exaggerated Spanish manner of the Franco-Gothic style. The penwork panels are in the same Franco-Spanish style. In the full-page panels. the Franco-Spanish elements are to be found in the division of the page into two compartments, in the sometimes compact compositon of figures and architecture which fill almost the entire height of each compartment, and in the painted and decorated grounds of some panels.

The Italianizing architectural elements, such as baldachins and coffered ceilings, were flatly rendered. In some panels the compact composition appears more spacious when the elements are painted on the vellum ground.

The figure style of the full-page panels is Italian, mainly noticeable in the proportions of the figures, in the fashions of clothes, turban-like headgear and caps, as well as in the modelling of drapery folds. The black outlines of figures and facial features, the light colouring with white highlights and the dark shading of faces and naked parts of the body (on fols. 1v–8v – Figs. 155–169, 17v – Fig. 187, and 18r – Fig. 188), are features of the Italian technique of illumination.

In spite of some differences in colouring between the panels on fols. 1v–8v and 17r–18r and those on fols. 9r–16v (Figs. 170–185), mainly the white rendering of the faces on fols. 9r–16v, the underdrawings point to a single artist, with the colouring perhaps being done by two apprentices.

The single figures in the text pages also show Italian stylistic elements, e.g., the proportions of the figures, the clothes and the drapery modelling. They are quite similar to those in the full-page panels, although somewhat more painterly and with heads larger in relation to their bodies. They may have been executed by a different artist of about the same period or by the same artist of the full-page panels, following a different model. Similar colour modelling can be found in the foliage scrolls above the *piyyuṭ "Dayyenu"* (fols. 48v – Fig. 200, 49r–v), which are more angular than the other marginal scrolls and have white highlights of the Italian type, rather than the white decorative flourishes of the Franco-Gothic type.

The mixture of Franco-Spanish and Italian-Gothic elements can also be found in the *Golden Haggadah*, though there the result is different. The compositions in the *Sister Haggadah* are more spacious, and the modelling is more Italian in all parts of the decoration except in the Gothic initial-word panels. The style of the *Sister Haggadah* resembles Catalan illuminated Latin manuscripts from Barcelona of around the middle of the fourteenth century, such as the Chronicles of Jaime el Conquistador of 1343 (University of Barcelona: MS. 1; see Domínguez-Bordona, Fig. 186). There, too, the figures fill the height of the panels, though the composition is quite spacious and the proportions and gestures exaggerated.

The shields with the arms of Barcelona on fol. 27v (Fig. 191) provide further support for a Catalan origin of our manuscript. The *Sister Haggadah* was therefore decorated in the middle of the fourteenth century, in Barcelona or near it, in a workshop where Italian as well as Franco-Spanish models were used and a somewhat archaistic manner was followed.

Bibliography

Margoliouth, No. 608, II, pp. 202–203.
Domínguez-Bordona, *Ars Hispaniae*, XVIII, Fig. 186.
Gutmann, Haggadah, p. 18, Nos. 26, 33.
Freehof, S.B., "Home Rituals", in *Studies in Honor of A.A. Neuman*, New York, 1962, pp. 222–226.
Narkiss, *HIM*, pp. 22, 58, Pl. 9.
Narkiss, *Golden Haggadah*, pp. 43–73, Figs. 11, 13, 15–17, 28, 33.

13. BARCELONA HAGGADAH

Barcelona, mid-fourteenth century

BL, Add. 14761

Figs. 209–245; Pl. LI: Figs. 211, 233

Haggadah with piyyuṭim, prayers and readings for Passover.

General Data

Codicology

Vellum; I + 161 + I leaves; 255 × 190 mm. Fols. 9v–99r (*Haggadah* and prayers): text space (125–140) × 100 mm; written in square Sephardi script, in brown ink, mostly 8 lines to a page (except for fols. 97r–99r, which have 5 lines). Fols. 2r–8v and 152r–160r (*piyyuṭim*): text space similar to that of *Haggadah* and prayers; written either in smaller square script or in round script, 15 lines to a page. Fols. 99v–101r and 105v–135v (readings): text space (173–177) × (115–120) mm; written in square Sephardi script; 21 or 27 lines per page. Ruling mostly by stylus, 8, 15, 21 or 27 horizontal and 2 vertical lines. Pricking is noticeable in all margins. 20 quires of 8 leaves each, except for Quires XV[7] and XX[10]. Part of the *piyyuṭ "Nishmat Kol Ḥai"* has been added by a later hand in the outer margin of fol. 81v.

Binding

Blind-tooled calf binding on wooden boards.

Colophon

None.

History

fols. 1r, 2r Owner's signature: Yeḥiel Naḥman Foah.
fol. 151v Owners' signatures: (1) Mordechai Otto-lenghi; (2) Raphael Ḥayyim Ottolenghi.
fol. 161v Sale entry: Shalom Latif of Jerusalem sold the *Haggadah* to R. Moses b. Abraham for 50 gold ducats at Bologna in 5219 (1459).
fol. 160r Censor's signature: "Visto per mi Fra. Luigi del ordine de San Domenico del 1599."
Purchased by the British Museum from Messrs. Payne and Moss in 1844 for 10 shillings; No. 123 (9005) in their catalogue.

Decoration

Almost every page of this manuscript is decorated and illustrated, often with biblical and ritual scenes. There are painted initial-word panels within, above or below the text, some of them very large. The scenes appear within these panels as well as on the vellum ground near them, most of them between fols. 18r and 71v. They are combined with foliage and grotesque motifs and marginal decorations that surround the text and usually extend from the panels, sometimes from ascenders and descenders of letters (e.g., fols. 50v, 51r, 59v – Fig. 238, 79v and 81r).

The decorations and the illustrations are painted vermilion and light magenta, with contrasting greyish blue and dull olive green. There is also ultramarine blue, ochre and grey, with gold and some silver. The shapes are outlined in black and heightened with white and are shaded with the same colours.

Many of the decorations and illustrations from fol. 49r onwards were not completed by the original artist. Many of these, especially from fol. 57r onwards, have been completed by a cruder contemporary hand. This hand was probably also responsible for the angular and stiff drawing and painting of foliage on fols. 66v and 89v.

Programme

A. Initial-word panels.
B. Marginal decorations.
C. Text illustrations and special decorations.
D. Later text illustrations.

Description

A. *Initial-Word Panels.*

The initial-word panels are mostly painted, although some are in penwork. They vary in size, some extending across the text and others smaller. Special combinations of panels present the repeated words of some *piyyuṭim* in columns alongside the text, e.g., fols. 11r–15r (*Peṣaḥ*) and 55v–58r ("*Dayyenu*"). There are also large, composite panels — some full-page — which include several initial-word or historiated panels in other combinations (e.g., fols. 17v, 21v, 28v, 61r – Figs. 209, 212, 222, 240, 77r, 80v and 88r – Fig. 244).

The panels have gold lettering on blue and magenta grounds, often in alternating sections of the two colours. In the more elaborate panels the initial words are placed in separate compartments, some of which are shaped like lobed arches. Many panels are historiated (see § C) and some are decorated with grotesques (e.g., fols. 21v, 36r and 56v) or foliage patterns (e.g., fols. 29v, 39v – Fig. 231, 42v, 49r–v, 50v, 51r, 55r, 56r and 88r – Figs. 219, 237, 244). The grounds and frames are covered with thin brush scrolls, mostly in white (some gold, e.g., on fols. 22v and 25r – Figs. 213, 216), or with diapers and chequers and other geometrical motifs.

Some initial words are written in ink within panels of red penwork which consists of curly scrolls filled with gold-club motifs or fine spirals (e.g., fols. 16v, 27r, 96v and 137r). On fol. 82v the penwork has brush gold ground fillings.

B. *Marginal Decorations.*

The rich marginal decorations which extend from the panels to surround the text consist of large grotesques and various foliage scrolls and are often inhabited by smaller human, animal and other motifs, some forming scenes. On many pages the foliage motifs in the side margins are symmetrically arranged round a slim bar, often with a vase-like shape at the bottom and a blossom motif composed of acanthus leaves at the top. Many of these bars are interrupted by grotesques, animals and humans (e.g., fols. 22v, 25r, 26r–v, 28v, 32v – Figs. 213, 216, 217, 218, 222, 41r and 47r). The foliage consists mainly of scrolls of long, jagged acanthus leaves, many combined with large acorns or blossoms (e.g., fols. 29v, 30v, 41r and 43v), and others with tendrils carrying gold and coloured vine or ivy leaves (e.g., fols. 49v, 50r, 51r and 80v) with gold studs among them. Some of the acanthus motifs issue from the mouths of grotesque heads attached to the side or corner of the panel (e.g., fols. 19v, 27v – Figs. 210, 220, and 50r), or from a frontal lion's mask (e.g., fols. 17v – Fig. 209, 20v, 25r – Fig. 216, 31r and 47v); others spring from jars resting on the panels (e.g., fols. 17v and 33v). The large grotesques include various dragons, birds and hybrids, some half-human. Many have tails terminating in foliage or in animal or human heads. The grotesque birds often have long, thin legs, derived from herons or cranes. In some places the grotesques are symmetrically grouped, usually in the upper or lower margins (e.g., fols. 24r, 26v, 28v – Figs. 214, 218, 222, 32v and 39r), and their necks or tails are often intertwined (e.g., fols. 31v, 39r, 40v, 44r, 50v and 55v). Some are twisted round the gold ascenders and descenders of the initial words (e.g., fol. 24v – Fig. 215). The scrolls are inhabited and accompanied by many small motifs, among them grotesque animals and humans playing musical instruments, mainly the trumpet and bagpipes (e.g., fols. 17v – Fig. 209, 18r, 25r – Fig. 216, 31v, 52v and 64r). There are grotesque tournaments, animal scenes (especially with rabbits and dogs), hunting scenes (e.g., fols., 17v, 18r, 19v, 22v, 24r, 24v, 25r, 26v – Figs. 209, 210, 213–218, 30v, 31r and 31v) and various animals holding wine cups, some illustrating the text (e.g., fols. 17v, 24r, 26v – Figs. 209, 214, 218, and 39r). There are also rabbits (e.g., fols. 26v – Fig. 218, 31v, 80r, 81r

and 88r), dogs (e.g., fols. 22v, 25r, 26v, 28v – Figs. 213, 216, 218, 222, 34v and 79v), naked humans (e.g., fols. 17v – Fig. 209, 20v and 22v – Fig. 213), human busts or heads (e.g., fols. 31v and 32v), archers (e.g., fols. 18r, 21v and 24r – Figs. 212, 214), monkeys (e.g., fols. 18r, 20v, 21v – Fig. 212, 31v and 81r), a fox (fol. 20v), goats (e.g., fols. 17v and 81r), lions (e.g., fols. 21v, 22v, 26r, 28v – Figs. 212, 213, 217, 222, and 36r), a stag (e.g., fols. 18r and 82r), snakes (e.g., fols. 18r and 47r), butterflies (e.g., fols. 17v – Fig. 209, and 18r), peacocks (e.g., fols. 17v, 20v, 22v, 24r, 25r and 28v – Figs. 209, 213, 214, 216, 222), roosters (e.g., fols. 21v, 22v and 30v), owls (e.g., fols. 17v, 18r and 31v) and numerous other birds. Many additional motifs are described separately below. There are also some geometrical motifs, notably a coloured interlace with gold fillings, mostly forming the centre of a symmetrical motif (e.g., fols. 21v, 28v – Figs. 212, 222, 29v, 32v and 76v).

C. *Text Illustrations and Special Decorations.*

The text illustrations, within the initial-word panels or on the vellum ground, depict biblical and ritual scenes. The historiated panels are on fols. 17v, 18r, 19v, 20v, 21v, 24v, 26r, 27v, 28r–v, 30v, 31v, 34r, 35v, 36v, 43v, 44r, 46r, 51v, 53r, 54r, 57v, 59v, 60r, 61r, 64v, 65v and 71v. The illustrations on the vellum ground are on fols. 19v, 24v, 26v, 30v, 34v, 35r, 36v, 39v, 40r, 43r, 49r, 55r, 66v and 85r, those on fols. 28r and 32v are within quatrefoil frames. The scenes are composed in a flat, ornamental manner which is reinforced by contrasting colours and ornamental linework. They are on neutral ground, the few landscape or architectural details signifying locality or belonging to the iconography of the scene. The proportions of the human figures vary according to their frame or architectural settings, but they are normally squat and child-like. The facial features are added in black drawing, and the hair and beards are striated. The four panels of the Passover table (fols. 17v, 19v, 20v and 28v) form an essential part of the illustrations. They all show the family behind a long table, with the father and sometimes another person at each end. The table is covered with an embroidered white cloth.

fol. 17v (Fig. 209) The Passover table, illustrating a full-page, historiated panel of 125 × 104 mm, which includes instructions and benedictions for Passover Eve. The father, on the right, presides over the table, lifting his gold cup. The long table is covered with a blue-embroidered cloth and laid with goblets, a covered basket and a flask. Seated are a youth, a bearded man, a woman with a child and another woman pouring wine into a gold goblet. Above this scene is the initial-word compartment, flanked by grotesques and topped by a band of scrolls inhabited by grotesques. Within the rich marginal decoration are two putti and two hybrids blowing trumpets directed into the four corners of the panel. These probably signify the four winds. In the middle of the lower margin — as part of the rich marginal decoration — two hybrids hold a gold goblet. This may illustrate the benediction of the first cup which is on the opposite page (fol. 17v is much rubbed).

fol. 18r The benediction of the wine: Two historiated panels decorated with hybrids, some of which hold goblets. Among the many motifs in the margins are grotesque hunting scenes: in the upper margin a grotesque archer is shooting a snail, and in the outer margin are a monkey, depicted as a huntsman with a gold horn and a green falcon, and an archer shooting a stag confronted by a hound (the page is much rubbed).

fol. 19v (Fig. 210) "And they drink the first cup while leaning to the left...": A historiated panel of 72 × 105 mm, depicting the Passover table, with a bearded man in an armchair at each end and a woman and two children seated behind it. All the figures are holding goblets and leaning their heads on their hands. A gold lamp hangs from a gabled arch on the left. Below the panel is a dog gnawing at a bone. In the lower margin, as part of the rich marginal decoration, is an illustration of "and washing their hands": A bearded man, helped by a servant holding a gold vessel and a towel, washes his hands over a silver bowl.

fol. 20v (Colour Pl. LI: Fig. 211) The breaking and hiding of the *mazzah*: A historiated panel of 59 × 102 mm, depicting the Passover table. To the left is the father, ready to break a *mazzah*, and, at the other end, a man hiding it under the table-cloth, his arm held by one of the four children who are seated behind the table. Gold and silver goblets and a bowl stand on the table. Next to the father is the Passover basket on a stool. Two lamps hang from trefoil arches.

The inhabited scrolls in the margins include, among other motifs, a hunting scene and a few grotesque scenes. In the outer margin is a dog with a lance, a falcon riding a donkey and an armed child riding a cock. A dog in the outer top corner offers a garment to a shivering, naked boy.

fol. 21v (Fig. 212) The benediction over wine when Passover Eve falls on the Sabbath: Two superimposed, historiated initial-word panels. In the upper panel, below the initial-word compartment on the right and a dragon on the left, are two bearded men seated on stools on either side of a tree. Both point downwards to the lower panel, where the father stands holding a gold goblet, ready to pronounce the benediction. Three children approach from the right, one holding a gold flask.

The rich marginal decoration includes two

confronting *lions rampant* within foliage scrolls in the lower margin.

fol. 22v (Fig. 213) The benediction over wine: Two large initial-word panels and rich marginal decorations which include a grotesque tournament in the upper margin. The participants are two naked children with helmets, shields and lances, one mounted on a lion and the other on a cock. One of the children holds a gold goblet.

fol. 24r (Fig. 214) The benediction of the feast: A painted panel and rich marginal decorations, including, among other motifs, one grotesque holding a goblet and another holding a flask. In the lower margin is an Atlas figure within foliage, flanked by two archers.

fol. 24v (Fig. 215) Instructions to the *Havdalah*: Two panels, the upper one historiated, and rich marginal decorations. In the lower margin, within the marginal decoration, a man holding a goblet is performing the *havdalah* over a twisted candle held by a boy. A gold lamp hangs from the initial-word panel. In the upper panel a bearded man is seated on a stool in the entrance to a house. He is pointing downwards, possibly to the *havdalah* scene (cf. fol. 21v), or perhaps to the right, where a naked Nebuchadnezzar rides a lion, rending its jaws (TB, *Shabbat*, 150a, and Rashi, *ibid.*). The dog chasing a rabbit in the outer margin may perhaps allude to the mnemonic word in the text יקנה"ז, *YaQeNHaZ*, which may be read as *Jag den Has*, "hunt the hare" in Yiddish.

fol. 25r (Fig. 216) Benediction over wine: Two panels and rich marginal decorations, including a dog blowing a horn and beating a drum, one rabbit spinning with a distaff and another rabbit chasing a dog.

fol. 26r (Fig. 217) *Havdalah*: A historiated panel. A seated man holding a gold goblet is performing the *havdalah* above a twisted candle held by a boy. On the right, below the initial-word compartment, is a lion. Rich marginal decorations, including three gold fleurs-de-lis in the upper margin and a quatrefoil with a blank shield flanked by two *lions rampant* with flying mantles in the lower margin. Behind each lion and within a curly leaf is a harp-like emblematic motif, its lower edge curving to the left, four tuning forks on top of it and a pendant hammer-like object on its left.

fol. 26v (Fig. 218) *Havdalah*: One panel and rich foliage decoration. In the upper margin, a clothed and hooded dog holding a gold cup faces a rabbit in a hooded mantle. The rabbit is tapping another dog on the head with a candle(?).

fols. 27v–28r (Fig. 220–221) קנ"ך יהנ"ה ממ"ך, *QoNaKh YeHaNeH MiMaKh*, a mnemonic sign for the order of the Passover Eve ceremony. On each page is a historiated panel, that on fol. 27v is topped by an initial-word compartment. Both panels depict a procession of nine men, each holding a different symbolic object. These are, from right to left, from fol. 27v to fol. 28r: (1) קדוש, *Qiddush*, the benediction of the day — a gold cup of wine; (2) נטילת ידים, *neṭilat yadayim*, "the washing of the hands" — a man tilting a gold pitcher hanging from the upper frame to wash one hand above a gold bowl on the ground; (3) כרפס, *karpaṣ*, "celery" — a green plant; (4) יבצע, *yevaẓẓa*, "breaking the *maẓẓah*" — two pieces of a broken wafer; (5) *Haggadah* — an open book inscribed הא לחמא, *Ha laḥma*, "This is the bread (of affliction)"; (6) נטילה, *neṭilah*, "washing" — similar to 2; (7) המוציא, *ḥamoẓi*, benediction of the bread — breaking a round *maẓẓah*; (8) מצה, *Maẓẓah* — lifting a round *maẓẓah*, which is inscribed *mem*; (9) מרור, *maror*, "bitter herb" — a large green leaf. The tenth symbolic figure, representing כריכה, *kerikhah* — the sandwich of *maẓẓah* and *maror* — is not depicted, but is mentioned in the text. In the outer margin of fol. 28r, within a quatrefoil frame, a child takes a *maẓẓah*, from under a towel, perhaps the *afikoman*, which is eaten at the end of the meal. Fol. 27v has rich marginal decorations.

fol. 28v (Fig. 222) "This is the bread of affliction" — the beginning of the *Haggadah*: A full-page, historiated panel of 133 × 113 mm, depicting the Passover table, with two bearded men seated in armchairs at either end and a woman, two boys and a girl behind. The boy nearest to the man on the left carries a covered Passover basket on his head, the covering cloth being lifted by the man to reveal the *maẓẓot*. On the table are three open books and some gold vessels. The background is a large green curtain hanging from pinnacles or lion masks, under three gabled, cinquefoil arches, each with a hanging gold lamp. There are rich marginal decorations, including two emblematic harps and a shield in the lower margin, as on fol. 26r, although the shield is flanked by foxes. In the upper margin, an ornamental disc — *maẓẓah*(?) — is supported by two grotesques.

fol. 29v The large panel encloses a hare, standing on a line of painted acanthus leaves. Rich marginal decoration, mainly of foliage.

fol. 30v (Colour Pl. LI: Fig. 223) "We were slaves to Pharaoh...": The scene on this page spreads from the panel into the margins. On top of a tower on the left, within the panel, a supervisor holding a hammer is directing work. A mason with a trowel watches another workman raise bricks with a pulley. On the ground, to the right, a mason is carving a stone, and another workman carries a stone up a ladder. A taskmaster raises a whip over the mason. In the outer margin are two riders, one pointing at the scene in the panel (Pharaoh and his attendant?). Three brickmakers are in the lower margin, one treading the mud next to a sun-like stud, a second moulding bricks and the third

carrying them to the pulley. Above the panel, among the marginal decorations, a dog offers wine to a rabbit seated in an armchair.

fol. 31r (Fig. 224) "Even if we were all wise": One panel and marginal decoration. In the scrolls in the lower margin are two mounted helmeted knights engaged in jousting, two dogs hounding a rabbit and another rabbit chasing a dog.

fol. 31v (Fig. 225) The five Rabbis of Benei Beraq: A historiated panel in which the heads of five rabbis are seen at the windows of a two-storeyed building. Two pupils approach from the right, one of them trying the lock and knocker of the wooden entrance door. Rich marginal decoration.

fol. 32v "R. Eleazar ben Azariah said": Among the rich marginal decoration in the outer margin, the bearded rabbi is seated within a quatrefoil frame, holding his beard and carrying a book.

fol. 34r (Fig. 226) The "wise" son: A historiated initial-word panel depicting a bearded man seated before a stand, on which two open books rest. Rich marginal decoration.

fol. 34v (Fig. 227) The "wicked" son: To the left of a panel a bearded, gold-helmeted man holds another man by the beard, aiming his lance at him.

fol. 35r (Fig. 228) The "innocent" son: To the left of the panel stands a hooded boy, stretching out his hand to a seated bearded man. Among the marginal decorations in the lower margin are two mantled helmets crested with grotesque heads.

fol. 35v (Fig. 229) The son "who knows not how to ask": A historiated initial-word panel flanked by marginal decoration. Within the panel is an open-mouthed youth facing another man, whose hands are raised towards him.

fol. 36r An initial-word panel enclosing a dragon and supported by a *lion rampant*. Marginal decoration.

fol. 36v (Fig. 230) "In the beginning (our fathers were idolators)": Abraham stands within the panel, before King Nimrod (*Genesis Rabbah* 38:13; *TB Pesaḥim* 118a; *Tana D'vei Eliahu* 6), who is sitting on his throne to the left of the panel. Abraham, having been accused of mutilating the idols, holds a stick. Beneath the panel and within the marginal decoration, is Abraham being saved from the fiery, domed furnace, accompanied by two angels; the crowned Nimrod stands to the left, pointing at the furnace.

fol. 38r Among the marginal decoration in the upper margin are two hybrids with human busts fighting a duel with swords and round shields.

fol. 39r "This has helped us" (at this point of the feast the participants usually raise their cups): Two confronting dragons, part of the marginal decoration, raise coloured goblets.

fol. 39v (Fig. 231) "Go forth and learn what Laban thought to do to Jacob": In the lower margin the bearded Jacob, leaning on a staff, walks and is followed by two armed soldiers. In the upper margin, on top of the panel, is a three-faced human bust flanked by two human-faced hybrids holding clubs.

fol. 40r (Fig. 232) "And (Jacob) went down to Egypt": A procession in the lower margin depicts Jacob, on the left, sitting cross-legged on a horse that is harnessed to a two-wheeled cart. The horse is led by a youth blowing a horn. Two men and two women follow the cart, the first man holding a whip.

fol. 41r A grotesque Atlas figure, forming part of the marginal decoration, suppports the initial-word panel. In the lower margin are dogs chasing rabbits.

fol. 42v From the decoration of the lower margin a tower projects into the panel. At the door a dog is standing holding in its mouth a foliage scroll, which spreads inside the panel.

fol. 43r (Fig. 233) "And they laid upon us heavy work": To the left of the initial-word panel and forming part of the marginal decoration are workmen building a tower. There are two masons on top of the tower; two others climbing ladders, bringing up building materials and another workman raising a basket with a pulley.

fols. 43v, 44r (Fig. 234) "And we cried out unto the Lord": On each page, within the panels and to the left of the initial word, is a man kneeling in prayer. Among the decorations in the upper margin of fol. 43v a long-legged bird is inserting its beak into the mouth of a small dragon (the fable of the stork and the fox?).

fol. 46r (Fig. 235) "He brought us out of Egypt": An Exodus procession is walking out of the panel through a triple arcade. The procession includes a banner-bearer, four other men and a boy. Two of the men have their right hands raised, illustrating "with a high hand".

fol. 49r "And with signs, that is the rod": In the outer margin, to the left of the panel, a youth is raising Aaron's budding rod.

fol. 49v Among the marginal decorations on both sides there are hairy men depicted in tinted pendrawing, each holding a shield and raising a club to attack two small coloured dragons on top of the wide initial-word panel.

fol. 51r The ten plagues: A panel and marginal decorations, among which is a green frog above the word "frog" in the top line.

fol. 51v "Rabbi Yosé ha-Gelili": The rabbi and two of his pupils are seated within the panel, holding open books.

fol. 52v Among the marginal decorations is a human-headed hybrid in the top margin, blowing a long gold trumpet decorated with a pendant banner.

fol. 53r "Rabbi Eliezer": A bearded man is seated within the panel, holding an open book.

fol. 54r (Fig. 236) "Rabbi Akiva": Within an arched compartment attached to the left side of the initial-word panel is a bearded man seated in front of a lectern.

fol. 55r (Fig. 237) "How many are the merits": To the left of the wide panel, within an arched frame, is a seated man lifting a gold flask.

fol. 59v (Fig. 238) "Rabban Gamaliel": In the lower section of the panel, next to a high lectern, sits a bearded man facing his pupils and two bearded men and two youths, who are seated behind a table with three open books. The decorated descender of the letter *nun* extends from the panel into the margin and terminates in foliage and grotesque heads.

fol. 60r פסח, "the Passover lamb": A historiated panel depicting a man turning a lamb on a spit.

fol. 61r (Fig. 240) "This *mazzah*": A large roundel of a decorated *mazzah* framed by foliage scrolls lies within a full-page panel of about 100 × 100 mm. The roundel is decorated with a circle of eight quatrefoils enclosing shields, four of them blank and the other four *en pal*, seven *azur* and *or*, resembling the arms of Barcelona (*en pal*, seven *gules* and *or*). Under the panel and within an arcade of 45 × 105 mm are five musicians dressed in motley. From left to right they are playing: tabor and pipe, viol, lute, bagpipes and kettle-drums, perhaps representing the Harmony of the Universe as Ameisenowa has suggested (see Bibl.). On top of the panel, between two initial-word compartments, is seated a bearded man holding two *mazzot*. In the side margins four putti, seated on the tops and bases of decorative columns, blow trumpets directed towards the centre of the *mazzah* through the corners of the panel.

fol. 64v "Therefore we are bound to thank": Inside the panel a man is lifting a gold flask. Two confronting birds are pecking at the flask. In both side margins there are dragons standing on decorative colonnettes.

fol. 65v (Fig. 241) "Halleluiah": A historiated initial-word panel of 70 × 105 mm, depicting the people in the synagogue. The *hazan* stands to the left in a domed pulpit, holding up the decorated case of the Torah scroll. Four adults and three children are approaching from the right. The synagogue is characterized by gothic gables, from which hang four lamps. The panel is supported by two slim colonnettes.

fol. 66v (Fig. 239) "When Israel came out of Egypt": A procession of two groups of Israelites, one on foot and the other on horseback, extends over the whole width of the page under the initial-word panel. Each group is headed by a banner bearer, and the six people walking include two women and a soldier. The scene is partly framed by green bars, probably intended as a frame for a panel.

fol. 67v Thanksgivings: Within the initial-word panel is a seated man holding a gold goblet.

fol. 71v (Fig. 242) "Pour out Thy wrath": In the left-hand part of the initial-word panel an angel tilts a gold flask above three men.

fol. 73r (Fig. 243) "*Hallel*": Two large, confronting angels, their coloured wings erect, support either side of the initial-word panel. The lower parts of their bodies are those of dragons, with foliage tails.

fol. 77r The initial-word panel is topped by a spire.

fol. 79v A small, pen-drawn tower on top of the initial-word panel is flanked by two crouching, pen-drawn dogs.

fol. 80r In the lower margin is a grotesque dragon, its long neck protruding through a mantled helmet, of which it forms the crest; the mantling bears a silver shield. On top of the upper initial-word panel is a pen-drawn rabbit in a gabled motif.

fol. 80v Two pen-drawn birds flank a gold bottle on top of the triple initial-word panel. In the lower margin is a dragon drinking from a gold goblet.

fol. 81r Rich marginal decorations.

fol. 82r End of the *Haggadah*: On top of the wide initial-word panel a pen-drawn hound confronts a stag.

fol. 85r "The Passover in Egypt" — *piyyut* for Passover Eve: On top of the initial-word panel stands a blue ram with gold horns.

fol. 88r (Fig. 244) "Next year in Jerusalem. Amen": This is a full-page panel, with alternating strips of script and painted scrolls. Thin leaves issuing from the corners and the sides enclose a hybrid on top and a rabbit at the bottom.

fol. 105v The panel for the *parashot* is shaped as a double arcade, with a small lion mask in the centre.

D. Later Text Illustration.

The illustration for "This *maror*" on fol. 62v (Fig. 245) is a later addition on an original leaf. It is executed in pen-drawing, with some crude green and red colouring, and comprises a large cluster of green foliage with a flower on each side. Below this area a red crescent and a green star, with a crowned parrot pecking at a plant and a seated dog in the lower margin.

Conclusions

The Barcelona *Haggadah* is unique among Sephardi *haggadot*. Unlike the characteristic arrangement of full-page illustrations, which precedes the text, the biblical, midrashic and ritual illustrations are incorporated within the text. Its unique page composition should also be compared with other Sephardi *haggadot* in that its painted panels have extending foliage scrolls framing the

text. This element derives from both French and Italian illuminations of the early fourteenth century which became fashionable in Spain — mainly in Barcelona — in the middle of that century. The Maimonides *Guide of the Perplexed* of 1348 from Barcelona, now in Copenhagen (Kongelige Bibliothek, MS 37; see Narkiss, *HIM*, Pl. 18), is an example of this kind of compostion, which blends Italian and French elements into a specifically Spanish type. The thin, elongated acanthus scrolls and the single, multi-coloured serrated leaves interspersed with grotesques, flowers and gold dots are rendered in a French manner, but their colouring and dark shadings are of Italo-Byzantine origin. The same applies to the panel paintings, where the composition is Franco-Spanish of the early fourteenth-century type, while the heavy coloration and shadings are Italo-Byzantine (e.g., fol. 36v – Fig. 230). A date in the middle of the fourteenth century seems appropriate for our

Haggadah; the style of Barcelona is to a certain extent corroborated by the armorial devices on fol. 61r (Fig. 240). Though the seven stripes of the escutcheons are blue and gold instead of red and gold, this was accepted in the fourteenth century as the arms of Barcelona, especially in Hebrew illuminations. An example of blue and red being interchangeable in the Barcelona arms can be found in the Sarajevo *Haggadah* (e.g., fol. 3r; see Roth, *Sarajevo*, p. 13).

Bibliography

Margoliouth, No. 605, II, pp. 197–198.
Leveen, p. 190.
Roth, *Sarajevo*, p. 13.
Ameisenowa, S., "Harmony of The Universe", in *Essays in Honor of Hans Tietze, 1880–1954*, New York 1958, pp. 349–364.
Narkiss, *HIM*, Pl. 12, 18.
Narkiss, *Golden Haggadah*, pp. 43–73, Fig. 36.

14. CATALAN PASSOVER PARASHOT AND PIYYUṬIM

Catalonia, third quarter of fourteenth century

BL, Or. 1424

Figs. 246–249

Parashot, haftarot and piyyuṭim for Passover.

General Data

Codicology

Vellum; 31 leaves; (252–256) × (186–192) mm. Text space 151 × (110–114) mm. Fols. 1v–15v are written in square Sephardi script in two columns, and fols. 16v–30v in round Sephardi script in one column. Fol. 16r is blank. Written in light brown ink, 17 lines to a page. Ruling by stylus, 17 horizontal and 1 + 2 + 1 (fols. 1r–15r) or 1 + 1 (fols. 16r–30v) vertical lines. Pricking in all four margins. 7 quires: I⁴, II⁸, III³, IV⁸, V⁴, VI² and VII². No catchwords.

Binding

Modern, gold-tooled, black binding.

Colophon

None.

History

Purchased by the British Museum from Fischel Hirsch on 12 January 1877.

Decoration

Programme

A. Initial-word panels.
B. Marginal decorations.
C. Penwork panels.

Description

A. *Initial-Word Panels.*

The eleven initial-word panels, measuring (15–71) × (30–60) mm, are painted magenta, ultramarine blue, vermilion, emerald green, brown and grey, with burnished and dusky gold, and the shapes heightened with white and lighter and darker shades.

The panels are either rectangular or consist of several (1–6) ultramarine blue or magenta rectangles, diapered and chequered (fols. 1v – Fig. 246, 3v – Fig. 247, 4v – Fig. 248, 6v, 8r, 9v – Fig. 249, and 12v) or decorated with thin gold or

white pen scrolls (fols. 1v, 2r, 7v, 8r, 9v and 11r), sometimes with coloured dots. The letters are in burnished gold, surrounded in some places by a thin white penline. The extension of the letter *lamed* on fol. 4v is shaped as a fleur-de-lis. The panels are framed by coloured fillets, many of them heightened with white or decorated with coloured and white lines, curves and dots.

B. *Marginal Decorations.*

The marginal decorations extend from the initial-word panels around the related column of text or into the near margin. They consist of foliage scrolls (fols. 1v – Fig. 246, and 8r) or other foliage patterns, with vine leaves (fols. 1v, 2r, 3v – Fig. 247, 6v and 81r), palmettes (fols. 1v, 3v, 7v, 8r, 9v and 12v), fleurs-de-lis (fol. 9v – Fig. 249), acanthus and other leaves, stylized flowers, eight-petaled open flowers with four gold petals in each flower (fols. 6v, 7v, 8r and 9v) and gold and coloured buds and dots; various kinds of birds (fols. 1v, 2r, 3v, 9v and 12v), including peacocks (fols. 1v and 12v), a duck (fol. 9v) and other birds; dogs (fols. 1v, 9v and 12v); a monkey (fol. 1v) and a bearded head wearing a high hat (fol. 3v). In some places the foliage pattern encloses coloured areas with grotesque heads (fol. 1v), a human(?) bust (fol. 1v), leaves (fols. 1v and 12v), flowers (fols. 1v and 8r) and pen scrolls (fols. 1v and 12v). On fol. 4v (Fig. 248) the foliage pattern extends from the mouth of a lion's head to the right-hand border of the initial-word panel. The grotesque or birds' heads in two corners of this panel, and those on fols. 9v and 12v, function similarly, as does the white and light green snake winding round a gold fillet with red dots that connects the two initial-word panels on fol. 9v (Fig. 249).

There are two scenes of hare hunting: On fol. 1v (Fig. 246), to the right of the initial-word panel, a helmeted warrior with magenta gown and gold shield decorated with blue does is drawing his golden sword against a magenta hare on the right; on fol. 9v (Fig. 249) the hare is caught in the mouth of a dog whose head is emerging from behind the top of the upper panel.

C. *Penwork Panels.*

There are three penwork panels (fols. 16v, 19r and 22v). The initial words in these panels are written in ink or burnished gold within a red or violet rectangle with a red penwork panel of scrolls, palmettes and round flowers with extending flourishes.

Conclusions

The manuscript is closely related in decoration to the *Kaufmann Haggadah* (Budapest, Academy of Sciences, MS 422, e.g. pp. 71, 72. See Scheiber). and is probably of the same Catalan provenance. The colours differ in that they are less vivid, but with a more ample supply of gold. Both manuscripts have almost the same foliage scrolls, and the design of some of the animals is almost the same, compare, e.g., the rabbits, peacocks and the dog. Some of the foliage scrolls are similar to those of Catalan Bibles, such as the *Duke of Sussex Catalan Bible* (No. 19). These relations indicate a date in the third quarter of the fourteenth century.

Bibliography

Margoliouth, No. 696, II, pp. 355–356.
Scheiber, *Kaufmann.*

15. RYLANDS SEPHARDI HAGGADAH

Catalonia, mid- and late fourteenth century

JRL, Heb. 6

Figs. 250–282; Pl. XCIII: Fig. 253 and Pl. XCIV: Fig. 257

Biblical picture cycle, Haggadah, piyyuṭim for Passover and the Sabbath before Passover, with commentary on the Haggadah.

General Data

Codicology

Vellum; I + 57 + II leaves; *c.* 280 × 230 mm. Text space (168–175) × (130–142) mm; height of the text space with commentaries 218–222 mm. Written in square Sephardi script, in brown ink which is very light in some places, mostly 14 lines per page in large script. The commentary on the *Haggadah* and Passover readings is in micrography, 2 lines in the upper and 3 in the lower margins. Some of the *piyyuṭim* (fols. 5v–7v and 37v–53v) are written in smaller script, 29–30 lines per page; others (fols. 20r–21r) are written in medium-sized script, 18 lines per page. The *piyyuṭim* for Passover Eve (fols. 2r–4v) and the grace after the meal (fols. 54r–57v) were added by a later, fourteenth-century Sephardi hand. Ruling by stylus, 2 + 24 + 3 or 2 + 30 + 3 horizontal and 1 + 1 vertical lines. Pricking is noticeable in all margins. Fols. 1r, 1v, 5r, 11r–13r and 37r are blank. 8 quires of 8 leaves each, except for Quires I⁴, VII¹⁰ (wrongly bound: fol. 45r should come after fol. 53v, conjoint with fol. 54; no text missing) and VIII³. Catchwords at the bottom of fols. 44v and 53v.

Binding

Seventeenth-century red morocco binding with green inlaid centrepiece. Gold tooled with two frames, the inner with black bands. Motifs of small garlands round the centrepiece, larger foliage motifs in the inner corners of the black frame and single motifs in its outer corners and at the middle of each side. Two brass clasp-plates on each cover, the clasps themselves missing.

Colophon

None.

History

Earl of Crawford Collection; his book-plate inside the back cover reads: "Bibliotheca Lindesiana L/1". Purchased by the John Rylands Library in 1901.

Second fly-leaf In pencil: "Hebrew Mss. 6. Service for the first nights of Passover, for the Sabbath preceding the festival of Passover, for the days of the Passover festival. Catl. and described by the Rev. A. Löwy."

Decoration

The decoration was done in two stages: the picture cycle and the *Haggadah* in the middle of the fourteenth century, and the grace after the meal at the end of that century.

Programme

A. Full-page panels:
 1. Biblical scenes.
 2. Ritual scenes.
B. Painted initial-word panels.
C. Text illustrations.
D. Penwork initial-word panels.
E. Micrographic decoration.
F. Marginal decorations for the grace after the meal.

Description

A. *Full-page Panels of Biblical and Ritual Scenes.*

The thirteen full-page panels, measuring (170–182) × (131–132) mm, depict a consecutive cycle of Exodus episodes from the call of Moses to the crossing of the Red Sea (fols. 13v–19r), of the Passover in Egypt and of the contemporary Passover meal at home (fol. 19v).

The scenes are painted in different shades of vermilion, magenta, pink, blue, yellow, green, grey, black and white, with brush and burnished gold and silver, heightened with lighter shades and white and shaded with olive green and black. There are thick black outlines to all shapes as well as to drapery folds and main ornaments, with thin brush work in white for minor decorative motifs and additional heightening. The paint has flaked off in several places, revealing the pale underdrawings (e.g., fol. 14r).

The full-page panels are framed by decorated bands following ruling by stylus. Each panel (except for fol. 19r) is divided horizontally into two equal compartments by a coloured fillet, with brush gold inscriptions for the lower compartments. Similar fillets, or several narrow panels (e.g., fol. 15v), above the tops of the frames bear the inscriptions for the upper compartments. Sometimes more than one scene is depicted in a single compartment. Most of the frames are decorated with interlacing, coiling or twisted bands in alternating blue, magenta and vermilion, some forming meanders (fols. 13v–14v) or open spirals (fols. 15r–v), others a zigzag (fols. 14v and 19r) or a guilloche (fol. 18v). Some are coloured in

alternating magenta and blue, decorated with white (fols. 16r–17v) or gold (fol. 19v) thin brush scrolls or within brush zigzag in white with foliage motifs (fol. 16v); one is decorated with a coloured palmette scroll (fol. 18r). All the frames are bordered by thin fillets in yellow or greenish brown, most of them crossed at the corners to form small squares decorated with small gold or coloured foliage and geometrical motifs on a coloured ground. Three black stems, each with a triple leaf at its end, extend from each corner.

Most panels have magenta or blue backgrounds which sometimes sub-divide the compartment into smaller, vertical sections. These sections usually correspond to the single scenes when several are depicted in one compartment. The backgrounds are mainly decorated with a chequered or diapered gold network, with gold and coloured foliage and floral motifs, dots or circles in a single unit, or with curly gold foliage scrolls, mainly with a triple leaf motif in the curls.

The composition is compact, with many figures, architectural and landscape elements grouped together and backgrounds to suit each element. The composition of the scenes is more or less symmetrical, usually with two groups of figures, one on either side of the panel (e.g., fols. 14v, a–b, 17v, b and 19v, b), sometimes with a third group in the centre either higher or lower than the other two groups (e.g., fols. 13v, b; 15r, a–b; and 15v, a). Variations occur when one or more of the groups is replaced by hillsides and buildings (e.g., fols. 13v, a; 15v, b; and 16r, a–b). Other compositions, mostly processions (e.g., fols. 18v, b; and 19r) or several scenes in the same compartment (e.g., fol. 14r, a), are directed from right to left, sometimes with minor movement from left to right indicated by turning several figures (e.g., fol. 18r, b) or a head (e.g., fol. 13v, b) against the general direction. The wave-like horizontal lines of the sky or that made by the heads of the figures accentuate the rhythm of the processional scenes (e.g., fols. 13v, b and 18r, b).

The figures are short with relatively large heads. Pharaoh, his counsellors and his taskmaster (fol. 15r) are larger, usually occupying almost the entire height of the compartment. Other figures are smaller, especially when set in a landscape (e.g., fols. 14r, b, 16r, b and 17r, b) or an architectural complex (e.g., fols. 18r, a and 18v, a), and also when set in large groups, which are usually massive and compact with a multiplicity of closely gathered heads above and legs below (e.g., fols. 18r, b and 18v, a–b).

Faces and hands are pinkish brown, heightened in white and shaded mostly with olive green. The facial features are executed in brown or black pen outlines (especially fols. 16r–18v) in addition to their modelling. Hair is brown, reddish brown or greyish blue, with some green and with linear white modelling. Beards are short. Eyes are large and expressive and usually focused sideways. Hand gestures are formal and exaggerated.

Garments are of different colours; those in blue are modelled more pronouncedly than the others (e.g., fols. 13v, b and 14r, a–b); all drapery has black outlines and fold lines. The men wear short gowns gathered at the waist, some open at the front to reveal the differently coloured linings (e.g., fol. 14r, a), others have an elegant fold at the side. Mantles are long and wide, with short or double sleeves revealing the sleeves of the undergown; some have hoods (e.g., fols. 15r, a and 15v, a–b). Stockings are black or brown. There are no shoes. The women wear net-like head-coverings (e.g., fol. 14r, b), with two-tiered gold hats. The hat on the woman on fol. 19v, b, is fastened with a gold band under the chin; she is also wearing an elegant dress with double sleeves and gold buttons. Many garments are decorated with additional thin brush lines and foliage motifs in white. Pharaoh wears a gold crown (a hood on fols. 15v, a and 17v, b), as well as a mantle, sometimes heightened with gold (e.g., fol. 15r, a) or decorated with gold or coloured patterns (e.g., fols. 15v, a and 17 v, a).

Animals are more realistically modelled. Sheep and cattle are often grouped close together and painted in white with ochre line work. Snakes and other reptiles are mostly in bluish grey elaborated with white dots, lines and spots.

The ground line is often the lower frame of the compartment, with the feet of the figures protruding into it. In some panels there is a ground line of stepped rock formations (e.g., fols. 13v, b; 14r, a and 18v, b) in red ochre with olive green and white, pink or grey, sometimes forming a hillside, mostly on the left of the compartment. Many mountains have red flowers with green foliage (e.g., fols. 13v, a, 14r, b, 14v, a and 17r, b). Trees are formed by a schematized, branched trunk in ochre, green or grey, with the foliage as one or more green spheres (e.g., fols. 14r, b, 14v, a, 15v, b, 16r, a–b, 17r, a, 16v, b and 17v, a) and the leaves in white brush drawing. Some panels have a wavy segment of sky in two shades of blue and white, studded with white or gold (e.g., fols. 14r, a, and 14v, b) stars (e.g., fols. 16v, a, 17r, a–b and 17v, b). Some segments extend across the entire width of the panel (e.g., fols. 13v, b, 14r, a and 14v, b). Water is rendered in stripes of different shades of the same colour, with white waves. Towns are represented by coloured walls, with gates and multi-coloured tower-like edifices within the walls, mostly with sloping roofs and arched windows. Interiors are represented by the back wall of a room (and an additional side wall on fols. 18r, a and 19v, a–b), mostly with arcades at the top and a coffered ceiling. Pharaoh is usually seated under

such an edifice, on a gold stool with a coloured cushion and a lap-dog (e.g., fols. 15r–v and 17r). Other stools and armchairs are in yellow ochre, with a wood-like pattern in red.

The captions above the scenes are mostly short extracts from the Bible (given in the detailed description below in inverted commas). These captions were copied by a much later hand in ink on the vellum ground in the outer margins. The sequence of the episodes is usually from right to left, and from the top compartment (a) to the bottom (b). The subjects and iconography of the scenes are closely related to those of the *Brother Haggadah* (No. 16); differences in representation are mainly mentioned there.

1. *Biblical Scenes.*

Fig. 250

fol. 13v, a, right (1) "And Moses was a shepherd" (Ex. 2:1): Moses is leaning on his crook, with the hook downwards. Behind him, amongst trees and flowers on the mountain, are his sheep and dog.

fol. 13v, a, left (2) "The burning bush which was not consumed" (Ex. 3:2): In the bush, on a mountain on the left, are traces of an angel's face in the flames. In the middle is Moses, standing on his left foot and lifting his bare right leg with his hands, in obedience to the order "Put off thy shoes from off thy feet" (Ex. 3:5). A black shoe is dropping to the ground.
Moses is depicted twice in this compartment.

fol. 13v, b, right (3) "What is there in thine hand" (Ex. 4:2): Moses is holding his crook upside-down and pointing at it while looking up to heaven.

fol. 13v, b, middle (4) "And it became a serpent" (Ex. 4:3): Moses points in astonishment to a serpent, the tail of which is beside his outstretched hand.

fol. 13v, b, left (5) "And it became a rod in his hand" (Ex. 4:4): In his right hand Moses is holding his crook, the lower part of which is a serpent's tail. Moses is depicted three times in the two sections, above which there is a segment of blue sky with stars.

Fig. 251

fol. 14r, a, right (6) "Put now thine hand into thy bosom" (Ex. 4:6): Moses' right hand, which he is putting into the neck of his robe, is covered with brown spots.

fol. 14r, a, middle-right (7) "Behold, his hand was leprous" (Ex. 4:6): Moses stretches his brown-spotted hand upwards.

fol. 14r, a, middle-left (8) "Put again thine hand" (Ex. 4:7): As in Scene 6.

fol. 14r, a, left (9) "And behold, it was turned again as his other flesh" (Ex. 4:7): Moses raises his clean hand.
Moses, looking upwards, is depicted four times

within the four separate sections. In the first two scenes he holds his crook upside-down, and in the last two, right side up.

fol. 14r, b, right (10) Moses' return to Egypt (Ex. 4:20): Entering from the right is Moses, who "took the rod of God in his hand", with the crook round the back of his neck. In front of him are Zipporah and their two children riding a donkey. In the top right-hand corner, within the walled city of "Midian", is a woman, her head covered by a mantle. In the top left-hand corner is a young man, blowing his horn from a balcony that projects from the turreted walls of "Egypt".

fol. 14r, b, left, below (11) The circumcision of Moses' son: "Then Zipporah took a sharp stone" (Ex. 4:25): Zipporah seated on the ground beside a tree which separates the two scenes, cuts off the foreskin of her naked son, who is lying in her lap.

fol. 14v, a, right (12) Moses going towards Aaron: "And he met him in the mount of God, and kissed him" (Ex. 4:27). Moses and Aaron are embracing each other.

fol. 14v, a, left (13) "And Moses told Aaron all the words of the Lord" (Ex. 4:28): To the left, separated from the first scene by a tree, Moses is holding his crook upside-down and pointing to the astonished Aaron.

fol. 14v, b (14) Aaron "performs the signs in the sight of the people" (Ex. 4:30; also inscribed with Ex. 4:31): On the right Aaron is holding a serpent by its tail, while Moses is pointing at it from behind Aaron. In front of them, in a separate section, are twelve bearded, kneeling people.

Fig. 252

fol. 15r, a (15) Moses and Aaron before Pharaoh (Ex. 5:1): The crowned "Pharaoh" is seated on the right, before a building, holding a little white dog on his lap. In the middle Aaron is kneeling before the king and talking to him. Behind him is Moses, his head turned towards two hooded "magicians" seated on the left. Inscribed: "Thus saith the Lord, God of Israel, let my people go" (Ex. 5:1).

fol. 15r, b (16) The increased labour of the Israelites (Ex. 5:6–18): On the right are two men digging with hoes and two others carrying wicker baskets on their shoulders, in fulfilment of the order "Let there more work be laid upon" (Ex. 5:9). In the middle, with his back to the diggers, stands a tall "taskmaster", lifting a stick at a man "gathering straw for themselves" (Ex. 5:7), with two other men behind him. At the extreme left are three men moulding "bricks".

Pl. XCIII: Fig. 253

fol. 15v, a (17) "But Aaron's rod swallowed up their rods" (Ex. 7:12): On the right is "Pharaoh", seated in a canopied chair and wearing a hood. Next to him is a lap-dog. Aaron, in front of him, holds the tail of a serpent who is swallowing two

other serpents. Behind Aaron is Moses, looking at the two "magicians" seated on the left and pointing at the serpents being swallowed.

fol. 15v, b (18) The plague of "blood" (Ex. 7:19–24): On the right is the crowned "Pharaoh, who goeth out unto the water" (Ex. 7:15), followed by three attendants, all on horseback. In the middle is "Moses" pointing at "Aaron", who is striking the red water with a stick. There are three fish in the water.

Fig. 254

fol. 16r, a (19) The plague of frogs (Ex. 8:1–3; inscribed with part of Ex. 8:2; A.V. 8:6): To the right is the crowned "Pharaoh", seated under an arcaded roof. Behind him are three "magicians". Frogs leap up at them from the blue water, which Aaron, on the left, is striking with a stick. In the middle is Moses pointing at both Pharaoh and Aaron.

fol. 16r, b (20) The plague of lice (Ex. 8:12–14): "And Aaron stretched out his hand with his rod and smote the dust of the earth and it became lice" (Ex. 8:13; A.V. 8:17). Lice cover the enthroned Pharaoh and the three magicians behind him on the right, under a coffered ceiling, as well as the sheep and goats on the mountain at the left, on which trees are growing. In the middle is Moses, pointing at both Pharaoh and Aaron.

fol. 16v, a, right (21) The plague of 'arov: "A grievous swarm of 'arov (beasts) into the house of Pharaoh and into his servants' houses" (Ex. 8:20; A.V. 8:24). To the right, the crowned Pharaoh and two magicians, seated under a roof, are being attacked by various wild "beasts and birds combined" (*Exodus Rabbah* 11:4), among them serpents, a boar, dragons, long-tailed frogs and a scorpion.

fol. 16v, a, left (22) "And I will put a division between my people and thy people" (Ex. 8:19; A.V. 8:23): Moses and Aaron are pointing at the previous scene, a group of three Israelites standing behind them. Behind the Israelites is the towered walled city of "Goshen", its gate closed.

fol. 16v, b (23) The plague of murrain (Ex. 9:1–3; inscribed with the second part of Ex. 9:3): On the right Pharaoh and two attendants, seated under a roof, are conversing with Moses and Aaron, who are standing in the middle pointing at dead sheep, cows, a donkey and a horse on the side of a hill behind them. On top of the hill are the live cattle of the Israelites (Ex. 9:4, 7).

Fig. 255

fol. 17r, a (24) "And it became a boil breaking forth with blains upon man and upon beast" (Ex. 9:10): In the middle are Aaron and Moses, the latter lifting his right arm after he has "sprinkled ashes of the furnace up toward heaven". On the right Pharaoh and two attendants are scratching

their speckled arms and legs while three lap-dogs lick them. To the left, on a mountain, are a shepherd and sheep covered with spots.

fol. 17r, b, right (25) "And the hail smote throughout all the land of Egypt all that was in the field" (Ex. 9:25): In the middle are Moses and Aaron, each lifting one hand to heaven and pointing with the other to Pharaoh and to a shepherd. The shepherd is mourning his dead sheep in the top left-hand corner. Pharaoh is seated on the right with two attendants. Large white hailstones fall on both Pharaoh and the sheep from segments of starry sky; they tilt Pharaoh's crown on his head (midrashic?).

fol. 17r, b, left (26) The salvation of the God-fearing people (Ex. 9:20, 26): At the foot of the mountain is a shepherd holding a crook and lifting a finger up to heaven. Before him is a flock of live sheep. Although this scene bears no inscription, on fol. 5r,b, of the *Brother Haggadah* (No. 16) it is inscribed by Ex. 9:20.

Fig. 256

fol. 17v, a (27) "And the locusts went up all over the land of Egypt, and rested within all the boundaries of Egypt" (Ex. 10:14): Moses and Aaron are looking backwards at Pharaoh and his two attendants, seated under a roof on the right. There are locusts flying over them, as well as over the trees on the hillside to the left. Moses is holding a stick.

fol. 17v, b, right (28) "And there was a thick darkness" (Ex. 10:22): Five men are seated on a black background. The entire section, including the people, is covered by black wash.

fol. 17v, b, left (29) "But all the Children of Israel had light in their dwellings" (Ex. 10:23): Moses, holding his crook upside-down, lifts his left arm towards a segment of sky. Behind him is Aaron, followed by four men.

Pl. XCIV: Fig. 257

fol. 18r, a, middle (30) The plague of the first-born (Ex. 12:29–30; inscribed with part of 12:30): The middle section of the compartment is divided into six units, five of which are arcaded. In the four top units are four dead youths in bed, with two female mourners bending over each of them. In the lower right unit a dead captive lies in a dungeon, chained to a column. In the lower left unit are the heads of dead cattle, including a bull, a goat, sheep, horses and a donkey.

fol. 18r, a, right and left (31) Pharaoh calling on Moses and Aaron to leave Egypt (Ex. 12:31): On the right, within a separate section, is Pharaoh rising from his canopied seat and pointing at the dead first-born in the middle section of the compartment. To the left, within a separate section, Moses and Aaron are pointing at Pharaoh and the dead.

fol. 18r, b (32) The spoiling of the Egyptians (inscribed with Ex. 12:36): On the right, four Egyptians are handing gold and silver goblets and chalices, a dress and a long decorated belt to four Israelites. One of them, a child, is being handed a bowl. On the left, five Israelites are walking away from the first scene, carrying a dress, chalices and gold coins.

fol. 18v, a (33) The Exodus from Egypt (Ex. 12:34–37; inscribed with parts of Ex. 12:34 and 13:18): In the middle are the Israelites leaving the walled city of "Rameses" on the right. Five Egyptians, watching from a window and roofed balconies of the city, are pointing at the Israelites, who are carrying a trough, a cup and sacks "being bound up in their clothes upon their shoulders" (Ex. 12:34) and are armed with silver helmets, lances, swords, an axe and a shield; *Exodus Rabbah*, 20:17; T. Jerus., *Shabbat*, 6:4; and the *Mekhilta* interpret the inscription וחמשים (Ex. 13:18) as "armed". On the left, the Israelites are faced by Moses and Aaron, one of them carrying a crook.

fol. 18v, b (34) The pursuit by the Egyptians (inscribed with Ex. 14:6): A procession of armed equestrian figures, which appears from the right, is headed by the crowned Pharaoh. In front of them are armed foot-soldiers carrying lances and banners. Two of the shields bear arms *le bande*, seven *sinople* and *or*; the other bears *azur* and *or*.

fol. 19r (35) The passage of the Red Sea (Ex. 14:21–30; inscribed with parts of Ex. 14:27, 29): A full-page panel, divided into five horizontal sections. The top, bottom and middle sections depict the drowning Egyptian soldiers, horses and crowned Pharaoh, covered by white waves and being bitten by fish (at the right-hand side of the middle section). The other two sections depict the procession of the Israelites on dry land with flowers. In the upper of these two sections Moses and Aaron, one of them holding a crook upside-down, are facing the Israelites. Many of the Israelites are armed; some are carrying troughs, gold and silver cups, coins and dresses in their hands and sacks over their shoulders.

2. *Ritual Scenes.*

Fig. 258

fol. 19v, a, right (36) The slaughter of the Paschal lamb (Ex. 12:3–8; inscribed with parts of Ex. 12:3, 7–8): In a room with a coffered ceiling and a silver lamp is a young man slaughtering a ram, pulling its head backwards with the aid of his foot as the blood gushes into a bowl on the floor.

fol. 19v, a, middle (37) "And they shall take of the blood and strike it on the two side-posts" (Ex. 12:7): A man, carrying a gold and silver dish with handles, is smearing blood on the top of an arched doorway with a bunch of hyssop.

fol. 19v, a, left (38) "Roast with fire" (Ex. 12:8): A seated youth is turning a spit, on which a whole, pink lamb is being roasted over a fire in an arched oven.

fol. 19v, b (39) Eating the Passover meal (Num. 9:2–5): No inscription. The composition is divided in the middle into two coffered rooms with people seated at tables covered by white cloths and laid with cups, flasks, knives and *mazzot*. A servant boy, entering each room through a door, carries a cup and a flask. On the right is an elderly bearded man holding a cup in his right hand and a closed book in his left. On the left, a young couple are eating white sticks (bitter herbs?) from a dish on the table. The young man holds a cup.

B. *Painted Initial-Word Panels.*

The painted initial-word panels, with their extensions and accompanying decorations in the margins, form the main decorations on the text pages. Two of the panels (fols. 31r and 31v) are text illustrations. Most of them measure (25–36) × (43–106) mm, though there are many smaller ones. Some panels are larger, almost the full width of the text: (29–42) × (130–143) mm (e.g., fols. 20r, 21v, 29r, 30r and 31r–v). In the *piyyut* "Dayyenu" (fols. 29r–30r – Figs. 267–269) the repeated words form two vertical panels on either side of the page. Other initial words are similarly joined to form longer panels (e.g., fols. 35r and 36r). Allied to the initial-word panels are text illustrations that depict either the word contained within a panel or the text it heads. In two instances (fols. 31r–v – Figs. 271, 272), illustrations attached to panels extend into the text; the other illustrations are in the margins (see § C below).

The initial words are written in burnished gold within alternating blue and magenta panels decorated with white brush scrolls with three-lobed leaves in the curls and black and white outlines to the letters. Most panels are framed with thick black lines; some of the larger panels have full (e.g., fols. 20r and 21v – Figs. 259, 260) or partial (e.g., fols. 21v, 22v and 23r–v – Figs. 260, 262) coloured fillet frames. The initial words of the commentary on the *Haggadah* are written in brush gold on small magenta or blue panels, outlined in black, similar to the inscribed fillets of the full-page panels. The larger panels have an added magenta band above (e.g., fols. 20r and 21v), below (e.g., fol. 24r), or at the side (e.g., fols. 20r, 22v – Figs. 259, 262, 23r, 23v, 25v, 28v, 31r–v and 33v – Figs. 266, 271, 272, 275) of the panels with coloured foliage scrolls. The *piyyut* "Dayyenu" (fols. 29r–30r – Figs. 267–269) has thin vertical panels on either side of the text column. Many foliage scrolls extend from the panels into all four margins, painted in similar colours and modelled

and decorated with rings, lobes, buds and large dots. The curls and cusped corners sometimes enclose composite flowers, three-lobed and other leaves, human figures, animals and grotesques. Among the hybrids are dragons (e.g., fols. 20r, 21v, 24r, 30r and 33r – Figs. 259, 260, 269, 274), several of which have human heads (e.g., fols. 22r – Fig. 261, 32v – Fig. 273, and 34r); some of the dragons are shooting a hare (e.g., fols. 27v – Fig. 264, and 34r) or an owl (e.g., fol. 29v – Fig. 267); some are fighting another dragon (e.g., fol. 30r – Fig. 269) or a human-headed crane (fols. 27v and 32v – Figs. 264, 273). Heads of lions (e.g., fols. 20r – Fig. 259 and 21r), dragons (e.g., fols. 21v – Fig. 260 and 25v) and humans (e.g., fols. 21r and 29v – Fig. 267) are incorporated into the bands. Among the animals and birds are a fox and a snail (fol. 33r – Fig. 274), a crane and an eagle (fol. 27v – Fig. 264), an owl (fol. 27r – Fig. 263) and a parrot (fol. 35v). On fol. 29v (Fig. 267), which has several grotesques, there are also a hunter carrying a hare on a crook, a dog catching a hare, a long-necked crane with a red apple in its beak, which it is presenting to a bearded human head emerging from a snail, and a crane eating a snake.

C. *Text Illustrations.*

The nine text illustrations, found mainly in the outer margins, depict single figures of people and rabbis performing rituals. They are designed similarly to those in the full-page panels; however, their colouring and modelling differ and are closer to the initial-word panels.

fol. 20r (Fig. 259) אתאן מפרקא, "When coming from the synagogue (they rinse the cup, pour the wine and bless)": To the left of the decorated initial-word panel, a young dark servant, standing on an extended scroll, pours wine from a jar into a cup.

fol. 21v (Fig. 260) הא לחמא עניא די, "This bread of affliction which…" — the beginning of the *Haggadah*: On the right-hand side of the wide panel, above an extended scroll, a man wearing a long pink robe and lifting a broad pink dish (Passover basket?) reclines on a vermilion cushion.

fol. 22v (Fig. 262) "R. Eleazar ben Azariah": A bearded man, seated on a bench to the right of the initial-word panel and pointing at it, is holding an open book inscribed with part of the saying in the text: "So that thou mayest remember the day when thou camest forth from the land of Egypt" (Deut. 16:3).

fol. 23r, top "The wise son": A bearded man seated on a stool displays an open book and points to the saying from the text: "The wise son, what does he say? 'What are the testimonies'" etc. (Deut. 6:20).

fol. 23r, bottom "The wicked son": A bearded soldier is brandishing his bloodstained silver sword

and carrying a vermilion shield and a silver cap. His face, arms and legs are grey.

fol. 28r (Fig. 265) "R. Yosé ha-Gelili": A bearded man seated on a stool points to an open book inscribed: "R. Yosé ha-Gelili said, 'How can you show that the Egyptians in Egypt were smitten?'"

fol. 28v (Fig. 266) Two similar illustrations: "R. Eliezer" and "R. Akiva". Both are bearded men seated in armchairs, one above the other, reading books inscribed with parts of their sayings. The first: "As it is written: 'He cast upon them His fierce anger'" etc. (Ps. 78:49); the second: "R. Akiva said: 'How can you show every blow upon the Egyptians in Egypt?'".

fol. 30v (Fig. 270) "Rabban Gamaliel": A bearded man, seated under a gabled roof with a coffered ceiling, reads from an open book resting on a wooden lectern that is joined to his wooden stool. Inscribed with parts of his sayings: "Rabban Gamaliel said: 'He who does not say, three'".

fol. 31r (Fig. 271) "This *maẓẓah*": A burnished gold roundel (diameter 62 mm), decorated with gold foliage scrolls and framed by a red fillet, hangs from the centre of the initial-word panel. Most of the gold has flaked off.

fol. 31v (Fig. 272) "This bitter herb": A bottle-green cluster of lettuce leaves, shaped like an artichoke, is painted within a rectangular panel that hangs from the centre of the initial-word panel. Its burnished gold ground has flaked off. The leaves of the artichoke are decorated with brush gold scrolls and framed by a red fillet.

D. *Penwork Initial-Word Panels.*

The penwork initial-word panels for the *piyyuṭim* are in red and violet, in large (28–43) × (143–147) mm and small (19–30) × (36–80) mm sizes. Some panels are divided into alternating red and violet rectangular (e.g., fols. 5v – Fig. 276, 37v, 41r – Fig. 277, 43r and 48r), triangular and lozenge-shaped compartments (e.g., fols. 8r–v, 10r, 39v and 51r — trellis). The penwork consists of curly scrolls enclosing club palmette motifs; on fol. 48r the scrolls and the palmettes are of opposite colours. Some panels have flourishes and lines extending from them into the margins; others have them spreading horizontally from the middle of the vertical sides of the panels (e.g., fols. 37v–51v).

E. *Micrographic Decorations.*

Some of the margins are outlined in micrography (fols. 5v – Fig. 276, 6r, 37v–38r, 40r, 40v – Fig. 278, 41r – Fig. 277, 42v – Fig. 280, 43r, 47v – Fig. 282, 48r – Fig. 281 and 50v–51r). The text of parts of *TB Pesaḥim* comprises elongated vertical panels (160–175) × (30–40) mm in the outer margins of the *piyyuṭim*, forming patterns in brown micrography, with red and violet penwork fillings. The decorative motifs consist of confronting

peacocks and foliage (fol. 5v); interlacing geometrical motifs (e.g., fols. 6r, 40v, 50v and 51r); floral scrolls (e.g., fols. 37v and 48r); palmette scrolls (fol. 43r); dogs chasing hares and stags (e.g., fols. 41r and 42v); a scroll-like procession of a fox, a grotesque bird, a dog and a stag (fol. 47v); and confronting winged dragons with foliated tails (fol. 38r).

F. *Marginal Decoration for the Grace after the Meal.*

fols. 54r–57v Several additional decorations for the grace after the meal were added to the *Rylands Haggadah* in the late fourteenth century. These were executed in brown pen-drawing, tinted blue and violet, with some red, olive green and poorly painted gold. Among the additions are one text illustration (fol. 54r – Fig. 279) and some initial-word panels (fols. 54r–57v). The words are written in gold, within alternating blue and violet panels, some with extensions for elongated letters and some with four (fol. 55r) or two (fol. 54v) single leaves surrounded by feathery scrolls and gold dots extending from their corners. These foliage extensions are more elaborate on fols. 54r and 57v, where the fleshy scrolls which spread across the text incorporate flowers and coloured dots. The title panel on fol. 54r is framed by violet fillets and has two extensions enclosing candle-like gold shapes.

fol. 54r (Fig. 279) In the outer margin: A bearded man, seated in an ochre chair and holding an open book under his arm, lifts a bowl of red wine.

Conclusions

The *John Rylands Haggadah* belongs to the group of *haggadot* that has full-page biblical and ritual panels as well as illustrations within the text. The biblical illustrations depict only the Exodus cycle. It belongs to the second iconographical recension of Sephardi *haggadot*, as does the *Golden Haggadah* (No. 11), and is closely related to the *Brother Haggadah* (No. 16).

The illustrations in the text do not include any biblical scenes, only the usual *maẓẓah* and bitter herb, some rabbis, two of the four sons and two other ritual illustrations.

The stylistic origins of the decorations of our *Haggadah* are clearly French and Italian. The French elements predominate in the text pages, mainly in the panel decorations and their extensions. They are the soft, undulating scrolls with small rounded leaves painted in blue, magenta and vermilion. The hybrids and animals that accompany them in the margins are also executed in French Gothic style, although their colouring and modelling lean towards the Italian technique. The French style comes to the fore also in the decoration of the frames of the full-page panels,

mainly those with thin brush scrolls (e.g., fols. 16r–18r) or painted scrolls (fol. 19r). On the other hand the Italian element is more evident in the full-page illustrations. They include the heavy proportions of the human figures, the full modelling of garments, the byzantinizing modelling of faces, mountains and trees, as well as the coffered ceilings and cleft ground motifs.

The roundness and softness of the human figures, an archaizing French element, is typical of the conservative Spanish School. Other Spanish elements are the compact compositions and the exaggerated facial expressions and hand gestures in most full-page panels.

These Spanish elements can be further observed in the marginal text illustrations, especially that of Rabban Gamaliel (fol. 30v). The Italian style is expressed in the figure proportions and in their modelling.

Although the influence of Italian Gothic style is evident in Spanish manuscripts from the second decade of the fourteenth century, the style of our *Haggadah* shows affinities with Spanish Latin manuscripts illuminated around the middle of the fourteenth century. The *Chronicles of the Aragonese King Jaime el Conquistador* of 1343 (University of Barcelona, MS 1 fol. 1r; see Domínguez-Bordona, Fig. 186) is one manuscript that may have influenced the artist of our *Haggadah*. The compact composition and the exaggerated gestures and facial expressions are the main elements common to both manuscripts.

Other details, such as the soft rendering of beards and hair, types of clothing, the women's headgear and the wooden furniture, should also be compared. Considering the royal patronage of the Chronicles, which obviously was executed by a proficient artist, our *Haggadah* may be ascribed to Catalonia of the middle of the fourteenth century. The under-drawings of the full-page panels reveal the work of one artist. However, on fols. 16r–17v, darker colours and additional black outlines can be discerned. The frames of these as well as those on fol. 19v are decorated with delicate white scrolls on blue and magenta grounds, as opposed to the geometrical frames on the other pages. These may be attributed to another hand.

The micrographic and pen-drawn panels of the *piyyuṭim* are very dense in composition. The panels in the outer margins employ archaizing Spanish motifs of oriental origin, such as the vine scroll on fols. 37v, 43r and 48r, that recall those in the carpet pages of the *Damascus Keter* of 1260 from Burgos, now in Jerusalem (University Library, Heb. 4° 690; see Narkiss, *HIM*, Pl. 5). However, they differ in style: the ground of the *Damascus Keter* is painted and has golden scrolls, whereas that of the *Rylands Haggadah* is in penwork. There is no reason to suppose that the micrography and

penwork were done later than the rest of the *Haggadah*, i.e., the middle of the fourteenth century.

The grace after the meal, which was added to the manuscript on fols. 54r–57v, is decorated with very clumsy, late fourteenth-century painted panels, with imitations of fleshy leaves and feathery scrolls similar to those of the *Oxford Catalan Levi ben Gershom* of 1391 (No. 31, cf. Fig. 374). The figure on fol. 54r is executed in the same painterly style, but is clumsily drawn.

Bibliography

Müller & Schlosser, *Sarajevo*, pp. 95–106; Pls. I–IV:2.
Domínguez-Bordona, *Ars Hispaniae*, XVIII, pp. 147–148; Fig. 186.
Rosenau, *Rylands*, 1954, pp. 468–483.
Roth, *Rylands*, 1960, pp. 131–159.
Narkiss, *HIM*, Pls., 13–14 and Bibliography on p. 170.
Bohigas, *Cataluña*, pp. 118–121; Figs. 51–52.
Narkiss, *Golden Haggadah*, pp. 43–73, Figs. 18, 19.
Gutmann, *Manuscript*, Pls. 13, 14.

16. BROTHER HAGGADAH

Catalonia, third quarter of fourteenth century

BL, Or. 1404

Figs. 283–305

Biblical picture cycle, Haggadah and Passover piyyuṭim.

General Data

Codicology

Vellum; II + 51 + II leaves; 273 × (227–234) mm. Text space (182–199) × (140–147) mm; height of the text space with the commentaries 231–234 mm. Written in square Sephardi script, in dark brown ink, the *Haggadah* (fols. 8r–22r) mostly 15 lines and the *piyyuṭim* (fols. 23v–50v) 28 lines to a page, except for fols. 27v–30r which have 14 lines to a page. The commentaries on the *Haggadah*, on the texts of the *hafṭarot* and the *parashot* for Passover (fols. 8r–50r) are written in smaller script, 2 lines in the top and 3 lines in the bottom margin. Ruling by stylus on the recto of each folio, but from fol. 30r onwards additional pencil ruling can be discerned: fols. 8–22 have 2 + 15 + 3 horizontal lines and fols. 28–30 have 2 + 14 + 3 lines; 1 + 1 vertical lines on all text pages. Two facing pages (fols. 22v–23r), between the *Haggadah* and the *piyyuṭim*, are blank. Pricking in the inner margins. 8 quires of 8 leaves each, except for Quire VII^{4-1} where the last folio is missing, gathered so that outward hair side faces hair.

Binding

Fifteenth-century Italian white parchment binding, coloured and gold-tooled framing bands.

Colophon

None.

History

fol. 1r On a strip of vellum stuck on a paper strip pasted on the original leaf: Meir b. Malkiel Ashkenazi sold the *Haggadah* to his brother-in-law, Moses Ibn Keves (כבש), in the month of Sivan 5162 (3 May to 1 June 1402).

fol. 50v "This belongs to me... Abraham Ḥen, son of the nobleman R. Ja'udah, physician (האלוף מוהר"ר יאודה רופא יצו), son of R. Emanuel Ḥen the physician (הרופא) of the house of Shealtiel..."

Paper fly-leaf Pencil note in English: "Spanish mss. of this age are so rare that the Brit. Mus. has not one like this."

Purchased by the British Museum in June 1876.

Decoration

Programme

A. Full-page panels.
 1. Biblical scenes.
 2. Ritual scenes.
B. Painted initial-word panels.
C. Marginal text illustrations.
D. Penwork initial-word panels.

Description

A. *Full-page Panels.*
Thirteen full-page panels, measuring (215–220) ×

(155–160) mm, depict episodes from Exodus, from the call of Moses to the crossing of the Red Sea (fols. 1v–7r), as well as the Passover in Egypt and the annual Passover meal at home (fol. 7v). They are painted in different shades of orange, blue, magenta, red, green, brown, grey, pink, yellow, black and white, with burnished gold and silver. All full-page panels are framed and divided into two horizontal compartments, except for fol. 7r, which is divided into four. The inscriptions describing the scenes are written above each compartment in brush gold on coloured bars; the lower bar divides the compartments. The inscriptions have been copied again on the vellum ground above and below the frames. Some of them are in fuller verse form, written in a fourteenth-century Sephardi hand similar to that of the text. Each compartment usually contains one scene, but some contain more than one (e.g., fols. 1v, 2r–v and 7v), and one scene (fol. 7r) extends over a full page.

Some compartments are sub-divided vertically into two, three or four smaller sections of alternating blue and magenta background decorated with brush gold. This sub-division usually accords with the number of scenes within the compartments (fols. 1v–2v) or enhances compositional groupings (e.g., fols. 3v–5v). The composition is rather dense, the figures, buildings and mountains filling the entire height of the compartments and sometimes extending beyond them (e.g., fols. 3r–v and 6r–7v).

The seated Pharaoh is larger in proportion to the other figures, which diminish in size whenever situated in a detailed landscape, in an interior required by the theme or in crowded scenes. Heads are large; the faces and gesturing hands are expressive and heavily shaded with olive green heightened with white and pink areas and lines. Hair is mostly dark brown with black threads, or greyish blue with white threads. Drapery is thickly modelled with darker shades of the garment colours, sometimes outlined in white.

Landscapes are rendered with stepped rock formations and very few trees. Buildings — in pink, orange, blue, grey and magenta — are depicted in perspective and are decorated with mock arches; interiors have coffered ceilings.

All the panels are framed by bands decorated with painted geometrical patterns of folded bands (e.g., fols. 2v, 3r, 6v and 7r), guilloches (e.g., fols. 4v and 5r), meanders (e.g., fols. 1v, 2r, 5v and 6r) and brush gold foliage scrolls with round and square motifs on blue and magenta grounds (e.g., fols. 3v and 4r). The frame on fol. 7v is decorated with a blue foliage scroll with orange, blue and magenta trefoils, all heightened with white, on a burnished gold ground. Most frames are bordered on both sides by thin yellow fillets (magenta on fol. 7v). In the corners of most frames there are brown or

black squares decorated with gold or yellow foliage patterns. Most backgrounds are sub-divided into alternating fields of magenta and blue, with chequered or diapered brush gold network filled with gold or coloured motifs in the single sections. Others are decorated with foliage scroll motifs in gold, as in the frames. The top right and two lower compartments on fol. 7v have burnished gold backgrounds. The background colours and patterns are sometimes repeated on Pharaoh's garments to balance the colour composition (e.g., fols. 3v, 4r and 5v).

The detailed descriptions of the panels below specify the differences between this and the *Rylands Haggadah* (No. 15).

1. *Biblical Scenes.*

Fig. 283

fol. 1v, a, right (1) "And Moses kept the flock" (Ex. 3:1): Moses' head rests on his arm, which is leaning on the hook of a crook. Behind him, on a mountain, are his sheep. The dog that appears in the *Rylands Haggadah* is not depicted.

fol. 1v, a, left (2) The burning bush: "And the angel of the Lord... in the midst of the bush" (Ex. 3:2). An angel's face appears among the flames. In the middle, Moses is standing on his left foot and lifting his bare right leg with his hands, in obedience to the order "Put off thy shoes from off thy feet" (Ex. 3:5). A black shoe is dropping to the ground.

In the two scenes depicting Moses' call (1–2) Moses appears twice, similarly to the *Rylands Haggadah* (fol. 13v, a).

fol. 1v, b, right (3) "What is there in thine hand?" (Ex. 4:2): Moses holds his crook upside-down and points at it, while looking up to heaven.

fol. 1v, b, middle (4) "And it became a serpent" (Ex. 4:3): Moses raises his hands in astonishment at the sight of a serpent, whose tail undulates beside his hand.

fol. 1v, b, left (5) "And it became a rod in his hand" (Ex. 4:4): Moses holds his crook in his left hand, the lower part of which is a serpent's tail, while his right hand points to the crook.

In the three scenes depicting the first of God's signs to Moses (Scenes 3–5) Moses appears three times, as in the *Rylands Haggadah* (fol. 13v, b), but within three sections.

Fig. 284

fol. 2r, a, right (6) "Put now thine hand into thy bosom" (Ex. 4:6): Moses puts his right hand into the neck of his robe.

fol. 2r, a, middle-right (7) "Behold, his hand was leprous" (Ex. 4:6): Moses lifts his brown-spotted hand upwards.

fol. 2r, a, middle-left (8) "Put again thine hand" (Ex. 4:7): As in Scene 6 above.

fol. 2r, a, left (9) "And behold, it was turned again

as his other flesh" (Ex. 4:7): Moses is raising his clean hand.

In the four scenes depicting the second of God's signs to Moses (Scenes 6–9) Moses appears four times within separate sections, as in the *Rylands Haggadah* (fol. 14r, a), though he holds his crook upside-down in all four scenes.

fol. 2r, b, right (10) Moses' return to Egypt (inscribed wih part of Ex. 4:20): Entering from the right is Moses, holding his rod in his hand. In front of him, on a donkey, rides Zipporah with the two children. The scene is framed by the turreted walls of Midian on the right and those of Egypt on the left.

fol. 2r, b, left, below (11) The circumcision of Moses' son: "Then Zipporah took a sharp stone and cut off the foreskin of her son" (Ex. 4:25), who is bleeding in her lap. Zipporah is depicted beside a tree, which separates the two scenes.

Scenes 10–11 are as in the *Rylands Haggadah* (fol. 14r, b), but without the personifications of Midian and Egypt.

Pl. XCIV: Fig. 287

fol. 2v, a, right (12) "And he (Moses) went and met him (Aaron) in the mount of God and kissed him" (Ex. 4:27): On a mountain plateau, Moses and Aaron are embracing.

fol. 2v, a, left (13) "And Moses told Aaron all the signs" (Ex. 4:28): On a mountain plateau, separated from Scene 12 by a tree, is Moses, holding his crook upside-down and pointing with his left hand to the astonished Aaron.

fol. 2v, b (14) Aaron "performing the signs in the sight of the people" (Ex. 4:30; also inscribed with Ex. 4:29): On the right stands Aaron, holding a serpent by its tail, with Moses behind him pointing at it. In front of them, within a separate section, kneel eight bearded elders.

Scenes 12–14 are as in the *Rylands Haggadah* (fol. 14v), and similarly compartmentalized.

Fig. 285

fol. 3r, a (15) Moses and Aaron before Pharaoh (inscribed with part of Ex. 5:1): The crowned Pharaoh is seated cross-legged on a bench on the right, in front of a coffered building, with a dog on his lap. He points towards the kneeling Aaron, who holds the crook. Behind Aaron is Moses, disputing with two bearded "magicians", seated on the left. Part of the later title reads: "That is(!) the magicians of Egypt."

fol. 3r, b (16) The increased labour of the Israelites (Ex. 5:6–18; inscribed with parts of Ex. 5:12–13): The scene is framed by two buildings, to the right and to the left, which are missing in the *Rylands Haggadah* (fol. 15r, b). On the right is a man digging with a hoe, while three others carry wicker baskets on their shoulders. In the middle, a tall taskmaster lifts his stick towards a man

"gathering stubble" (Ex. 5:12) into a heap. On the left is a group of seven men, three of whom "mould bricks".

On the whole, Scenes 15–16 are similar to those in the *Rylands Haggadah* (fol. 15r).

Fig. 286

fol. 3v, a (17) "But Aaron's rod swallowed up" (Ex. 7:12; also inscribed with Ex. 7:10): The crowned Pharaoh, seated in front of a curtain, is astonished at the sight of a large serpent swallowing two smaller ones. Aaron, facing the king, holds the tail of the large serpent. Moses, behind him, points out the swallowed serpents to two magicians seated on the left.

fol. 3v, b (18) The plague of blood (Ex. 7:19–24; inscribed with parts of Ex. 7:15, 20): On the right are three equestrian figures: the crowned Pharaoh, "who goeth out unto the water" (Ex. 7:15), and two attendants. In the middle, beneath a tree, Moses is pointing both at the king and at the water, which Aaron, by striking it with his stick, turns into blood. There are red fish in the blood-red water.

Scenes 17–18 are as in the *Rylands Haggadah* (fol. 15v).

Pl. XCIV: Fig. 288

fol. 4r, a (19) The plague of frogs (Ex. 8:1–3; inscribed with parts of Ex. 8:2, 4; A.V. 8:6, 8). On the right, in front of a building, the crowned Pharaoh is seated, with an attendant behind him. Frogs leap up at them from the water, which Aaron ("Moses" in the original inscription), on the left, is striking with his rod. In the middle, "Moses" looks back at the king, while pointing at Aaron.

fol. 4r, b (20) The plague of lice (Ex. 8:12–14): "And Aaron ("Moses" in the original inscription) stretched out his hand with his rod and smote the dust of the earth and it became lice" (Ex. 8:13; A.V. 8:17), which cover the crowned Pharaoh, two magicians on the right and the sheep and goats on a mountain on the left. In the middle, Moses is pointing at both Pharaoh and Aaron.

Scenes 19–20 are similar to those in the *Rylands Haggadah* (fol. 16r).

Fig. 289

fol. 4v, a, right (21) The plague of 'arov (Ex. 8:16–20): "And there came a grievous swarm of 'arov into the house of Pharaoh, and into his servants' houses" (Ex. 8:20; A.V. 8:24). Behind the crowned Pharaoh, two magicians are being attacked by various "beasts and birds combined" (*Exodus Rabbah* 9:2), among them a serpent, a winged dragon and long-tailed frogs.

fol. 4v, a, left (22) "And I will put a division between my people and thy people" (Ex. 8:19; A.V. 8:23): Moses and Aaron are pointing at the previous scene, a group of Israelites standing behind them. On the left is a walled city, as in the

[95]

Rylands Haggadah (fol. 16v), where it is identified by the inscription "Goshen".

fol. 4v, b (23) The plague of murrain (Ex. 9:1–3; inscribed with parts of Ex. 9:1, 3): On the right, the crowned Pharaoh is sitting with two attendants, conversing with Moses and Aaron, who point at them and at the dying sheep, cow and donkeys on a mountain to the left. The live cattle of the Israelites (Ex. 9:4, 7) that appear in the *Rylands Haggadah* (fol. 16v, b) are missing.

On the whole, Scenes 21–23 are similar to those of the *Rylands Haggadah* (fol. 16v).

Fig. 290

fol. 5r, a (24) "And it became a boil breaking forth with blains upon man and upon beast" (Ex. 9:10): In the middle stands Moses, lifting his right arm after he "sprinkled ashes of the furnace up toward heaven". Behind him, Aaron is pointing to the right at the seated Pharaoh and at three attendants scratching themselves. On a mountain to the left is a shepherd scratching himself, with his herd of sheep, cows and donkeys, all speckled.

fol. 5r, b, right (25) "And the hail smote throughout all the land of Egypt, all that was in the field" (Ex. 9:25): Pharaoh is seated on the right, with an attendant behind him. Hail is falling on his head and tilts his crown (Midrash?). In the middle, Moses and Aaron are pointing at them and to heaven. In the top left-hand corner, hail is striking a mourning shepherd and his dead sheep and donkey.

fol. 5r, b, left (26) "He that feared the word of the Lord" (Ex. 9:20): On the left, at the foot of the mountain, is a shepherd with his sheep, donkey and cow among flowering plants.

Scenes 24–26 are similar to those in the *Rylands Haggadah* (fol. 17r).

Fig. 291

fol. 5v, a (27) "And the locusts went up over all the land of Egypt and rested within all the boundaries" (Ex. 10:14; also inscribed with part of Ex. 10:13): Moses, standing in the middle with Aaron, points his stick at a stepped mountain on the left, which is covered with insects eating the herbs of the land. The locusts fly towards and over the seated Pharaoh and his two attendants on the right, as in the *Rylands Haggadah* (fol. 17v, a).

fol. 5v, b, right (28) "And Moses stretched forth his hand; and there was a thick darkness in all the land of Egypt, three days" (Ex. 10:22): The crowned Pharaoh, surrounded by six attendants, is depicted on a black background to indicate darkness.

fol. 5v, b, left (29) "But all the children of Israel had light" (Ex. 10:23): Unlike the depiction in the *Rylands Haggadah* (fol. 17v, b), this is an abbreviated scene. Moses and Aaron, representing the Children of Israel, have the usual background, indicating light. Moses stretches his hand towards heaven.

Fig. 292

fol. 6r, a, middle and left (30) The plague of the first-born (inscribed with parts of Ex. 12:29, 30): In the top middle section of the compartment, the crowned Pharaoh stands lamenting with four attendants. Looking backwards, he points to five small units on the left, where four men in bed, a cow and a donkey lie dead. An attendant next to Pharaoh points downwards, where, under an arcaded battlemented building, a captive lies dead in a dungeon.

fol. 6r, a, right (31) Pharaoh calling on Moses and Aaron to leave Egypt (Ex. 12:31): On the right, Moses and Aaron are looking out from the roofed balcony of a fortified and embattled building. They point to the Pharaoh of the previous scene, who looks back at them.

The composition of Scenes 30–31 differs from that of the *Rylands Haggadah* (fol. 18r, a).

fol. 6r, b (32) The spoiling of the Egyptians (inscribed with parts of Ex. 12:35–36): On the right are four Egyptians, handing out a gold church vessel, a purse and a long belt to four Israelites, including a child. On the left are five Israelites, walking away from the first scene and carrying a gold church vessel. A building is depicted behind them. Similar to the *Rylands Haggadah* (fol. 18r, b).

Fig. 293

fol. 6v, a (33) The Exodus from Egypt (Ex. 12:34–37; inscribed with Ex. 12:34 and part of 12:35): In the middle are the Israelites, leaving the walled city of Rameses on the right. Unlike the *Rylands Haggadah* (fol. 18v, a), an Egyptian trumpeter stands on a roof, pointing at the Israelites. On the left, Moses and Aaron, holding a crook, face the Israelites, who carry two sacks and two oval "kneading troughs being bound up in their clothes upon their shoulders" (Ex. 12:34). They are armed with swords and sticks, wear helmets and hold shields. (*Exodus Rabbah* 20:17 interprets Ex. 13:18: וחמשים, inscribed in the *Rylands Haggadah* as "armed".)

fol. 6v, b (34) The pursuit by the Egyptians (inscribed with part of Ex. 14:9): A troop of five cavalry men approach from the right, headed by Pharaoh wearing gold armour and a crown. Two carry lances, and their shields bear arms *le bande* and *sinople*. On the left, in front of them, is a group of seven foot-soldiers, with lances, swords and shields.

Fig. 294

fol. 7r (35) The passage of the Red Sea (Ex. 14:21–30; inscribed with parts of Ex. 14:22, 27): A full-page panel, as in the *Rylands Haggadah* (fol. 19r), but divided into four horizontal sections, in

which the Israelites and the drowning Egyptians are depicted alternately. In the second from top and bottom sections, the procession of Israelites is shown, some carrying oval troughs, sacks and a goblet; the soldiers carry shields and are armed with swords, lances and a halberd. Moses and Aaron, one of them holding an inverted crook, face the procession in the left-hand corner of the second section. In the top and third sections, the Egyptian soldiers, horses and the crowned Pharaoh (in the third section on the left) are shown drowning under the waves and being eaten by sea creatures.

2. *Ritual Scenes.*

As in the *Rylands Haggadah* (fol. 19v), depicting the Passover in Egypt (Ex. 12:21–27; inscribed with parts of Ex. 12:22; 3; 8).

Fig. 295

fol. 7v, a, right (36) The slaughter of the Paschal lamb (Ex. 12:3–8): On the right, in a coffered room, a man is slaughtering a ram, pulling its head backwards with the aid of his foot.

fol. 7v, a, middle (37) "And ye shall take a bunch of hyssop and dip it in the blood that is in the bason" (Ex. 12:22): In the middle, a man carrying a basin prepares to strike the lintel and side posts of a doorway with hyssop covered with blood.

fol. 7v, a, left (38) "Roast with fire" (Ex. 12:8): On the left, a seated man is turning a spit on which a lamb is being roasted over a fire. The building-shaped furnace has a large chimney.

fol. 7v, b (39) Eating the Passover meal (Num. 9:2–5; inscribed with Num. 9:2): The composition is divided in the middle into two coffered rooms. Each room has a table, laid with a wine flask, two cups and *maẓẓot*. On the right, a young couple is seated at the table, holding a large goblet between them and gazing at each other. A servant near the doorway offers another flask. On the left, an elderly couple sits at the table, looking at each other. The bearded man is holding a large wine goblet, and the woman is pointing at a white stick (bitter herb?).

B. *Painted Initial-Word Panels.*

There are many initial-word panels with foliage extensions for the *Haggadah* and for four of the *piyyuṭim* pages, which are written similarly to those of the *Haggadah* (fols. 27v–28r and 29v–30r). Most panels, measuring (15–37) × (25–100) mm, are scattered within the text. The panels at the main divisions (e.g., fols. 8r, 9r, 15v, 16v, 17v, 18r and 27v) head the text space and extend across it. They measure (32–40) × (130–168) mm and sometimes combined with more elaborate decoration, as, for instance, the panels with text illustrations within the text on fols. 8r and 17v–18r (Figs. 296, 304, 305). Other examples are the

vertical panels for the repeated words of the *piyyuṭ* "*Dayyenu*", which flank the text (fols. 15v, 16r – Fig. 302), embellished in a similar way to that of the *Rylands Haggadah* (fols. 29v–30r). Illustrations in the margins accompany the related portions of the text with their initial-word panels (see § C below).

The initial words are written in burnished gold, outlined in black and white. The panels are blue or magenta, frequently alternating, decorated with white pen scrolls and framed by black, coloured or gold fillets. Many panels have foliage scrolls extending into the margins, with floral motifs of trefoils, buds, cusps and large dots. The leaves are usually acanthus, and there is one branch of holly (fol. 8r). The scrolls are painted mostly on alternating blue and vermilion or magenta grounds, with brownish green leaves and buds, heightened and decorated with white. One elaborate scroll of magenta and vermilion flowers on a blue ground is placed beneath an initial-word panel (fol. 9r – Fig. 297); a similar blue scroll on magenta flanks another panel (fol. 17v). Some extensions bear human figures, animals, birds and grotesques, painted and modelled in a similar way. There is also a hunting scene (fol. 15v), similar to that in the *Rylands Haggadah* (fol. 29v), where the hunter is carrying a hare on a stick, and his dog is chasing another. The most elaborate extension (fol. 8r – Fig. 296) — where the scroll is painted on a burnished gold ground, which has mostly flaked off — has a mole confronting a snail in the lower margin, resembling the border decoration of fol. 33r in the *Rylands Haggadah*. On the left is a human-headed, grotesque bird, lifting one wing. Another one (fol. 16r – Fig. 302) is hooded, blowing a horn, similar to fol. 32v in the *Rylands Haggadah*. Two human-headed grotesques flank the initial-word panel on fol. 18r. To the right, a dragon wearing a hat has a foliage scroll in its mouth; at the tip of the scroll is a round object, at which a crane is pecking. On the left, a bearded human grotesque holds a foliage scroll in one hand and points to an owl with the other. Both the owl and the pecking crane appear on fol. 29v in the *Rylands Haggadah*, though reversed.

C. *Marginal Text Illustrations.*

The ten marginal text illustrations, usually in the outer margins, mainly depict single figures of rabbis holding books. They are painted on the vellum ground and coloured and modelled in a similar way to that of the full-page panels (§ A) and of the initial-word panels (§ B). They also resemble the marginal text illustrations in the *Rylands Haggadah* (fols. 20r, 22v, 23r, 28r, 28v and 30v).

fol. 8r (Fig. 296) אתאן מפירקא, "When coming from the synagogue": Three scenes of the preparation and eating of the Passover meal.

(1) To the right, a man is skinning a white lamb, which is hanging from a hook in the ceiling, its blood dripping into a bowl below.

(2) To the left, within an arched interior, is a seated man, roasting a lamb on a spit over the fire, similar to the representation of fol. 7v. Inscribed in gold: צלי אש, "Roast with fire" (Ex. 12:8).

(3) In the middle section is the long Ṣeder table, covered with a cloth and laid with goblets, knives and *mazzot*. Round the table are three groups of people — two of three people and one of four — eating, drinking and talking. In the group to the left are two women wearing stepped hats, like the women on fol. 7v. Buildings and towers on both sides of the illustrations of the panel have balconies and coffered ceilings.

fol. 9r (Fig. 297) On this page are two text illustrations:

(4) מוזגין לו כוס שני, "Pouring for him a second cup": Above the initial-word panel is an inscription. In the inner margin, to the right of the initial-word panel, a youth is standing on a foliage scroll, pouring wine from a jar into a goblet — in a similar (though reversed) attitude to that on fol. 20r in the *Rylands Haggadah* — illustrating the pouring of the first cup.

(5) הא לחמא עניא, "This is the bread of affliction" — the beginning of the *Haggadah*: To the left of the initial-word panel is an old man, seated in a *cathedra* and displaying a book inscribed with lettering resembling Arabic.

fol. 9v (Fig. 298) (6) The five Rabbis of Benei Beraq: In the outer margin, an old man is sitting on a bench facing the text and pointing at it, holding an open book inscribed as on fol. 9r.

fol. 10r On this page are two text illustrations:
(7) "R. Eleazar ben Azariah said": At the top of the outer margin is an old man seated on a bench, holding up a book and pointing at it.

(8) Below "the wise" son is an old man seated in a *cathedra*, similar to the one on fol. 9r, holding up a book.

fol. 10v (Fig. 299) (9) "The wicked" son: A dark soldier, dressed in a short brown tunic, is wearing silver armour and helmet and holding a vermilion shield and a silver sword.

fol. 14v (Pl. XCIV: Fig. 300) The page has two text illustrations:
(10) "R. Yosé ha-Gelili": At the top of the outer margin is an old man, seated on a bench similar to the one on fol. 9v, displaying an open book.

(11) "R. Eliezer": An old man, seated on a bench and wearing a kerchief-like hat, is holding an open book on his lap.

fol. 15r (Fig. 301) (12) "R. Akiva": In the outer margin is an old man, seated on a cushioned bench and holding up a book like the top one on fol. 10r.

fol. 17r (Fig. 303) (13) "Rabban Gamaliel": In the top left-hand corner is an old man, seated in a *cathedra* and displaying an open book similar to that on fol. 9r.

fol. 17v (Fig. 304) "This *mazzah*": Two panels, one above the other, depict two scenes:
(14) Two hooded men are supporting a roundel of *mazzah*, the diameter of which is 44 mm — the same height as themselves. The roundel has an outer blue band, decorated with black brush scrolls, and a magenta inner roundel, with a hooded, human-headed gold dragon in the centre. Both roundels are framed by a yellow fillet.

(15) Behind a covered table, laid with silver plates, goblets and a flask, are a man and a woman, wearing a stepped hat and pointing at each other. A silver lamp hangs from the top.

fol. 18r (Fig. 305) "This bitter herb": Two panels, one above the other, depict two scenes:
(16) Two men, one wearing a hood and the other a hat, are supporting a large, olive-green cluster of lettuce leaves arranged in artichoke form, similar to that in the *Rylands Haggadah* (fol. 31v). They are standing within a quatrefoil framed in yellow. The spandrels are blue.

(17) A man and a woman are sitting alongside a table, which is laid with goblets, ochre sticks (bitter herb?) and a flask. The woman is wearing a red, stepped hat and holding a goblet. The man, in a red mantle, points at the woman — an allusion to "this bitter herb"(?).

D. *Penwork Initial-Word Panels.*

There are many penwork initial-word panels for the *piyyuṭim* (fols. 23v–50r, *passim*), larger ones (21–27) × (152–192) mm as well as smaller ones (16–25) × (26–91) mm, done in red and violet. Some are divided into rectangular units of alternating red and violet, placed either horizontally across the text column (fol. 23v), or vertically along it (e.g., fols. 23v–24v, 25v and 28r–29v).

The penwork consists of curly scrolls, with abstract foliage and floral motifs enclosed in the curls. Most panels have beaded borders, with flourishes and lines extending into the margins. On fol. 23v appear shapes of a human face and of a bird.

Conclusions

This *Haggadah* is similar in iconography and decoration to the *Rylands Haggadah* (No. 15). Its full-page biblical illustrations similarly belong to the second recension of Sephardi *Haggadot*, and the illustrations in the text are likewise textual, and not biblical. The differences in iconography are minute, but it is impossible to state with accuracy whether one was copied from the other. It is most likely that a similar model, now lost, was used for both. As in the *Rylands Haggadah*, there are two stylistic origins for the decoration of our *Haggadah*: French and Italian. The French elements are predominant

in the text pages, namely in the initial-word panels — with their foliage extensions, animals and grotesques — as well as in colours. The Italian elements predominate in the full-page panels and in the text illustrations, both within the text and in the margins. The heavy, byzantinizing modelling of faces and hands, using olive-green shading surrounding pinkish areas heightened with white, may suggest the Siena School, transformed into an exaggerated Spanish style (cf. No. 15, Conclusions). Although one master was responsible for the entire decoration of the *Haggadah*, two people seem to have coloured it. The main, Italianate artist used heavier and at times cruder colours than those of the *Rylands Haggadah*. The heavy gouache paints must have flaked off easily at an early stage, as is evident in most panels and text illustrations (e.g., fols. 8r, 9r, 10r and 17v – Figs. 296, 297, 304). Some colours have been overpainted, e.g., the figures of two women, a young man and a servant in the lower part of the panel on fol. 7v (Fig. 295). In many places a corrector draftsman may have been responsible for the pen-lines added to figures in the full-page panels to accentuate eyes, hair and the outline of hands (e.g., fols. 2r,b; 2v,b; 3r,b; 3v,a; 4r,b; 4v,a; and 7v,b) and for corrections to garment decoration (e.g., fols. 2v,b; 3r,a; 4v,a; and 5r,a).

In its composition, this *Haggadah* should be compared with the Chronicle of 1343 of the Aragonese King Haime I el Conquistador (*Libre dels fets del rey Jaime*, Barcelona, Biblioteca Universitad, MS 1, fol. 27r; cf. our fol. 8r; see Domínguez-Bordona, Fig. 186). Furthermore, the single figures of rabbis depicted in the margins (e.g., fol. 15r – Fig. 301) are similar to the figures of 1346 in the reredos of S. Marco in Manresa Cathedral (Bohigas, pp. 118 ff., Fig. 52), attributed to Arnau (brother of Ferrer) Bassa. They have large heads, squat bodies, covered by soft, falling drapery, and expressive faces. Considering the royal patronage of the *Chronicle* and of the reredos and the cruder workmanship of the *Haggadah*, it can be concluded that this *Haggadah* was executed not before the middle of the fourteenth century, and possibly later, in the third quarter of the century.

Bibliography

Margoliouth, No. 606, II, pp. 198–200.

Müller & Schlosser, *Sarajevo*, pp. 95–106; Pls. I–IV:2.

Rosenau, Rylands, 1954, pp. 468–483.

Roth, Rylands, 1960, pp. 131–159.

Domínguez-Bordona, *Ars Hispaniae*, XVIII, pp. 147–148; Fig. 186.

Narkiss, *HIM*, p. 68, Pl. 14, and Bibliography on p. 170.

Bohigas, *Cataluña*, pp. 118 ff., Fig. 52.

Narkiss, *Golden Haggadah*, pp. 43–73, Fig. 20.

17. CATALAN HAGGADAH, GENIZAH FRAGMENT

Catalonia, early fourteenth century

CUL, T-S, K. 10.1

Figs. 306–307

A fragment of a Haggadah.

General Data

Codicology

Vellum; one fragmentary leaf; largest dimensions *c.* 188 × 165 mm. Text space *c.* 128 × 105 mm. Written in square Sephardi script, in light brown ink, 9 lines per page. Ruling by stylus, 9 horizontal and 1 + 1 (?) vertical lines.

Colophon

None.

History

From the Cairo Genizah, Taylor-Schechter collection, 1898.

Decoration

Programme

A. Large initial word.
B. Minor decorated initial words.

A. *Large Initial Word.*

fol. 1r (Fig. 306) The initial word רב(ד) is done in large, zoomorphic letters, divided into alternating red and blue sections, separated by bands decorated with dots. The upper termination of each letter is decorated with a bearded grotesque head in blue.

B. *Minor Decorated Initial Words.*

fol. 1v (Fig. 307) The word אלו is written in ink

with each letter surrounded by red linear pen decoration and some leaf motifs. The word דם is written in red, surrounded by similar brown decoration.

Conclusions

The zoomorphic decorated letters resemble those in the *Golden Haggadah* (above, No. 11; fols. 31r, 34v and 38r) of *c.* 1320, which are dependent on thirteenth-century models, such as the *Hamilton Şiddur* (Berlin, Preussische Staatsbibliothek, Ham. 288; see Narkiss, *HIM*, Pl. 7). They are also found in the *Mocatta Haggadah* (above, No. 10) and the *Cervera Bible* of 1300 (Lisbon, Biblioteca Nacional, MS 72).

Bibliography

Never published.

18. CAMBRIDGE CATALAN HAGGADAH

Catalonia, late fourteenth or early fifteenth century

CUL, Add. 1203

Figs. 308–309

Piyyuṭim for the Festivals and special Sabbaths (without prayers) and Haggadah.

General Data

Codicology

Vellum; I + 164 leaves (leaves missing after fols. 136 and 138); *c.* 205 × 160 mm. Text space (139–155) × (94–115) mm. Written in round Sephardi script, in brown ink, 19 lines per page. Ruling by stylus, 19 horizontal and 1 + 1 vertical lines. 22 quires of 8 leaves each, except for Quires I[7], VIII[7], VII[10], VI[6], XVIII[6], XXI[6] and XXII[2].

Colophon

None.

History

fol. 8 At the top: Abraham. At the bottom: Damaged sale inscription.
fol. 103r Owner's inscription in fifteenth-century Sephardi cursive: Moses b. Maimon.
fol. 141r Owner's inscription in fifteenth-century Sephardi cursive: Abraham the son of R. M. b. Maimon.
fol. 92r Censor's signature: "Revisto per me Antonio Francesco Enriquez 1683."
fols. 19v, 30v In eighteenth-century cursive: Joseph Shwaki b. Israel Shwaki.
Front paper fly-leaf In nineteenth-century square script: Elijahu Ashwaki b. Israel Ashwaki (אשואכי).
No. 6 in a private collection.
Purchased by the University of Cambridge from F. Hirsch on 14 April 1875.

Decoration

Programme

A. Text illustrations.
B. Penwork initial-word panels.
C. Painted initial-word panels.

A. *Text Illustrations.*

The two text illustrations for the *Haggadah* are coloured in blue, red, black and green tempera and wash, with some burnished gold.
fol. 66v (Fig. 308) מצה זו, "This *mazzah*": A decorated rosette (diameter 50 mm), painted in red, blue and black, with gold edges and black flourishes round it.
fol. 67r (Fig. 309) מרור זה, "This bitter herb": A bunch of green lettuce leaves, tied together at the bottom by a string.

B. *Penwork Initial-Word Panels.*

The panels, in red and violet, are mostly rectangular (e.g. fols. 66v, 67v – Figs. 308, 309), but some are of other shapes, such as a triangle (e.g., fol. 68v) or a lozenge (e.g., fol. 55r). The main penwork motifs are variations of foliage palmette scrolls (e.g., fols. 2r, 5r, 7v, 13r, 16v, 23r, 48r and many others), foliage scrolls with palmette motifs in the large lobes (e.g., fols. 3v, 11r, 16v, 23r, 48v–51v, 63r, 66v, 67v – Figs. 308, 309), or with geometrical motifs in the lobes (e.g., fols. 14r, 14v, 18v, 23r and 58v), drop-like curves enclosing palmette motifs (e.g., fols. 20r and 21r), a band of flower-like double spirals (e.g., fol. 26v), plaits (e.g., fols. 50r, 107r and 107v) and geometrical divisions of the panel or compartments with palmette motifs in the individual units (e.g., fols. 23r, 48r and 58r). Some panels are larger and composed of several alternating red and violet smaller sections (e.g., fol. 3v: 70 × 104 mm; fol. 23r: 87 × 203 mm; fol. 60r: 48 × 109 mm). Many panels have flourishes extending into the

margins (fols. 1r, 13v–14v, 23r, 25v, 84v and many others), some with additional pen drawings: fish (e.g., fols. 3v, 57v, 73v, 75v, 87r, 96r and 100v), a pair of wing-like leaves (fols. 22r, 53r, 58v, 65v, 75v, 107r and many others) and a human face (e.g., fol. 75v).

The more elaborate penwork is arranged along the side margins in the form of a band, incorporating several red and violet panels (e.g., fols. 13v–14v, 48v–51v, 63r–v and 70v–72v). Those for the *piyyuṭ "Dayyenu"* (fols. 65v–66r) are on both sides of the page, forming a U-shaped frame at the end of the *piyyuṭ* (fol. 66r), where there is an additional horizontal panel.

C. *Painted Initial-Word Panels.*

The two painted panels have the title and the initial words written in gold, on a blue ground with silver pen scrolls.

fol. 31r Title: The panel is framed by a dark magenta fillet, with a foliage motif in gold, magenta, green and blue on either side of the panel and a pink and green flower on top.

fol. 60v The beginning of the *Haggadah*: The panel is framed by a gold fillet, with red fruits at the four corners (badly damaged).

Conclusions

The illustrations are confined to the essential *mazzah* and bitter herb only. They are rendered, like the painted initial-word panels, in a manner closer to the fifteenth-century. This is evident mainly in the painterly, almost realistic way in which the shadings of the bitter herb (fol. 67r) and the foliage motifs (especially on fol. 31r) are rendered. On the other hand the motifs of the penwork panels and their spacing seem to be of a late fourteenth-century type. The script is more angular than the common Sephardi script and may be from an area bordering on France.

Bibliography
Loewe, *Hand List*, No. 480.

Catalan Bibles of the Second Half of the Fourteenth Century
[Nos. 19–26]

The most characteristic codicological element of the Catalan Bibles is their large format, sometimes as large as 350 × 280 mm. These manuscripts are mostly written on fairly thick vellum, in large, square script, and in the traditional two or three text columns. They are vocalized and massorated with both *massorot*, evidently to facilitate the preparations for the public readings of the Torah and *haftarah* in synagogue on the Sabbath. It is appropriate that these monumental volumes are sometimes called *Miqdashiah*, i.e. God's Temple, since both the synagogue and the Bible were regarded as stand-ins for the Temple of Jerusalem (e.g. the *King's Bible*, No. 22). Even those manuscripts which were written for private owners were probably used by the community for similar purposes (e.g. the *Farḥi Bible*, Sassoon, MS. 368).

The decoration of these Bibles is based on earlier traditions of illuminated Bibles adapted for use in synagogue. Generally, six categories of decoration can be distinguished in Sephardi Bibles of that period: (1) Sanctuary implements painted as full-page panels displaying various implements on the opening pages, in contrast to the Castilian Bibles which have no such displays and the *Second Kennicott Bible* (No. 3) which has a proper plan of the Temple with each implement arranged in its prescribed place; (2) decorated arcades incorporating massoretic comparative tables and various computistic calendars, an arrangement resembling the shape of the New Testament Canon Tables; (3) title and initial-word panels, as well as panels for the ends of books, which sometimes incorporate the number of verses in each book and their mnemonic sign; (4) decorated *parashah* signs in the Pentateuch and their corresponding *haftarot*, as well as decorated enumerations of Psalms; (5) Massorah Magna in micrography, outlining various shaped designs, placed in the outer margins; and (6) text illustrations, usually placed in the margins or between the text columns, sometimes outlined in micrography.

The display of implement pages, and the massoretic arcaded pages, are the main difference between the Catalan and the Castilian Bibles (see Metzger, T., Objets du culte).

The terms of the most frequently occurring illustrations, the Sanctuary implements, will be enumerated here. Others will be mentioned in the individual descriptions.

The term "Sanctuary" is used here to indicate the eclectic variety of implements generally depicted in these Sephardi Bibles. The variety incorporates elements from Moses' Tabernacle in the wilderness, Solomon's Temple, the Second and Herod's Temples, as well as the Mount of Olives, which alludes to the coming of the Messiah. This display does, in fact, portray the implements of the forthcoming eschatological Sanctuary, as indicated by Maimonides in the *Mishneh Torah*, VIII, I, 1:4.

Most of the implements depicted in these Bibles are dependent not on the biblical text, but on Talmudic interpretations, mainly on Maimonides' and Rashi's commentaries. The following enumeration of implements and their parts is given to clarify the terms used in the Catalogue, and to specify their literary allusions.

The *menorah*, the candelabrum, which stood in the inner part of the Sanctuary, is described in the Bible (Ex. 25:31–37; 37:17–24; etc.) as made of pure beaten gold, and as comprising a main shaft (*qaneh*, in the text: *qanah*, i.e. its shaft, Ex. 25:31); six branches (*qanim*, Ex. 25:32); and its leg (*yerekhah*, Ex. 25:31). Each of the branches and the upper part of the shaft are decorated with three bowls (*gvi'im*), one knop (*kaftor*) and a flower (*perah*, Ex. 25:33), in this order, one above the other.

In addition, the shaft is decorated with three knops at the three points of branching (Ex. 25:35). The lower part of the shaft is decorated with one more bowl (Ex. 25:34 states that the shaft, called *menorah* in this verse, has four knops), above which are another knop and a flower. An additional flower is placed beneath, at the point of junction between the shaft and its base (T.B., *Menahot* 29a, based on Ex. 25:34 and Num. 8:4). The base, not specified clearly in the Talmud, is described by Rashi (on Ex. 25:31) as being "made in the form of a box, three legs protruding from underneath it". Maimonides (Commentary on Mishnah, *Menahot* 3) gives a clear picture of the *menorah*, even to the point of giving an actual illustration of what it looked like. Most of the Sephardi Bibles of the fourteenth century base their depictions on Maimonides' and Rashi's specifications. According to Maimonides, the bowl is shaped like a goblet (*kos*), "narrow in its lower part" (based on T.B., *Menahot* 28b; similarly, Rashi on Ex. 25:31). The comparison to almonds in Exodus (25:33) is explained by Rashi as chasing, or a kind of niello work (based on Onkelos, *mezayrin*).

"The knop is like a ball (*kadur*) which is not entirely round... similar to a fowl's egg" (according to the Talmud, *ibid.*, they are similar to Cretan apples; Rashi likewise on Ex. 25:31: "such as are made for candlesticks for princely houses"). The flowers, according to Maimonides, are shaped like lilies. In the Talmud, *op. cit.*, they are "like blossoms on the capitals of columns". In his *Mishneh Torah*, VIII, I, 3:9, Maimonides mentions column capitals whose flowers are basin-shaped with outward curving petals.

The seven lamps (*nerot*, Ex. 25:37), one atop each of the six branches and one on the middle shaft, constitute an integral part of the *menorah* (Maimonides, *Mishneh Torah*, VIII, I, 3:7–8). According to Rashi, they are "a kind of small bowl into which the oil and the wicks were put" (on Ex. 25:37). The flames "are turned towards the middle shaft" (Rashi, *ibid.*; Num. 8:2; *Mishneh Torah*, *ibid.*).

The specific measurements of the *menorah* and all its parts are best summed up in Maimonides' Commentary on Mishnah, *Menahot* 3, based on Talmud, *Menahot* 28b. None of the *menorah* depictions in the Sephardi Bibles follows the above descriptions to the letter, but they do relate to it in most details.

The tongs (*melqahayim*) of the *menorah* (Ex. 25:38; 37:23; Num. 4:9) are "made for taking the wicks out from the oil, to put them in position and to draw them into the mouths" (Rashi on Ex. 25:38), and are usually depicted as hanging from the *menorah*, though they do not constitute an integral part of it (Maimonides, *Mishneh Torah*, VIII, I, 3:6).

The snuff shovels (*mahtot*) of the *menorah*, which were used for raking the ashes of the wicks every morning (Rashi on Ex. 25:38), are likewise depicted hanging from the *menorah*, not being an integral part thereof (Maimonides, *Mishneh Torah*, *ibid.*).

"There was a stepping stone (*even*) before the *menorah* in which were three stairs; the priest stood on this to trim the lamps" (Mishnah, *Tamid* 3:9; T.B., *Menahot* 29a; *Tamid* 30b; *Mishneh Torah*, VIII, I, 3:11).

An additional pitcher, sometimes depicted in connection with the *menorah*, might be explained as "the *kuz*,

which resembled a large gold pitcher" (T.B., *Tamid* 30b). It is placed upon the second stair of the stepping stone (Mishnah, *Tamid* 3:9), and contained oil for the *menorah* (*Mishneh Torah*, VIII, I, 3:11).

The Shewbread Table (*shulḥan leḥem hapanim*) which stood in the inner part of the Sanctuary, was, as specified in the Bible (Ex. 25:23–30; 37:10–16), rectangular in shape, covered in gold, with a band (*zer*) round it and a border (*misgeret*) which has four rings (*taba'ot*) for inserting two carrying staves (*badim*). It stands on four legs (*raglayim*). The twelve loaves of bread are placed on the table arranged in two rows (*ma'arakhot*), six in each row, according to Leviticus 24:6. The shape of the bread and its location on the table are not described in the Bible; from the discussion in the Babylonian Talmud (*Menaḥot* 94b), there were probably two possible shapes for the bread, either like a "broken box" (*teva pruẓah*) with two of its opposite sides missing, or like a V-shaped "ship's keel" (*sfinah roqedet*).

Both Rashi and Maimonides (on Mishnah, *Menaḥot* XI) prefer the first shape, "which had a bottom but no top, and this bottom was turned up on both ends to form walls (*ktalim*). On this account it is called 'bread with faces' (*leḥem hapanim*), because it has faces (surfaces) looking in both directions, towards the sides of the House (the Sanctuary)" (Rashi on Ex. 25:29). "The bread is placed lengthwise across the breadth of the table with its sides standing up exactly in a line with the edge of the table" (Rashi on Ex. 25:29, based on Mishnah, *Menaḥot* XI:5), and the table is placed lengthwise, parallel with the length of the Temple (T.B., *Menaḥot* 98a). The twelve loaves of bread (*ḥalot*) are arranged in two piles of six each. Beneath each of the loaves are "hollow canes split along their length" (*keḥaẓi qane ḥalul*) which support them. These are usually depicted as six shelves on which the loaves rest. In some instances the bottom two loaves rest upon the table, in which case the sixth shelf covers the top loaves (T.B., *Menaḥot* 96a; 97a; Rashi on Ex. 25:29; Maimonides on Mishnah, *Menaḥot* XI; idem, *Mishneh Torah*, VIII, I, 3:14). The cans rest on six pegs (*ṣnifim*) jutting out from four supporting golden poles (*ṣnifim mefuẓalim*), two for each row, placed vertically on both sides of the table (T.B., *Menaḥot* 94b; Mishnah, *Menaḥot* XI:6).

The existence of poles and canes in the Talmud is based on two ambiguous terms in the Bible (Ex. 25:29): *qsotav* and *mnaqiotav*. According to the Babylonian Talmud (*Menaḥot* 97a), *qsotav* are the *ṣnifim*, i.e. the poles with their pegs, and *mnaqiotav* are the *qanim*, i.e. canes. Maimonides follows this terminology, but Rashi gives two explanations and reverses the terms.

Two more implements belong to the Shewbread Table (Ex. 25:29): (1) the moulds (*qe'arot*) for baking the bread (according to T.B., *Menaḥot* 97a; Rashi, *ibid.*; Maimonides, *ibid.*); and (2) spoons (*kapot*) for frankincense (*levonah zakah*) (Lev. 24:7), which, according to the Talmud, are called *bzikhin* (T.B., *Menaḥot*, *ibid.*; Rashi, *ibid.*; Maimonides, *ibid.*) and were placed above each row of bread.

The Altar of Incense (*mizbaḥ haqtoret*), which stood between the *menorah* and the Shewbread Table, is specified in the Bible (Ex. 30:1–6; 37:25–29) as a golden cuboid (*ravu'a*) with horns (*qarnayim*), a golden band (*zer*) round it, and four rings (*taba'ot*) for two carrying staves (*badim*). This Altar of Gold (*mizbaḥ hazahav*), as it is sometimes called, has no additional serving implements. Fire-pans (*maḥtot*) for burning incense are used to carry live coals from the Altar of Sacrifice (Lev. 16:12; Rashi on Ex. 27:3). This last detail sometimes inspired the depiction of additional fire-pans (*maḥtot*) next to the Altar of Incense and next to the *menorah*, sometimes formed like a ball-shaped church censer (*maḥtah*) attached by chains to the *menorah*.

The mortar-like vessel and pestle (*makhtesh ve'eli*), which are sometimes placed among the implements, may have been used to pound the incense for the altar (Ex. 30:34–36; Rashi on Lev. 16:12), or to press olive oil for the *menorah* (Rashi on Ex. 27:20 and Lev. 24:2). Rashi states that pounding incense and pressing oil are both done in a *makhteshet*, i.e. a mortar.

The most frequently depicted implements from the Holy of Holies are the Ark of the Covenant (*aron ha'edut*) and its objects. According to the Bible (Ex. 28:10–15; 37:1–5), the Ark was covered in gold both without and within. It had a golden band (*zer zahav*) round it and rings (*taba'ot*) at its four corners. The staves (*badim*) were never removed from the rings. The mercy seat (*kaporet*) of pure gold, above which God communes with Moses, was placed upon the Ark (Ex. 25:17; 25:21–22; 37:6). According to Rashi (on Ex. 25:17), the *kaporet* is a board covering the open top of the Ark at a height of one cubit (T.B., *Ṣukkah* 5a). The two golden cherubim (*kruvim*) were placed facing each other at either end of the mercy seat, sheltering part of it with their lower wings and touching each other above it with their wings (Ex. 25:18–21; 37:7–9).

The Tablets of Testimony (*luḥot ha'edut*), upon which the Ten Commandments were written (Ex. 31:18; 34:1–4; Deut. 10:4), were placed in the Ark of the Covenant (Ex. 25:16; 40:20; Deut. 10:1–5; I Kings 8:9; II Chron. 5:10; Rashi on Ex. 25:16). Next to the Tablets within the Ark of the Covenant were placed the jar of manna (*ṣinṣenet haman*; Ex. 16:33–34, and Rashi on it), usually depicted as an amphora or pitcher, and Aaron's rod (*maṭeh Aharon*; Num. 17:17–24; revised version 17:2–10), which blossoms next to the barren rod belonging to one of the princes of Israel. This last may also represent the rod of Moses. In the Sephardi Bibles most of these implements appear on their own, not within the Ark.

The Ark of the Covenant and all its objects existed in the Tabernacle in the wilderness and in Solomon's Temple. According to Maimonides, the Ark, hidden by King Josiah, was not recovered, and was therefore not present in the Second Temple, nor in Herod's Temple (*Mishneh Torah*, VIII, I, 4:1).

The two silver trumpets (*ḥaṣoṣrot*) usually depicted were blown to call the assembly or the princes, to alarm the people in wartime, and over the sacrifices on **solemn and feast days** (Num. 10:2–10). Next to the trumpets is a horn (*shofar*), used for blowing on the Day of Atonement (Lev. 25:9).

In the court of the Sanctuary were the Altar of Sacrifice (*mizbaḥ ha'ola*), with its serving implements, and the laver (*kiyyor*). The Altar, a cuboid covered in brass (Ex. 27:1–7; 38:1–6), had horns (*qarnayim*) at its four corners; a brazen network grate (*mikhbar ma'aseh reshet neḥoshet*) beneath its surrounding ledge (*karkov*), rings (*ṭaba'ot*) at the four corners of the grate; and staves (*badim*) for carrying it. According to Mishnah, *Middot* 3:1, the pre-exilic altar had three steps: the base (*yesod*); above it, the walking circuit (*sovev*), which had ample room for the priests to walk on and to incorporate the four horns of the altar; and, above that, the place of sacrifice (*meqom hama'arakhah*). In the Second Temple another area, in the shape of the Greek letter *gamma* (Γ), was added to the lower base part, on the northern and western sides of the altar (see also *Mishneh Torah*, VIII, I, 2:5–10; Rashi on Ex. 27:5).

The ramp (*kevesh*) built on the southern side of the altar (Mishnah, *Middot* 3:3; T.B., *Menaḥot* 19b; *Mishneh Torah*, VIII, I, 1:17; 2:13) was used by the priest to ascend to the altar. According to Rashi (on Ex. 27:5), there were no stairs, as it was not allowed to ascend to the altar by stairs (Rashi on Ex. 20:23).

The brass implements of the Altar of Sacrifice are all mentioned in the Bible (Ex. 27:3; 38:3), as follows: Pots (*sirot*) "to take away the ashes", which Rashi (on Ex. 27:3) describes as looking like cauldrons (*yorot*), are usually depicted as basins. Shovels (*ya'im*) to rake the ashes. According to Targum Onkelos and Rashi (*ibid.*), these are usually depicted either as a rake (*magrefah*) or as hearth brushes. Basins (*mizraqot*) to collect the sacrificial blood (Rashi, *ibid.*). Flesh-hooks (*mizlagot*) to turn the sacrificed meat on the altar (Rashi, *ibid.*). Fire-pans (*maḥtot*) resembling shovels, into which the live coals were raked from the Altar of Sacrifice and carried to the inner Altar of Incense (Rashi, *ibid.*; Lev. 16:12).

The brass laver (*kiyor*) and "its stand" (*kano*), used for washing the priests' hand and feet (Ex. 30:18–21; 38:8), are usually depicted as a pitcher or basin on a long pillar or a base.

A tree upon the cleft Mount of Olives, sometimes depicted on the implement pages, alludes to the coming of the Messiah, in accordance with Zechariah's vision (14:4) (see Gutmann, Kingdom, pp. 168–175), and to the renewal of sacrifices such as the burning of the red heifer, which the Mishnah (*Middot* 2:4) describes as taking place there.

Some manuscripts, such as Joshua Ibn Gaon's *Second Kennicott Bible* (No. 3), depict part of a proper Temple plan, with each of its implements shown in the prescribed place. Since this and other Temple plans include additional implements, see the detailed description in each case.

19. DUKE OF SUSSEX CATALAN BIBLE

Catalonia, third quarter of fourteenth century

BL, Add. 15250

Figs. 310–323; Pl. XXVIII: Figs. 310–311.

Bible.

General Data

Codicology

Vellum; II + 437 + III leaves; 357 × (280–285) mm. Text space (234–236) × (188–190) mm; height of the text space with Massorah 281–84 mm. Written in square Sephardi script, in light brown ink, 31 lines in 3 columns, except for Psalms, Job and Proverbs (fols. 319v–367r), which are written in two columns. Massorah in 2 lines above the text, 3 lines below it, and sometimes in the outer margin. Ruling by stylus on hair side, 2 + 31 + 3 horizontal and 2 + 3 + 3 + 1 vertical lines. Pricking is noticeable in all four margins. 55 quires of 8 leaves each, except for Quires I⁴ and LV¹⁺⁸ which are gathered so that outward hair side faces hair. All 54 text quires are numbered with Hebrew letters on the top of the first pages and bottom of the last pages. Fols. 1r, 4v and 5r are blank.

Binding

Eighteenth-century Italian red velvet binding on wood, with copper mounts in the corners and centre. One clasp remains out of four.

Colophon

None.

History

fol. 1r Owner's inscription: Joseph Lunel, Nice.
fol. 437r Birth entry: A son, the 15th of Nisan 5253 (2 April 1493).
Front fly-leaf Book-plate of the Duke of Sussex Collection, VI.H.e.I., with an erroneous ascription to the fifteenth century.
Purchased by the British Museum at the Duke of Sussex Sale, 31 July 1844, Lot 101.

Decoration

Programme

A. Full-page painted panels of Sanctuary implements.
B. Full-page painted arcades.
C. Decorative micrography of the Massorah.
D. Massoretic notes in micrography.

Description

A. *Full-Page Painted Panels of Sanctuary Implements.*

Two facing panels (fols. 3v, 4r – Figs. 310, 311) are painted in magenta, blue and burnished gold, with some vermilion, green, grey, brown, black and burnished silver. Most colours are modelled with darker shades and heightened with white or grey lines, roundels and flourishes. The burnished gold and silver are outlined in black. The ground of each panel is divided into four compartments of alternating magenta and blue rectangles decorated with chequered pattern. The frames are blue and magenta bands and, in contrast with the rectangles, are decorated with pen flourishes bordered by various coloured fillets interlacing in the middle of each side and studded with gold roundels and squares. From these interlacings a double foliage motif in colours and gold drops extends into the margins. Extending from the two outer borders are coloured lotus buds, each enclosing a palmette. The implements of the Sanctuary, mainly in burnished gold, are placed disregarding the boundaries of the alternately coloured compartments in the background; they are not inscribed. For biblical and other references, see introduction above.

fol. 3v 240 × 190 mm. The seven-branched *Menorah* with round branches and a shaft. In each branch there are three goblet-like bowls, a round knop, a double-leaved flower (acanthus in profile) and a bowl-like lamp receptacle. The shaft, with three additional knops at the branching, and with a knop, flower and bowl, in that order, one above another, rests on a thick, three-legged base. This order does not concord with either the Bible, Maimonides, nor with Rashi's commentary, and the lower flower is missing. There are no flames in the lamp receptacles. On the lower branches two snuff shovels and two pairs of tongs hang symmetrically. Under the branches are two mortars with pestles and a pair of stone steps, one with six and the other with five stairs.

fol. 4r 245 × 190 mm. On the top, from right to left, are: the incense altar, with four stairs on either side; the *shofar* below it; the Ark of the Covenant with the tablets, in marble-like grey speckled with white, vermilion, blue and green dots; the carrying staves, inserted into the four rings of the Ark. Under the Ark and the altar are the two silver trumpets. On the left is Aaron's flowering rod, in grey with green leaves, and a golden amphora-like jar of manna. In the lower part to the right is the shewbread table standing on two legs, with two rows of loaves and with additional canes on top. Beneath the table is a basin. To the left is the altar

of sacrifice, with five stairs and two horns on top. Below it are two shovels and a basin. Three rods with flower-like tops extending from the altar might be shovels, flesh-hooks or fire-pans. At the bottom left is the Mount of Olives, coloured in brown, black and blue-grey, heightened in white; it is cleft, with a green tree on it and a stream of water on each hillock.

B. *Full-Page Painted Arcades.*

The four arcades (fols. 1v – Fig. 312, 2r–3r) framing the differences between Ben Asher and Ben Naphtali, are here incomplete, and are written only up to the middle of the first arch on fol. 2v. They are painted in the same colours as the pages described in §A, but with more vermilion and green and with brighter blue. Each page consists of three trefoil arches completely framed (232–236) × (184–188) mm by a fillet with an interlace of a double fret in alternating sectional colours. The arches on fols. 2v–3r are formed by the intersection of larger arches. The columns of the arches, similarly decorated with coloured frets, are resting on stepped golden bases (fols. 1v – Fig. 312, and 2r) and crowned by ring-like capitals in blue (fols. 1v–2r) and gold (fols. 2v–3r). The spandrels are decorated with interlacing multi-coloured acanthus foliage motifs on a blue ground and with gold drops.

C. *Decorative Micrography of the Massorah.*

A most elaborately decorated Massorah, sometimes completed by pen-drawing, appears at regular intervals in most of the text quires. In each of the first 14 text quires (Quires II–XV in the extant manuscript, ending on fol. 46v), which contain the Pentateuch and the beginning of Joshua (up to 1:10), the verso of the first folio (e.g., fol. 5v – Fig. 313) and the recto of the second folio have decorative micrography in the lower margins and in one or two of the outer margins. In addition, in each quire the recto of the last folio and one or two other folios (usually the sixth and fourth) have decorative micrography in the outer margins. In the rest of the quires, up to text Quire 51 (extant Quire LII, ending on fol. 412v), only the verso of the first folio and the recto of the second folio are decorated symmetrically in the lower and the two outer margins, except for text Quire 40 (extant Quire XLI), which has double displayed micrography on the verso of the third folio and the recto of the fourth (fol. 319v), where the book of Psalms begins. The same applies to text Quire 48 (extant Quire XLIX), where the Book of Esther starts (fol. 384r). All the decorative micrography exposes underdrawings in brown plummet.

Outer Margins

The decorations in the outer margins mostly consist of:

(1) Candelabrum-like trees, with the central shaft and branches interrupted by, or terminating in, knops, buds, palmettes, demi-palmettes, fleurs-de-lis and other symmetrical foliage motifs, most of which enclose minute pen-drawn circles. Some trees are more elaborate and have three shafts combined (e.g., fols. 110r – Fig. 315, 213v–214r, 245v–246r and 333v–334r). The shaft usually rests on a lotus bud, a wing-like demi-palmette or inverted palmettes; some rest on a winged dragon (e.g., fols. 92r – Fig. 314 and 205v), a crouching lion (e.g., fol. 206r – Fig. 319) or crowned *lions rampant*, with a large fleur-de-lis on top (fols. 319v, 320r – Fig. 322: beginning of Psalms).

(2) More natural-looking trees (e.g., fols. 165v – Fig. 317, 166r, 179v and 180r – Fig. 318).

(3) Micrography in zigzag patterns (e.g., fols. 117v, 118r – Fig. 316, 237v, 238r – Fig. 320, 253v and 254r – Fig. 321).

(4) A guilloche with a rosette on top (e.g., fols. 341v – Fig. 323 and 342r).

Lower Margins

The micrographic decoration in the lower margins is in different geometric forms, mostly circles, semi-circles, triangles and clusters of lozenges.

D. *Massoretic Notes in Micrography.*

At the end of the books, the massoretic notes are written in micrography outlining geometrical forms. Some of the forms are more elaborate, e.g., fols. 95v (end of Numbers) — a shield; 145v (Judges) — circles; 180r (Fig. 318: II Samuel) — Star of David; 270v (Jeremiah) — a rectangle; 297r (Ezekiel) — a zigzag.

Conclusions

The decoration of this Bible comprises two techniques. One is the decorative Massorah in micrography; the second is the painted decoration of the Sanctuary implements and the framed arcades, all in the first quire of four leaves. Both techniques were used by the artists who copied and illuminated the group of Catalan-Provençal Bibles in the second half of the fourteenth century. The script and decorative Massorah are similar to those of the *Catalan Bible of 1357* in three columns (Paris, Bibliothèque nationale, hébr. 30. See Sirat & Beit-Arié, *Manuscrits*, I, No. 44), which is also similar in size to our manuscript. This manuscript also resembles the undated *Harley Catalan* and *London Catalan Bibles* (Nos. 20–21). The candelabrum-like tree motifs of the Massorah are especially close to the undated *Cambridge Catalan Bible* (No. 23), where the decoration plan, motifs and technique of fol. 97v, for example, are very similar to those of fol. 69v in our manuscript, although that Bible is somewhat smaller and written in two text columns.

The painted Sanctuary implements are most

typical of the Catalan-Provençal School from the end of the thirteenth century, but it is difficult to specify their exact date from the stylized gold and silver implements on chequered blue and magenta grounds. The spaciousness with which the different implements are spread over the page is very different from the crowded composition of the early fourteenth-century Bibles. The only elements with a distinguishable style are the painted trees and the Mount of Olives, depicted in most manuscripts, as well as the foliage decorations in the borders and on the arcaded pages. The painterly style in which the acanthus leaves and the mountain are rendered in our manuscript is closer to the decorations of the middle of the fourteenth century than to the crisper and more detailed trees, leaf motifs and mountains of the *Farḥi Bible* of 1382 (Sassoon, MS 368) and the *King's Bible* of 1384 (No. 22). Moreover, the painterly manner apparent in the tree and the Mount of Olives and the multi-coloured, fleshy leaf motifs can be found in Spanish Latin manuscripts of the third quarter of the fourteenth century, such as the *Decretum*

Gratiani in London (BL, Add. 15274–15275). That manuscript, as Miess (pp. 71–72), Wormald (p. 78) and Bohigas (II, pp. 131 ff.) have proved, is dependent on the *Copenhagen Maimonides Guide* of 1348 from Barcelona, now in Copenhagen (Kongelige Bibliothek, heb. 37; see Narkiss, *HIM*, No. 18), as well as on the Catalan additions to the *Third Copy of the Utrecht Psalter* in Paris (Bibliothèque nationale, lat. 8846).

Bibliography

Margoliouth, No. 53, I, pp. 23–24.
Warner, *British Museum*, No. 40.
Domínguez-Bordona, *Ars Hispaniae*, XVIII, pp. 144–162, Lam. V.
Sassoon, *Ohel David*, MS. 363.
Sotheby Sale, 31.7.1844, Lot 101.
Meiss, Catalonia.
Wormald, Copenhagen.
Bohigas, *Cataluña*, pp. 122–153.
Narkiss, *HIM*, pp. 21, 25; Pl. 18.
Sirat & Beit-Arié, *Manuscrits*, I, No. 44.
Metzger, T., Masora, Pl. XCVIII.

20. HARLEY CATALAN BIBLE

Catalonia, third quarter of fourteenth century

BL, Harley 1528

Figs. 324–327

Bible.

General Data

Codicology

Vellum; I + 424 + I leaves; 350 × 263 mm. Text space (238–242) × (182–186) mm; height of the text space with Massorah 285–290 mm. Written in square Sephardi script, 32 lines in three columns, except for Psalms, Job and Proverbs (fols. 309r–355v), which are written in two columns. Ruling by stylus on hair side, 2 + 32 + 3 horizontal and 2 + 3 + 3 + 1 vertical lines. Pricking is noticeable in all four margins. 54 quires of 8 leaves each, except for Quires I^{10} (fols. 5 and 6 are later additions), LIII4 and LIV2 (later addition), gathered so that outward hair side faces hair. The 52 text quires are numbered with Hebrew letters at the top of the first pages and bottom of the last pages. Leaves are numbered with Hebrew letters in the top left-hand corner of each recto; many of these have been cut off by a binder. Fols. 1r–v, 10v, 11r, 423r and 424v are blank.

The order of the books of the Hagiographa is: Ruth, Psalms, Job, Proverbs, Ecclesiastes, Song of Solomon,

Lamentations, Daniel, Esther, Ezra, Nehemiah and Chronicles.

Binding

Eighteenth-century brown leather binding with gilt edges, gold-tooled, with the initials M.B.
Eighteenth-century paper fly-leaf at the back binding, with watermark of a lamb holding a cross and the initials JW, of James Whatman II, 1764–1793.

Colophon

None.

History

Owners' Inscriptions

fol. 424r David Finzi b. Menahem Finzi.
fol. 11r Very faded: Eliakim b. Hosea Finzi sold the manuscript to Jacob b. Abraham of Sforno on Tuesday, 29 April 5271 (1511).
fol. 374r Outer margin: Illegible inscription in Latin characters.

Censors' Signatures

fol. 422v (1) 12 December 1555, D. Jacomo Giraldini;
(2) Fra Luigi da Bologna, 1602, Reggio.
Purchased by the British Museum, together with the
Harleian Collection, in 1753.

Decoration

Programme

A. Full-page panels of Sanctuary implements.
B. Full-page framed arcades.
C. Decorative micrography of the Massorah.
D. Decorative micrography of massoretic notes.

A. *Full-Page Panels of Sanctuary Implements.*

The Sanctuary implements are depicted in two confronting, full-page panels (fols. 7v and 8r). They are mostly in burnished gold, with a few of them in silver, on a background of manganese blue and light magenta rectangles, with an overall pattern of thin white brush scrolls. The frames of geometrical patterns are similar to those on the arcaded pages, with additional small gold squares. For biblical and other references, see introduction above.

fol. 7v (Fig. 326) To the right, over the entire height of a panel measuring 235 × 190 mm, is a seven-branched *Menorah* with round branches and a shaft in the centre; each branch is decorated with round knops, fleurs-de-lis and goblet-like bowls. From the lamps at the tops of the branches rise vermilion flames which bend towards the centre. In the leg part of the central shaft, arranged from bottom to top, there are: a flower, a goblet-like bowl, a knop and another flower, as described in the Bible. There are three additional knops at the branching points, and the whole rests on a thick, three-legged base. Two snuff shovels and two pairs of tongs hang from each of the lowermost branches, and flanking the central shaft are a pair of stone steps with four stairs. On the top, to the left, is the Ark of the Covenant with its carrying staves divided horizontally into two tablets inscribed with the opening words of the Ten Commandments in gold on a silver ground. Under it are two bowls, or mortars, as in the *Duke of Sussex Catalan Bible* (No. 12), fol. 3v (Fig. 311). Below those is a pitcher, which usually represents the laver, although here the laver takes a different shape (see below, fol. 8r). On its right is Aaron's flowering rod, with green leaves.

fol. 8r (Fig. 327) Measures: 232 × 194 mm. At the top, from right to left: the כיור, "laver", on a tall foot; a silver pan and a golden *shofar*; מזבח העולה, "the altar of burnt offerings", with three stairs on either side; two horns and a כבש, "ramp", separated from the altar. The flower-tipped rods on the altar and the ramp may be interpreted as two flesh-hooks, fire-pans or shovels, as in the *Duke of Sussex Catalan Bible*, fol. 4r (Fig. 310). Above the

altar are two יעים, "shovels", and below it are two silver חצצרה, "trumpets". To the extreme left is an amphora-like צנצנת המן, "jar of manna". In the lower part, on the right, is the שלחן, "table" of shewbread with six shelves, one on top of the other, supported by brackets. The loaves, shaped like open boxes, rest on the shelves, except for the lowest pair which rest on the table itself. There are no loaves on the top shelf. To the left of the table is מזבח הקטרת, the "incense altar", wrongly provided with a ramp. Beneath it to the left are two goblet-like קערות, "bowls" on top of two סירות, "pots", each pair alternately of silver and gold. Above the altar is a pair of flesh-hooks. In the left-hand corner is the cleft Mount of Olives, with a green tree on top and a stream of water on each hillock.

B. *Full-Page Framed Arcades.*

Twelve full-page framed arcades (fols. 1v–4r, 4v – Fig. 324, 7r and 8v–10r) with coloured arcades framing the differences between Ben Asher and Ben Naphtali; fols. 7r and 8v are without text. The four painted arcades, measuring (230–234) × (184–192) mm, are in magenta, manganese blue, vermilion, orange, light green, olive green and white, with burnished gold and silver and some brush gold. Each page consists of four trefoil arches on slim columns with ring-like capitals. The columns and frames are of various geometrical patterns. On some pages the trefoil arches are formed by larger, intersecting arches (e.g., fols. 1v–2r, 3v–4r and 9v–10r). The arches, columns and frames are heightened in white. In the spandrels are white and some silver foliage patterns and drop-like shapes, mostly in brush gold.

C. *Decorative Micrography of the Massorah.*

The Massorah in micrography, in the outer left or right margins, is most elaborate at the beginnings of books. The motifs are mostly differently shaped candelabrum-like trees (e.g. fol. 36v – Fig. 325), or elongated bars intersected by circles and other geometrical forms (e.g., fols. 11v, 20r, 34r and 113v). At the beginnings and ends of some quires, the Massorah in the lower margin is written in geometrical forms, mainly semi-circles, triangles, scale motifs (e.g. fol. 36v – Fig. 325).

D. *Decorative Micrography of Massoretic Notes.*

The number of verses of each book of the Pentateuch, and their mnemonic signs, are written in micrography outlining a circle enclosing the Star of David (e.g., fols. 36v – Fig. 325, 58r, 113v and 172v). Other verses form circles (e.g., fols. 290v, 296r and 299r).

Conclusions

The script and decorations are similar to those of the *Duke of Sussex Catalan Bible* (No. 19). The first

quire of 10 leaves (excluding fols. 5 and 6, which have been added later), with the arcaded pages and the Sanctuary implements, is an original part of the manuscript, though it may have been written by another hand. Its script and illumination are so closely related to the *Duke of Sussex Catalan Bible*, that our manuscript can be regarded as a second, slightly less elaborate example from the same workshop. The Sanctuary implements are painted on similar blue and magenta grounds and are of similar shape; e.g., the shewbread table — which is usually rectangular — is depicted in both manuscripts as having semi-circular sides. One difference between the two is that a greater number of implements is represented in our manuscript: the available space is due to the reduced size of the *Menorah* which fills only three quarters of a page, as in the *Perpignan* and *Copenhagen Bibles*. Another difference is that the implements are designated by their names written in ink on the gold and silver, though some of these

are effaced. The arcades, though slightly less ornate, are of the same type as in the *Duke of Sussex Catalan Bible* and certainly belong to the original decoration. Moreover, the script, which is in a different Sephardi hand, has been added to these pages at a somewhat later date. The Massorah is written in similarly shaped, though simplified, candelabrum-like trees; the candlestick pattern is less varied, and plainer, angular and geometrical patterns are applied. There is no way of distinguishing with certainty which of the two manuscripts is earlier. Both are probably the product of the same workshop in the third quarter of the fourteenth century.

Bibliography

Kennicott, *Dissertatio*, No. 100.
Ginsburg, *Introduction*, No. 3, pp. 477–478.
Margoliouth, No. 57, I, pp. 28–29.
Leveen, p. 183.

21. LONDON CATALAN BIBLE

Catalonia, third quarter of fourteenth century

BL, Add. 15252

Figs. 328–331

Bible.

General Data

Codicology

Vellum; I + 477 + II leaves; 305 × 225 mm. Text space 202 × 151 mm; height of the text space with Massorah 252–256 mm. Written in square Sephardi script, in light brown ink, 30 lines in two columns. Ruling by stylus on hair sides, 2 + 30 + 3 horizontal and 2 + 3 + 1 vertical lines. Pricking in upper and lower margins. 60 quires of 8 leaves each, except for Quires XV[4] and LX[10], which are gathered so that outward hair side faces hair. Catchwords on the verso of the last page of each quire.

Colophon

None.

History

fol. 1r (1) Samuel de Modena (Medina), the fifteenth-century Rabbi, and his sons. (2) Birth entries, in Spanish, of four sons of an unknown family in 1699, 1700, 1702 and 1704.
fol. 477v Censor's signature: Gio. Dominico Carretto, 1618.

Duke of Sussex Collection, VI.H.e.2 (No. 5). Purchased by the British Museum from his sale, 31 July 1844, Lot 103.

Decoration

Programme

A. Panels for the numbers of verses.
B. Decorated *parashah* signs.
C. Decorative micrography of the Massorah Magna.

Description

A. *Panels for the Numbers of Verses.*

At the end of each book, the number of its verses is written within a panel of blue, violet or red fine penwork (e.g., fol. 116r – Fig. 329).
fol. 315v (Fig. 331) Before Zephaniah there is a three-towered castle within the penwork.

B. *Decorated Parashah Signs.*

At the beginning of the 54 *parashot* of the

Pentateuch, the abbreviation פרש (*parash*) is written inside a penwork frame, mostly of paisley motifs, with a gold (fols. 4r–19r, 19v – Fig. 328, and 20r–74r) or silver (fols. 76v–113r) design of geometrical or floral motifs and some fleurs-de-lis.

C. *Decorative Micrography of the Massorah Magna.*

In the lower margin the micrography of the Massorah Magna is written in many geometrical patterns. In the outer margin of fol. 116v – Fig. 330 (the beginning of the book of Joshua and the verso of the first folio of a quire) it forms a candelabrum-like tree.

Conclusions

In size, script and layout, this manuscript belongs to the group of Catalan Bibles from the second half of the fourteenth century. In the absence of any painted illumination, the only decorations which can date the manuscript are the penwork panels at the beginnings and ends of books and the micrographical Massorah patterns, especially the candelabrum-tree in the margin of fol. 116v. The penwork panels are delicate and not very elaborate.

The micrography decoration is similar to that in other Catalan Bibles, such as a Bible of 1357 in Paris (Bibliothèque nationale, hébr. 30; see Sirat & Beit-Arié, I, No. 44) and the *Harley Catalan Bible* (No. 20). The candelabrum-like tree and the geometrical and foliage motifs are closest to the undated *Cambridge Catalan Bible* (No. 23); however, our manuscript is larger in size and the penwork in our manuscript is more delicate than that of the *Cambridge Bible*. The penwork in our manuscript is also not sufficiently similar in style for it to be dated as the *King's Bible* of 1384 (No. 22); its delicacy of outline is closer to the above-mentioned Bible in Paris, and may suggest an earlier date — the third quarter of the fourteenth century.

Bibliography

Sotheby Sale, 31 July 1844, p. 10, Lot 103.
Ginsburg, *Introduction*, No. 23, pp. 590 ff.
Margoliouth, No. 60, I, pp. 31–32.
Leveen, p. 184.
Sirat & Beit-Arié, I, *Manuscrits*, No. 44.
Metzger, T., Masora, Pl. XCVIII.

22. KING'S BIBLE *Solsona, 1384*

BL, King's 1 Figs. 332–336

Bible.

General Data

Codicology

Vellum; 1 + 429 + 1 leaves; 332 × (260–266) mm. Text space (205–216) × (167–170) mm. Written in a square Sephardi script, in dark brown ink, 32 lines in two columns, except for poetical parts. Ruling by stylus, on hair side, 2 + 32 + 3 horizontal and 2 + 2 + 1 vertical lines. Pricking is noticeable in all four margins. 55 quires, each consisting of 8 leaves, except for Quires I[2], II[6] (fols. 2r–7v) and LV[7] (last folio, pasted on back cover), which are gathered so that outward hair side faces hair. Each of the 53 text quires is numbered in Hebrew letters (some of which were cut off by a binder) at the top right-hand corner of the first leaf and at the bottom left-hand corner of the verso of the last leaf. Fols. 8r–427r were paginated in Hebrew letters at the top outer corner by a later, seventeenth-century hand. Ruth is preceded by Psalms, and followed by Job.

Colophon

fol. 427r (Fig. 336) Written by Jacob b. Joseph of Ripoll for R. Isaac b. Judah of Ṭulusah (Toulouse), and completed at Solsona in Kislev 4145 (16 November to 15 December 1384).

History

fol. 2v (Fig. 332) Original frontispiece: A design with an inscription stating that this מקדשיה, "God's Temple" — i.e., Bible — was given by the original patron, R. Isaac b. Judah of Toulouse, possibly to a synagogue (see Weider, Sanctuary).

fol. 1r Seventeenth-century Latin title page giving the names of the scribe, "Iacobo, Filio Rab. Iosephi de Riphullo in honorem Rab. Ishac, Filii Rab. Iehudah Tholosani, etc.", and also stating that the manuscript was given to a Jerusalem synagogue and dedicated in Narbonne.

A fly-leaf, dated 1768 and affixed to the manuscript, gives Dr Kennicott's English translation of the history of the book, which is written in Latin on fol. 1v. The manuscript belonged to a synagogue at Jerusalem, where it remained "till on account of the persecution of the Turks the Jewish Chief carried it to Aleppo, where his widow sold it. It came into the possession of the celebrated d'Avrieux, Consul for France and Holland at Aleppo in 1683. It is attested by three rabbis at Aleppo and witnessed by two Christians." It is also stated that Laurentius d'Avrieux ordered that the titles, chapters and verses, as well as three decorated pages (fols. 2r, 7v and 8r), the decorated massoretic lists (fols. 4v–7r and 427v–429r) and initial-work panels to all books, be added (see Kennicott, *Dissertatio*, No. 99).

fol. 8v Hebrew inscription by the scribe who was employed by d'Avrieux to make the additions, explaining the significance of his work.

Presented to the British Museum by King George IV in 1823.

Decoration

Programme

A. Full-page illustrations:
 1. Ornamental dedicatory frontispiece.
 2. The Sanctuary implements.
B. Decorated colophon.
C. Additional decorations:
 1. Full-page illustrations.
 2. Initial-word panels.
 3. Decorated chapter numbers.

Description

A. *Full-Page Illustrations.*

There are four full-page panels of pen-drawings, tinted with ultramarine blue, vermilion, olive green, brownish red, ochre and burnished gold, and with some red, violet and white penwork scrolls, all on the vellum ground. All are framed by verses written in ink and with gold squares in the corners. For biblical and other references to the Sanctuary implements, see above, introduction to Chapter Two, Section II.

1. *Ornamental Dedicatory Frontispiece*

fol. 2v (Fig. 332) Measures: 198 × 165 mm. The title מקדשיה is written in gold on an ultramarine blue panel with white penwork scrolls framed by a gold fillet. The tail of the Hebrew letter *qof* is extended, ending in a fleur-de-lis. Under the panel is a diapered carpet with a flowery scroll pattern in red and violet penwork tinted olive green and brownish red on the vellum ground. The carpet encloses the dedicatory inscription: ממני יצחק בר יהודה דטולושה זצ״ל, "From me, Isaac b. Judah of Ṭulusah..." The page is framed in brown ink by inscriptions from Ps. 119:1, 72, 97 and Prov. 3:16.

2. *The Sanctuary Implements.*

Three full-page panels (fols. 3r–4r) illustrate the Sanctuary implements.

fol. 3r (Fig. 333) The panel, measuring 226 × 181 mm, depicts a *Menorah*, consisting of six round branches and a shaft. Each branch has three goblet-like bowls, a large round כפתור, "knop", filled in with blue, and a double-leaved flower. The flower encircles blue cup-like lamps, from which rise red flames that bend towards the central shaft. There are three knops at the branching points on the shaft. The lower part of the shaft is decorated with two flowers and a bowl. A knop is missing and the lower flower is at the junction of the leg and its base. The shaft rests on three legs; a sketch of a rectangular base can be seen. A pair of gold tongs and a gold snuff shovel hang on each of the two lowest branches. Two ochre stone steps, each consisting of four stairs formed by four rows of bricks, flank the *Menorah*. The space between the branches is filled with red and violet penwork scrolls. The biblical verses on three sides of the frame (Ex. 25:31–40; 37:17–24 and the beginning of Prov. 6:23) allude to the making of the *Menorah*.

fol. 3v (Fig. 334) Measures: 222 × 117 mm. At the top right שולחן לחם הפנים, "The shewbread table", standing on four legs, is painted in tinted ochre with a gold (flaked off) frame and two rows of six gold shelves supported by four vertical gold poles (the lower shelves resting on the table). The loaves of bread, shaped like boxes, but with no front and back sides, are placed on the shelves. The four pointed shovel shapes on the tops of the four poles may represent the spoons for frankincense, as they resemble the shape of spoons inscribed with בזיכי לבונה in other depictions of the Sanctuary implements — e.g., the *Perpignan Bible* of 1299 in Paris (Bibliothèque nationale, Lib. 7, fol. 12v) — or ornaments, as can be seen from the tops of the shafts of other implements in our manuscript.

At the top left are כיור וכנו, "the laver and its stand". The laver — in the form of a gold (flaked off) pitcher with a long-necked dragon as a spout — is surrounded by an olive green gabled frame and rests on a three-legged base on a violet penwork-scroll background. Below, on the right, is the green הר הזתים, "Mount of Olives", with a three-branched tree on top. On the left is מזבח הקטרת, "The incense altar", painted in gold with a blue band and two gold horns. On either side of the altar is a green stave. A מחתה, "fire-pan", resembling a goblet-like censer, hangs from three chains. Two ochre objects, inscribed ואת הסירות, "and the pots", are above the altar; under it are two similar golden objects, each inscribed סירות, "pots". The pots do not belong to the incense altar, but to the altar of burnt offerings. The page is framed by an inscription from the end of Prov. 6:23 and from Ps. 19:8–10.

fol. 4r (Fig. 335) Measures: 219 × 186 mm. At the top right is a framed amphora-like implement

in gold, inscribed: צנצנת המן, "jar of manna". Its background is similar to that of the laver on the opposite page. To the left, the rectangular Ark of the Covenant, incorporating the Tables of Testimony, is framed in blue and inscribed with the beginnings of the Ten Commandments in blue and red, alternately. The inscription above it reads: ארון ולוחות, "Ark and Tables (of Testimony)". Above the Ark are two wings representing שנים כרובים, "two cherubim". A green rod stands on either side of the Ark; the one on the right, with leaves, is מטה אהרן, "Aaron's rod", that on the left is the barren rod of Moses. Beneath the Ark is a coloured acanthus scroll with gold fillings, which may allude to the golden vine over the entrance to the Sanctuary (Mishnah, *Middot* 3:8). Under a jar of manna is a golden *shofar* between two gold (not silver) trumpets inscribed with part of Ps. 98:6: בחצצרות וקול שופר, "With trumpets and sound of cornet". In the lower part, on the right, is the gold מזבח העולה, "The altar of sacrifice", with two steps on either side, two horns on top and two white rings on its base. On the left, separate from the altar, is an inclined ochre כבש, "ramp". Among the various tools and vessels arranged under the altar are: two brush-like ochre יעים, "shovels", and four מזלגות, "flesh-hooks", flanking a shovel-like fire-pan. Beneath these are two cauldron-like objects, each inscribed סיר, "pot", and two מזרקות, "basins", all in gold. On the left are the two columns of Solomon's Temple, יכין ובעז, "Yakhin and Boaz" (I Kings 7:15–22), twice inscribed. They are green with blue capitals and golden rings under the capitals and round the middle. A gold מחתה, "fire-pan", shaped as a bowl, hangs between the columns from three chains. The page is framed with inscriptions from the end of Ps. 19:10–11 and from Prov. 16:24; 3:8; Ps. 119:103.

B. *Decorated Colophon.*

The colophon (fol. 427r – Fig. 336) is framed by penwork in red and violet, with motifs similar to those used in the implement pages: scrolls of palmette and paisley motifs surrounded by various pearled lines and with linear elongations ending in tendrils, four grotesque heads and two confronting birds flanking a double-winged motif resembling a tree.

C. *Additional Decorations.*

The additional decorations were done for Laurentius d'Avrieux after he acquired the manuscript in 1683.

1. *Full-Page Illustrations.*

The three full-page illustrations: fols. 2r, 7v and 8r, measuring 222 × 188 mm, are richly painted in ultramarine blue, linden green, yellow, ochre, crimson and brush gold with all the shapes outlined in black. All the full-page panels, as well as the massoretic tables (fols. 2r and 4v–7r), are framed by biblical verses in brown ink, blue or gold, with gold squares in the corners.

fol. 2r Frontispiece depicting the glory of God: The name of God is written in large letters within a radiating aureole and surrounded by the names of the nine categories of angels, the four archangels and the four beasts of Ezekiel.

fol. 7v The Tables of Testimony, in ultramarine blue, are inscribed in gold with the beginnings of the Ten Commandments and framed by two gold fillets with a white band between them inscribed with verses from Ex. 31:18; 32:16; Deut. 4:13. The name of God is written above in white, within a golden aureole radiating white, red and gold rays on a blue background. The inner frame of gold and purple bands is inscribed in gold with Deut. 5:22 and Ex. 19:16. The page is framed by Ps. 34:20–23, written in gold.

fol. 8r Title page: The title is inscribed in gold within a purple triumphal arch on a blue ground, with linden green columns and other decorations — some in gold — inscribed with the names of the tribes, patriarchs and kings, the name of God on the gable, and Ps. 118:20 and Prov. 4:2. The page is framed in blue by Ps. 24:7, 10; Is. 26:2; Mal. 3:22; Deut. 33:4; 4:44.

2. *Initial-Word Panels.*

The initial-word panels to all books are mostly over one column (78–88) × (36–48) mm (see fols. 31r, 51r, 65v and 87r and many others), but some extend over both columns (106–108) × (35–38) mm; e.g., fols. 8v and 363r. The titles, in gold letters, are written on a coloured ground surrounded by a floriated gold cartouche and within a coloured panel which in some cases (e.g., fols. 8v and 363r) includes additional gold patterns. The backgrounds are coloured olive green, ultramarine blue or purple. The panels are framed by one or more green, purple, blue or gold fillets with black and red lines. Some initial words have only the cartouche, without a panel (e.g., fols. 278r, 283v, 288v, 330r, 331v and 370v). All shapes and most letters are outlined in black.

3. *Decorated Chapter Numbers.*

The red penwork decorations for the chapter numbers consist of filigree patterns, feathers, buds, spirals, leaves, flowers and geometric shapes.

Conclusions

The manuscript is a late example of the fourteenth-century group of Catalan Bibles having a full-page display of the Sanctuary implements. The date in the colophon is important for dating other manuscripts in this group. The second quire (fols. 2–7), which includes the dedicatory page and the Sanctuary implements, is written by a different

though contemporary hand. It may have been added at the time of the assumed donation to a synagogue, probably at the time the Bible was written, as suggested by the style of the penwork decoration. At any case, it was added in the lifetime of the donor, R. Isaac b. Judah, for whom the manuscript was written.

The seventeenth-century illuminations were, as already stated, added after 1683 by the order of Laurentius d'Avrieux.

The iconography and lay-out of the implements is dependent on the Roussillon tradition of around 1300, namely the *Perpignan Bible* of 1299 (Paris, Bibliothèque nationale, hébr. 7, see Gutmann, *Manuscript*, Pls. 6, 7) and the *Copenhagen Bible* of 1301 (Kongelige Bibliothek, MS II; see *Synagoga, Cat. Exhib.*, No. 138), which ultimately derive from the Bible of 1277 from Toledo, now in Parma (Biblioteca Palatina, Parm. 2668; see *Manoscritti biblici ebraici*, No. 32).

The composition of the implement pages is much more spacious than in the earlier Bibles in the British Library (above, Nos. 19–20). Despite having no background, there is a similarity between them: none of the implements is framed, although some seem to be grouped together, and the two confronting folios (3v and 4r) are balanced in their composition. The sketchy Mount of Olives, coloured in green and ochre wash, looks loftier than in the other Bibles mentioned above and should be related to the *Ambrosian Pentateuch* (Cod. C.105 sup., fol. 2r; see Nordström, *Bibles*, Figs. 15, 16). The foliage in the scroll of the golden vine in our Bible (fol. 4r) is rendered similarly to the four corner-leaves of fol. 2r in the *Ambrosian Pentateuch*.

Bibliography

Kennicott, *Dissertatio*, No. 99.
Ginsburg, *Introduction*, No. 9, pp. 512 ff.
Margoliouth, No. 56, I, pp. 26–28.
Leveen, Pl. VI.
Nordström, Bibles, pp. 89–105.
Weider, Sanctuary.
Synagoga, Cat. Exhib., No. 138.
Manoscritii biblici ebraici, No. 32, Pls. 24, 25.
Gutmann, *Manuscript*, Pls. 6, 7.

23. CAMBRIDGE CATALAN BIBLE

Catalonia, last quarter of fourteenth century

CUL, M.m.5.27

Fig. 337

Bible.

General Data

Codicology

Vellum; 465 + II (fols. 466 and 467) leaves; 260 × 200 mm. Text space 175 × (122–125) mm; height of the text space with Massorah 240–245 mm. Written inS square Sephardi script, in brown and light brown ink, mostly 33 lines in 2 columns. Ruling by stylus, 2 + 33 + 3 horizontal and 1 + 2 + 1 vertical lines; often 3 double lines for the Massorah in the outer margins. Pricking is noticeable in the inner and upper margins. 58 quires of 8 leaves each, except for Quire LVIII^{8-1}, of which fol. 464 is missing; fol. 465 is a fly-leaf. All 58 quires are numbered in Hebrew letters in the top right-hand corner of their first page. They are gathered so that outward hair side faces hair. Catchwords are at the bottom of some last pages, others have been cut off by a binder. The chapters are numbered by a later hand, except for Psalms where the numbering is original.

Binding

Modern morocco binding by Douglas Cockerell & Son, 1951, replacing seventeenth-century French or Italian boards of light brown sheepskin, with a narrow blind-tooled band round the edges and a rhomboid in the centre. Up to 1951 the manuscript was wrongly bound, and a later hand noted the correct sequence (Schiller-Szinessy, p. 15).

Colophon

None (see below, History and Conclusions).

History

fol. 463r End of the Bible: The so-called colophon is, perhaps, a copy of an archetype of 856, or a forgery. Possibly it is an owner's or corrector's inscription of 1650 in a square Italian hand. It reads: "I, Jacob ha-Levi, a scribe (סופר) / completed (or signed) this book /

the 7th of the 12th month, which is Adar / in letters and script of elegance / the year 4616 (or 5411: הַתּוֹרה) of Creation (Tuesday, 18 February 856 or 28 February 1651) / תקק (or חקק; 600 or 208) to the building of the Temple / etc... Let the voice of the Redeemer be heard soon / in gathering our nation from beyond the river etc..." (for the complete Hebrew inscription, see Schiller-Szinessy, p. 13).

Jacob ha-Levi is probably to be identified with "hand 6" of Schiller-Szinessy's description, having numbered the biblical chapters — except for Psalms — in Hebrew characters according to the Christian division (compare especially the letters *yod*, *hé* and *qof*). He also retouched the script where the ink had faded and made pencil notes of where to find the continuation of the text (e.g., fols. 224v, 232v, 240v, 248v, 256v and 164v: "*x* pages ahead"), as the manuscript was still wrongly bound. These additions and corrections may be the "elegant letters" to which he refers in his "colophon".

Acquired by Bishop Moore, along with other manuscripts from France, shortly after 1697; No. 1006 (e.15) in his collection.

Presented to the University of Cambridge by King George I, together with the rest of Bishop Moore's Collection, in 1715.

fol. 466r Description and signature in Latin on a paper leaf: "Hic Codex fuit exaratus Anno Mundi 4616, id est Anno Christi 856. Israel Lyons Jun. 1753."

Decoration

Programme

A. Decorative micrography of the Massorah.
B. Full-page imprint of missing page.
C. Decoration in penwork and micrography.

Description

A. *Decorative Micrography of the Massorah.*

Micrographic Massorah, in candelabrum- or tree-like forms, is written in the outer margins, mostly on three pages at the beginning and one page at the end of the quires (e.g. fol. 97v – Fig. 337). Many are topped by palmettes, and some incorporate small panels for marginal notes such as *parashah* signs and Psalm numbering. On fol. 241v is a band with a double zigzag pattern. The patterns in the lower and in some of the upper margins consist mainly of combinations of triangles and circles attached to the straight Massorah lines. All the micrography shapes enclose pen-drawn circlets.

B. *Full-Page Imprint of Missing Page.*

fol. 465v This is an imprint of a missing full-page arcade in green and purple. The leaf possibly belonged to a missing quire at the beginning of the manuscript and faced a decorative arcade containing massoretic differences (cf. No. 12).

C. *Decorations in Penwork and Micrography.*

At the beginnings and ends of books there are decorations in penwork and micrography. The penwork title panels extend across one text column. The word ספר, "book", or the title, is written in burnished gold (red on fols. 304r and 314r), mostly within small coloured compartments enclosed in rectangular penwork panels (fols. 56v, 97v – Fig. 337, 181r, 216v, 241v and others). In some places the central compartment is missing and the decoration consists of penwork alone (e.g., fols. 118r and 133r). The panel for Job (fol. 373v) extends over both text columns. Many panels are flanked by penwork roundels with additional flourishes extending into the margins (e.g., fols. 31v, 56v, 118r, 300v, 304r and 373v).

The penwork is in red, violet, green and ochre. The main motifs are various geometrical and foliate shapes filled with club motifs, as well as curly scrolls (e.g., fols. 31v, 56v, 118r, 133r and 146v) and scrolls with scallop-edge leaves (e.g., fols. 56v and 273r). The title compartments are mostly blue or violet, though one is gold (fol. 304r) and some are in penwork (e.g., fols. 146v, 216v and 241v). Some have small stylized flowers extending from their corners (e.g., fols. 118r, 181r and 304r). On fol. 97v a blue compartment with crude, thin silver scrolls is placed against a red chequered ground. In a few places small micrography panels of geometrical patterns decorate the ends of books (e.g., fol. 322r — end of Latter Prophets). That on fol. 73v (end of Leviticus), extending from the micrography tree in the outer margin, is further decorated with pen flourishes. A small penwork panel on fol. 31v fills a spared space in the text.

Conclusions

The date of the manuscript can be determined by both the script and the decoration. Although the tree-like design of the micrographic Massorah is similar in its angularity to that of the *Duke of Sussex Catalan Bible* (above, No. 19) and *Harley Catalan Bible* (above, No. 20), both dating from the third quarter of the fourteenth century, the script and the penwork may point to a later date. The penwork on the panels is closer to that on the implement pages of the *King's Bible* of 1384 (No. 22) and to its script. The small painted panels within the larger penwork may point to a date later than that of the *King's Bible*. The penwork of the initial-word panels divided into compartments and the use of scalloped acanthus and club motifs are similar to those of the *Cambridge Catalan Maimonides*, dated to 1396 (No. 32), although there they are somewhat cruder. The smaller size of our Bible corroborates its dating to the last quarter of the fourteenth century. The ninth-century date suggested by the so-called colophon is, therefore, very unlikely.

As Kennicott has suggested, this so-called colophon may be a forgery, or it may be a copy of the colophon in the ninth-century archetype, as

assumed by Loewe (*Hand List*, No. 21), who bases his supposition on Kahle's arguments regarding the antiquity of the Massorah in the manuscript (Kahle, *Massoreten*, p. 7). In a later publication, however, Kahle changed his mind about the antiquity of the manuscript, though he maintained that the massoretic model was old (Kahle, *Cambridge Bible*). The inscription is more likely to be by a later owner, who added a few elements to the Bible (see above, History, fol. 463r). This owner may also have been a scribe, or his name may have happened to be Sofer. The possibility of reading the mnemonic sign הַתּוֹרָה as 5411 (1651) makes this date more plausible. The script is completely different from that of the text and is probably of seventeenth-century Italian origin. The reference to the building of the Temple does not make any sense (see Zunz).

The desire for "the gathering of our nation from beyond the river" is a general one and does not mean that the manuscript was written in Palestine (cf. Schiller-Szinessy, p. 14), as opposed to "beyond the river", i.e., Babylon (cf. Josh. 24:2 and Is. 7:20). Any part of the Jewish Diaspora could have been referred to poetically as "beyond the river" in the Middle Ages. The language and verses of the so-called colophon also point to a later date.

Bibliography

Kennicott, *Dissertatio*, No. 89, pp. 374–376.
Zunz, *Geschichte*, I, pp. 214–215.
Schiller-Szinessy, No. 12, pp. 12–15.
Loewe, *Hand List*, No. 21.
Kahle, *Massoreten*, p. 7.
Kahle, Cambridge Bible.
Metzger, T., Masora, Pls. XCVIII, XCIX.

24. CASTELLÓN D'AMPURIAS PROPHETS/AND HAGIOGRAPHA

Castellón d'Ampurias, 1396

BL, Harley 5774–5775

Figs. 338–351

Prophets (Vol. I, Harley 5774) and Hagiographa (Vol. II, Harley 5775).

General Data

Codicology

Vellum; Vol. I: I + 323 + 1 (fol. 322a) + II; Vol. II: I + 217 + 1 (fol. 217a) + I leaves; (233–240) × 175 mm. Text space (145–150) × (103–105) mm; height of the text space with Massorah 190–205 mm. Written in square Sephardi script, in light brown ink, 25 lines in two columns. Ruling by stylus on hair side, 2 + 25 + 3 horizontal and 2 + 2 + 1 vertical lines. 41 and 28 quires of 8 leaves each, except for Vol. I, Quire XLI⁴, and Vol. II, Quires I⁵ and XXVIII⁵, which are gathered so that outward hair side faces hair. Each quire is numbered, in Hebrew alphabetical order, at the top right-hand corner of the first leaf and at the bottom left-hand corner of the verso of the last leaf. Most of the markings at the ends of the quires have been cut off. Vol. II, fol. 125 is a later replacement. Vol. I, fols. 322a recto to 323v; Vol. II, fols. 2r and 217a recto and verso are blank. The Pentateuch volume is missing.
Names of books and chapters have been added in Latin.

Colophon

II, fol. 217v (Fig. 351) Written in Castellón d'Ampurias and completed in the month of Elul 5156 (6 August to 4 September 1396) by Ezra b. Jacob b. Aderet.
II, fol. 2v In the original hand: Genealogy and list of dates from Adam to Mohammed (4335!).

History

II, fols. 1r, 1v (Fig. 339) List of the beginnings of Psalms (division into 149 psalms), in a fifteenth-century round Sephardi hand.
II, fol. 217v (Fig. 351) Two separate Latin calculations of the date of the manuscript: (1) 1696 — stating it was written in "Castilion d'Amphora" (!) and completed in "mense Julio"; (2) 1708 — by the owner, Bernardi de Monfaucon.

Owners' and Inheritance Inscriptions

All are in eighteenth-century Hebrew oriental decorative script.
I, fols. 1r, 24r (Fig. 342), *169r, 323r* Abraham; Makhluf; Obadiah ha-Levi b. Joshua.
II, fol. 217a verso Samuel al-Qavez.
Nos. 148.C.3–4 in the Harley Collection.
Purchased by the British Museum from the Countess of Oxford and Mortimer and from the Duchess of Portland in 1753.

Decoration

Programme

A. Decorative micrography of the Massorah.
B. Decorative frames in micrography.
C. Titles of *haftarot* in decorative micrography.

Description

A. *Decorative Micrography of the Massorah.*

Very elaborately decorated pages, sometimes completed by pen-drawings, with similar decorations round two opposite pages or round a single one, are often found at the openings of books (Vol. I, fols. 1v – Fig. 339, 2r – Fig. 338, 23v, 24r – Fig. 342, 46v – Fig. 341, 47r – Fig. 340, 100v–101r, 158v–159r, 196v–197r, 245r – Fig. 343, 288v – Fig. 344, 289r, 293v–294r, 296v–297r and 301r; Vol. II, fols. 3r – Fig. 347, 3v–4r, 6v–7r, 59v–60r, 79v – Fig. 349, 80r – Fig. 348, 101v–102r, 107v–108r, 115r, 129v, 136v–137r and 159v – Fig. 350). Most other beginnings of books are decorated at the top and bottom, between the text columns or in the outer margins (e.g., Vol. I, fols. 302r, 303v, 308r, 309v and 320r). At the beginning and end of many quires, the micrography in the lower margin is decorated in similar confronting motifs (most quires of Vol. I, fewer quires of Vol. II).

Side Margins at the Beginnings of Books.

The decorations in the side margins at the beginnings of books consist of:

1. Candelabrum-like trees with a central shaft, interrupted by or terminating with branches of knops, buds, lozenges, demi-palmettes, fleurs-de-lis and other symmetrical foliage motifs, most of which enclose minute pen-drawn circles (e.g., Vol. I, fols. 1v – Fig. 339, 2r – Fig. 338, 301r, 308r, 320r; Vol. II, fols. 2v – Fig. 346, 3r – Fig. 347, 6v–7r, 59v–60r, 79v – Fig. 349, 80r – Fig. 348, and 217v – Fig. 351).
2. Naturalistic trees with interlacing branches; small pen-drawn leaves, mostly with a segment of ground and with one or two birds on top (e.g., Vol. II, fols. 46v, 47r and 294r).
3. A "weeping willow" made up of a string of oval beads, with pairs of pear-shaped leaves (Vol. I, fol. 309v).
4. Angular plaits with large and small rosettes (Vol. I, fol. 245r – Fig. 343).
5. A large rosette on a linear stem (e.g., Vol. I, fols. 296v and 303v).
6. Bands with foliage scrolls at the four corners of the text (e.g., Vol. I, fols. 23v, 24r – Fig. 342).
7. Large and small rosettes strung along a wavy line (Vol. II, fols. 101v and 159v – Fig. 350), or roundels on a line (Vol. II, fols. 115r and 129v).

Upper and Lower Margins at the Beginnings of Books.

Most of the micrography in the upper and lower margins consists of a central motif, often flanked by various geometrical motifs. The central motifs are:

1. A fish-scale pattern enclosing minute, pen-drawn circles that are clustered together to form triangular or various lozenge shapes. The scale pattern is at times used as a flanking motif for a similar form (e.g., Vol. I, fols. 1v – Fig. 339, 2r – Fig. 338, 256v–257r, 272v–273r and 304v–305r; Vol. II, fols. 3v–6r, 29v–30r, 101v and 213v–214r). In some instances the flanking motifs are joined to the central one to form a continuous pattern of spheres along the lower margin (e.g., Vol. II, fols. 79v – Fig. 349, 80r – Fig. 348, and 115r). Other forms sometimes incorporate similar circles and semi-circles.
2. A Star of David (e.g., Vol. I, fols. 1v–2r), combined with circles (e.g., Vol. I, fol. 24r – Fig. 342) or enclosed in a rosette (e.g., Vol. I, fols. 46v – Fig. 341, and 296v).
3. Different rosettes (e.g., Vol. I, fols. 16v–17r, 47r – Fig. 340, and 293v–294r; Vol. II, fols. 2v – Fig. 346, 136v and 159v – Fig. 350), including two concentric circles (e.g., Vol. I, fols. 23v, 120v, 121r and 159r; Vol. II, fols. 6v–7r, 20v–21r, 59v–60r and 107v) and other variations of circles composed of incomplete circles (e.g., Vol. I, fols. 168v–169r and 240v–241r; Vol. II, fols. 8v–9r and 137r).
4. Fleurs-de-lis (e.g., Vol. II, fols. 5v, 107v, 108r and 159v).
5. An interlace of crossed ovals (e.g., Vol. I, fol. 145r) or a small interlace shaped as a foliage motif (e.g., Vol. I, fol. 1v – Fig. 339).
6. Bands decorated in continuous geometrical forms such as circles and spirals (e.g., Vol. I, fols. 293v–294r; Vol. II, fols. 157v–158r and 159v – Fig. 350); spirals and circles round the text and between the text columns, also incorporating small rosettes and lozenges (e.g., Vol. I, fols. 32v–33r, 184v–185r and 196v–197r); V-shapes forming lozenges or zigzags (e.g., Vol. I, fols. 8v, 72v and 73r; Vol. II, fols. 21v–22r, 53v–54r, 69v, 77v, 78r and 149v–150r); and pear shapes (e.g., Vol. I, fols. 248v–249r; Vol. II, fol. 46r) or rosettes (e.g., Vol. I, fol. 322r – Fig. 345; Vol. II, fol. 3r – Fig. 347) interrupting the straight lines.

Between the Text Columns.

In some places between the text columns there is a motif connected with the central motif (at the top, bottom, or both) by a straight or wavy vertical line. The motif is that of a small foliage (e.g., Vol. I, fols. 1v – Fig. 339, 2r – Fig. 338, 288v – Fig. 344, and 289r; Vol. II, fols. 101v–102r, 107v–108r, 115r and 137r), a small circle (e.g., Vol. I, fol. 158v; Vol. II, fols. 3r – Fig. 347, 45v–46r, 79v and 129v) or a fleur-de-lis (e.g., Vol. II, fols. 3r – Fig. 347, 79v – Fig. 349, 107v–108r and 189v).

Above and Below Text Columns.

This decoration consists of fleurs-de-lis (e.g., Vol. I,

fol. 288v – Fig. 344) or helmets with crests (Vol. I, fol. 288v – Fig. 344).

B. *Decorative Frames in Micrography.*

The frontispiece to Vol. II (fol. 2v – Fig. 346) and the end of both volumes are framed with decorative micrography of some Psalms, similar to that of the Massorah.

1. The genealogical list (Vol. II, fol. 2v – Fig. 346) written in two narrow columns is framed by verses (Ps. 119:1–4) in bold script and surrounded by a micrographic frame with two candelabrum branches on either side, three small rectangles on a wavy line on top and a large rosette as a central motif flanked by horizontal lines at the bottom. There is a band of single foliage scrolls between the text columns, and a fleur-de-lis on top of each.

2. The end of the book of Prophets (Vol. I, fol. 322r – Fig. 345) written in one text column is framed by a wavy line in micrography, interspersed with rosettes, fleurs-de-lis, circles, interlacing polygons, with two dragon heads back-to-back at the bottom.

3. The numbers of verses of the twelve Minor Prophets (Vol. I, fol. 322v) are written in the shape of a roundel at the centre of the otherwise empty page, and are enclosed in an eight-pointed star formed by two interlacing squares (78 × 78 mm).

C. *Titles of Haftarot in Micrography.*

Titles of *haftarot* in the margins are surrounded by decorative forms in micrography (e.g., Vol. I, fols. 4v, 28r and 66r).

Conclusions

These two volumes of an incomplete Bible are somewhat smaller in size than the large *King's Bible* of 1384 (above, No. 22) and the large, single-volume Bibles which usually contain full-page illustrations of the Sanctuary implements, e.g., the *Duke of Sussex Catalan Bible* (above, No. 19) and the *Harley Catalan Bible* (above, No. 20). In spite of its size, the missing Pentateuch volume of this Bible may also have had an array of implements, similar to those in the fifteenth-century stage of the *Second Cambridge Castilian Bible* (below, No. 52) which has a page of Sanctuary implements (fol. 11r) as part of its decoration.

Although the manuscript was copied in 1396, after the destruction of most of the Spanish Jewish communities in 1391, it shows a traditional illumination programme and decorative micrography related directly to the group of pre-1391 Bibles. This entails the more elaborate openings and endings of books and of quires typical of the earlier Catalan Hebrew Bibles. The geometrical and foliage motifs favoured by Ezra b. Jacob b. Aderet, and especially the candelabrum-like tree, are frequently used in the large Bibles of the third quarter of the fourteenth century. These motifs may help to date other Bibles of the late fourteenth and beginning of the fifteenth century.

It is possible that the Catalan tradition of illuminated Bibles was saved by the proximity of this area to Roussillon, a Provençal-speaking region linking southern France and Spain, where the *Farhi Bible* (Sassoon Collection, MS 368, see Sassoon, *Ohel David*, I, p. 11 ff.) was executed by Elisha b. Abraham Benvenisti (called Crescas) between 1366 and 1382.

Bibliography

Margoliouth, No. 121, I, pp. 88–89.

Sassoon, *Ohel David*, I, pp. 11–23.

Metzger, T., Masora, Pls. XCVIII–XCIX.

25. LONDON CATALAN PENTATEUCH

Catalonia, late fourteenth century

BL, Harley 5773

Figs. 352–360

Pentateuch, haftarot and the Five Megillot.

General Data

Codicology

Vellum; II + 248 + 2 (fols. 171a and 171b) leaves; *c.* 220 × 170 mm. Text space (137–144) × (117–125) mm; height of the text space with Massorah 175–178 mm. Written in square Sephardi script, in brown ink, 25 lines in two columns. Ruling by stylus on the recto of folios, 3 + 25 + 4 horizontal and 2 + 3 + 2 vertical lines. Pricking is noticeable in some of the lower margins and in the outer margin (e.g., fol. 246r). Fol. 248 is a fragment mounted on paper. The edges of some other leaves are also mounted. 31 quires of 8 leaves each, except for Quires (XV–XIX)[10], XX[6], XXI[5] and XXXI[5], which are gathered so that outward hair side faces hair. Numbering in Hebrew alphabetical order has survived at the beginning of many quires: the beginning of Quire I is marked *alef*, and again *alef* marks a new sequence at the beginning of the *haftarot* on Quire XXII (fol. 172r). Catchwords, in several hands, have survived at the ends of some quires. Fol. 171v, its two following leaves and fol. 247r–v are blank.
Some chapter numbers and sometimes even verses (e.g., fols. 103v–104v) have been added in Roman numerals, as well as some titles in Latin.
Hebrew chapter numbers have also been added in the margins, as have the names of the *parashot* in the upper corners of the rectos. The titles and beginnings of the *haftarot* are repeated in the margins of the relevant leaves.

Colophon

None.

History

The original binding of this manuscript, which is lost, had according to Margoliouth (I, pp. 50–51): "... a Latin description of 1678 pasted on the back of fol. 2*, this manuscript is reckoned as the first volume of a series completed by Harley mss. 5774–5775. Cf. inscriptions in Harley 5775, fol. 217v."
Other illegible inscriptions are on fols. 1r and 246v –248r (see also § D).
Purchased by the British Museum from the Countess of Oxford and Mortimer and from the Duchess of Portland, together with the Harleian Collection, in 1753.

Decoration

Programme

A. Decorative micrography of the Massorah.
B. Panels in micrography.
C. Decorative *parashah* signs.
D. Ornamental writing of the word *hazaq*.

Description

A. *Decorative Micrography of the Massorah.*
The Massorah is written in geometrical shapes in the margins and between the text columns of almost every page up to fol. 51v; after that they become rare. The more elaborate schemes of decoration are placed at important parts of the text, where they form a full-page frame (e.g., fol. 1v: the beginning of Genesis; fols. 55v, 56r – Fig. 360: the First Song of Moses). In other places, often near the ends of quires, the decoration partly frames the text (e.g., fols. 8r – Fig. 353, 16r, 24v, 31v, 49r, 49v, 80r, 112v, 168v and 169r); on the last pages of some of the first quires it runs between the text columns. On other pages the decoration consists mostly of motifs in the upper and lower margins, or extending into the space between the text columns.
The writing and decorating of the Massorah was executed by two hands: the first one wrote fols. 1v–47r, whereas the second wrote from 47v onwards.
1. Typical of the first hand are the motifs between the text columns, which consist of elongated triangles extending from the Massorah lines and terminating in angular or rounded plaits or single curls. On the last pages of the first four quires the plaits are continuous along the space between the text columns (fols. 8v, 16v – Fig. 354, 24v and 32v); at the end of the fifth quire (fol. 40v) there is a band with a zigzag pattern in the same place. Also employed are segments of circles, zigzags and single V-shapes attached to the Massorah lines in the upper or lower margins, as well as knots (e.g., fols. 2v and 18r), curls (e.g., fols. 11r–v, 13r, 14r and 32v) or circles (e.g., fol. 10r) at the middle or end of the lines (cf. the full-page frame on fol. 1v); sometimes the Massorah lines are written in a plait (e.g., fols. 5r, 6v, 15r) or wave (fol. 31v – Fig. 356) pattern.
Patterns in the side margins consist mostly of different combinations of semi-circles (e.g., fols. 8r – Fig. 353, 16r, 24v and 31v – Fig. 356) or zigzags (e.g., fols. 9v, 10r, 11r, 27r, 43r and 46r). In some places there are small pen-drawn sections of plait

within the Massorah lines (e.g., fols. 2v, 21r, 28r, 33r and 36r). Other motifs fill micrography triangles: a tree composed of sections of plait and curls (fol. 18v – Fig. 355) and a small panel with a spared ground interlace (fol. 41v; cf. § C).

The style of this group of decorations is rigid and angular, and many of the motifs are executed in double lines of micrography.

2. The second hand employs different combinations of large sections of a circle and pear-shapes, often at the middle of the Massorah lines. Other shapes, among them bands with single or double rows of semi-circles, are also used in different locations in the margins and between the text columns (e.g., fols. 47v, 48r – Fig. 358, 48v–49v, 50r – Fig. 359, 50v, 51v, 54r, 57r–v and 81r–v); they frame the text in fols. 55v–56r — the First Song of Moses. On fol. 56r (Fig. 360) there is also a section of angular plait between the text columns in the lower part of the page and small framed pen-drawn knots at three corners of the full-page frame. This hand also employs many irregular angular shapes (e.g., fols. 47v–49r, 64v–65r, 66r, 72v–73r, 80r, 88v–89r, 104v, 113v and 163r) and a few zigzag bands (e.g., fols. 47v, 51r–v and 89r–v).

B. *Panels in Micrography.*

The massoretic notes at the ends of three books are written in micrography that forms rectangular panels. The panel on fol. 171r (end of the Pentateuch) consists of three rectangles, one inside the other, the inner two with semi-circles at their inner corners. The single rectangle on fol. 80r (end of Exodus) also has such semi-circles, with a circle at the centre; the rectangle on fol. 106r (end of Leviticus) was originally plain (see § D).

C. *Decorated Parashah Signs.*

Two of the *parashah* signs (fols. 5v – Fig. 352, and 22r) have a small pen-drawn panel above the sign decorated with an angular, interlacing pattern in spared-ground, and sometimes with a section of plait pattern. On fol. 22r the sign and its decoration are surrounded by additional curls. There is also a small, crude frame to the *parashah* sign in the outer margin of fol. 42v (Fig. 357).

D. *Ornamental Writing of the Word Ḥazaq.*

Pen-drawings were written in yellow ink by the same hand that added the inscriptions on fols. 1r, 246v, 247r and 247v. These include ornamental writing of the word *ḥazaq* at the end of Genesis (fol. 42v – Fig. 357) and of Leviticus (fol. 106r), the latter in much smaller letters written within the original micrography frame.

Conclusions

This manuscript belongs to a group of small Bibles written in square Sephardi script, in two columns, with micrographic decoration. It can be compared with the two-volume *Castellón d'Ampurias Prophets and Hagiographa* of 1396 (above, No. 24), in which the more sumptuous micrographic decoration has similar elements. It is also related to the undated *Oxford Catalan Pentateuch* (No. 26), which belongs to the same group.

Bibliography

Margoliouth, No. 76, I, pp. 50–51.

26. OXFORD CATALAN PENTATEUCH

Catalonia, late fourteenth century

Bodl., Hunt. 69

Figs. 361–362

Pentateuch.

General Data

Codicology

Thick parchment; I + 191 + I leaves; *c.* 310 × 215 mm. Text space (185–191) × (152–155) mm; height of the text space with Massorah 235–270 mm. Written in square Sephardi script, in brown ink, mostly 22 lines in two columns. Ruling by stylus, mostly 2 + 22 + 3 horizontal and 2 + 3 + 1 vertical lines. 25 quires of 8 leaves each, except for Quires V^6, XXII6 and XXV5. Most quires are marked with catchwords at the end. A later hand added, in black ink, foliation in Hebrew letters, titles in the upper margins, as well as chapter numbering and other notes in the side margins.

Binding

Modern.

Colophon

None.

History

None.

Decoration

Programme

A. Decorative micrography of the Massorah.
B. Spaces for frames and initial-word panels.

Description

A. *Decorative Micrography of the Massorah.*

Decorative writing of the Massorah is found in the upper and lower margins, especially at the beginnings and ends of quires (e.g., fols. 8v, 24v–25r, 32v–33r, 38v–39r, 46v–47r, 54v, 62v, 71r, 78v–79r, 86v–87r, 92v – Fig. 362, 108v–109r,

116v, 132v–133r, 140v, 156v–157r and 187r) and at the important parts of the text (e.g., fols. 1v–2r — beginning of Genesis; fols. 63v, 64r – Fig. 361: the First Song of Moses and the preceding page). There is also some decorative Massorah on a few other pages (e.g., fols. 2v, 4r, 19v and 36v). The decoration consists of various combinations of micrography in circles, semi-circles and ovals, as well as X- and V-shapes attached to the straight Massorah lines. These lines sometimes extend into the margins in irregular shapes.

B. *Spaces for Frames and Initial-Word Panels.*

Space has been left for full-page frames and initial-word panels at the beginning of Genesis (fol. 1v) and of Deuteronomy (fol. 157r). A blank page (fol. 90v) and space for a panel (fol. 91r) have been left at the beginning of Leviticus.

Conclusions

The manuscript originally belonged to a three-part Bible, but the other two volumes are lost. In script, general appearance and the spaces left for full-page frames, it resembles a volume from another three-part Bible (Bodl. Opp. Add. fol. 15, Neubauer No. 41), which is, however, larger in size. The micrographic decoration of this manuscript resembles that of the *London Catalan Pentateuch* (above, No. 25) and the *Castellón d'Ampurias Prophets and Hagiographa* (above, No. 24), of which Vols. II–III were completed in 1396.

Bibliography

Neubauer, No. 41.

Various Books of the Fourteenth-Century Catalan Schools
[Nos. 27–32]

No specific decoration programme distinguishes this group from other manuscripts of the fourteenth-century Catalan schools. Their subject matter varies from philosophy and polemics to Maimonides' *Guide of the Perplexed* (Nos. 29, 32) and Levi ben Gershom's *Book of the Wars of God* (No. 31).

There is one commentary on the Pentateuch (No. 30), a Midrash (No. 27), and a rare collection of *Maimonides' Aphorisms in Arabic* (No. 28), written in Hebrew characters. Most of the decoration in these manuscripts pertains to the opening or title pages, which have full-page decoration, and to initial-word panels at the beginning of chapters and other divisions. The common use of penwork – as part of the work of the scribe – makes the odd painted scroll appear a lavish decoration. The absence of text illustrations and dearth of figural depictions make it difficult to attribute these manuscripts to any specific school. Only because some of the decorations are related in style and motif to other manuscripts whose school and date are known have we been able to place and date them. It is hoped that some of these identifications will be corrected by further studies.

27. OXFORD MIDRASH TANḤUMA *Spain, 1332*

Bodl., Hunt. Don. 20 *Figs. 363–364*

Midrash Tanḥuma

General Data

Codicology

Paper and vellum; 1 (unfoliated original vellum folio) + 189 leaves; 310 × 230 mm. Text space 320 × 140 mm. Written in round Sephardi script, in light brown ink, 31 lines per page. Ruling by stylus, 31 horizontal and 1 + 1 vertical lines. 12 quires of 16 leaves each, of which outermost and innermost sheets are of vellum and the rest of paper, except for Quire XII[14] (last two pages missing).

Binding

Nineteenth-century cardboard binding.

Colophon

fol. 189v (Fig. 364) Completed on the 22nd of Adar II 5092 (21 March 1332).

History

fol. 1r In the upper margin: Bought on Thursday, on the 20th of Shvat 5350 (25 January 1590), for five [...] by the young Solomon ha-Levi, Binder (כורך).

Many notes by a seventeenth-century hand concerning comparison with a printed version.

Decoration

Programme

A. Penwork panels.
B. Triangular shapes.

Description

A. *Penwork Panels.*

Penwork panels in red, black and violet extend across the text, enclosing the concluding words of

one division and the introduction to the next. The crude penwork consists of angular S-scrolls and simplified golf-club-like motifs fitted into bands, rectangular compartments, lozenges and various curved shapes. Most panels are surrounded by additional penwork and some long flourishes: fols. 40v — Exodus; 101r (Fig. 363) — Leviticus; 175r — Deuteronomy; 189v (Fig. 364) — end of the book; fol. 134v (Numbers) is not decorated. The penwork decoration measures (32–77) × (142–145) mm.

B. *Triangular Shapes.*

The text and the ends of the main divisions are written in triangular shapes (fols. 100v, 134v, 174v and 188v–189v – Fig. 364).

Conclusions

This manuscript can be attributed to Spain because of its script. Since the decorated penwork is intertwined with the display script, it is probably of the same provenance. The importance of this manuscript lies in the fact that it is dated.

Bibliography

Neubauer, No. 153.

28. MAIMONIDES' APHORISMS IN ARABIC

Spain (?), 1352

Bodl., Poc. 319

Figs. 365–366

Maimonides' Aphorisms in Arabic, in Hebrew script.

General Data

Codicology

Paper; 1 + 123 leaves; *c.* 290 × 210 mm. Text space (202–210) × (145–150) mm. Written in round Sephardi (?) script, in brown ink, 28–31 lines in two columns, with rubrics in red and green. Ruling by stylus, 1 + 2 + 1 vertical and hardly noticeable horizontal lines. Pricking is noticeable in the upper and lower margins. 9 quires of 14 leaves each, except for Quire I[11]. Quires are marked at their beginnings in Hebrew alphabetical order and at their ends with decorated catchwords. Many pages have been repaired towards the seams with different paper, some bearing writing.

Binding

Brown leather binding on cardboard.

Colophon

fol. 123r (Fig. 366) Completed on the 11th of Elul 5112 (22 August 1352) by Makhluf, son of the Ḥazzan Samuel Demansi (דמנשי).

History

A small piece of vellum bearing a Hebrew poem is inserted between fols. 14 and 15.
A letter signed Isaac Zion is inserted between fols. 82 and 83.

Decoration

Programme

A. Small title panels.

B. Decorated catchwords.

Description

A. *Small Title Panels.*

The titles on fols. 2r (Fig. 365) and 109v (Fig. 366) are written within small panels measuring (15–35) × (50–70) mm. The penwork, in black and violet, consists of S-scrolls with a few flower-like serrated roundels, as well as of long flourishes extending vertically from the corners of the panels into the margins. Other headings in the book are written in red or green on the vellum ground.

B. *Decorated Catchwords.*

The catchwords (fols. 11v, 25v, 39v, 53v, 67v, 81v, 95v and 109v – Fig. 366) are accompanied by pen-drawings of small geometrical patterns and stylized foliage, mostly in symmetrical arrangements, some incorporating a pair of confronting birds.

Conclusions

The importance of this manuscript lies in the fact that it is dated. Similar penwork can be found in other undated manuscripts. Its script, however, is of doubtful origin and may be either Spanish or North-African.

Bibliography

Neubauer, No. 2113.

29. OXFORD CATALAN MAIMONIDES

Catalonia, mid-fourteenth century

Bodl., Laud. Or. 234

Figs. 367–369

Maimonides' Guide of the Perplexed in Samuel Ibn Tibbon's translation.

General Data

Codicology

Vellum; 216 leaves; (283–287) × (210–215) mm. Text space (179–185) × (120–123) mm. Written in round Sephardi script, in very slim, elongated characters, in brown ink, mostly 23 lines per page. Ruling mostly by stylus on the recto of folios, 23–25 horizontal and 1 + 1 (mostly) vertical lines. The horizontal lines reach to the vertical lines, except for 2 at the top, 2 at the bottom and mostly 2 in the middle, which are carried to the edges of the leaf. Pricking is noticeable in all margins. 26 quires of 8 leaves each, except for Quire XXVI[10], gathered so that outward hair side faces hair; a vellum fly-leaf and 5 paper leaves attached before Quire I. Some quires at the beginning of the manuscript are marked with Hebrew letters at their beginnings and ends, and some at the end of the manuscript are marked with catchwords.

There are annotations in the margins; on fols. 10v–36r there are indications of parts and chapters in red ink in the margins. Fols. 1v, 83r and 141r are blank. The 5 paper leaves (fols. 2–6) contain an index of *parashot* of the Pentateuch in a different Sephardi round script.

Binding

Seventeenth-century brown morocco binding, gold-tooled with Archbishop Laud's arms.

Colophon

None.

In some places pen-drawn hands point to words in the text, on two occasions (fols. 52r and 188v) at the word Asher.

History

fol. 216r Don Zraḥah ben Gwiosnero (גוױושנרו) lent the owner of this manuscript, Reuben b. Judah Ḥisdai in בושקה (Bosca?), 100 dinars upon its being pawned on the 4th day before the end of Iyyar 5116 (26 April 1356).

fol. 1r Fly-leaf of the original binding: (a) A letter from Moses Boniak Botril to all Jewish rabbis to send him all their legal problems. (b) Archbishop William Laud's Collection.

fol. 215v A partially erased inscription. Presented to the Bodleian Library in 1636.

Decoration

Programme

A. Title panels.
B. Decorated titles.

Description

A. Title Panels.

The three panels at the main divisions run the full width of the page: fol. 7v — 240 × 158 mm, and fols. 83v and 141v — 177 × 123 mm. Two of them are complemented by part-page panels above the text of the facing pages: fol. 8r — 94 × 123 mm, and fol. 142r — 43 × 123 mm.

The panels are divided into bands and rectangular compartments, some containing the script. They are decorated with various penwork motifs in red and violet on the vellum ground and with painted motifs in magenta, violet, blue, grey, green and some red, with burnished gold and silver on similarly painted grounds, the shapes of individual letters often determining the background patches in different colours and ornamental motifs. The rich variety of ornamental motifs gives the panels the appearance of carpet pages.

The painted motifs include rosettes and other floral motifs, including scrolls (e.g., fols. 83v – Fig. 368, and 142r), geometrical interlaces (e.g., fol. 7v – Fig. 369) and quatrefoil shapes (e.g., fols. 8r – Fig. 367, and 141v). A typical combination comprises series of geometrical shapes, chequers, triangles, lozenges, ovals and zigzag or wavy lines enclosing small, stylized foliage and floral motifs. Spiral flourishes often issue from some of the painted shapes into the margins. The penwork consists of paisley leaves, roundels, rectangles, triangles and rounded forms filled with club-like palmette variations, beads and other foliage, floral or geometrical motifs.

The painted grounds are mostly decorated with thin brushwork, sometimes with diapered or chequered patterns (e.g., fols. 7v and 141v).

The frames which surround most of these panels consist of thin fillets divided into sections of coloured magenta, blue and gold and carrying ivy leaves on thin stems. At the lower margin and at the centre of the upper margin the fillets turn into thin stems, intersecting at the centre to form a vertical eye-shape or a roundel filled with gold (magenta on fol. 8r). The frame on fol. 142r lacks the lower border, and each of its side borders terminates with two foliage curls enclosing ivy leaves on a burnished gold ground.

fol. 7v (Fig. 369) In this full-page panel, which is richer than the others, the penwork forms a large

central compartment with two gold fleurs-de-lis at its upper corners and another two somewhat below its lower corners. Painted decoration forms the frame of this compartment. The lower border of the frame is much wider than the others; it includes two roundels with coloured winged dragons on a diapered or chequered ground flanking a silver flower vase. The roundels are framed by long multi-coloured acanthus leaves issuing from the mouths of two small winged dragons at the lower corners. The different motifs in the side borders are strung on thin coloured bars; they include, in addition to those described above, acanthus leaves winding round the bars; dragons' heads; trumpet-like motifs with gold and coloured rings; and birds in cages in the centres of two of the interlacing geometrical motifs.

B. *Decorated Titles.*

A letter on fol. 1r has a U-shaped frame with attached geometrical shapes, all decorated with a pen-drawn quilloche pattern on a green ground, with extending flourishes. Another title (fol. 16r),

written in large letters in brown ink, is decorated with a few foliage motifs in ink.

Conclusions

The manuscript is written in very slim, elongated characters, not "Greek" as Neubauer calls them, but Sephardi of the mid-fourteenth century. This can be seen from comparison with the *Guide of Perplexed* of 1348 from Barcelona, now in Copenhagen (Kongelige Bibliothek, Cod. heb. 37; see Narkiss, *HIM*, Pl. 18), written in a similar script with similar decorations. The foliage scroll decorations are similar to those of the *Barcelona Haggadah* (No. 13), which is also Catalan, attributed to the middle of the fourteenth century.

Bibliography

Neubauer, No. 1250.
Meiss, Catalonia.
Wormald, Copenhagen.
Narkiss, *HIM*, Pl. 18.

30. LONDON CATALAN NAḤMANIDES

Catalonia, second half of fourteenth century

BL, Add. 26933

Figs. 370–373

Naḥmanides' commentary on the Pentateuch.

General Data

Codicology

Vellum; 181 + 1 leaves; 144 × 105 mm. Text space 92 × 65 mm. Written in small, round Sephardi script, in brown ink, 20 lines to a page. Ruling by stylus, sometimes accentuated with pencil, 20 horizontal and 2 vertical lines per page. 19 quires of 10 leaves each, except for Quire XIX² which is gathered so that outward flesh side faces flesh. Catchwords in the bottom left-hand corner of the verso of the last leaf of each quire.

Colophon

None.

History

fol. 1r Unclear inscription in the upper margin.
fol. 182v Two Italian censors' signatures, one of 1559. Purchased by the British Museum from A. Asher & Co. of Berlin, together with the Almanzi Collection (No. 41), in October 1865.

Decoration

Programme

A. Penwork initial-word panels.
B. Pen-drawn motifs.

Description

A. *Penwork Initial-Word Panels.*

The panels for the main divisions (fols. 6v – Fig. 370, 54r – Fig. 372, 104v, 139r – Fig. 373 and 156r) extend across the text, while many other smaller ones are placed on the right. The shapes of both types of panel are determined by the space left by the scribe, apparently not intended for such decoration. They are decorated with dense scrolls in red and violet ink, with long curved lines of various foliage motifs and flourishes extending to the margins.

B. *Pen-Drawn Motifs.*

These motifs, which accompany the panels for new chapters or mark the ends of the previous chapters, are in the margins or in the blank spaces within the text, normally on the left. They include: seated dogs (fols. 1v and 54r); various birds (fols. 1r–v, 25v and 40r); bearded human heads (fols. 40r, 41v and 51v) or animal heads (fol. 43r); and foliage (fols. 28r and 82r) or interlacing (fols. 37r and 43r) motifs. They also include more elaborate drawings, such as: a dragon with a foliaged tail (fol. 6v – Fig. 370); a winged grotesque (fol. 8r); an arm with its hand pointing to the text (fol. 41v); a bust of a man blowing a trumpet, his long beard in the form of a scroll and a fleur-de-lis shield over his shoulder (fol. 45v – Fig. 371); a stork with a snake in its beak (fol. 46v); a partial drawing of a bird of prey with a ring round its neck (fol. 73v); a crowned grotesque head in the lower margin (fol. 104v — Leviticus); in the lower margin, among rocks and trees, a seated lion and a dog with a chain round its neck (fol. 139r – Fig. 373: Numbers); and a dog chasing a rabbit (fol. 175v).

Conclusions

The figure style and penwork of our manuscript, though crude in execution, point to the second half of the fourteenth century. The busts on fols. 45v (Fig. 371) and 51v can roughly be compared to the grotesque faces in the *Brother Haggadah* (No. 16, fols. 16r and 18r), which is of the same period.

Bibliography

Margoliouth, No. 213, I, p. 159.

31. OXFORD CATALAN LEVI BEN GERSHOM

Catalonia, 1391

Bodl., Poc. 376

Figs. 374–375

Levi ben Gershom, Sefer Milḥamot Hashem.

General Data

Codicology

Vellum; 1 + 231 leaves; 295 × 220 mm. Text space 176 × 125 mm. Written in round Sephardi script, in brown ink, 28 lines per page. Ruling by stylus on the hair side, 28 horizontal and 2 + 1 vertical lines. The horizontal lines reach the vertical ones, except for 2 at the top, 2 at the bottom and 2 in the middle, which reach the edges of the leaves. Pricking is noticeable in all margins. Two fly-leaves at the beginning and two at the end are blank. 19 quires of 12 leaves each, except for Quire I[11] (one leaf cut off at the beginning), which is gathered so that outward hair side faces hair. The quires are numbered with Hebrew letters at their beginnings and ends. The chapters are indicated in the upper margins.

Colophon

fol. 229v The manuscript was completed in the week of *parashat ḥuqat* (Num. 19) in the year [5]151 (10–16 June 1391).

History

fol. 231v In fifteenth-century Sephardi round script: From me, Samuel b. Samuel Cavallier b. Reuben b. Samuel b. Reuben b. R. Jonah, I bought it with my own money from the wise... my grandfather, Samuel de Lunel.

fol. 230v In sixteenth-century round Sephardi script: Solomon Cavallier sold it to a physician (erased) at Adrianople, through Abraham Baruch, on the 16th of Av [5]274 (8 August 1514).

Decoration

Programme

A. Illuminated title page.
B. Penwork panels.
C. Rubricated titles and chapter lists.

Description

A. *Illuminated Title Page.*

fol. 3r (Fig. 374) The page has a large title panel (58 × 170 mm) above the text and further decorations in the other margins. The title is written in gold within a large reddish magenta compartment, and the space between the letters is in dark blue with white flourishes spreading over both colours. The panel border consists of an

angular interlace of thin fillets in blue, green and magenta. The spaces framed by the interlacing bands are filled in with burnished gold. Acanthus leaves in blue, magenta and green issue from the corners of the panel, forming the ascender of the letter *lamed*; they spread along the side margins, where they are set against a gold bar, of which the upper part is jagged and the lower part terminates in a branch bearing ivy leaves. A pen-drawn bird is standing on a leaf curling from the left-hand bar. In the middle of the lower margin is a green dragon with a blue acanthus leaf in its mouth.

B. *Penwork Panels.*

There are many red and violet penwork panels to the titles and initial words of the different chapters. The writing is in brown, blue or red, within narrow panels measuring $(11–16) \times (18–92)$ mm. The panels are framed by a bead motif and decorated with pen lines and curly scrolls, sometimes forming roundels enclosing golf-club-like motifs (e.g., fols. 3v, 4r, 144v and 219v). Flourishes extend from some panels; other panels are topped by a motif of two leaves resembling open wings (e.g., fols. 45v and 207r – Fig. 375). On fol. 3v, three panels are joined to form one larger panel.

C. *Rubricated Titles and Chapter Lists.*

There are rubricated titles and chapter lists (e.g., fols. 144v and 145r).

Conclusions

The decorations of this dated manuscript are contemporary with its script. The penwork panels were probably executed by the scribe, whereas the painted frontispiece was done by an artist. The painting and the penwork are typical of the second half of the fourteenth century in Catalonia based on the decoration of the *Oxford Catalan Maimonides* (No. 29). They can therefore help in dating some manuscripts.

Bibliography

Neubauer, No. 1286.

32. CAMBRIDGE CATALAN MAIMONIDES

Catalonia, 1396

CUL, Add. 1493

Figs. 376–377

Maimonides' Guide of the Perplexed in Samuel Ibn Tibbon's translation.

General Data

Codicology

Vellum; 303 leaves; *c.* 242×178 mm. Text space $(151–153) \times (88–92)$ mm. Written in round Sephardi script, in brown ink, with red and blue rubrics, 24 lines per page. Ruling by stylus, 24 + 2 horizontal and a varying number of vertical lines, often unrelated to the text space (e.g., fols. 39, 93 and 161). 39 quires of 8 leaves each, except for Quires III[7] (one leaf cut off at the beginning), XXXVIII[6] (one leaf cut off at the beginning and three at the end) and XXXIX[2] (six leaves cut off at the beginning). The quires are numbered in Hebrew alphabetical order at their beginnings and ends, although most marks have been cut off by a binder. All leaves are marked with catchwords. The numberings for the three parts of the book are repeated in the upper margin of the recto of all leaves.

Binding

Brown leather binding.

Colophon

fol. 301r Joseph b. Elijah wrote the book for himself and completed it in Shevat 5156 (12 January to 10 February 1396). The scribe marked the letters which form his name in several places in the text (e.g., fols. 230v and 251v).

History

None.

Decoration

Programme

A. Initial-word title panels.

B. Decorated marginal notes.

Description

A. *Initial-Word and Title Panels.*

Crude penwork initial-word and title panels appear on most pages between fols. 1v and fol. 44v. There is unused space for penwork decoration round all other titles.

Most panels are small — (14–20) × (21–58) mm — and within the text, though those for the introductions on fols. 1v, 4v and 5r extend across the text space, the last two being composed of several oblong panels measuring (37–47) × (93–95) mm. The first panel (fol. 1v) has a damaged silver ground, but all the others have penwork decorations in red, blue, green, greyish purple and brown on the vellum ground, with the titles written in them in the same colours. The panels are divided into compartments enclosing various motifs, among which the most common are foliage scrolls forming sections filled with foliage, spirals, golf-club-like foliage, wavy lines and other motifs. There are also small squares filled with small spared-ground motifs, as well as a few plaits and criss-cross and other geometrical shapes. Many panels have flourishes extending into the margins, some including small animal heads (e.g., fols. 17r–v and 28r).

B. *Decorated Marginal Notes.*

Chapter numberings and other notes in the margins are decorated by very stylized foliage motifs — some including palm leaves — above the sign, which is often framed by a small panel. These decorations are found on the same pages as the title panels as well as on other pages (e.g., fols. 191r, 195v, 200r and 203r). Decorations for the marginal signs also include a small grotesque animal (fol. 16r – Fig. 376), a panel topped by a tree-like penwork patch in green with red fruit-like dots (fol. 25r – Fig. 377), a frame of leaf motifs (fol. 30r) and small panels similar to the title panels (fols. 13r and 13v).

Conclusions

The importance of this manuscript lies mainly in its date, which may help in dating other similar crudely decorated manuscripts, like the *London Catalan Naḥmanides* (No. 30).

Bibliography

Loewe, *Hand List*, No. 661.

III. Miscellaneous Spanish Schools of the Late Fourteenth and Early Fifteenth Centuries

[Nos. 33–40]

It is not always possible to relate all Hebrew illuminated manuscripts directly to a specific artistic school or even date them with accuracy. Even in cases when the colophon places and dates a manuscript, its decoration is not necessarily related to the same school. Artists are usually not mentioned in colophons and, like scribes, were peripatetic. The following eight manuscripts, presumably dating from the late fourteenth and early fifteenth centuries, have been placed together in one chapter, not as a related group, but rather as individual manuscripts whose place of origin is still uncertain and needs further study. It is only because of some stylistic elements that they have been ascribed to the period round 1400.

As already stated (p. 15), the shock of the 1395 massacre and destruction of Jewish communities must have passed quickly enough for the production of illuminated manuscripts to be resumed before long. Not all of these eight manuscripts are of high quality, but all show a continuous tradition in their decoration programme and iconography. In all of them the decoration pertains to the opening and title pages, or surrounds the initial-word panels. Colour, penwork and drawings are all used in well-established techniques. Further studies of codicology habits and artistic motifs will extend our ability to relate these manuscripts to more specific schools.

33. HARLEY SPANISH MAIMONIDES

Spain, late fourteenth century

BL, Harley 7586 B

Fig. 378

Maimonides' Guide of the Perplexed in Samuel Ibn Tibbon's translation.

General Data

Codicology

Vellum; II + 230 + 2 (fols. 80a and 143a, precede the second and third parts of the book, respectively) + I leaves; *c.* 195 × 153 mm. Many leaves are damaged, especially at the beginning and the end, and the edges are mounted on new vellum. Text space (132–135) × (98–102) mm. Written in small, square Sephardi script, in light brown ink, 26 lines to a page. The ruling in not noticeable, except for occasional 1 + 1 vertical lines. 27 surviving quires of 8 leaves each, gathered so that outward hair side faces hair. The first 16 leaves are badly damaged and mounted, but they probably formed two quires. This is confirmed by the surviving numbering, in Hebrew letters, of the quires on fols. 40v (5), 48v (6), 87v (11) and 174v (perhaps 22). Catchwords exist at the ends of most quires.

Fol. 1 is a fragment of a Latin commentary on the Psalms (Spain, fourteenth or fifteenth century). Fol. 230v contains a table of contents in a later round script.

Colophon

fol. 229r Without name or date.

History

Purchased by the British Museum, together with the Harleian Collection, in 1753.

Decoration

Programme

A. Title and initial-word panels.
B. Marginal penwork.

Description

A. *Title and Initial-Word Panels.*

There are many penwork panels for the titles and initial words in the first and second parts of the book (up to fol. 142r), most of them small and within the text. Their height is 5–17 mm, and their width varies from 16 mm to the full width of the text space, i.e., 16 × 100 mm (e.g., fols. 4v and 5r). Some are especially large (e.g., fol. 11r; partly damaged), and on some pages several panels are combined to form a larger pattern (e.g., fols. 9v, 67r–v, 81r, 81v – Fig. 378, 82v, 110r and 139r–v). The words are written in brown ink. The penwork consisting of multi-linear S-scrolls, often forming roundels, is in red violet. All the spaces are filled with variations of a club-like palmette or with curly flourishes. In some places the roundels formed by the scrolls are filled with decorations in the second colour. The large panel on fol. 11r is divided into chequers filled with alternating red and violet penwork. On fol. 4v, the title is written on a strip of similar penwork in brown ink. The panels are framed by pen lines, some beaded.

B. *Marginal Penwork.*

Penwork lines, beads and flourishes are attached to the sides of most panels and spread to some extent along the margins. Those of fol. 11r incorporate a crowned bird's head, with foliage in its beak, and a stylized leaf.

Conclusions

The small Sephardi square script of this manuscript is somewhat similar to a manuscript of 1352 in Paris (Bibliothèque nationale, hébr. 1218; see Sirat & Beit-Arié, I, No. 41). A triangular penwork projection at the sides of panels resembles those in the *Oxford Midrash Tanḥuma* of 1332 (No. 27), although they differ in style. The penwork motifs can be compared to small-sized undated manuscripts in the British Library: the *London Hebrew Grammar* (No. 37), the *London Spanish Maḥzor* (No. 39) and the *London Spanish Prayer-Book* (below, No. 38), all of which are written in Sephardi round script and similarly decorated with penwork common in the first half of the fifteenth century. Our manuscript could belong to an intermediate stage between the early and later groups in the late fourteenth century.

Bibliography

Margoliouth, No. 907, III, pp. 213–214.
Sirat & Beit-Arié, *Manuscrits*, I, No. 41.

34. CAMBRIDGE SPANISH PENTATEUCH

Spain, late fourteenth century

TCLC, F.12.104

Fig. 379

Pentateuch, up from Genesis 1:26.

General Data

Codicology

Vellum; II + 129 + II leaves; 220 × 180 mm. Text space (163–167) × (125–128) mm. Written in square Sephardi script, in light brown ink, 28 lines in two columns. Ruling in stylus (?), 28 horizontal and 2 + 3 + 2 vertical lines. The names of the *parashot* and books have been added in round script, in black ink, at the top of many pages. Quires are unidentifiable because of the modern binding. The pages are damaged in the lower corner.

Colophon

None.

History

fol. 129v Among lists of biblical accents and notes written in Sephardi cursive, in a sixteenth-century Italian hand: "Hezekiah Ashkenazi".

On the inside of the top cover: Given to the College by W.A. Wright in 1912 (*ex libris* as F 18.32.33).

Decoration

Programme

A. Penwork frames.
B. Additional decorations.

Description

A. *Penwork Frames.*

The *parashah* signs and the 613 precepts, written in the margins and between the text columns of the Pentateuch, are framed by elongated penwork cartouches in red, violet and green, with additional foliage, palmettes, scrolls and other motifs above and below. A common variation is of frames alternating with penwork panels (e.g., fol. 45v – Fig. 379). The whole is surrounded by lines, leaves and bead motifs, often with a symmetrical palmette motif at the top.

B. *Additional Decoration.*

fol. 39v Two birds' heads flank the palmette motif at the top.

fol. 68r An edifice with three turrets appears on top of the frame in the outer margin.
fol. 79r Within a penwork panel in the inner margin: a human face.

Conclusions

The manuscript is written on fine vellum, in a size which became popular in the fourteenth century. The script is somewhat angular, possibly influenced by a French type of script. The penwork decoration is elaborate, at times crowding the page. The delicate and meticulous pen scrolls are elegantly rendered with foliage resembling French Gothic illumination. The greyish purple and brown pen scrolls create shadings within some of the panels and foliage decoration. It is difficult to date the manuscript and its decoration. However, the soft round pen scrolls point to the late fourteenth century.

Bibliography

Loewe, *Trinity*, No. 19, p. 3.

35. CAMBRIDGE SPANISH PRAYER-BOOK

Spain, fifteenth century

CUL, Add. 1204

Figs. 380–381

Prayer-book of the Sephardi (or North-African) rite.

General Data

Codicology

Vellum; 104 leaves (missing leaves replaced by paper leaves; fols. 65–68, 87 and 90); 148 × 106 mm. Text space (95–97) × (58–62) mm. Written in square Sephardi script, in light brown ink, 16 lines to a page (in two columns on fols. 28r–38v). Notes in the margins are written in round script. Ruling by stylus, 16 horizontal and 1 + 1 vertical lines. Pricking is noticeable in all margins. 14 quires of 8 leaves each, except for Quires I⁴, III¹⁰, VI¹⁰, IX⁴ (paper quire) and XIV⁴. Some catchwords.

Colophon

None.

History

fol. 1r Owner's name (?): Solomon Ḥazzan.

Decoration

Programme

A. Initial-word and title panels.
B. Additional decorations.

Description

A. *Initial-Word and Title Panels.*

The titles and initial words are written in red, brown and gold, within panels of different shapes and sizes. Some panels run across the text (e.g., fols. 1v, 5r, 17r, 27r, 36v, 43v, 62r, 64r and 83v – Fig. 381); others are smaller (e.g., fols. 1r, 3r, 4r, 49v, 89r, 95v, 97v and 98r). There is also a large penwork panel at the end (fol. 104v). Most common among the larger panels is the inverted U-shape partly framing the text, with the word in the

top bar and the side bars sometimes cusped (e.g., fols. 62r and 64r). Other panels are rectangular (e.g., fols. 4r, 43v, 49r, 49v, 83v and 89r) or of a small U-shape enclosing the title (e.g., fols. 1r and 95v). In most of the larger panels the word is within a special, often undecorated compartment. The panels and various compartments are normally framed by pen lines, but sometimes by gold or coloured fillets (e.g., fols. 5r, 17r and 100v); some have an angular plait pattern (e.g., fols. 83v and 100v). The penwork is in brown, violet and red ink, with some green and red paint, especially for dots and fillings of ground sections and other shapes. The main motifs are: dense S-scrolls (e.g., fols. 1v, 3r, 4r, 5r, 17r — gold, 62r and 64r); similar scrolls with large curls enclosing floral motifs (e.g., fols. 27r, 36v, 43v and 104v) and other foliage scrolls (e.g., fol. 1r); and plait and knot patterns (e.g., fols. 49v, 95v and 100v). Small geometrical pen motifs, flourishes and coloured dots often surround the panel frames. Very small panels consist of some linear pen decoration of the word with flourishes (e.g., fols. 97v, 98r, 101r, 103r and 120v). Some words in the text are written in red or gold (e.g., fol. 47v).

fol. 104v A half-page rectangular penwork panel (*c.* 53 × 65 mm), divided by diagonals into four triangles of alternating red and violet penwork scrolls. Two large curls in each triangle enclose large floral motifs on a green ground.

B. *Additional Decorations.*

Further decorations appear along the margins, especially on pages with titles or initial words (with or without panels), including one text illustration (fol. 81r – Fig. 380). They extend round the panel and along the side margins (e.g., fols. 17r, 27r, 34r and 49v), sometimes forming a full frame or an inverted U-frame to the panel and text (e.g., fols. 1v, 5r — traces, and 43v). This decoration consists of pen-drawn foliage and flourishes with dots and leaves, with some green tint and a very little red (e.g., fols. 1v, 3r, 4r, 5r — traces, 27r, 43v, 49v and 62r). The scroll on fol. 100v forms foliate roundels enclosing large gold dots. Other pages have similar decoration, sometimes extending from a small penwork panel or other shapes into vacant spaces at the beginning or end of a line (e.g., fols. 6r, 7r, 16r, 21v, 24r, 28r, 40v and many others), or from a title or a word in the text, which is indicated in this way (e.g., fols. 23r, 23v and 77r). A more sumptuous though less frequent method of decoration consists of coloured or penwork bars along the margin, interrupted by large stylized flowers in gold and some colour (fols. 17r and 83v). On fol. 83v (Fig. 381), each flower carries two flourished gold dots on thin stems, and the flower at the top is fan-shaped. Fols. 28r–29v, where the text is written in two columns, have decorative penwork bars between the text columns; they consist of plait motifs (fol. 28r); foliage scrolls (fols. 28v and 29r), with a hand and double, wing-like leaves at the top (fol. 39r); and a column of flourishes (fol. 29v). There are also penwork shapes filling spaces (e.g., fols. 6v and 63r).

fol. 81r (Fig. 380) Benediction over wine: In the outer margin, a hand holding a cup, inscribed: כוס ישועות אשא, "I will lift up the cup of salvation" (Ps. 116:13).

Conclusions

The penwork decoration and the pen flourishes in the borders foreshadow late fifteenth-century types, like the *First Kennicott Bible* of 1476 (No. 48) and the *Dublin Castilian Pentateuch* of 1478 from Toledo (No. 53). However, the columns of flowery scrolls with delicate blossoms and naturalistic flowers are of a different type, known from other fifteenth-century schools.

Bibliography

Loewe, *Hand List*, No. 408.

36. LONDON IBN EZRA

Spain, early fifteenth century

BL, Or. 1487

Figs. 382–385

Abraham Ibn Ezra's commentary on the Pentateuch.

General Data

Codicology

Vellum; 194 leaves; 186 × 150 mm. Text space (115–117) × (88–90) mm. Written in small round Sephardi script, in brown ink with some corrections in black, 30 lines to a page. Fol. 110v is blank. Some ruling by stylus is noticeable, 2 + 1 vertical lines. 25 quires of 8 leaves each, except for Quires I⁵, II⁹, XVI⁷ (one leaf missing after fol. 119) and XXV⁵, which are gathered so that outward hair side faces hair. Catchwords at the bottom left-hand corner of the verso of every page. Fol. 194 is a recent restoration of the missing leaf mentioned above.

Binding

Yellow parchment binding with tooled decoration in black.

Colophon

None.

History

Purchased by the British Museum from W. Shapira on 24 November 1877.

Decoration

All of the decorations are in penwork, in blue, red, violet and green.

Programme

A. Initial-word panels.
B. Penwork at ends of *parashot*.
C. Penwork in the margins.
D. Full-page panel.

Description

A. *Initial-Word Panels.*

There are initial-word panels to all the *parashot* and *sedarim*, mostly very small and within the text. Those for the main divisions according to the books of the Pentateuch (e.g., fols. 41r, 111r – Fig. 383, 139r and 165v) and for the individual *parashot* are larger and more elaborate, extending across the text space.

B. *Penwork at Ends of Parashot.*

Several ends of *parashot* have panels or pen-drawn motifs. Some are large and elaborate (e.g., fol. 40v – Fig. 382, which run almost the full page: 93 × 90

mm and fol. 135r – Fig. 384); and some are within the text space (e.g., fol. 78r). There are also penwork borders to parts of the text, written in geometrical — mostly triangular — forms (e.g., fols. 110r, 148v, 181r and 183r), or panels shaped to fit the spare spaces of these forms (e.g., fols. 134v and 161v).

The motifs of the initial words and the ends of *parashot* described in §§ A–B are mainly stylized angular scrolls (e.g., fols. 11r, 40v and 78v), which almost turn into a zigzag in some places (e.g., fol. 107v); in other places they form small roundels filled with palmettes formed by dotted club motifs or with other motifs (e.g., fols. 23v, 85v, 96v, 113r, 135v and 156v). The larger panels are mostly divided into geometrical shapes filled with penwork motifs in different coloured inks, to form a rich pattern. Among these geometrical shapes are lozenges (e.g., fols. 11r, 37r, 144v and 173r); zigzags (e.g., fols. 19r, 109r and 125v); rectangles in different combinations (e.g., fols. 121r, 124v, 128v, 139r, 164r and 187v), some enclosing smaller rectangles with concave sides (e.g., fols. 40v, 41r, 54v, 100r and 110r); squares or rectangles with further geometrical sub-divisions (e.g., fols. 41r, 78v, 85v, 103r, 111r, 151r and 173r); stripes arranged diagonally or in zigzags (e.g., fols. 115v and 161v); roundels (e.g., fols. 133r, 151r, 165v, 176v and 185v); chains or interlaces (e.g., fols. 2v, 62r, 110r, 135r and 148v); intersecting circles (e.g., fol. 41r); squares enclosing rosettes (e.g., fols. 41r, 54v, 78v and 111r); and others.

Some panels have fleurs-de-lis (e.g., fols. 124v and 128v) or human faces within the penwork (e.g., fols. 78r and 135v). The panel on fol. 41r has an upper extension.

C. *Penwork in the Margins.*

The penwork which extends into the margins from many panels (e.g., fols. 28v and 40v – Fig. 382) is sometimes used to cover repairs in the vellum leaf (e.g., fols. 27r and 125r). It consists of lines, mostly with strung dotted pearls, flourishes and other small motifs, sometimes also with dotted club motifs (palmette variation) and stylized floral motifs. On fol. 111r there are a man and a bird among the large flourishes; included on fol. 125r are a rabbit and a bird pecking at the flourishes; and on fol. 125v a grotesque.

D. *Full-Page Panel.*

The full-page panel on fol. 138v (Fig. 385), measuring 118 × 92 mm, precedes the commentary on Numbers. It is divided by a diagonal trellis into lozenges filled with palmettes formed by very stylized club motifs. Nine lozenges, forming a larger lozenge situated approximately in the centre of the panel, are decorated with flourishes. The blank page preceding the chapter on Leviticus (fol. 110v) was perhaps left for similar decoration.

Conclusions

As it is in a round script, it is difficult to date and place our manuscript palaeographically. The patchwork composition of the penwork panels could be of either the fourteenth or fifteenth century, probably from Spain. The club motif and the dense, parallel lines point to the fifteenth century. The neatly drawn pen flourishes with the man and a bird extending to the margin on fol. 111r resemble Italian pen drawings of the late fourteenth century. Some of the pen flourishes and drawings on other pages are by a second hand. The manuscript was probably executed in the fifteenth century.

Bibliography

Margoliouth, No. 191, I, p. 145.

37. LONDON HEBREW GRAMMAR

Spain, early fifteenth century

BL, Add. 18970

Figs. 386–387

Hebrew grammar.

General Data

Codicology

Vellum; 2 + 125 + 1 (fol. 105a, unfoliated) + 2 leaves; *c.* 163 × 115 mm. The beginning is missing and fols. 104r–106v are blank. Text space (102–104) × 60 mm. Written in round Sephardi script, 17 lines per page. Ruling by stylus, 17 horizontal and 1 + 1 vertical lines. 17 quires of 8 leaves each, except for Quires X[6], XIV[4] and XVII[4]. The last word of every quire is repeated at the beginning of the next one.

Colophon

None.

History

Owners' inscriptions

fol. 104v "The young (הצעיר) Joseph Zarur" (יוסף צרור).

fol. 125v (1) "Mine, the youth (הבחור) Samuel Dafno" (דפנו). (2) "These opening words (אשטי פתח דברי) belong to the honourable (לנישה ונעלה) Don Meir b. Banbanest (באן בנשת) b... Don Avraham Banbanest."

Decoration

Programme

A. Title and initial-word panels.
B. Marginal penwork.

Description

A. Title and Initial-Word Panels.

The titles and initial words are written in ink within penwork panels; most of them run across the text: (12–20) × (66–70) mm; others are smaller: (12–17) × (32–52) mm. There are many in the first half of the manuscript, but fewer later on. The penwork consists mainly of wavy red scrolls of two or more parallel lines, sometimes forming roundels. All spaces are filled with thin scrolls, spirals and flourishes, or with lobed foliage resembling club motifs; the latter are occasionally in violet (e.g., fols. 1v, 30v, 55v, 60v and 74r). Other panels are wholly or partly decorated with wave and bead motifs (e.g., fols. 33v, 40v, 47r, 56v, and 90r – Fig. 387). The panels are framed by violet lines, the outer ones of engaged beads which often resemble small foliage motifs, and sometimes with leaves in the corners.

B. Marginal Penwork.

Vertical beaded and flourished extensions spring from a foliage motif attached to the side of the panel or from twin spiral or twin foliage motifs near the corners; they spread to some length along the margin, some with additional small leaves (e.g., fols. 23v – Fig. 386, and 65r).

Conclusions

The Sephardi round script and penwork decoration of our manuscript can be compared to some small-sized manuscripts in the British Library, e.g., the *London Spanish Maḥzor* (No. 39) and the *London Spanish Prayer-Book* (No. 38), probably of the first half of the fifteenth century. Some of its penwork motifs, however, are similar to the *Harley Spanish Maimonides* (No. 33), which may date from the late fourteenth century.

Bibliography

Margoliouth, No. 964, III, pp. 287–289.

38. LONDON SPANISH PRAYER-BOOK

Spain, early fifteenth century

BL, Add. 27126

Figs. 388–389

A Prayer-book of the Sephardi rite, with Keter Malkhut and a series of dinim in the margins (fols. 1r–157r).

General Data

Codicology

Vellum; 299 + I leaves, 86 × 60 mm. Text space (51–53) × (30–33) mm; text space with the additional text, which is written in small script in the outer and lower margins, up to fol. 157r (61–64) × (40–45)mm. Written mostly in round Sephardi script, in light brown ink, 11 lines per page. Ruling by stylus, 11 + 2 horizontal and 2 + 1 + 1 vertical lines (apparently done throughout the book, including those pages which lack the marginal texts). Pricking is noticeable in all margins. 39 quires of 8 leaves each, except for Quires I⁵, II⁷ (one leaf cut off after fol. 9), XIV⁶, XV⁶, XX⁴ and XXV⁷, which are gathered so that outward hair side faces hair. The quires are marked in Hebrew alphabetical order at their beginnings and ends; many of the marks at the beginnings have been cut off.

Colophon

None.

History

None.

Decoration

Programme

A. Title and initial-word panels.
B. Title and initial-word decorations.
C. Marginal text in decorative shapes.

Description

A. *Title and Initial-Word Panels.*

The words are written in silver (e.g., fols. 1r, 92r, 165v and 198r), brown ink (e.g., fols. 133r – Fig. 389, and 241v), or in ink covered with red (e.g., fol. 236v), within rectangular panels occupying a large part of the text space: *c.* (26–35) × (33–45) mm; they often have pointed, rounded and other small extensions. On fols. 165v and 241v, several small panels are combined to form a large panel of irregular shape, almost full-page in size. The panels are decorated with red, brown or blue penwork consisting of curly scrolls forming roundels that are filled with lobed foliage that resemble a club motif, mostly decorated with dots, and with ground filling within the roundels in another colour. A similarly decorated U-shaped, jagged, irregular frame on fol. 132r (Fig. 388) encloses the lower part of the text, which is written in lines of diminishing length.

The panels are framed by pen-drawn lines, flourishes and some beading, with similar vertical extensions along the margins. Those on fols. 1r and 192v are very faded.

B. *Title and Initial-Word Decorations.*

Other initial words are written in ink, sometimes tinted red. Some are surrounded by a red, brown or blue flourished line (e.g., fol. 135r), often extending as a beaded and flourished penwork bar along the margins (e.g., fols. 3r and 77r), sometimes ending in a segment of a penwork scroll (e.g., fol. 43r). A similar scroll segment decorates the quire number of fol. 267v. A marginal note on fol. 18v has a small pen-drawn frame.

C. *Marginal Text in Decorative Shapes.*

The marginal texts are written as a zigzag on

fols. 3v–4r, and as a bar with semi-circular extensions on fol. 12v. On fols. 164r, 164v and 179v, it is written in triangular shapes.

Conclusions

This small prayer-book is sparingly decorated with initial words written in silver and some penwork. The style of this decoration, and of a few of the motifs, belongs to the beginning of the fifteenth century. It can therefore be compared with two undated manuscripts in the British Library, the *London Spanish Maḥzor* (below, No. 39) and the *London Hebrew Grammar* (above, No. 37), which are similarly decorated and also written in round Sephardi script.

Bibliography

Margoliouth, No. 692, II, pp. 346–347.

39. LONDON SPANISH MAḤZOR

Spain, early fifteenth century

BL, Or. 5600

Figs. 390–392

Maḥzor for the New Year and the Day of Atonement (North-African rite?).

General Data

Codicology

Vellum; 160 + I leaves, 186 × 160 mm. Text space (136–142) × (88–105) mm. Written mostly in round Sephardi script, in light brown ink, mostly 20 lines to a page, many in verse form. Ruling by stylus, 20 horizontal and I + (mostly) 2 + 1 vertical lines. Pricking is noticeable in the inner and lower margins. Fols. 1–4 and 135–160 carry later additional texts on additional leaves (except for fol. 4). There are some more additional texts (e.g., on fol. 62v). Fols. 29v and 30r are blank. 21 quires of 8 leaves each, except for Quires I[3] (additional), XIII[12], XX[3] and XI[6] (additional; one leaf cut off after fol. 156), which are gathered so that outward hair side faces hair.

Colophon

None.

History

fol. 2v Owner's name in upper margin: Yeḥiel b. David b. Ṣoreq (סורק), in an Italian cursive hand of the sixteenth century.
Paper fly-leaf at the end Purchased from B. Quaritch in the De Castro sale on 17 May 1899.

Decoration

Programme

A. Initial-word and title panels.
B. Minor titles in decorative script.
C. Text in geometrical shapes.

Description

A. *Initial-Word and Title Panels.*

The panels for the initial words or titles are of two types.

1. The words are written in burnished gold (e.g., fols. 4v – Fig. 390, 45r and 50v – Fig. 391), or in ink (e.g., fols. 9r and 23v), within a panel across the text measuring (16–30) × (92–98) mm (fols. 4v, 9r, 45r and 50v). Sometimes the panel is smaller; on fol. 23v there are two small panels measuring 15 × 26 and 13 × 15 mm. The panels are filled with red and violet penwork of multi-linear curly scrolls forming roundels (semi-circular sections on fol. 23v). All shapes are filled with lobed foliage resembling club motifs, some in symmetrical groupings. The panels are framed by lines accompanied by beads and flourishes extending vertically beyond the corners of the panel, often to some length along the margins (and also within the text on fol. 4v – Fig. 390). A small roundel, also filled with foliage motifs, is sometimes attached to the side of the panel (fol. 4v) or to its top; another is attached to an extension (fol. 50v – Fig. 391).

2. The titles are written in large gold letters within a rectangular pointed panel measuring *c.* 15 × (48–70) mm. There are often extensions for the letters *lamed* or final *pe* (e.g., fols. 110v, 124v – Fig. 392, and 138v), painted blue or magenta and decorated with thin flourishes in white. The panels are in the middle, running the width of the text; that on fol. 124v has a penwork frame enlarging the panel to the full width of the text space (22 × 95 mm).

B. *Minor Titles in Decorative Script.*

Some initial words or titles are written in ink. That on fol. 4v (Fig. 390) is surrounded by a red flourished line; others are written in burnished

gold (e.g., fols. 30v, 63r and 75r), violet (e.g., fols. 10v, 11r and 25r) or red (e.g., fol. 25r).

C. *Text in Geometrical Shapes.*

The text on some pages is written in triangular forms (e.g., fols. 44a and 154v).

Conclusions

This manuscript is written in a round script of the type that became fashionable in Spain and Portugal, as well as in North Africa, during the fifteenth century (cf. Paris, Bibliothèque nationale, hébr. 689). In the present stage of palaeographical research it is not possible to state its origin explicitly; nor is it possible to state with certainty that the rite is exclusively North-African, though based on the Spanish rite. The style of the penwork and some of its motifs were common in Spain in the beginning of the fifteenth century. It can be compared to the *London Spanish Prayer-Book* (above, No. 38) and to the *London Hebrew Grammar* (above, No. 37), both similar in script and decoration. If the manuscript is North-African, it must have been influenced by Spanish decoration of the fifteenth century.

Bibliography

Margoliouth, No. 704, II, pp. 380–384.

40. OXFORD SPANISH PRAYER-BOOK

Spain, early fifteenth century

Bodl., Opp. Add. 8° 1

Fig. 393

Prayer-book of the Castilian rite.

General Data

Codicology

Vellum; 2 stumps + 175 leaves; *c.* 132 × 99 mm. Text space (80–84) × 50 mm. Written mostly in round Sephardi script, in brown ink, 17 lines per page. Ruling by stylus, 17 horizontal lines, usually reaching the edges, and 1 + 1 vertical lines. Pricking is noticeable in all four margins. 23 quires of 8 leaves each, except for Quires I[3] (incomplete, with two stumps at the beginning) and V[4], which are gathered so that outward hair side faces hair. From Quire VI on, the quires are numbered in Hebrew alphabetical order, with Quire VI marked *aleph* at its end (fol. 39v).

Colophon
None.

History
None.

Decoration

Penwork panels

The titles are written in larger square script, and those in Quires VI–VIII (fol. 32r, 32v – Fig. 393, to fol. 55v) are within small panels of red penwork. The panels have uneven linear frames and their ground is mostly filled with golf-club-like motifs. They are surrounded by beaded bands, often dotted and interrupted by spirals, mainly at the corners. They are enriched by flourishes and circlets, which extend into the margins. Some of the spirals enclose small open rosettes (e.g., fols. 47r, 49v and 55v).

Conclusions

In its script and penwork decoration this manuscript resembles a group of small-sized, undated manuscripts in the British Library, such as the *London Hebrew Grammar* (above, No. 37), the *London Spanish Prayer-Book* (No. 38) and the *London Spanish Maḥzor* (No. 39), all probably executed at the same period, i.e., the beginning of the fifteenth century.

Bibliography
Neubauer, No. 1088.

IV. Portuguese School of the Late Fifteenth Century
[Nos. 41–47]

The late-blossoming Portuguese School, concentrated round Lisbon, developed very definite decorative elements in the last third of the fifteenth century. Typical of its style and programme are the very dense and colourful interlacing floral borders to frontispieces and ends of books, which appear contrastingly with simple geometric carpet pages outlined in micrography (e.g., Fig. 407). Very few text illustrations are found in manuscripts from this short-lived but very prolific school of illumination. The few birds and grotesques which do appear in the margins serve as ornament rather than as text illustrations. The style of the Portuguese School combines earlier Hispano-Moresque elements with the Italian and Flemish motifs common to Latin as well as Hebrew illumination in Spain and Portugal.

The earliest dated illuminated manuscript of the school is the *Lisbon Maimonides Mishneh Torah* of 1472 (No. 41), and the latest is the *Bibliothèque nationale Portuguese Şiddur* (Paris, hébr. 592) of 1484. Despite its size, the decoration of this small *şiddur* follows the most sumptuous manuscripts of this school: the three-volume *Lisbon Bible* of 1482 (No. 42); the undated *Hispanic Society of America Bible* (in New York, MS. B. 241); and the *Bibliothèque nationale Portuguese Bible* (Paris, hébr. 15). G. Sed-Rajna has listed most of the illuminated and decorated manuscripts of this group in her *Manuscrits hébreux de Lisbonne* (Paris 1970), characterizing their codicology and style, and T. Metzger has written an entire book reviewing Sed-Rajna's work (Paris 1977).

The school is comprised mainly of religious books, such as large and small Bibles, Pentateuchs with *haftarot*, small, horizontally elongated Psalters, and *şiddurim*. The *Lisbon Maimonides* (No. 41) excepted, other types of books from this school have almost no illumination.

The script of these manuscripts is generally square; but the large round script, which became fashionable in Spain in the second half of the fifteenth century, is also fairly common. Not all the colophons mention Lisbon by name, indicating that they may have been copied in other Portuguese centres. Most of them have the formula ישע יקרב "Redemption is near at hand" as their final verse, which may serve to identify manuscripts of this school (see Sed-Rajna, *Lisbonne*, pp. 97–99).

The decoration programme common to most of the manuscripts comprises full-page painted borders framing titles or texts; penwork panels for titles and initial words; and elaborate penwork surrounding the borders. Five motifs are commonly found in the painted border decoration: (1) feathery scrolls, a development of foliage scrolls, delicately rendered with composite open flowers, painted either directly on the vellum or on a coloured ground; (2) foliage scrolls with open flowers, buds and gold dots; (3) rich scrolls of large acanthus leaves, twisted to reveal their multi-coloured reverse sides, some issuing from dragons' or lions' mouths, interspersed with multi-coloured birds such as parrots, peacocks, cocks and owls, and mostly painted on the vellum ground, which is densely filled with feathery sprigs, scrolls and gold dots; (4) a variation of Type 3: large acanthus leaves and flowers symmetrically arranged round a bar; and (5) acanthus scrolls, sometimes with large palmette buds in the curls, painted in multicolours on a gold ground or in gold on a painted ground.

The prototype of these decorative motifs can be found in various combinations in Italian, mainly Ferrarese, illumination of the fifteenth century. For example, the main painted motifs are surrounded by a network of penwork, feathery sprigs and gold dots in the *Bible of Borso d'Este* (Modena, Este Library, MS. V.G. 12; see Salmi, *Miniatures*, Pl. LIII). The large, fleshy, twisted acanthus leaves were also common in fifteenth-century Italian illumination, as, for example, in a *Ferrarese Gradual* executed by Guglielmo Giraldi in the middle of the century (Ferrara, Schifanoia Museum, Cod. 3; see Salmi, *Miniatures*, Pl. LV).

Contemporary Flemish illumination shows an even greater resemblance than that of Italy to the Portuguese Hebrew manuscripts in type of decoration, compositional combinations and motifs. For example, in the *Hours of Catherine of Cleves*, from Utrecht, *c.* 1440 (Collection of the Duke of Arenberg; see Byvanck, *Pays-Bas*, p. 117, Pls. XLV, XLVI), the text is framed by delicate feathery scrolls with fleshy acanthus leaves, as well as by feathery scrolls on a coloured ground. Foliage scrolls similar to our Type 2 appear in the *Breviary of George of Egmond*, from Utrecht, *c.* 1430 (New York, J.P. Morgan Library, MS 87; see Byvanck, *Pays-Bas*, p. 149, Pls.

XIX, XX, XLVII, XLVIII). The most developed feathery scrolls, with flowers on a vellum ground, are found in a *Delft Book of Hours, c.* 1470 (Oxford, Bodleian Lib., Douce 248; see Byvanck, *Pays-Bas*, p. 152; Pl. LVI).

It is unlikely that these motifs, which we find fully developed in the Portuguese School of Hebrew illumination, stem directly from Italian or Flemish sources. They may have developed earlier in Castilian schools, or concurrently in Portugal and Spain. Certain Italian motifs, incorporated in Flemish illumination, can also be found in Spain and Portugal in the first half of the fifteenth century. The border decorations of the mid-fifteenth-century *Castilian Breviary*, from Toledo (Madrid, Biblioteca Nacional, Vit. 18–10, see Domínguez-Bordona, *Manuscritos*, I, Fig. 314), provide an earlier example of the fleshy acanthus leaves with sprigs and gold dots. This, however, does not provide a satisfactory explanation for the abundance of feathery scroll motifs, or for their combination with other types of decoration, which became a characteristic feature of our Portuguese school.

The Portuguese schools of Hebrew illumination can be subdivided into several groups. The *Lisbon Maimonides* of 1472 (No. 41) has features which do not appear in any of the other manuscripts; it is more Italianate in style and does not contain developed feathery scrolls. The main group is related to the *Lisbon Bible* of 1482–1483 (No. 42), which does have all the main types of decoration characteristic of the school. The manuscripts close to the *Lisbon Bible* in type and style are the two small Pentateuchs in the British Library (Nos. 43, 44), and the *Oxford Portuguese Bible* (No. 45) in the Bodleian Library. The large *Hispanic Society of America Bible* (New York, MS. B. 241) and the large *Bibliothèque nationale Portuguese Bible* in Paris (hébr. 15), as well as its small *ṣiddur* of 1484 (Paris, Bibliothèque nationale, hébr. 592), also belong to this *Lisbon Bible* group. The *De Bry Psalter* (Zürich, Fleursheim Collection; see Sed-Rajna, *Psautier de Bry*) and the *Oxford Portuguese Pentateuch* (No. 46) belong to another, third, group, possibly from another atelier. Its motifs consist of thin, more intricate, interlacing scrolls. Its penwork decoration has elaborate flourishes issuing from *parashah* signs, from initial-word panels and from the mouths of animals, some of which turn into feathery scrolls with gold dots.

Two manuscripts from collections in the British Isles have not been catalogued: the *Balliol College Bible* of 1490 (Oxford, MS. 382; cf. Sed-Rajna, *Lisbonne*, pp. 82–83, Pls. LXX, LXXI, and Metzger, T., *Lisbonne*, No. 7, pp. 66–72, Pls. IX–XII), which has micrographic decorations only; and the *Oxford Effaced Ṣiddur* (Bodleian Library, Can. Or. 108; cf. Metzger, T., *Lisbonne*, Supp. No. 1, pp. 165–168, Pls. XXX, XXXI), which has effaced decorations framing the openings of prayers, somewhat similar to the *Cambridge Portuguese Prayer-Book* (No. 47).

The Portuguese School and its various groups influenced the illuminators in other areas of Spain, as well as in North Africa, during the last quarter of the fifteenth century, some of which will be discussed in Chapter Five.

41. LISBON MAIMONIDES

BL, Harley 5698–5699

Lisbon, 1471–1472

Figs. 394–403

Maimonides' Mishneh Torah.

General Data

Codicology

Two volumes; vellum; I + 301 + 1 (blank after fol. 251v) + I leaves in Vol. I and II + 435 + 1 (blank after fol. 160v) + I leaves in Vol. II; 332 × 240 mm. Text space (203–205) × (148–150) mm. Written in small square Sephardi script, in brown ink, 36 lines in two columns. Ruling by stylus, mainly on the verso of folios, 36 horizontal and 1 + 2 + 1 vertical lines. 37 and 53 quires of 8 leaves each, except for Quires I¹⁰, XXIV¹⁰ and XXXVII¹⁰ in Vol. I, and Quires XI¹², XIX¹², XXII⁶, XXIII⁶, XXXVII¹⁰, XXXVIII¹⁰, XLIII¹⁰ and XLVIII¹⁰ in Vol. II, which are gathered so that outward hair side faces hair. Catchwords at the bottom left-hand corners of the versos of the last leaves of most quires. Foliation in Hebrew letters.

Binding

Modern. The fly-leaves of Harley 5698 belong to the previous Harley binding, with watermarks similar to those of 1736–1759 (Heawood, No. 2744). Harley 5699 has a fly-leaf belonging to an earlier binding, with a watermark similar to those of the late seventeenth century (Heawood, No. 734).

Colophon

II, fol. 434v (Fig. 403) Written by the scribe Solomon b. Alzuk for Joseph b. David ben Solomon b. R. David b. Gedaliah the elder 'n Yaḥya, completed in 5232 (September 1471 to August 1472).

History

Owners' Inscriptions
I, fol. 301r; II, fol. 435v Bernard Mould, Smyrna 1724.

Censors' Signatures
II, fol. 434r (1) Laurentius Franguellus, Novembris 1574; (2) Fra Renato da Modena, 1626.
II, fol. 433v (1) Fra Luigi da Bologna, 1601; (2) Camillo Jaghel, 1613.
I, fol. 1r Fra Giov(anni) da Durallano de Predi, 1640.

Decoration

Programme

A. Full-page decorative frames.
B. Space allocated for the illustration of the Temple and its implements.
C. Decorations in micrography.

Description

A. *Full-Page Decorative Frames.*

Full-page foliage and floral frames to all fourteen books, to the introductions and to the colophon (Vol. I, fols. 11v, 12r, 13v, 31v, 63v – Fig. 398, 106v, 197v and 252v; Vol. II, fols. 2v, 34v, 94v – Fig. 401, 161v, 189v, 277v, 313v, 355v, 397v and 434v – Fig. 403: the colophon). Most frames enclose red and violet penwork panels which mostly extend over both text columns and break in the upper border with a bar containing abbreviated good omens in gold. The panel in Vol. I, fol. 11v is full-page.

The panels are divided into compartments, symmetrically set on the two sides of a decorative bar, between or below the text columns. The penwork motifs in the compartments are roundels and scrolls in double lines, with large curls enclosing palmette variations, fruits, acanthus leaves or flowers. The latter occur more in the second volume. Othe spaces are filled by dense scrolls. In many panels, the compartments are separated by thin bands with a chain pattern. This also occurs more often in the second volume.

The initial words are written in burnished gold, and the panels and the related text columns are framed by gold fillets. In some places (e.g., Vol. I, fols. 106v and 252v; Vol. II, fols. 355v and 397v) the fillets are decorated with a geometrical interlace in blue or green.

The foliage decoration of the frames is coloured ultramarine blue, purple, light green, violet, magenta, grey, vermilion red, light ochre and brown; it is modelled with lighter and darker shades or heightened with white and gold on the vellum ground. There are three main types of frame decoration:

1. Scrolls of fleshy acanthus leaves, twisted to reveal their differently coloured other side, with some flowers and other smaller leaves (e.g., Vol. I, fols. 11v and 106v). In some places the space enclosed by the curls of the leaves is filled with burnished gold (e.g., Vol. I, fols. 11v and 12r — the opening pages; Vol. II, fol. 434v – Fig. 403: the colophon), and in some, brush gold (e.g., Vol. II, fol. 434v).

2. Feathery pen-drawn scrolls with naturalistic flowers (e.g., Vol. I, fol. 13v).

3. Floral scrolls with small green leaves (e.g., Vol. I, fol. 63v – Fig. 398).

Most of the frame decorations are a combination of Type 1 with Type 2 or Type 3, or with both. The combination of Types 1 and 2 is very common in the second volume. The foliage decoration sometimes comes out from dragons' mouths or from dragons' heads (e.g., Vol. I, fols. 11v and 197v).

The vellum ground is strewn with gold dots between penwork flourishes, and there are various motifs within the foliage. In the middle of some of the lower borders there are vases or pots with foliage (e.g., Vol. I, fol. 63v; Vol. II, fols. 2v, 313v and 434v), a spread peacock in the middle of the lower margin (e.g., Vol. I, fols. 11v and 252v; Vol. II, fol. 189v), other peacocks (e.g., Vol. I, fols. 31v and 252v – Fig. 400; Vol. II, fols. 313v and 355v), owls (e.g., Vol. I, fols. 11v and 31v; Vol. II, fols. 2v and 313v), a rooster (Vol. I, fol. 11v) and many other birds and rabbits (e.g., Vol. I, fol. 106v; Vol. II, fol. 2v). A recurring motif is an interlace of coloured bands (e.g., Vol. I, fols. 11v, 12r, 31v and 106v; Vol. II, fol. 34v). Among the flowers are some with a large stylized centre, as well as stylized roses or carnations (e.g., Vol. I, fols. 11v, 13v and 63v; Vol. II, fols. 2v and 161v).

I, fol. 11v (Fig. 395) The foliage scroll (Type 1) springs from the mouths of dragons at the two top corners, from the mouth of a green and red dragon whose tail twists round the gold fillet frame at the lower right-hand corner, and from a vase resting on a lion, whose paws lean on a branch with acanthus leaves, in the other corner. The central bar, interrupted by penwork compartments, is decorated with coloured acanthus and floral sprays, among them forget-me-nots in a vase.

I, fol. 12r (Fig. 396) The border is decorated with a variation of Type 1 in which the foliage is symmetrically arranged to form pairs of acanthus leaves resembling palmettes. These are strung on central stems interrupted by floral motifs. Between the text columns are acanthus leaves winding round a bar which ends in a large flower.

I, fol. 13v The initial-word panel is topped by a gold crown decorated with coloured dots.

II, fol. 34v A pen-drawn face in the middle of an interlace in the outer border.

II, fol. 180v (Fig. 402) The spread peacock in the centre of the lower margin is flanked by two crouching animals with human heads. That on the left is bearded and wears a pointed, curling hat.

II, fol. 434v (Fig. 403) The foliage frame for the colophon is enriched by an inner frame of penwork with gold borders and gold inscriptions.

B. *Space Allocated for the Illustration of the Temple and its Implements.*

Vol. II, fols. 97–98, 99r–v, 101r and 108v are either blank or contain blank spaces. The text implies that these spaces were intended for the depiction of the Temple and its implements.

C. *Decorations in Micrography.*

I, fol. 2r (Fig. 394) The text is framed by a gold fillet and a border framed by an angular interlace of micrography bands with penwork fillings. Penwork scrolls with single-coloured flowers and gold dots fill the space between the gold frame and the interlace border.

Conclusions

This copy of Maimonides' *Mishneh Torah*, completed in 1472, is the earliest dated work in a group of manuscripts from the Portuguese School. Included in this group are the *Lisbon Bible* of 1482, in three volumes (No. 42), and other manuscripts. According to the colophon, this copy was written in 1471 or 1472, for Don Joseph b. David b. Solomon b. David b. Gedaliah b. Yaḥya, scion of a famous Portuguese family. Although no place-name is mentioned, its Lisbon origin can be deduced from its style, as well as from the fact that Don Joseph, who was born in Lisbon in 1425, continued to live in that city, and was probably a patron of other manuscripts written there. Another manuscript, copied for him in 1487 (BL., Or. 1045, Sed-Rajna, *Lisbonne*, pp. 21–22, 52), has the name Lisbon mentioned in its colophon. It can therefore be assumed that our manuscript was also copied for Don Joseph in Lisbon.

This manuscript is similar to the *Lisbon Bible* (No. 42) in its plan of decoration, composition, motifs and style. Like the other manuscripts of the Portuguese group, it is decorated with coloured frame borders and extensive additional penwork decoration. The various types of floral and foliage scrolls in our manuscript; the fleshy acanthus leaves, curling to reveal their multi-coloured sides and arranged either in scroll form or issuing symmetrically from a bar; the pen-drawn feathery scrolls with flowers; the floral scrolls with thin stems and leaves — are all found in similar forms or variations in these manuscripts. The decoration style of this group is influenced by Italian as well as Flemish illumination. However, in our manuscript the Flemish influence is not yet pronounced. Its acanthus foliage is particularly rich (e.g., Vol. I, fols. 11v – Fig. 395, and 12r; Vol. II, fol. 434v – Fig. 403), with a fullness of form and plasticity not to be found in Flemish manuscripts, but comparable to those in the border decorations of Italian manuscripts such as a *Ferrarese Gradual* (Ferrara, Schifanoia Museum, Cor. 3; see Salmi, *Miniatures*, Pl. LV).

The most pronounced Italian influence is found in Vol. I, fols. 11v and 12r (Figs. 395, 396), as is evident from the symmetrical grouping of the

foliage motifs, the geometrical interlaces, the gold filling in the empty spaces enclosed by the leaves, and the large upright flower between the two text columns.

The border decoration on other pages of the manuscript (e.g., Vol. I, fol. 31r; Vol. II, fol. 180v – Figs. 397, 402) shows a variant type of composition, with a few acanthus leaves alternating with thin foliage scrolls and interspersed with birds and gold dots. This combination of two types of scrolls within one border is further developed later in this school. The feathery scroll as the sole motif of a decorated border, which became the hallmark of the Portuguese School, appears in our manuscript only in combination with other types of scrolls (e.g., Vol. I, fol. 13v; Vol. II, fol. 434v – Fig. 403).

The delicate, formalized penwork comprises scrolls and club motifs found abundantly in other Sephardi schools of the second half of the fifteenth century.

Although it falls within the tradition of Spanish illumination, the decoration of our manuscript marks the beginnings of a new trend, that of the Portuguese School.

Bibliography

Margoliouth, Nos. 486–487, II, pp. 102–104.
Heawood, *Watermarks*, Nos. 734, 2744.
Domínguez-Bordona, *Ars Hispaniae*, XVIII, Fig. 139.
Salmi, *Miniatures*, Pl. LV.
Narkiss, *HIM*, No. 19.
Sed-Rajna, *Lisbonne*, Nos. 1, 12, pp. 20–23, 52–53; Pls. I–VI.
Metzger, T., *Lisbonne*, No. 1, pp. 25–32, Pl. I.

42. LISBON BIBLE

Lisbon, 1482

BL, Or. 2626–2628

Figs. 404–419

Bible.

General Data

Codicology

Three volumes; vellum; 184 + II leaves in Vol. I, 273 + II leaves in Vol. II and 186 + I leaves in Vol. III; 300 × 245 mm. Text space (183–187) × (153–160) mm; height of text space with Massorah 230–232 mm. Written in square Sephardi script, in light brown ink, 26 lines in two columns. Ruling by stylus on the verso side, 2 + 26 + 3 horizontal and (1–2) + (2–3) + 1 vertical lines. 24, 34 and 24 quires of 8 leaves each, except for Quires III[6], XI[6], XX[6] and XXIV[6] in Vol. I; Quires XVII[7] and XXVI[10] in Vol. II and Quires XVII[6], XXIII[6] and XXIV[6] in Vol. III, which are gathered so that outward hair side faces hair. Catchwords at the bottom of the verso of the last folio of nearly every quire.

Binding

Modern British Museum green bindings with gold tooling has replaced the blind-tooled brown leather bindings, to which belong the fly-leaves with water-mark of 1606–1607 (Heawood, No. 2312).

Colophon

III, fol. 185v (Fig. 419) Written by the scribe Samuel b. Samuel 'n Muṣa, for R. Joseph, son of R. Judah called al-Ḥakim, and completed on a Friday in Kislev 5243 (12 November to 10 December 1482) in "Lisaboa".

III, fol. 50r At the end of Chronicles, in micrographic script within a rosette, an incomplete inscription; Chronicles were completed on the 4th of Kislev (or: on a Wednesday in Kislev) 5200. It is possible that the inscription is not complete, and that the words "forty-three" are missing, which should make it 5243 (i.e., 15 November 1482).

History

Purchased by the British Museum from Benjamin Cohen of Bukhara on 17 November 1882.

Decoration

Programme

A. Full-page decorative frames.
B. Initial-word panels.
C. Decorations in micrography.
D. Decorated *parashah* signs.

Description

A. *Full-Page Decorative Frames.*

The frames have wide borders of coloured foliage and floral decorations. Those for the massoretic texts usually enclose inner frames of penwork, mostly with gold inscriptions and with a penwork

bar between the text columns. Many pages contain additional small penwork initial-word panels, in which the words are written in gold. In Vol. II, the opening pages of Jeremiah and the Latter Prophets are decorated with a frame which encloses the initial-word panel as well as the borders of different decoration surrounding each of the text columns (e.g., fols. 168r, 246r, 250v, 252r – Fig. 414, 256r, 256v, 258r – Fig. 415, 260v, 263r, 264v, 265v and 271v). Many of these pages, and some others, have elaborate feathery flourishes round the frame (also Vol. II, fol. 1v; Vol. III, fol. 1v – Fig. 416, a different kind of flourish, and 186r).

The foliage and floral decoration is coloured ultramarine blue, light green, magenta, yellow, vermilion red and wine red, with gold and some silver, mostly on the vellum ground. The coloured shapes are modelled with darker shades and heightened with white and silver. Some penwork panels (e.g., Vol. II, fols. 1v, 168r, 246r, 250v, 252r, 256v and 261v) and decorative borders (e.g., Vol. I, fols. 2r, 4r and 6r; Vol. II, fol. 1v; Vol. III, fol. 1v) have gold fillet frames.

This decoration consists of several types of scrolls:

1. Feathery scrolls are the most common, mostly in black ink or gold, sometimes in violet (e.g., Vol. I, fols. 180v – Fig. 408, and 180r–184v; Vol. III, fols. 179v, 180r and 183v). They are mostly on the vellum ground, but those in gold frequently have a coloured ground, usually wine red or blue (e.g., Vol. I, fols. 2v, 3r, 10r, 11r, 14v and 16v – Fig. 409; Vol. II, fols. 250v, 252r – Fig. 414, 256r, 256v and 261v; Vol. III, fol. 186r). The ends of the pen-drawn scrolls are sometimes tipped in green to resemble leaves.

2. Floral scrolls with thin stems and small, simple green leaves (e.g., Vol. I, fol. 7v; Vol. II, fol. 210r: upper margin; and fol. 258r: with gold dots and flourishes), some of them on a coloured ground (e.g., Vol. I, fol. 13v – Fig. 406: violet; Vol. II, fol. 263r: silver with some gold; and fol. 264v: silver). Both Types 1 and 2 have various flowers, some with a large fruit-like centre, natural or stylized roses (e.g., Vol. I, fols. 5r, 6v, 7r, 7v, 12v, 13v, 14r and 15r; Vol. II, fols. 210r – Fig. 413, 252r – Fig. 414, 256r, 263r, 264v and 265v) or carnations (e.g., Vol. I, fols. 5r, 7v and 15r; Vol. II, fol. 250v) and coloured dots.

3. Acanthus scrolls with long leaves which curl to reveal their differently coloured other side, some with gold fillings (e.g., Vol. II, fols. 264v and 265v; Vol. III, fol. 185v – Fig. 419), and, when on the vellum ground, mostly with gold dots and flourishes (e.g., Vol. III, fol. 1v – Fig. 416). This type is mostly found in combination (e.g., Vol. I, fols. 1v, 5r and 14r; Vol. II, fols. 246r, 252r–v, 256r, 261v, 263r, 264v and 265v).

4. A variation on Type 3: acanthus leaves or flowers symmetrically arranged round or winding around a bar with pairs of leaves springing from stylized flowers, a flower with a fruit-like centre at the top and a dragon holding the central bar in its mouth at the bottom (e.g., Vol. II, fols. 210r – Fig. 413, and 260v). In Vol. I, fol. 7v, a dragon supports thin stems of symmetrically arranged flowers.

5. Acanthus scrolls with large blossoms composed of acanthus leaves enclosed in the curls. This type is mostly on a gold ground (e.g., Vol. I, fols. 4v, 5v and 8v; Vol. II, fols. 136v – Fig. 412, 168r, 246r and 265v; Vol. III, fol. 186r).

On many pages there are other motifs among the foliage: owls (e.g., Vol. I, fols. 5r, 6v, 7v, 8r – Fig. 405, and 14r; Vol. II, fols. 210r, 246r and 252r); spread peacocks (e.g., Vol. I, fol. 1v), some of them in the middle of the lower border (e.g., Vol. I, fol. 5r; Vol. II, fol. 261v); a rooster (e.g., Vol. I, fol. 1v); parrots and other birds (e.g., Vol. I, fols. 4r, 5r, 6v, 7v and 8r; Vol. II, fols. 246r, 252r, 256r, 261v and 265v). On some pages there is a vase or pot with flowers in the middle of the upper or lower border (e.g., Vol. I, fols. 1v and 7v; Vol. II, fols. 1v, 210r and 260v).

The penwork of both full-page frames and the initial-word panels is mostly in violet. There are two main types of design: 1. A dense, irregular pattern of scrolls formed by thin bands and enclosing smaller scrolls with small dotted and serrated flowers, the smaller scrolls sometimes arranged in a fan pattern. 2. Sequences of club-leaf fans.

Special Decorations
I, fol. 1v (Fig. 404) In the upper border, a coat of arms: *azure* and fleur-de-lis *or*.
I, fol. 5r In the upper border, a roundel with peacock's tail or pine-cone decoration.
II, fol. 1v (Fig. 410) The foliage decoration of the full-page frame is different from the rest; it is similar to Vol. III, fol. 1v (Fig. 416), in its gold fillet-frame, the finely elaborated acanthus leaves heightened with white and silver, and the more elaborate flourishes with many gold dots among the acanthus, which is similar to the marginal decoration attached to the initial-word panels. On this page, some of the acanthus is symmetrically arranged, and some leaves and enclosed spaces have a peacock's tail or pine-cone decoration. In the middle of the upper border there are a bunch of green stems in a stylized acanthus-leaf container and a star-like brush gold flower.
II, fol. 136v (Fig. 412) Beginning of Isaiah: The text, the inner penwork border and the outer painted border are all framed by a wine-red fillet with a brush gold chain pattern. The initial words are written within a lozenge-shaped blue panel,

similarly framed, at the upper border of the inner frame. The painted decoration is of Type 5, but with reversed colouring: the shapes are in burnished gold and the ground is coloured.

II, fol. 246r Above the penwork initial-word panel is a brush gold band with a pen-drawn purple scroll.

III, fols. 185v–186r The colophon is written in burnished gold, within a double frame.

III, fol. 185v (Fig. 419) The outer frame is a rich example of Type 3, on the vellum ground, with a spread peacock in the middle of the upper margin and a coat of arms in the middle of the lower: a purple background, divided diagonally by a gold band, held in dragons' mouths at the top right and lower left. In each field there are a crescent, stars and dots (Lisbon ?). The coat of arms is flanked by a gold lion in the right-hand corner and a dragon, from whose mouth the scroll of the inner border springs, in the other corner. Among the foliage there are also parrots, an owl, a rooster and other birds. The inner frame is of Type 1, in silver on a wine red ground, and the flowers are blue and green, with some vermilion.

III, fol. 186r The outer frame is an opulent example of Type 5, on a gold ground with flourishes round it. The rich colours are badly damaged. The inner frame is of Type 1, in gold on a wine-red ground; the flowers are blue and green, with some vermilion.

B. *Initial-Word Panels.*

At the beginnings of all books which have no full-page decorative frame there is an initial-word panel (Vol. I, fols. 23v, 61v, 94r, 117r and 150r; Vol. II, fols. 21r – Fig. 411, 40r and 85v; Vol. III, fols. 50v, 93r, 107r, 127r, 138v, 141r, 144r, 147r, 152v and 159r); there is also one partial border (Vol. III, fol. 50v – Fig. 417).

The initial-word panels extend over one text column. They are filled with penwork and the script and frame are in burnished gold or silver. They are surrounded on three sides when at the top of the text column, and on two sides when in the middle, with decoration of Type 3 on the vellum ground, in magenta, blue, green and brush gold, with more flourishes and small coloured dots, flowers and leaves which are sometimes heightened with silver (e.g., Vol. I, fols. 23v, 117r and 150r), or with feathery penwork scrolls and flourishes of Type 1, with green magenta, blue and gold (and some silver, e.g., Vol. III, fols. 144r, 147r and 152v) dots, flowers and leaves (e.g., Vol. I, fols. 61v and 94r). However, in most places the decorations round the panels combine both types and extend along the margins, sometimes to their full length (e.g., Vol. II, fols. 21r and 40r).

III, fol. 50v (Fig. 417) Beginning of Psalms: There is no initial-word panel, but the first letter of the first word is written in burnished gold, and a partial border similar to that of the initial-word panels extends from the top right-hand corner to the centre of the upper and outer margins.

III, fol. 107r A vertically elongated penwork panel framed by a silver fillet is attached to the top left-hand corner of the initial-word panel, to form an L-shaped panel.

C. *Decorations in Micrography.*

I, fol. 179v (Fig. 407) A full-page micrography panel (181 × 155 mm) of a rosette framed by three concentric circles within a rectangle. There is a row of semi-circles between the second and third circles.

III, fol. 50r In the lower half of the page, a micrography rosette in two concentric circles.

III, fol. 185r (Fig. 418) A full-page micrography panel, with a rosette similar to that in Vol. I, fol. 179v, and similarly framed, but here the spaces between the micrography shapes are filled with acanthus and palmette scrolls in violet penwork, other palmette motifs and a chain pattern. The panel is framed by an inner penwork frame bearing an inscription in ink, and an outer floral frame of Type 1, with the pen-drawn scroll in black on the vellum ground.

D. *Decorated Parashah Signs.*

Signs for the *parashot* of the Pentateuch are in burnished gold. They are mostly within small penwork panels framed by gold fillets, with decoration similar to that round the initial-word panels, but symmetrically arranged, extending along the whole margin or part of it. In Vol. I, fol. 40r, the panel is polygonal, with fleurs-de-lis projecting from four corners.

Conclusions

This manuscript is the most luxurious and accomplished dated book of the Portuguese School. Dated to 1482, it must be one of the later manuscripts of the group. The elaborate decorations, which were planned and executed at the same time and in the same workshop, consist of decorated framing borders and penwork panels. Particularly rich and inventive is the penwork, with its complicated scroll, palmette and floral motifs, which are typical of general Spanish ornamentation in the second half of the fifteenth century. The borders display examples of the different types of Portuguese decoration in the fifteenth century, which are Italian as well as Flemish in origin. Most of them have long, feathery pen scrolls, those on coloured grounds executed in gold. The frontal, open flowers and the birds are influenced by Italian decoration, but have been executed in a Spanish manner. Other borders, decorated with feathery and acanthus scrolls in bright colours on gold and

silver backgrounds, point to a Flemish influence. In its variety, the manuscript is an important specimen of Portuguese decoration, and its date can help date other manuscripts of the group. The coats of arms in the borders of the manuscript have not yet been identified (e.g., Vol. I, fol. 1v; Vol. III, fol. 185v – Figs. 404, 419).

Bibliography

Margoliouth, No. 62, I, pp. 33–35.

Leveen, p. 184.
Heawood, *Watermarks*, No. 2321.
Ginsburg, *Introduction*, No. 48, pp. 707–714.
Leveen, *Bible*, pp. 113 f., Pls. XXXVII, XXXVIII.
Sed-Rajna, *Lisbonne*, No. 2, pp. 24–29; Pls. VII–XVI.
Narkiss, *HIM*, p. 80; Pl. 20.
Metzger, T., *Lisbonne*, No. 2, pp. 33–48; Pls. II, III, XXXVII.

43. DUKE OF SUSSEX PORTUGUESE PENTATEUCH

Lisbon, c. 1480–1490

BL, Add. 15283

Figs. 420–423

Pentateuch, haftarot and Megillot.

General Data

Codicology

Fine vellum; 265 + 1 leaves; 196 × 138 mm. Text space 117 × 85 mm. Written in round Sephardi script, in dark brown ink, 21 lines in two columns, except for four of the opening pages of the Pentateuch (fols. 2r, 48v, 88r and 152r), which are written in one column, and the poetical parts, which are written in the traditional manner. The initial words of the books of the Pentateuch and the Five *Megillot*, in gold, and the *haftarot* titles, in ink, are written in square Sephardi script. Ruling by stylus on the versos, 1 + 21 + 2 horizontal and 2 + 2 + 1 vertical lines. 33 quires of 8 leaves each, except for Quires XI[6] and XXXIII[10], which are gathered so that hair side faces hair. Most catchwords have been cut off by a binder.

Binding

Modern.

Colophon

None.

History

Back binding From the collection of the Duke of Sussex, with his book-plate, marked "VI.H.b.d." and "No. 4".
Fly-leaf Purchased for the British Museum at his sale on 2 August 1844, Lot 315.

Decoration

Programme

A. Full-page decorative frames.

B. Small initial-word panels.
C. Penwork filling spaces in the text.

Description

A. *Full-Page Decorative Frames.*

There are five full-page frames, one at the beginning of each book of the Pentateuch, enclosing the text with penwork initial-word panels (fols. 1r, 48v, 88r, 114v and 152r).

The frames, of painted foliage and floral borders, enclose inner frames or initial-word panels in penwork. The initial words are in burnished gold; the penwork, in violet ink, consists of scrolls, guilloches, zigzags and club-leaf fans, with additional flourishes. Most borders are surrounded by gold lace penwork. The painted decoration differs greatly from one panel to another.

fol. 1r (Fig. 420) Curly acanthus scrolls in green, blue, wine red, ochre and black, with gold and silver, enriched with gold dots and black flourishes on the vellum ground, like Type 3 of the *Lisbon Bible* (No. 42; Vol. II, fol. 252r). A spread peacock is in the centre of the lower border. In the upper border is a coat of arms, *azure*, four stars *or* (middle damaged), flanked by two birds.

fol. 48v (Fig. 421) The border is decorated with curly leaf scrolls with large blossoms, all in gold on a blue, emerald green and wine red ground (cf. the *Lisbon Bible*, Type 5; e.g., Vol. II, fol. 136v).

fol. 88r (Fig. 422) Gold feathery scrolls, with blue and green flowers on a wine red ground (cf. the *Lisbon Bible*, Type 1; e.g., Vol. II, fol. 252r).

fol. 114v (Fig. 423) The border is decorated with large acanthus scrolls in gold, modelled with red and greenish brown penwork on a blue ground, with small greenish brown circlets.

fol. 152r Large foliage scrolls, with flowers and birds on a gold ground. Most of the colour has flaked off. The irregular shape of the penwork panel is determined by the lay-out of the text.

B. *Small Initial-Word Panels.*

There are four small initial-word panels (fols. 242v, 248v, 255r and 258v) and one painted border (fol. 245v) to the Five *Megillot*; each panel runs over one text column. The borders of these panels extend to the margins and are filled with coloured acanthus scrolls and gold dots on the vellum ground. The panels are painted in violet, olive green or wine red, decorated with feathery gold scrolls, and have the initial word in gold written within a small penwork compartment in the centre. The borders and panels are framed by gold fillets, and gold lace penwork surrounds the borders.

fols. 242v, 248v, 258v Inverted U-shaped acanthus borders with slanting ends surround the initial-word panels. The border on fol. 248v has a peacock with a spread tail, and that on fol. 258v has a bird on the left.

fol. 245v An inverted U-shaped border to the upper part of the right-hand text column, with straight ends. The acanthus scrolls end with a bird on either side. No initial-word panel.

fol. 255r The initial word is written in a small penwork compartment, with cinquefoil top within the painted panel. The two long acanthus borders flanking the panel and text both have angular ends surrounded by rich gold lace penwork.

C. *Penwork Filling Spaces in the Text.*

fol. 42r In the middle of the right-hand text column is a violet penwork panel on a grey ground, and violet penwork flourishes in the margins.

Conclusions

The manuscript was probably decorated in the same workshop that produced the *Lisbon Bible* of 1482 (No. 42); compare, e.g., fols. 1r, 48v, 88r and 152r in our manuscript (Figs. 420–422) with Vol. I, fols. 1v, 3r and 8v; Vol. II, fol. 265v, respectively, in the *Lisbon Bible* (Figs. 404, 405). Although on a smaller scale, it is similar in quality and has the same types of border decoration, some of which are also found in the *Almanzi Portuguese Pentateuch* (No. 44; e.g., fol. 11v). There are the same feathery gold scroll borders on a red ground, almost a hallmark of the *Lisbon Bible* decoration, and the same type of conventional gold foliage scrolls. Moreover, the acanthus scrolls are similar and the colouring is the same. The technique of the floriated scrolls on silver and gold grounds is similar to the extent that the colours in both Bibles have flaked off, and only the white design and a few traces of colour remain. The gold lace penwork is more extensive than that of the *Lisbon Bible* and of particularly fine design.

Bibliography

Margoliouth, No. 84, I, pp. 59–60.
Sotheby Sale, 2.8.1844, Lot 315, p. 28.
Sed-Rajna, *Lisbonne*, No. 18, pp. 18–75; Pls. LX–LXIII.
Metzger, T., *Lisbonne*, No. 18, pp. 117–122; Pls. XX–XXIII.

44. ALMANZI PORTUGUESE PENTATEUCH

Lisbon, c. 1480–1490

BL, Add. 27167

Figs. 424–425

Pentateuch, haftarot and Megillot.

General Data

Codicology

Vellum; 464 leaves; 170 × 117–119 mm. Text space (107–110) × (69–71) mm. Written in square Sephardi script, in dark brown ink, 19–20 lines to a page. Fols. 9r–11r, 407r and 454 are blank. Ruling by stylus on the verso, 2 + 19–20 + 3 horizontal and 2 + 1 vertical lines. 60 quires of 8 leaves each, except for Quires II², XIV⁶, XVII¹⁰ (with 4 single leaves: fols. 122, 123, 128 and 129), XXXVI⁶, XLIII⁵, XLVI⁸ (with 2 single leaves: fols. 354 and 355) and LX², which are gathered so that outward hair side faces hair. Some catchwords, many of them cut off by a binder. Fol. 464 does not belong to this manuscript.

Binding
Late eighteenth-century Italian green morocco binding with gold tooling.

Colophon
None.

History
fol. 10v Inscription, partly cut off by a later binder: "Nel anno [...] [ilescio [...] anno 1598."
Back paper fly-leaf From the Joseph Almanzi Collection in Padua, bought for the British Museum at his sale in 1864, No. 277, by Asher & Co. from Berlin. Reached the museum in October 1865.

Decoration

Programme
A. Full-page decorative borders.
B. Penwork frames and panels.

Description

A. *Full-Page Decorative Borders.*
The five painted borders at the beginning of the books of the Pentateuch (fols. 11v, 86r, 148v, 192v and 256r) are decorated with scrolls of variously coloured twisting acanthus leaves (fols. 11v and 256r), in some places forming stylized flowers (e.g., fol. 192v), or scrolls of carnations (fol. 86r) or roses (fol. 148v – Fig. 424). Both types include other, smaller flowers, and are painted on the vellum ground (fols. 11v, 148v and 256r) or on a burnished gold (fol. 86r) or silver (fol. 192v) ground. The scrolls are enriched with birds and beasts, among which are: a peacock (fol. 11v), a rooster (fol. 11v), owls (fols. 148v and 256r), pheasants and other birds (fols. 11v, 86r, 148v and 256r), two lions holding a coat of arms *azure* (fols. 11v; repeated on fol. 256r) and a human-faced sun (fol. 256r). The scroll in the left-hand border on fol. 256r is symmetrical, growing from the mouth of a dragon at the bottom and terminating with a flower at the top. The paintings are coloured emerald green, wine red, violet, ultramarine blue, yellow ochre, black and pink, with burnished gold and silver and many gold dots with black flourishes. The shapes are modelled with lines of darker shades and with white lines and dots. The painted borders enclose initial words in burnished gold, written within a penwork panel. Panels and borders are framed with gold fillets

(with some silver on fol. 256r and an additional inner gold frame on fol. 11v).

B. *Penwork Frames and Panels.*
The penwork consists of frames and borders with brown ink inscriptions, some enclosing small initial-word panels (fols. 1v–8v and 455r–462r), small panels to the signs of the *parashot* and initial-word panels to the names of the *haftarot* (fols. 311r–406v). The initial words for the Five *Megillot* are written in burnished gold (except for fol. 419v – Fig. 425), within bigger penwork panels (fols. 407r, 413v, 419v, 427v and 441r).
The penwork decoration is in violet, red, blue and black ink, mostly scrolls in double lines filled with small circles and dots, with some club-leaf rosette patterns (e.g., fol. 192v) and rich flourishes extending to the margin and round the text column, and two owls on fol. 419v.

Conclusions

The decoration of our manuscript can be compared with that of the *Lisbon Bible* of 1482 (No. 42). They are similar not only in motifs, but also in the style of their painted borders and penwork panels (cf., e.g., fols. 11v, 192v, 256r and 419v in our manuscript with Vol. I, fol. 1v; Vol. II, fols. 168r and 260v; Vol. III, fol. 20r in the *Lisbon Bible*, respectively). Even the same technique has been employed: brushwork gold and silver grounds, where the colour has peeled off when overpainted. The penwork pages surrounded by lacework of the massoretic lists and the Five *Megillot* are also similar to the massoretic pages of the *Lisbon Bible*. Other details similar in both manuscripts are the types of peacocks, parrots, dragons and owls, which may point to the same workshop at about the same period.
The acanthus borders and penwork of our manuscript also resemble those in the *Duke of Sussex Portuguese Pentateuch* (No. 43; e.g., fol. 1r – Fig. 420), which is ascribed to the same Lisbon studio and was probably executed in the same decade.

Bibliography

Margoliouth, No. 83, I, pp. 58–59.
Luzzatto, *Almanzi*, No. 277, p. 35.
Sed-Rajna, *Lisbonne*, No. 17, pp. 70–72; Pls. LIV-LIX.
Metzger, T., *Lisbonne*, No. 17, pp. 110–116; Pl. XIX.

45. OXFORD PORTUGUESE BIBLE

Lisbon, late fifteenth century

Bodl., Or. 414

Figs. 426–427

Bible.

General Data

Codicology

Fine vellum; 653 + 1 (fol. 1a) leaves; 182 × 132 mm. Text space (117–120) × 78 mm. Written in small square Sephardi script, in brown ink, 26 lines in two columns. Ruling by stylus, 26 horizontal and 1 + 2 + 1 vertical lines. 81 quires of 8 leaves each, except for Quires I^9 (a single leaf at the beginning — fol. 1 — containing the frontispiece is pasted to the first page of the quire, fol. 1a); II7 (a single leaf in the middle); V^6, IX10, XII12, XVI10, XXX6, XXXIX9, LI6, LII10, LIV6, LIX6, LX4 (the book of Ruth, fols. 473v–476v; see below, written on a quire of 4 conjoint leaves, is now bound and titled at the beginning of the Hagiographa, before Psalms. It was once bound in front of Joshua, fol. 166, as can be deduced from the imprint of the burnished gold title of Joshua, which can still be seen on fol. 476v. Fols. 473r and 476v are blank); LXI–LXIII12, LXXX6 and LXXXI7 (3 leaves cut out after fol. 651). Foliation and names of books in violet ink in the upper margin of every recto. The chapter and verse numbers were added in wine red after 1683 (see below, History).

Binding

Seventeenth-century Italian blind-tooled morocco binding.

Colophon

None.

History

fol. 653v At the end of the manuscript, a Latin inscription: "Illustrissimo Clarissimoque Domino D. Laurentio d'Arvieux Ordinis Deiparae Virginis de M. Carmelo & S. Lazari Ierosolimitanis Equiti. R. Xpmo, a consiliis pro ejusd. Mtis. in Syria, Cypri Insula & Caramania, Consuli, meritissimo. Offerebant Humillmi & obligatmi. Servi & Interpretes. Samuel Laniado, Isaac Sarmon, 1683." The book was given to Laurentius d'Arvieux by Samuel Laniado and Isaac Sarmon in 1683, in Syria, Cyprus or Caramania.

fols. 166r, 317r and 476v A small oval stamp, perhaps of a bookseller, inscribed in Hebrew and Arabic "Menashe b. Joseph".

Decoration

Programme

A. Full-page decorative frames.
B. Frontispiece and title panels.

Description

A. *Full-Page Decorative Frames.*

There are nine full-page decorated frames, to the frontispiece (fol. 1r), to the main divisions of the Bible (fols. 1a verso, 166r, 317r and 473v) and to Job, Proverbs, Ecclesiastes and the Song of Songs (fols. 513v, 530v, 545v and 552r). The frames consist of floral borders, and most include panels decorated with violet penwork above the beginnings of the books. These are within the frames, at the top of the text (fol. 166r — across the text space; and fols. 317r and 473v — over one text column), within the text (fols. 513v, 530v and 545v — across the text space; and fol. 552r — across one text column) or replacing the upper border of the frame (fol. 1a verso). Those on fols. 530v and 545v are supported by a panel with similar decoration, between the two text columns. The panel on fol. 477r (Psalms — over both text columns) is similar, though it is not accompanied by a full-page frame.

The framing bands are bordered by an ink line (thin flaked-gold fillets on fol. 1a verso) and are decorated with feathery sprays and scrolls in brush gold, violet or wine red ink, often spreading from the corners of the borders, and all ending with small flowers in blue, wine red, green and yellow paint. Most of the larger flowers have a gold centre decorated with linework which is sometimes elongated or shaped like a vase (e.g., fol. 530v). In the centres of two of the flowers on fol. 1a verso (Genesis) are two small human heads in slightly tinted pen drawing, one of a woman and the other of a tonsured cleric.

The penwork consists of undulating scrolls with small serrated flower-like roundels, often enclosing small circlets. The scrolls often spread from one or more corners of the panel. Some of them enclose fruit-like motifs (e.g., fol. 545v), and sometimes flourishes extend from the panels (e.g., fols. 317r, 477r and 530 – Fig. 427). Most of the titles inscribed within the panels are later additions (see below, § B); the only original inscriptions within the panels are "with the help of Heaven" (fols. 1v – Fig. 426: Genesis; 166r: Joshua; and 477r: Psalms) and titles at two of the main divisions (fols. 166r: Joshua; and 473v: Ruth). These are

mostly written within a small compartment on the vellum ground.

B. *Frontispiece and Title Panels.*

The frontispiece pasted on fol. 1, and some of the title panels, were done for Laurentius d'Arvieux in or after 1683. This decoration is in wine red, olive green, ultramarine blue and ochre, with brush and burnished gold, like the additional decoration in the *King's Bible* (No. 22), which was executed for the same patron.

On fol. 1r, two pieces of vellum are inserted into an original full-page frame. The title and the names of the archangels and the nine groups of angels are written on them in gold on a coloured ground, sub-divided geometrically; the names of God are written in silver. There are also title panels with the title written in burnished gold on a coloured ground and framed by gold and coloured bands. The panels are mostly rectangular; that on fol. 99v is hexagonal. Three such panels are inserted in original penwork panels (fols. 530v, 545v and 552r); other original panels have inserted inscriptions; only that on fol. 166, in green, has been partly erased.

Conclusions

This manuscript belongs to a group of small-size Portuguese books for religious usage, all of which show distinct stylistic similarities to the large-size *Lisbon Bible* of 1482 (No. 42). Other typical examples of the group are the *Duke of Sussex*

Portuguese Pentateuch (No. 43), the *Almanzi Portuguese Pentateuch* (No. 44) and a *şiddur of 1484* in Paris (Bibliothéque nationale, hébr. 592). The *Oxford Portuguese Pentateuch* (No. 46) and the *Cambridge Portuguese Prayer-Book* (No. 47) are of a somewhat later date. Typical of the group are the full-page decorative frames which enclose the text with penwork panels. These are decorated with a wide range of foliage ornament, of which only one type — the feathery scrolls with flowers — is represented in this manuscript. The delicate feathery scrolls are closer to the Flemish prototypes of this group than to any of its Italian origins. Those on fol. 1a verso can be compared to the *Book of Hours from Delft* of *c.* 1470 (Bodl., MS Douce 248; see Byvanck, Pl. LVI). The rest of the decorated frames are similar to those of the *Lisbon Bible* (cf., e.g., fol. 530v in our manuscript with Vol. I, fol. 182r, in the *Lisbon Bible*). Considering the rarity of the human figure in this group, the two human heads within the scrolls on fol. 1a verso are noteworthy. The penwork in the panels is also typical of the group, although similar penwork also occurs in Spanish and not necessarily Portuguese manuscripts of the same period.

Bibliography

Neubauer, No. 12.

Byvanck, *Pays-Bas*, p. 152; Pl. LVI.

Sed-Rajna, *Lisbonne*, No. 19, pp. 76–78; Pls. LXIV–LXVI.

Metzger, T., *Lisbonne*, No. 19, pp. 123–131.

46. OXFORD PORTUGUESE PENTATEUCH

Lisbon, late fifteenth century

Bodl., Or. 614

Figs. 428–436

Pentateuch.

General Data

Codicology

Vellum; 1 + 253 leaves; 160 × 105 mm. Text space 95 × 57 mm; text space with Massorah, which is written in the upper, outer and lower margins, (135–140) × (73–85) mm. Written in round Sephardi script, in brown ink, 18 lines per page. Ruling by stylus, hardly noticeable. 33 quires of 8 leaves each, except for Quires I⁵ and II⁴ (both replacements, written in round Sephardi script after the expulsion of 1492), III⁷ (one leaf missing at the beginning), XVI⁷ (a decorated page has been torn out after fol. 113), XXIII⁶, XXVIII⁶ and XXXIII¹⁰.

Binding

Blind-tooled calf binding with gilt edges.

Colophon

None (see below, History).

History

fol. 1r Referring to the additional part on fols. 1r–9v: "This book, 'orphaned' by our teacher R. Zabbaro(?), exiled from Castile, was corrected by me(?), the meek son of the Israelites, Haẓarfati (the Frenchman)."

Decoration

Programme

A. Initial-word panels and decorative frames.
B. *Parashah* signs.
C. Decorative micrography of the Massorah.
D. Later initial-word panel.

Description

A. *Initial-Word Panels and Decorative Frames.*

There are penwork initial-word panels and painted frames for Exodus, Leviticus and Numbers (fols. 62r – Fig. 431, 117r – Fig. 434, and 156v – Fig. 436, respectively) and another decorated initial-word panel for Deuteronomy (fol. 212r). On fols. 62r, 117r and 156v, burnished gold fillets form complex frames, measuring (131–140) × (87–92) mm. There are separate compartments for the initial-word panel, for the portions of text above and below it and for the L- (or inverted L-) shaped border. The borders are decorated with pen-drawn interlaces of circles and figures of eight in different combinations, with foliated endings and extensions including cloud shapes in burnished gold between and round the interlacing bands, and with blue and green ground fillings. The initial-word panel on fol. 212r (30 × 58 mm) has a double frame of green and gold fillets, the inner frame incorporating an arched initial-word compartment. The initial-word panels are filled with violet penwork and the initial words are in gold. On fol. 62r (Fig. 431) the word is written within a green penwork compartment, and on fol. 156v (Fig. 436) within a green and violet compartment framed in gold. The penwork consists of small scalloped or serrated flowers and flourishes fitted into geometrical sub-divisions or into the curls of dense S-scrolls. Other motifs, as well as the penwork lace round the frame, are similar to the decoration of the *parashah* signs (see §B).

B. *Parashah Signs.*

The *parashah* signs are written elaborately in the margins, within penwork panels, and with additional penwork spreading from them all along the side margin and sometimes into the other margins (e.g., fols. 127v and 150r – Fig. 435). These decorations are mostly in violet ink, accompanied by more elaborate penwork in brown ink, usually in the lower margins; both types have been partly trimmed with the margins. The panels are mostly rectangular and are often compartmented. From fol. 58v on, the compartment enclosing the sign is mostly in green, sometimes with another green compartment below it (e.g., fols. 163v, 176r, 181r, 194v, 202r and 207r). The central compartment on fol. 24r is circular. On fol. 13v a small compartment above the sign is filled with burnished gold. The penwork motifs are similar to those of the initial-word panels, and some of the larger scroll curls are filled with palmette variations of fan-shaped, club-like floral motifs (e.g., fols. 37v – Fig. 430, 123r, 131r, 145r, 176r and 184v). There are also schematic human faces replacing flowers (e.g., fols. 58v and 134v), and spared ground interlace patterns (e.g., fol. 138v). On fols. 67v (Fig. 432), 93r (in brush gold) and 108v (Fig. 433), the interlace patterns fill the cross-shaped panels, extending upwards and downwards as vertical bars along the margins (e.g., fols. 73r, 78v and 88r; cf. smaller decorations for other signs in the margins, e.g., fols. 42v, 59v and 249v). However, most of the penwork extending from the panels consists of multi-linear bars carrying dense feathery foliage, which resemble ostrich feathers, with additional flourishes and many gold dots (e.g., fols. 13v, 18r, 24r, 28r – Fig. 428, 32r – Fig. 429, and many others). The foliage sometimes incorporates large roundels filled with geometrical motifs of schematized human faces (e.g., fols. 142r, 152v and 241r). One of the bars in the margin of fol. 152v contains the interlacing branches of a tree.

The brown penwork motifs which accompany many of these decorations are mostly in the lower margins, but some of them are in the upper margins (e.g., fol. 207r), and some are incorporated into the violet penwork (e.g., fols. 43v, 216r, 226v, 236r, 241r and 248v). The brown penwork, though generally very similar to the violet, is sometimes modelled with fine, dense linework and shading (e.g., fols. 13v and 28r), and often includes more elaborate motifs. There are large blossoms (e.g., fol. 134v) or stylized pine cones (e.g., fol. 48r). Fol. 125v also has a human figure below, partly cut off, and fol. 246v has a cock hanging from a branch. In some places the foliage issues from the beak of a bird or grotesque bird (e.g., fols. 13v, 43v, 145r, 207r and 216r), or from the mouth of a lion (e.g., fol. 28r – Fig. 428), a dragon (e.g., fol. 32r – Fig. 429) or a human head (e.g., fols. 54r and 150r – Fig. 435). A common variation includes two intersecting branches of a tree (e.g., fols. 37v – Fig. 430, 73r, 125v, 236r and 244r).

C. *Decorative Micrography of the Massorah.*

The Massorah is written in the upper, outer and lower margins, in decorative shapes which frame the text and consist of scallops or zigzag shapes extending outwards from the straight lines — mostly four such shapes from the top and bottom lines, and three from the lines in the outer margins. A few enclose gold, red or penwork dots (e.g., fols. 152r–166r), small flowers (e.g., fols. 161r and 166r) or small interlaces of two crossed ovals (e.g., fols. 161v and 166r–167v).

D. *Later Initial-Word Panel.*

The black pen-drawn initial-word panel for Genesis (fol. 1r) was done later.

Conclusions

This manuscript belongs to a group of small-size books for religious use which show distinct stylistic similarities to the large-size *Lisbon Bible* of 1482 (No. 42). Full-page frames with foliage ornament are typical of the group, although the motifs of the frames in our manuscript have no exact parallel in

the group, the closest being the gold scrolls on a blue and green ground in the *Lisbon Bible* (e.g., Vol. II, fol. 136v). Like the other foliage types in the Lisbon group, the origin of this type is probably also Italian. Within the Lisbon group, the *De Bry Psalter* (Zürich, Fleursheim Collection; see Sed-Rajna, *Lisbonne*, No. 23) is the closest to our manuscript with regard to the round script, the fragmented or intersecting frames, the penwork panels and their extensions, and the rich marginal penwork. The penwork in the margins of the *De Bry Psalter* is also especially close to our manuscript in the elaborate feathery scrolls and the animal and bird motifs which are shaded in fine linework. This latter feature may point to a date somewhat later than the *Lisbon Bible* for the two manuscripts.

Bibliography

Neubauer, No. 43.
Sed-Rajna, *Lisbonne*, Nos. 22–23, p. 89.
Sed-Rajna, Psautier de Bry, pp. 375–387.
Metzger, T., *Lisbonne*, No. 22, pp. 139–143.

47. CAMBRIDGE PORTUGUESE PRAYER-BOOK

Lisbon (?), late fifteenth century

CUL, Add. 541

Figs. 437–440

Prayer-book of Sephardi rite, including piyyuṭim and Haggadah.

General Data

Codicology

Vellum; 187 leaves (190, with fols. 4, 5 and 32 missing); 106 × 85 mm. Text space (73–75) × (47–49) mm. Written in round Sephardi script, in light and dark brown ink, 14 lines per page. No ruling is noticeable. 20 quires of 10 leaves each, except for Quires I⁵ (two leaves missing), II⁹, III⁸, IV⁹ (one leaf missing), VIII⁸, XVII⁸, XIX¹¹ and XX⁹ One catchword has survived on fol. 44v. Foliation with Hebrew letters, up to fol. 35r, by a later hand.

Binding

Black leather binding on wooden boards, blind-tooled with lozenges, with foliage patterns at the corners and centres, and lines round the edges.

Colophon

None.

History

Owners' Inscriptions

fol. 31v Raphael Simeon Alzaphia (אלזפיאה) Abraham Alluf.

fol. 46r Judah Aṣẓur (אסצור).

Decoration

Programme

A. Full-page decorative frames.

B. Initial-word panels.

Description

A. *Full-Page Decorative Frames.*

Full-page frames in penwork and brushwork enclose the text and the initial-word or title panel for *Keter Malkhut* (fol. 1v), *Nishmat qol ḥai* (fol. 113r – Fig. 439) and *Avot* (fol. 169r – Fig. 440). The frames on fols. 1v and 169r (100 × 68 mm)

are decorated with feathery scrolls in gold brushwork, with open flowers and leaves in blue, green and wine red. All frames are bordered within and without by wine red fillets, intersecting at the inner corners; those on fol. 1v are heightened with a blue line. On fol. 113r the reduced text space and the initial-word panel are enclosed within a large foliage motif in violet penwork. This is surrounded by penwork scrolls in gold and violet, with three gold triangles above, and the whole is bordered by thin bands of geometrical pen motifs measuring 88 × 68 mm.

B. *Initial-Word Panels.*

There are many penwork initial-word panels, with penwork extensions into the margin.

The initial-word panels are in violet, with gold lettering. Most are small, within or across the text, though the panel on fol. 104v (Fig. 438) is almost full-page: 56 × 48 mm; fols. 24r, 61v, 68v and 77r (Fig. 437), are relatively large: (28–43) × (48–53) mm. Fol. 73v (42 × 28 mm) is a combination of three panels. The marginal decorations extend from the sides of the panels, and where the panel is within the text, horizontal penwork bars across the text connect it with the marginal ornament. On many pages the marginal decoration is almost full-page (e.g., fols. 10v, 11v, 37r, 134v and 136v). The main motifs in the panels are curly scrolls with small flower-like, serrated roundels or paisley leaves and spiralling scrolls. On fol. 51r there is a human face within the scrolls. Many panels are sub-divided and the compartments filled with various motifs: pen-drawn acanthus scrolls (e.g., fols. 47r, 72r and 77r); geometrical patterns filled with small foliage motifs or circlets (e.g., fols. 47v, 51v, 61v, 79r and 136v); rosettes or flowers of various sizes, some formed by golf-club-like and other stylized motifs (e.g., fols. 54v, 57r, 65r, 66v, 68v, 85r, 104v – Fig. 438, 138v, 149v and 164r), in various combinations (e.g., fols. 45v, 50v, 51v, 71v and 134v), including peacock-tail patterns (e.g., fol. 104v). The panels are mostly framed by penwork bars with curls or beads; some have different chain, plait or wave patterns (e.g., fols. 24r, 37r, 52v, 61v, 158v and 159r). The extensions consist of multi-linear bars and branches carrying curls, flourishes and feathery scrolls, often with elaborate floral and fruit motifs modelled with linework (e.g., fols. 13v, 16r, 26r, 81r and 86v and many others), sometimes with additional feathery scrolls in gold (e.g., fols. 6v, 24r, 39r, 52v, 64v and 73v), which on fols. 74v and 77r incorporate small leaves and flowers in blue, green and wine red.

fol. 33r An elaborate branch with floral and fruit motifs in violet penwork separates the two text columns.

Conclusions

This manuscript belongs to a group of small-size Portuguese books for religious use, which show distinct stylistic similarities to the large-size *Lisbon Bible* of 1482 (No. 42). Other typical examples of the group are the *Duke of Sussex Portuguese Pentateuch* (No. 43), the *Almanzi Portuguese Pentateuch* (No. 44), the *Oxford Portuguese Pentateuch* (No. 46) and the *De Bry Psalter* (now in a private collection; see Sed-Rajna, *Lisbonne*, No. 23); as well as the *Oxford Effaced Ṣiddur* of *c.* 1485 (Oxford Bodl. Bib. Can. Or. 108; cf. Metzger, T., *Lisbonne*, Supp. No. 1, pp. 165–168, Pls. XXX–XXXI). The full-page decorated frames, typical of the group, are decorated with a wide range of foliage ornament, of which only one type, the feathery scrolls with flowers, is represented in our manuscript. Other motifs typical of the group which do occur in our prayer-book are the pen-drawn acanthus, which is incorporated into the penwork (cf., e.g., the *Lisbon Bible*, Vol. I, fol. 185r), and the gold lace with coloured motifs on fols. 74v and 77r (Fig. 437), as well as the penwork scrolls with fruit and flowers of the panel extensions, which should be compared with the *parashah* signs of the *Lisbon Bible*. The best parallel to the latter motif is found in the *Oxford Hispano-Portuguese Psalter* (No. 56), which should also be associated with this group. Within the Lisbon group, the manuscripts which most resemble ours are the *Oxford Pentateuch* and the *De Bry Psalter*, which have similar script, penwork panels, fragmented or intersecting frames and marginal penwork occasionally shaded with linework. Typical of the group is also the combination of two-coloured penwork in the marginal decorations found in our manuscript as well as in the *Oxford Pentateuch*. Of the three manuscripts, our prayer-book is the closest to the *Lisbon Bible* in style, and probably in date.

Bibliography

Loewe, *Hand List*, No. 403.

Sed-Rajna, *Lisbonne*, Nos. 22–23, p. 89.

Sed-Rajna, Psautier de Bry.

Metzger, T., *Lisbonne*, App. No. 3, pp. 158–162; Pls. XXVI–XXIX, and Supp. No. 1, pp. 165–168, Pls. XXX–XXXI.

V. Hispano-Portuguese Illumination of the Fifteenth Century
[Nos. 48–61]

The fourteen manuscripts described in this chapter do not form a homogeneous group. They are placed together mainly because of their stylistic dependence on the late-fifteenth-century Portuguese School. The manuscripts were divided into three sub-groups.

In the first sub-group, which is centred round the *First Kennicott Bible* (No. 48), the decoration programme and the pen-drawn technique are the common features. The main characteristic elements of the second sub-group, which is related to the *Abravanel Pentateuch* (No. 55), are its micrographic decoration and page lay-out. The relation between the first two sub-groups is illustrated by the imprint of the inner cover in the *Abravanel Pentateuch*, which resembles the inner covers of the *Kennicott Bible*. The third sub-group, which comprises three unrelated manuscripts (Nos. 59–61), betrays some Portuguese elements.

First Kennicott Bible Group
[Nos. 48–53]

The *First Kennicott Bible* of 1476 (No. 48), which used the *Cervera Bible* of 1300 (Lisbon, Biblioteca Nacional, Ms. 72) as a model for its programme and iconography, is a notable exception of the non-figurative manuscripts of the late fifteenth century. The decorative elements framing the full-page panels, as well as the zoo- and anthropomorphic letters of the *Kennicott Bible*, are basically archaistic, with additional contemporary motifs borrowed directly from French, Italian, Portuguese and Flemish illumination. These even include secular models such as the playing-cards designed by the Master of the Power of Women. The elaborate penwork and flourishes of the *First Kennicott Bible* are typical of the decorative tendency found in late fifteenth-century Latin as well as Hebrew illumination.

I have grouped manuscripts Nos. 49–53 with the *First Kennicott Bible* mainly beause of their penwork and floral motifs, which may have as their forerunner the floral decoration of the *Cambridge Spanish Prayer-Book* (No. 35). The *Second Cambridge Castilian Bible* (No. 52) is included in this group because, although it was copied and partly decorated in 1279, it was mostly retraced and overpainted in the middle of the fifteenth century.

48. FIRST KENNICOTT BIBLE

La Coruña, 1476

Bodl., Kenn. 1

Figs. 441–486

Bible and R. David Kimḥi, Ṣefer Mikḥlol.

General Data

Codicology

Vellum; 1 + 453 + 7 (fols. 17a, 143a, 151a, 266a, 281a, 332a and 412a) leaves; 298 × 240 mm. Text space (175–178) × (144–146) mm; height of the text space with Massorah 223–227 mm. Written in square Sephardi script, in brown ink, 30 lines in 2 columns. Ruling by stylus, 2 + 3 + 2 vertical lines, almost no noticeable horizontal lines. Fols. 1r, 9r, 121v, 123v, 124r, 220v, 444v, 446v and 447v–453r are blank. 39 quires of 12 leaves each, except for Quires I⁸, X¹⁰, XI¹⁰, XVIII¹⁴, XIX¹⁴ and XXXIX⁹ (including one leaf stuck to the inner back cover). Quires II–XXXVIII are numbered in Hebrew alphabetical order א–לז, at their beginnings and ends.

Binding (Figs. 458–461)

The original box-like case binding of reddish-brown morocco over wooden boards, with blind-tooled decorations on both covers and sides formed by plain bands on a background of criss-cross pattern, is probably contemporary with the manuscript. On the top cover (Fig. 460) there is a rosette formed by interlacing circles and trefoil shapes within a large circle flanked by two pendants. The bottom cover (Fig. 461) and the sides have rectangular, geometrical interlaces. The inside of the covers is also decorated. On fol. 445v there is an imprint of the inner front cover. Some of the original silver studs survive in the back cover, but the leather straps are missing.

Colophons

Scribe

fol. 438r (Fig. 463) End of the Bible: Moses Ibn Zabarah completed the writing, punctuating and massoreting the Bible in La Coruña, on Wednesday, the 3rd of Ab 5236 (24 July 1476) in 37 quires (II–XXXVIII), for Isaac b. Don Solomon di Braga.

Illuminator

fol. 447r (Fig. 464) In painted zoomorphic and anthropomorphic letters: "I, Joseph Ibn Ḥayyim, illustrated and completed this book".

History

Bought by the Radcliffe Trustees in 1771, at the suggestion of their librarian, Dr B. Kennicott. Transferred to the Bodleian Library, together with the non-scientific collection of the Radcliffe Library, in 1872.

Decoration

Programme

A. Full-page panels:
 1. Sanctuary implements.
 2. Decorative frames for *Ṣepher Mikḥlol*.
 3. Decorative carpet pages.
B. Book end panels.
C. Decorated signs:
 1. *Parashah* signs.
 2. Psalm numbering.
D. Zoomorphic lettering.
E. Decorative micrography of the Massorah.
F. Decorative lettering.

Description

A. *Full-page Panels.*

1. *Sanctuary Implements.*

The Sanctuary implements are depicted in two panels (fols. 120v–121r), in burnished gold on a blue or penwork ground. They are painted in an ornamental, stylized way, and are framed by flourishes. For a detailed iconography of the implements of the Sanctuary, see introduction to Catalan Bibles of the Fourteenth-Century above (pp. 101–104).

fol. 120v (Fig. 441) The *Menorah* is depicted with rounded branches, each decorated from bottom to top by a knop, three flowery bowls and a lamp (drip-pan). The flames are bent towards the centre. The shaft is decorated with three flowery knops, one beneath each branching point, four flowery bowls in the top part and two other flowery shapes in the lower part. It is resting on a three-legged base, which rests in turn on the back of a crouching brown lion. Two pairs of tongs hang on the lower branches, and two censers flank the *Menorah*.

All the shapes are in gold, the spaces they enclose wholly or partly filled with green, whereas those between the branches of the *Menorah* alternate in green and red. The background is of dense penwork S-scrolls in turquoise.

fol. 121r (Pl. CLIV: Fig. 442) This panel includes other implements of the Sanctuary, in gold on a blue ground, with some coloured details. At the

top, from right to left are: the laver, or the jar of manna, shaped like a pitcher, above an altar(?) — the stepping stone of the *Menorah*(?), to which a flesh-hook(?) and Aaron's rod are attached; the rectangular Ark of the Covenant topped by foliage motifs and enclosing the Tables of Testimony, one in silver and the other in gold, and the coloured Mount of Olives with a symmetrical tree of three foliage roundels. Below it is the sacrificial altar with five stairs and a ramp on each side; its openings are shaped like a gabled window and an arched doorway. The door is ajar and is flanked by two horse-shoe shapes and surrounded by gold dots. To the right of the altar, below the Ark, are two shapes that may be interpreted as pots. The upper part of the panel is separated from the lower part by a row of dots, two long trumpets(?) and two horns.

Below, from right to left, are: the jar of manna (or the laver?) with two handles above a similar vessel and two pitchers; the table of shewbread with two piles of six loaves of bread, shaped as semi-circles within rectangles. The loaves are separated from each other by groups of three canes, but the top loaves are supported by only two canes; the loaves at the bottom rest on the table. Each pile is topped by a crown. Between the two piles of loaves are two bird-like cherubim (their place according to the Bible is above the Ark), whose wings are shaped like fish. Between the table legs, formed by angular fret motifs, are various gold vessels. On the left are flesh-hooks(?).

2. Decorative Frames for Șefer Mikhlol.

There are twenty-seven decorative frames for *Șepher Mikhlol* (fols. 1v–8v, 438v–444r – Figs. 443–445), measuring (223–232) × (168–180) mm and shaped as double arcades within rectangular frames. The spaces between the arcades and the frames are filled with different motifs, forming wide decorative borders. The decoration is painted in several shades of blue, including ultramarine and greenish blue, as well as vermilion, wine red, orange, pink, green, purple, brown, red and yellow ochre, yellow and grey, with no shading and with much burnished gold and some silver. Facing pages usually carry similar decoration.

The style is ornamental and archaistic, with strong colour contrasts and elaborate linework in brush or pen over unmodelled surfaces. This linework is often shaped like stitches (mostly in black and brown, some in red), which, together with the cloisonné-like painted fields and the high stylization, gives the painting the appearance of patchwork.

Most panels, as well as most decorations of all types, are accompanied by brush- or penwork in red and turquoise with some green, mostly consisting of groups of straight lines of diminishing length, each ending with flourishes and some having additional gold dots.

The motifs in the border, mostly done on the vellum ground, are of several types:

(a) Brush- or penwork in red or turquoise (black and brown ink on fols. 1v–2r, where the ground is silver). The most common brushwork pattern consists of dense paisley scrolls with small serrated flowers in a different colour or dots in colour, gold or silver in their rounded ends and triangular spirals filling their pointed ends. This pattern appears on almost every page on fols. 1v–8v (Figs. 443–449) and is also common in other types of decoration in the manuscript (e.g., fols. 243v, 306r, 310v, 311v, 316r, 317r, 317v – Fig. 457, 318r, 352v – Fig. 462, 360r, 366r, 382v, 392r and 402v). It is applied to various coloured spaces and shapes, as well as to the vellum ground. On some pages this pattern fills the whole space of the decorative border (e.g., fols. 1v, 2r–v, 4v, 5r–v, 439v and 440r), sometimes incorporating painted motifs such as dragons at the corners of the panel biting the penwork scrolls of the ground (fols. 3v, 4r – Fig. 444) or various birds (fol. 3r – Fig. 443). On fol. 8v (Fig. 449; cf. Roth, *Bodley,* Pl. 5) there are a grotesque bird, a swan and a griffin fighting a dragon in the upper border.

(b) Other frames have painted decoration, also spreading along all four borders. On fols. 7v–8r (Figs. 447, 448) it consists of animal scenes, and on fol. 6r (Fig. 445) of scrolls of multi-coloured, stylized acanthus and imaginary flowers, with a monkey in the central spandrel and a hare in the lower border.

(c) In several panels, the decoration of the upper border (the shape of which is determined by the spandrels of the arcades) varies from that of the other borders. The latter are decorated with brushwork (fols. 6v – Fig. 446, 7r) or with a running pattern of lobed foliage shaped as lotus buds filled and surrounded by small foliage and floral motifs (fols. 438v–439r – Fig. 450). These are green, with some additional ornamentation in other colours, and pink and violet ground fillings. On fols. 6v–7r the upper borders of these panels are decorated with animal scenes; fols. 438v–439r have a bold pattern of silver scrolls, with buds ending in large gold crowns, the whole enclosed by curls on a blue ground. On fol. 438v the scroll is surrounded by trefoils and on fol. 439r (Fig. 450), by an array of coloured leaves in many shades of dark and light red and blue, black, green, pink and yellow (cf. Roth, *Bodley,* Pl. 6).

A variation of this type of frame consists of borders of equal width all round, with the space between the upper border and the spandrels differently decorated. On fols. 440r–441r (Fig. 451) the borders are decorated with a running pattern of knots, with coloured and gold ground fillings; fols.

441v–442r have a penwork scroll in the upper part and a coloured floral scroll in the lower; and fols. 442v–443r (Figs. 452, 453) have stylized blue and gold acanthus leaves with wine red and vermilion ground fillings. In these panels the spaces above the arches are decorated with an all-over pattern of interlacing bands, mostly forming knots (fols. 440v–442r), with spare spaces shaped as eight-pointed stars (fols. 440v–441r), similar elongated stars (fols. 443v–444r – Figs. 454–455; cf. Roth, *Bodley*, Pl. 10) or squares (fols. 441v–442r) with gold and coloured ground fillings. On fols. 442v–443r these spaces are decorated with animal scenes. The outer fillet frames bordering the panels are mostly in gold or blue, but sometimes of penwork on the vellum ground (e.g., fols. 438v and 439r – Fig. 450). The inner frames, also formed by coloured penwork or gold fillets, are sometimes decorated with different geometrical and foliage brush- or penwork patterns. Most of the arches are horse-shoe shaped (e.g., fols. 7v–8r and 440v–443r – Figs. 447, 448, 451–453), with several variations, e.g.: the central spandrel is filled with a rounded shape (fols. 1v–2r); decorative colonettes spring from the spandrels (fols. 4v–5r); the arch is enclosed within a rectangle (fols. 8v, 438v–439r – Figs. 449, 450 and 439v–440r). Some arcades are gabled (fols. 2v–3r and 5v–7r – Figs. 445, 446) or combine a gable with a round top (fols. 3v–4r – Fig. 444); others have segmented trefoil arches (fols. 443v–444r – Figs. 454, 455). The fillets forming the arcades often interlace to form different patterns round the arches. On fols. 5v and 6r (Fig. 445) additional angular interlacing spreads from the arches across the top border. Various interlacing motifs are formed by the fillets along the central columns of the arcades (fols. 1v–2r, 4v–8r and 438v–439r). The capitals and the bases of the columns are also often formed by such fillets, and take various geometrical shapes (e.g., fols. 2v–3r and 4v–6r) or the shapes of stylized foliage (e.g., fols. 4v–5r and 439v–440r). On fols. 443v–444r (Figs. 454, 455) the whole of the lower frame is shaped as stylized symmetrical foliage in gold. Some bases are of coloured brick pattern (fol. 8v – Fig. 449); other capitals and bases are of human, animal or grotesque forms, such as dragons with multi-coloured bat-like wings (fols. 442v–443r – Figs. 452, 453); horned hybrids biting themselves (fols. 443v–444r – Figs. 454, 455); grotesque human heads crowned with foliage (fols. 440v–441r); dragons' heads (fols. 440v–441r), some biting the fillets of the inner frame (fols. 441v–444r); a large lion's head, with its mane in elaborate linework, serving as a capital for the central column (fols. 442v and 443r); or lions' heads as bases, their paws clasping the columns (fols. 442v and 443r).

The full-page panels with illustrations are:

fols. 6v (Fig. 446), *7r* Animal scenes in the upper border: A partly dressed monkey, with a bell at the end of its hood, is seated in the central spandrel and blowing a pipe. It is flanked by two peacocks, one in each of the side spandrels, and each turning its head towards a smaller bird above its back (cf. Roth, *Bodley*, p. 5, Pl. 1b: "Bear-jester playing his pipe").

fols. 7v–8r (Figs. 447–448) Animal scene in the upper border: White, orange, ochre and grey hens and chickens pecking at grain, a group of them concentrated round one spot, as if seen from above; on fol. 8r a bird of prey chases a chick. Round the borders are grey foxes with chickens in their mouths; one is being chased by a red and white hound. Ochre, white and red hounds chase and catch white and grey hares and rabbits (cf. Roth, *Sefarad*, Pl. VII; idem, *Bodley*, Pl. 4 – fol. 7v).

fol. 442v (Fig. 452) In the upper border: A scene depicting rabbits storming a wolf's castle. On a green ground, a group of twelve grey rabbits carrying spears, mostly represented only by their heads, are approaching a castle on the right. They are headed by a standing rabbit who is wearing a gold crown and carrying a sword and sceptre. The castle, which is separated from the rabbits by a vertical row of gold battlements, is decorated with brickwork and has three embattled towers from which the head of a wolf and three red banners emerge. Behind the marching rabbits is a seated rabbit who is wearing a gold crown (cf. Roth, *Bodley*, No. 9, p. 8: "Assault by an army of dogs on a castle garrisoned rather than defended by a solitary deer").

fol. 443r (Fig. 453) In the upper border: Cats storming the castle of the mice. On a green ground, eight cats' heads between two fully figured grey cats holding blue and red shields and brandishing swords. The front cat has a gold crown above its head. The army of cats faces a castle on the right, separated from them by a vertical crenellated bar similar to that on fol. 442v (Fig. 452), from which a double red banner, spears and the heads of six mice are emerging (cf. Roth, *Sefarad*, Pl. VIII; idem, *Bodley*, p. 5, Pl. 9).

3. Decorative Carpet Pages.

There are seven carpet pages (fols. 120r, 122r – Fig. 456, 122v, 123r, 317v – Fig. 457, 318r and 352v – Fig. 462) in various techniques of drawing, painting and micrography. They measure (175–205) × (145–173) mm. The inner binding covers are also decorated with carpet patterns: the front inner cover (Fig. 458) is rectangular and measures 215 × 200 mm; the back inner cover is round (Fig. 459) and is 220 mm in diameter. Both are made of two parchment leaves pasted together according to a perforated pattern.

These carpet pages fall into two types:

(a) A central rosette formed by bands interlacing in different rounded and angular shapes or by different combinations of squares, triangles, lozenges, circles and segments of circles (e.g., fols. 122r, 317v–318r, 352v and the back inner cover – Figs. 456, 457, 459), and often forming star shapes in the centre (fols. 122v, 317v and the back inner cover). On fol. 122v and on the back cover the rosettes are framed not by a panel but by a circular frame. These panels differ greatly from each other in detail. On fol. 122r the interlacing bands are coloured on the vellum ground, with some gold fillings; the corners of the panel above and below the rosette are decorated with coloured dragons, their heads turned towards each other. This panel is framed by a pen-drawn pattern of knots, with a gold ground mostly decorated with brushwork. The interlacing shapes on fol. 122v are of bands of red penwork on a turquoise penwork ground; the framing circle is decorated with a pen-drawn pattern of knots on a coloured ground (cf. Roth, *Bodley*, Pl. 17a, reversed and inverted; idem, *Sefarad*, Pl. VI). The interlacing bands on fol. 352r (cf. Roth, *Sefarad*, Pl. II; idem, *Bodley*, Pl. 7b, inverted) are pen-drawn, with multi-coloured fillings for the large spare spaces, gold fillings for the small dot-like spaces and brushwork in the rest of the panel. On fols. 317v (Fig. 457) and 318r, where the bands are in micrography (Psalms 1–18), the ground is of red penwork floral scrolls with green flowers, incorporating (on fol. 318r) some larger curls with tinted palmette variations. The bands on the lower inner cover are yellow, and the ground spaces (of the bottom layer) are coloured and decorated with foliage, floral and other brush motifs.

(b) All-over patterns of interlacing squares, lozenges, straight bars or circles, with much variation in technique and detail from panel to panel, e.g., gold on a blue ground on fol. 123r. On the front inner cover the interlacing shapes are of gold heightened with white, whereas the ground (as on the back inner cover) is decorated with small spread eagles in black or yellow brushwork on a green ground. On fol. 120r the pen-drawn bands form knots on a coloured ground. The *Menorah* and censers overleaf show through empty spaces in the centre of this panel.

B. *Book End Panels.*

The panels at the ends of books are also of several types.

1. Rectangular panels, mostly the width of one text column, and of varying heights: 24 mm (fol. 59v); 188 mm (fol. 119v, where the panel replaces the second text column). The panel on fol. 252r, which replaces most of the second text column, measures 165 × 95 mm; that on fol. 272r measures

c. 215 × 80 mm (see § B3). Some panels frame massoretic notes (e.g., fols. 59v, 76r and 403v); that on fol. 35v is in a separate compartment. The panels (or the main compartment on fol. 35v) are decorated with a geometrical interlace pattern formed by bands of fine penwork (e.g., fol. 119v), pen-drawn bands (e.g., fol. 59v), or coloured fillets (e.g., fols. 317r and 352r) on gold, penwork or coloured grounds. The pattern consists of interlacing geometrical shapes (e.g., fols. 35v, 119v and 317v) or different knot patterns (e.g., fol. 59v). The panel on fol. 35v is flanked by two bands framed in gold with a pen-drawn lacing pattern; that on fol. 59v has stylized foliage motifs in gold attached to the side frames, the band on the right incorporating slightly tinted pen-drawn human heads.

2. Rectangular panels (except for fol. 370r – Fig. 470, where the panel is of irregular shape), stretching mostly across the whole text, except for fols. 416r (53 × 60 mm) and 424r (54 × 69 mm), at the main division of the Book of Psalms (fols. 360r, 466r and 370r – Fig. 470), as well as at the ends of some books (e.g., fols. 382v: Psalms; 392r: Proverbs; 402r: Job). The panels are filled with pen- or brushwork, mostly on the vellum ground (coloured ground on fol. 424r), and are framed by differently decorated bands in gold and colour. On fol. 366r the upper border is shaped as a row of semi-circles with leaf-like motifs at both ends; the U-shaped frame on fol. 370r (Fig. 470) encloses the lower part of the text (which includes the panel), and consists of a fine stylized acanthus scroll of gold and blue leaves with small flowers and dots in colour (see also below, the note on fol. 370r). The panel at the end of the Bible (fol. 438r – Fig. 463, below the colophon), measuring 91 × 125 mm, has a central compartment of this type, with a triple frame. The inner frame is decorated with a knotted plait pattern; the middle one is done with a brush gold fillet bordered in green and the wide outer one is decorated with stylized pen-drawn acanthus scrolls with green dots in the individual lobes and red, blue, green and brush silver ground fillings.

3. Small panels over one text column, mostly decorated with brushwork or various interlacing patterns (e.g., fols. 297r, 301v, 308r, 308v and 309v). The panel on fol. 151a recto is decorated with a yellow pattern of lotus(?) buds on a brown ground. The main feature of this type of panel is the decoration extending from it, which wholly or partly frames the related text column. This decoration, and sometimes the panel frames as well, consists of coloured fillets (e.g., fols. 185r, 309v, 311v and 404v), sometimes with coloured leaves or buds extending from them (e.g., fols. 301v and 304v), accompanied by frontal flowers

formed by dots and connected by blue bars (fol. 310v) and a similar pattern forming the extending frame bar (fol. 316v); gold fillets (e.g., fol. 76r); bands with different knot patterns of coloured or pen-drawn bands (e.g., fols. 139r, 243v and 306r); bands with dense penwork scrolls (e.g., fol. 297r); stylized cloud-like foliage motifs (e.g., fol. 316r) decorated with coloured dots (e.g., fols. 406v and 410r); and various painted motifs (e.g., fol. 151a recto: end of Samuel). This frame consists of two dog-headed dragons. The very large penwork panel (*c.* 215 × 80 mm) on fol. 272r is decorated with similar motifs which form the side borders and consist of spotted snakes winding round green poles. The panel on fol. 99r (Fig. 466) is formed by two intersecting hybrids, with rich brushwork round them; the related text column above is framed by stylized acanthus scrolls.

4. Two panels (fols. 185r and 305r) are accompanied by text illustrations for the following book. These are on the vellum ground in the top outer corners and, like most of the decorations, are painted similarly to the full-page frames (see § A2).

fol. 185r (Fig. 468) Beginning of Kings: The old King David, his feet resting on a rounded step, sits on a stylized gold and coloured throne decorated with geometrical, foliage and penwork motifs. He has a long beard, wears a large crown and holds a large gold club for a sceptre. The draperies are indicated by many irregular lines.

fol. 305r (Fig. 469, and colour frontispiece to text volume) Beginning of Jonah: In the outer margin, to the left of a panel at the top, Jonah is being swallowed by the fish. Beneath a white ship with large patterned sails simulating bricks is Jonah, floating on green waves and being swallowed by a large green and red fish in fine linework. Two sailors wearing pointed hats, sit in the ship and converse. The sail is blue and magenta, the ropes red, the mast green, and the crow's nest — with spears in it — blue. A red dragon serves as the figurehead.

fol. 370r (Fig. 470) This panel has an additional fine illustration of Ps. 90. Since Ps. 90 is a "prayer of Moses", which happens to be the name of the scribe, Roth suggests that it "is conceivably a delicate compliment to the scribe on the part of the illuminator" (Roth, *Bodley*, p. 4).

C. Decorated Signs.

1. Parashah Signs.

There are forty-nine decorated *parashah* signs in the margins of the Pentateuch, five less than the usual number since there are no signs for the beginnings of each of the five books.

Most of these *parashah* signs incorporate or frame the abbreviation for *parashah*, written mostly in ink or gold, and the serial number (cf. Roth, *Bodley*, Pls. 11–19). The colours, as well as the frames and ground motifs, are similar to those described above; a large number have additional elongated penwork extensions.

There are several types of this decoration:

(a) Within shield-shaped panels (e.g., fols. 29v, 34r, 38r, 47r – Figs. 473, 474, 477, 49r) measuring *c.* (38–58) × (40–50) mm, or rectangles (e.g., fol. 27r – Fig. 472) measuring 31 × 43 mm. There are various crest motifs: a stylized blue cock (fol. 27r) and another stylized bird (fol. 34r); the head of a hound with a gold collar (fol. 29v – Fig. 473); a stylized symmetrical foliage motif with an owl either above (fol. 49r) or combined with a text illustration (e.g., fol. 47r – Fig. 477). In two of these panels (fols. 27r and 29v – Figs. 472, 473) the abbreviation for *parashah* is written in zoomorphic and anthropomorphic letters similar to those in the artist's colophon (fol. 447r – Fig. 464; see below, §D). On fol. 34r the "large letters" are formed by interlacing pen-drawn bands. Other panels are vertically elongated rectangles, subdivided by gold bands also framing the panel (e.g., fols. 32r, 40v, with jagged ends, and 45v – Figs. 475, 476) with two animal heads forming the lower border, measuring (71–110) × (21–23) mm. The panels on fols. 40v and 45v have text illustrations; that on fol. 32r has a monkey sitting on a gold circle and eating a red fruit.

(b) Most of the *parashah* signs are structured in different motifs on the vellum ground, very colourful and varied and with much gold; three of them (fols. 88v, 90r and 92r – Figs. 485, 486) are text illustrations (see below). There are various dragons and grotesques, often in extremely contorted postures (e.g., fols. 16v, 62r, 68v, 97r, 106r, 111r and 113r), some biting their tails, paws or other parts of their bodies (e.g., fols. 55v, 65v and 71v), including a dragon biting its tail under a tower (fol. 53r – Fig. 478). There also are: pairs of grotesques with intertwined necks and tails framing the *parashah* sign (e.g., fols. 12r, 70r and 109r); dragons with large bat's wings (e.g., fols. 67r – Fig. 481, and 84v – Fig. 483) or with grotesque human heads (e.g., fols. 14v and 79r); dragons with foliated tails or tongues (e.g., fols. 24v and 115v); a crowned spread eagle (fol. 18r – Fig. 471); grotesque birds (a goose(?) on fols. 22r and 103v); lions (e.g., fols. 46r and 64r – Fig. 480; crowned on fol. 51r, and seen from above on fol. 82r); bears (e.g., fols. 58r – Fig. 479, and 95r), that on fol. 73v with its muzzle deep in a large yellow jar and that on fol. 74v (Fig. 482) facing a red wolf(?) below it; a camel (fol. 101r); a covered chalice (fol. 116v); a lion-hybrid with a human head, carrying a club and a shield-shaped human mask with a lion's mane (fol. 86v – Fig. 484); and a crowned grotesque female centaur with the pectoral fins of a whale instead of arms (fol. 119r).

The text illustrations of the *parashah* signs are:

fol. 40v (Fig. 475) *Parashat Bo.* The angel of death in Egypt (Ex. 12:29): In the upper compartment of the panel is a naked broad-winged angel. The lower compartment has an interlace pattern.

fol. 45v (Fig. 476) *Parashat Yethro.* The text illustrations in the two compartments of the panel illustrate the two last episodes of the preceding *parashat Beshalah*: (a) In the top part — the waters of Massah and Merivah (Ex. 17:6-7): A naked man carrying a water-skin, with a small green dragon in front of him. (b) At the bottom — the battle with Amalek (Ex. 17:8-13): A naked man drawing his crossbow.

fol. 47r (Fig. 477) *Parashat Mishpatim.* The treatment of a slave (Ex. 21:2-6): Two trussed naked captives sit, confronting each other, under a stylized green and gold tree on top of a shield-like panel.

fol. 88v *Parashat Parah.* The law of the red heifer (Num. 19:2): A red cow.

fol. 90r (Fig. 485) *Parashat Balaq.* Balaam being asked by Balak to curse Israel (Num. 22:5-6): Balaam the prophet is depicted as an astrologer, wearing a long robe and holding a round blue astrolabe(?) with red stars. This representation alludes to the Midrash on the History of Moses, which states that Balaam was one of three who prophesied that Moses would destroy Egypt (cf. Roth, *Sefarad*, pp. 359-360, Pl. IV).

fol. 92r (Fig. 486) *Parashat Pinhas.* Phineas the Zealous (Num. 27:7): Phineas, wearing a long robe with a tunic and a triangular gold hat, is standing brandishing his spear and holding a semi-circular gold shield (cf. Roth, *Sefarad*, p. 360).

2. *Psalm Numbering.*

The number of each psalm (fols. 353r-382r) is written in the margin within a small gold and/or painted panel surrounded by elongated pen scrolls. Most of the panels have fantastic shapes, stylized floral or geometrical motifs, with some interlacing and penwork. Some are distinguishable objects, such as towers (fols. 353r and 364r), two chalices (or censers? — fol. 353v), two snakes (fol. 354v), a vase (fol. 355r), a pomegranate and a vase (fol. 356v), two intertwined fish (fol. 359v), three and four intertwined fish (fol. 360v) and a small green dragon (fols. 371v and 376r). These motifs often form a full-length decoration along the margin.

D. *Zoomorphic Lettering.*

The illustrator's colophon on fol. 447r and some *parashah* signs (e.g., fols. 27r - Fig. 472, and 29v - Fig. 473) are written in zoomorphic and anthropomorphic letters, most of them terminating in human heads — one with three faces, another crowned — or in animal and grotesque heads.

They also include different dragons, distorted naked humans, birds and grotesque birds, fish and various animals — including a rabbit being chased by a dog. One of the letters in the colophon (the Hebrew letter פ), the upper part of which is formed by a naked woman, is very similar to the same letter in the *parashah* sign on fol. 27r (Fig. 472; cf. Roth, *Sefarad*, Pl. I; idem, *Bodley*, pp. 9-10, Pl. 21; idem, *add. Ken.*, pp. 569-662, Pls. XIV-XV).

E. *Decorative Micrography of the Massorah.*

The micrographic Massorah, mostly in the upper and lower margins, is written in different combinations of triangles, lozenges, circles and segments of circles (e.g., fols. 43v, 44r, 107r, 113v, 260v, 318v and 353r) or in zigzag form (e.g., fols. 34r, 36r, 44r, 80v and 90v).

On fol. 44v, alongside the end of the First Song of Moses, there is also a micrography panel (70 × 38 mm) consisting of an angular interlace of micrography bands on a brushwork ground. Gold, coloured and penwork stylized foliage, geometrical motifs and dots fill and surround the micrography shapes. Brushwork flourishes often extend along most of the margins or all of them (e.g., fols. 34r - Fig. 474, 36r, 43r, 43v, 90v, 107r, 113v, 117v - Fig. 467, 118r and 119r-v). Occasionally the shaped Massorah in the margins is accompanied by brushwork and by — among other motifs — acanthus scrolls (e.g., fol. 119r), interlaces (e.g., fols. 252v and 254r) and other penwork motifs (e.g., fols. 254v, 264v, 282r and 289r). Other marginal patterns are formed by gold or coloured bars and other gold shapes (e.g., fols. 9v - Fig. 465, 103r, 116r and 392r). The space between the text columns is sometimes decorated with vertical bands, mostly consisting of additional micrography lines, and with an interlacing pattern of knots.

F. *Decorative Lettering.*

Initials (e.g., fols. 9v - Fig. 465: Genesis; 318v, 382v, 404v and 408v), as well as all the traditional "large letters" of the Bible, are written in gold, usually filled and surrounded with colour, brushwork or penwork. There is a head in the brown penwork on fol. 318v.

Conclusions

This sumptuous Bible is a masterpiece of the late fifteenth century. According to the colophon, it was decorated by Joseph Ibn Hayyim. The content, decoration programme and some of its iconography resemble those of the *Cervera Bible* of 1300 (Lisbon, Biblioteca Nacional, MS 72), which was illuminated by Joseph the Frenchman. Its resemblance to the *Cervera Bible* lies in the elaborate frame around the text of Kimhi's *Sefer Mikhlol*, the decorated beginnings and endings of books, the *parashah* signs, the decorative

micrography and the full-page artist's colophon executed in coloured zoomorphic and anthropomorphic letters (fol. 447r – Fig. 464, and fol. 449r in the *Cervera Bible*, cf. Roth, *Additional Note, 1961*). Further affinity between the two manuscripts can be found in choice of subject and iconography, e.g., the chickens in the yard (fols. 7v, 8r – Figs. 447, 448; cf. T. Metzger, La poule) and Jonah being thrown into the water from a ship and being swallowed by a fish (fol. 305r – Fig. 469).

The close relationship between the *Cervera* and *Kennicott* Bibles is not accidental. The former may, in fact, have been used as a model for the latter. Birth notices of 1375 and 1439 in the *Cervera Bible* indicate that its owners lived in La Coruña — where the *Kennicott Bible* was copied (Roth, *Additional Note*, 1961).

The similarities notwithstanding, there are pronounced differences between the two manuscripts. Joseph Ibn Ḥayyim did not use all the pictorial material in the *Cervera Bible*, eliminating even full-page illustrations, such as the *Menorah* in Zachariah's vision (cf. Narkiss, *HIM*, Pl. 6). His illumination is also based on other models, probably the fourteenth century Catalan Bibles, as he reintroduced such elements as the full carpet pages, Sanctuary implements pages and arcades framing the text of Kimḥi's grammatical text (rather than the polygons in the *Cervera Bible*).

Ibn Ḥayyim also added text illustrations, as *parashah* signs and as book openings, e.g., the two confronting slaves (fol. 47r – Fig. 477), Balaam the astrologer (fol. 90r – Fig. 485), Phineas with his lance (fol. 92r – Fig. 486) and the old King David at the opening of the first book of Kings (fol. 185r – Fig. 468). Most interesting is the fact that the artist used secular models as a basis for the decorative framing arcades and the *parashah* signs (cf. Edmunds, *SBB*). For these, as Sheila Edmunds has proved, Ibn Ḥayyim used as a model the playing cards designed by the Master of the Power of Women (e.g., fols. 3r, 8v, 27r, 34r – Figs. 443, 449, 472, 474). The text illustration of King David may also have been taken from a set of cards.

Joseph Ibn Ḥayyim's linear, highly stylized and somewhat archaistic style for the late fifteenth century is consistent throughout the manuscript. All the elements are painted with single colours, have almost no gradation in colour and are heavily outlined, all of which creates a highly decorative effect. The heavy penwork and flourishes, in the full pages as well as in the text, add compactness to the illuminations.

The carpet pages closely resemble leather binding (compare fols. 317v and 352v – Figs. 457, 462, to the binding on the top cover of the box — Fig. 460), and similar decorative interlace does appear in the parchment-cut pages pasted to the back inner cover (Fig. 459) as well as on a carpet page at the end of the Pentateuch (fol. 122r – Fig. 456). Joseph Ibn Ḥayyim may have executed part of the binding himself or worked closely with the binder, while the contemporary binding is a box which could have contained unsewn quires; the quires as one found them were sewn in six raised cords, with head and tail bands.

Bibliography

Neubauer, No. 2322.
Leveen, *Bible*, pp. 114–117.
Roth, Kennicott, *Sefarad*, 1952, XII, pp. 351–368.
Idem, *Kennicott, Bodley*, 1957.
Idem, Additional Note, 1961.
Metzger, T., La poule.
Narkiss, *HIM*, pp. 24–25, 52, 74, 170, Pls. 6, 17.
Edmonds, Ibn Ḥayyim.

49. MANCHESTER FRANCO-SPANISH BIBLE

Spain, last quarter of fifteenth century

JRL, Heb. 36

Figs. 487–488

Bible.

General Data

Codicology

Vellum; I + 445 + 1 (fol. 366b) leaves; 193 × 138 mm. Text space 118 × (82–84) mm; height of the text space with Massorah 140–145 mm. Written in very small, square Sephardi script, in different shades of brown ink. Some ink has turned orange where the vellum is too oily (e.g., fols. 231r–249v). 35 lines in two columns. Ruling by stylus, 2 + 35 + 3 horizontal and 1 + 2 + 2 vertical lines. 37 quires of 12 leaves each, except for Quire I[14]. All quires are marked with Hebrew letters at their ends. Foliation in Hebrew letters in the top left-hand corner of every recto, many of them cut off. The names of the *parashot* and books are written in darker ink in the upper margin of every recto. The beginnings of the *parashot* are spaced, and each *parashah* has a larger initial word in ink on a line by itself.

Binding

Modern binding, signed by W. Pratt. Gilt edges.

Colophon

See below, History.

History

fol. Iv An inscription has been copied twice by a later hand: "In good fortune, on a Sunday, the 26th of Ṭevet 5086." Since this date fell on a Thursday, the inscription is erroneous. However, the 26th of Ṭevet fell on a Sunday in 5087 (21 December 1326). It is possible, therefore, that a lost opening inscription to the manuscript contained the date פז = (50)87, which was corrupted to פו = (50)86 when the similar letters *zayin* and *waw* were interchanged by the later hand as he wrote the present inscription. The inscription may have been copied from an older manuscript. The assumption that an original model for the present inscription existed in the manuscript is supported by the fact that the same hand copied existing inscriptions from fol. 444r on to fol. 445v (see below).

fol. 1r Owners' inscriptions: (1) Joseph b. Jacob, called Qashti; (2) Ṭaria of Qaṣṭoria (טרייא מקסטוריא); and other names.

fol. 2r Illegible inscription in cursive.

fol. 444r Sale inscription: Mordekhai b. Jacob of Qaṣṭoris (קסתתוריש) bought it from Aaron ʿArabi (ערבי), who got it from Isaac Corfili (קורפילי) and the "Karaite". Bought in the week of *parashat Balaq*, 9th–15th of Tamuz 5271 (5–11 July 1511). Birth entry: A son to Mordekhai b. Abraham, on Tuesday, the 22nd of Shevat 5292 (29 January 1532). Both inscriptions on this page have been copied on to

fol. 445v in large, square letters by the same hand that wrote the so-called colophon.

fols. 1v, 445v Owner's inscription: Johannes van der Hagen, Amsterdam, 26 April 1726.

Book-plate inside the binding John Rylands Library 1894.

Decoration

Programme

A. Painted initial-word panels.

B. Initial words.

Description

A. *Painted Initial-Word Panels.*

Large initial-word panels measuring (38–48) × (82–90) mm each, are placed over both text columns on fols. 1r, 119r and 134v. They are framed by a gold fillet extending in the outer margin along the text, with additional floral decoration issuing from the outer side of the panel. The initial words are written in gold (fol. 1r: Genesis; fol. 119r – Fig. 487: Joshua) and as spared ground (fol. 134v – Fig. 488: Judges). The panels are painted blue (fol. 1r), wine red (fol. 119r) and burnished gold (fol. 134v) and are decorated with pen flourishes in different colours. The floral decoration issuing from the panels comprises flowers, buds and fleshy leaves in blue, red, magenta, green and burnished gold, surrounded by pen-drawn stalks and tendrils. On fol. 164v, there are two birds within the tendrils, tinted green and blue.

B. *Initial Words.*

Except for Genesis, Joshua and Judges, which have initial-word panels (see § A), all the books up to Hosea (fol. 302r), as well as Ruth (fol. 392v), have initial words in burnished gold on the vellum ground. All the other books have vacant spaces left for initial words or other decorations.

Conclusions

The inscription on fol. Iv may reflect a genuine date, 1326, of a model from which this manuscript was copied (see above, History). This early date can hardly be corroborated by its style. The panels, with fine scrolls on a painted ground and gold bars descending along the margins and terminating in

small grotesques, are French in character, combined with floriated sprigs of Italian origin. The existence of Italian elements in a predominantly French style may point to any stage of Italian influence. As its floriated sprigs are similar to decorations in the *First Kennicott Bible* of 1476 (No. 48, e.g., fols. 6r, 370r – Figs. 445, 470), it may be dated to the last quarter of the fifteenth century. The manuscript belongs to a group of small Bibles with similar features, of which the closest in style and probably in date is the *Cambridge Illustrated Small Bible* (No. 50). The *Escorial Small Bible* (G.II.8; see Domínguez-Bordona, Fig. 131) and the *Cambridge Franco-Spanish Pentateuch* (No. 51) are of the same type and date.

Bibliography

Rylands Exhibition, 1958, No. 4, p. 7.
Domínguez-Bordona, *Ars Hispaniae*, XVIII, Fig. 131.

50. CAMBRIDGE ILLUSTRATED SMALL BIBLE

Franco-Spanish, last quarter of fifteenth century

CUL, Add. 468

Figs. 489–498

Pentateuch and Former Prophets with Maimonides' Guide of the Perplexed in the upper and lower margins.

General Data

Codicology

Vellum; 279 leaves (some paper reconstructions); (170–178) × (122–125) mm. Text space (103–107) × (68–70) mm; height of the text space with Maimonides' *Guide of the Perplexed* 134–137 mm. Written in small, square Franco-Spanish script, in brown ink, 32 lines in two columns. Ruling by stylus, hardly noticeable for the horizontal lines, 2 + 2 + 1 for the vertical lines. 24 quires of 12 leaves each, except for Quire XXIV3 where the end is missing. Fols. 1, 2, 11, 157, 159, 160, 165, 166 and 168 are paper reconstructions, and some other leaves, especially in the first quire, are partly reconstructed. The quires are numbered with Hebrew letters at their ends. The titles are repeated in the top left-hand corner of the recto of every leaf.

Binding
Modern.

Colophon
None.

History
None.

Decoration

The decorations are painted in deep blue, wine red, magenta and light violet, with some vermilion and brown and with gold and much silver (mostly oxidized). The painted shapes are modelled with fine linework. The decorations described in §§ B–C are cruder than those described in § A. Most of the illustrations described in § B are badly preserved.

Programme
A. Decorative panels.
B. Marginal text illustrations.
C. Animals, birds and grotesques.

Description

A. Decorative Panels.
1. At the beginning of books the initial letters, in gold, are contained within small square panels measuring (14 × 14) – (19 × 19) mm. In most of the cases the new book begins at the top of a text column (fols. 37r, 68r – Fig. 496, 149v – Fig. 497, and 169r). However, where the book begins in the middle of the text column (fols. 90r, 121v, 187v and 232r) the letters are written within inverted L-shaped panels measuring (22–30) × (30–35) mm. In these cases the upper part of the panel extends across the text column, indicating the end of the previous book. On fol. 37r the initial-word panel for Exodus is at the top of the second text column. Gold bars and foliage motifs extend from the panels into the margins.

The panels have coloured grounds covered with thin brush scrolls with serrated, flower-like

roundels. Their gold frames extend as gold bars, descending from the right-hand side of the panel along the text column and terminating in a coloured motif. The panel on fol. 187v has an additional bar ascending from its left-hand side, and that on fol. 232r has two descending bars flanking the text column. Most panels also have floriated sprigs of small coloured leaves and gold dots issuing from their sides. Especially rich is the opening to the Book of Joshua (fol. 149v – Fig. 497) decorated by wine-red acanthus leaves. The foliage motifs at the ends of the gold bars consist of similar foliage sprigs, leaves or composite flowers; that on fol. 68r (Fig. 496: Leviticus) is particularly rich, with a twisting, multi-coloured acanthus scroll extending across the bottom of the first text column and indicating the end of Exodus.

2. At the end of Genesis (fol. 37r), across the bottom of the first text column, is an oblong panel (10 × 30 mm) with a spared ground interlace and gold dots filling the ground.

B. *Marginal Text Illustrations.*

The illustrations in the margins of the text are small, crude and badly preserved. Although they are frequent in the first chapters of Genesis, there are none after fol. 12v (Fig. 495).

fol. 3r (Fig. 489) (1) Cain's offering (?) (Gen. 4:3, overleaf): At the bottom, between the text columns, is a helmeted (or hooded) man, lifting an elongated object — a sheaf of corn (?). The figure is almost effaced, and unclear, even under ultra-violet light. (2) The murder of Abel (ויקם קין; Gen. 4:8, overleaf): At the bottom of the outer margin is a man lifting a golden axe.

fol. 4v (Fig. 490) Noah's Ark (Gen. 6:14): At the bottom of the outer margin is a gabled structure, with a pennon painted in magenta with gold ornaments.

fol. 5v (Fig. 491) The dove (Gen. 8:11): At the bottom, between the text columns, is a bird with a leaf in its beak.

fol. 6r (Fig. 492) Noah's covenant (Gen. 9:13): At the bottom, between the text columns, is a rainbow with three bands of colour.

fol. 8v (Fig. 493) The quarrel between the shepherds of Abraham and those of Lot (Gen. 13:7): Flanking the first text column are an archer on the right and a man holding a spear and a large shield on the left, both wearing pointed helmets.

fol. 9v (Fig. 494) Abraham's covenant between the pieces (Gen. 15:9): At the bottom of the outer margin are a cow, a goat, a ram, a peacock and another bird.

fol. 12v (Fig. 495) Lot and his daughters (Gen. 19:30–35). A crowned man is flanked by two women in elaborate dresses, the woman on the left is pouring wine from a flask into a goblet.

C. *Animals, Birds and Grotesques.*

The *parashah* signs are decorated with small, crude animals, birds and grotesques, similar to the text illustrations (e.g., fols. 4v – Fig. 490, 8r, 40r, 43v, 62v, 65v, 71r, 86v, 88r, 93v, 124v, 128r, 131v and 148r). The sign on fol. 46v has a small gold frame which supports a gold candle. The beginning of the second book of the Maimonides' *Guide of the Perplexed* (fol. 216r – Fig. 498) is indicated by a spread peacock in gold and colour.

Conclusions

The manuscript is very close in size and script, as well as in its initial-word panels, to the *Manchester Franco-Spanish Bible* (No. 49). In both manuscripts fine scrolls on a painted ground and descending bars of a French type are combined with floriated sprigs of Italian origin. The grotesques of the *parashah* signs may be compared with the bar terminals of the *Manchester Franco-Spanish Bible* (e.g., fol. 134v – Fig. 488). The grotesques and the small text illustrations peculiar to our Bible developed from a French type of marginal decoration, which uses human figures, animals and grotesques. These were usually combined with foliage motifs in the thirteenth and fourteenth centuries, in French illumination. They are found, for instance, in a French *Psalter of Guy de Dampierre*, of the second half of the thirteenth century (Brussels, Bibliothèque royale, MS 10607; see Delaissé, No. 9). They appear in a Spanish-Hebrew context in the *Barcelona Haggadah* (No. 13) and in the *Rylands Sephardi Haggadah* (No. 15) of the second half of the fourteenth century, but the *Haggadot* display a far greater Italian influence than our Bible. The existence of the Italian type of floriated sprigs in a predominantly French type of decoration may point to any stage of Italian influence. Its dating to the last quarter of the fifteenth century is based on the similarly decorated panels of the *Manchester Franco-Spanish Bible* (No. 49), as well as the *Cambridge Franco-Spanish Pentateuch* (No. 51) and the *Escorial Small Bible* (MS G.II.8; see Domínguez-Bordona, Fig. 131). The acanthus scrolls in the lower parts of the bars (e.g., fol. 68r – Fig. 496) can be compared to those of the *First Kennicott Bible* of 1476 (No. 48, e.g., fols. 6r, 370r – Figs. 445, 470).

Bibliography

Loewe, *Hand List*, No. 14.
Domínguez-Bordona, *Ars Hispaniae*, XVIII, Fig. 131.
Delaissé, *Brussels*, No. 9.

51. CAMBRIDGE FRANCO-SPANISH PENTATEUCH

Spain, 1415 or late fifteenth century

CUL, Add. 469

Fig. 499

Pentateuch, haftarot and the Five Megillot.

General Data

Codicology

Vellum; 206 foliated leaves (fols. 66 142 and 175–182 are missing, though counted; no text is missing between fols. 65 and 67; fols. 3 and 6 are text replacements on paper); 182 × 145 mm. Text space 118 × (95–97) mm. Written in square Sephardi script, in light brown ink, 28 lines in two columns. Ruling by stylus, 28 horizontal and 1 + 2 + 1 vertical lines. Pricking in outer, inner and lower margins. 24 quires of 8 leaves, except for Quires VIII^{10-3} (fol. 66 missing at end of quire) and XVII^{12-1} (fol. 142 missing at end of quire). Catchwords on the last pages of most quires.

Colophon

fol. 206r The colophon containing common formulae, does not give the scribe's name, place or date. The date may be deduced by adding up the numerical equivalents of the letters decorated with three dots in Ps. 31:25. This would give (5)175 (1415 A.D.).

History

fol. 1r (Fig. 499) In a cursive Sephardi hand: The book was pawned by Niḥami(?) (ניחמי) b. Samuel the Punctuator(?) (הנקֹ׳).
fol. 206r The Pentateuch was dedicated by Solomon Oliama (אוליאמא) b. Moses to the community of Kraireit (קריירט), in the name of his deceased son Moses.
Purchased by the Cambridge University from H. Lipschütz in 1869.

Decoration

Programme

A. Title and initial-word panels.
B. Decorated *parashah* signs.
C. *Haftarah* titles.

Description

A. *Title and Initial-Word Panels.*

There are title and initial-word panels with penwork decoration at the beginnings of books (e.g., fols. 1r – Fig. 499, 67r, 87v, 116r, 143r, 187v, 189v, 192r and 198r). The initial words, titles, or the word ספר, "book", are written in burnished gold within penwork panels, mostly over one text column. These panels appear at the beginnings of four of the books of the Pentateuch (fols. 1r – Fig. 499: Genesis, 67r, 87v and 116r), at the

beginnings of the *haftarot* (fol. 143r) and at the beginnings of four of the *Megillot* (fols. 187v, 189v, 192r and 198r). The panel for Genesis (Fig. 499) extends across both text columns and is framed by gold fillets which extend on both sides of the columns and between them. The panels for Ruth (fol. 187v) and Esther (fol. 192r) have no writing in them.

Lamentations (fol. 203r) has a blank space left for a panel at the bottom of the previous text column. Penwork in red and violet extends from the panels on both sides of the text column in bands and flourishes, often with protruding dragons' heads (e.g., fols. 67r, 116r, 143r, 192r and 198r). The main penwork motifs are: large paisley leaves and scrolls filled with dots, spirals and flourishes; large scrolls filled with parallel motifs decorated with acanthus-like leaves (e.g., fol. 187v); foliage scrolls encircling large fig leaves, with acanthus leaves in the spandrels (e.g., fol. 192r); some fleurs-de-lis and small trees above the upper frame of the panel (e.g., fols. 1r and 67r).

B. *Decorated Parashah Signs.*

These signs are in red and violet penwork, with some green tint mostly faded to ochre (e.g., fols. 18v, 31r, 52v, 54v and 57r), spreading along the outer border. The abbreviation פרש is written within small penwork panels, most of them hexagonal in shape, but some elongated cartouches (e.g., fols. 27v and 31r) or roundels (e.g., fols. 57r, 60v and 69v). The penwork motifs are similar to those of the initial-word panels, with the addition of motifs executed in spared-ground technique (e.g., fols. 21v, 25r, 27v, 34r, 39r, 42r, 45r, 48r, 50r, 52v, 63v, 74r, 81v, 84v, 98r and 134r). The penwork extends along the margins as: (1) bars with flourishes, many with acanthus leaves, some with a pair of stylized, double-winged acanthus leaves at the top, each leaf with a stylized eye (e.g., fols. 25r, 34r, 76r and 113v); (2) a variation of this motif, such as a pair of dragons' heads, some with thin scrolls or flourishes extending from their mouths (e.g., fols. 72r, 76r, 137r and 138v); (3) foliage scrolls and flourishes, sometimes with tendrils or ivy leaves, mostly issuing from flowers drawn at the top and bottom corners of the panel (e.g., fols. 13v, 18v, 39r, 42r, 48r, 54v, 98r, 103r, 118v, 125r, 131r, 141r and many others).

C. *Haftarah Titles.*

These titles are in large letters, in either red or violet, surrounded by lines of the other colour.

Conclusions

The small size of this manuscript is typical of a practical codex, containing the Pentateuch, *haftarot* and the Five *Megillot*, used at the synagogue and at home on the Sabbath and festivals. This kind of book became smaller during the fifteenth century, when it was apparently mass-produced.

The manuscript is similar in size, script and decoration to the *Manchester Franco-Spanish Bible* (No. 49) and the *Cambridge Illustrated Small Bible* (No. 50), which are probably both from the last quarter of the fifteenth century. It is also similar in type and style to the *Escorial Small Bible* (G.II.8; see Domínguez-Bordona, Fig. 131), which belongs to the same group. This similarity is especially apparent in the penwork panel for Genesis, with bars accompanied by penwork descending along both margins and between the text columns and terminating in small foliage motifs. The penwork panels and *parashah* signs of our manuscript are typical of Sephardi decoration of the fifteenth century and if there is indeed an indication of the date 1415 (see above, Colophon), our manuscript may be the earliest in this group.

Bibliography

Schiller-Szinessy, No. 18, pp. 27–29.
Loewe, *Hand List*, No. 29.

52 = 1A. SECOND CAMBRIDGE CASTILIAN BIBLE *Castile, c. 1279 and mid-fifteenth century*

CUL, Add. 3203 Figs. 500–511

Bible with massoretic lists and computistic tables.

General Data

Codicology

Vellum; 601 leaves (two leaves missing before fol. 341 and two after fol. 346; no text missing); 307 × 250 mm. Text space (183–187) × (148–150) mm; height of the text space with Massorah 227–232 mm. Written in square Sephardi script, in light brown ink, 25 lines in two columns. Ruling by stylus, 2 + 25 + 3 horizontal and 2 + 3 + 2 vertical lines. Pricking in all margins. 101 quires of 6 leaves each, except for Quires II², III⁸, IV⁸, (LVII, LIX)⁶⁻² (two leaves out of six cut off) and CI⁶⁻¹ (one leaf out of six missing). Catchwords at the bottom of the last page of each quire, mostly cut off by a binder. The titles are repeated in a different hand at the bottom left-hand corner of every recto; this same hand added the *parashah* numbering. The massoretic lists on fols. 1v–5v, 157v–162v and 341v–344v are framed by inscriptions in display script. Blank pages: fols. 1r, 9r, 157r, 341r, 346v and 600v, always at the beginning or end of a quire with new subject matter.

Binding

Reddish-brown leather binding on wooden boards, with decorated outer and inner covers, contemporary with the later stage of decoration of the manuscript. The outer covers are blind-tooled in geometrical interlacing patterns, with perforated bosses on red velvet at the corners and centres of both covers, of which only three on each cover survive. The outer front cover also has two perforated discs, with traces of black velvet. For the inner cover decorations, see § G. Woodworm damage to the side of the binding indicates that it was once mounted on wood and that the binding was of the box type, as that of the *First Kennicott Bible* (No. 48). The quires were mounted on leather by a modern binder who also re-attached the binding to the book with leather straps. Gilt edges.

Colophon

None.

History

fols. 9v (Fig. 500)–*10v* Computistic tables for the years 1279–1515.

fols. 7r–8v Computistic tables for the years 1428–1523 have been added.

Bought by Prof. W. Robertson Smith, former Librarian of the University Library, from Thomas Toon,

bookseller, on 7 July 1887 (a receipt for £20 is stuck in after fol. 601).

Decoration

Programme

The decoration was done in two stages:
(1) At the time of the copying of the manuscript, *c*. 1279:
 A. Decorative computistic tables, 1279 to 1515.
 B. Decorated beginnings of books.
 C. Decorated *parashah* signs.
(2) At the time of its binding in the mid-fifteenth century.
 D. Full-page illustration of Sanctuary implements.
 E. Decorative computistic tables, 1428–1523.
 F. Carpet pages and carpet panels.
 G. Inner cover decorations.

Description

(1) The first stage of decoration is delicate in outline and range of colours, executed in pen and brush with gold fillets, surrounded by penwork.

A. Decorative Computistic Tables, 1279 to 1515.

Fols. 9v (Fig. 500), *10r and 10v* are full-page tables, measuring (217–222) × (163–172) mm. They are divided into small square compartments, in which the mnemonic signs of each year are written diagonally on the gold ground. The bands dividing the compartments and framing the pages are decorated with pen-drawn scallop-leaf scrolls on ground, filled alternately with red and violet ink.

B. Decorated Beginnings of Books.

The decorations at the beginnings of books consist of border decorations for the text and small panels or large palmette-like arabesque motifs. The three types, all in gold and paint, are often combined, and surrounded by and filled with additional motifs in pen and brush drawing. The borders consist of gold or coloured bars, stylized foliage and floral motifs, small angular interlaces and other geometrical shapes extending across the text column at the head of the new book and occasionally spreading along the sides of the text column (e.g., fols. 11v – Fig. 501, 63v, 165r – Fig. 502: Psalms across the page, 425r, 539r and 573r). In some places double gold bars across the text form elongated panels (e.g., fols. 47r and 78r). Similar decorations form U-shaped frames to the massoretic notes at the end of some books (e.g., fols. 29v, 99v, 383r and 500r). A common variation of this border decoration is a small panel with a foliage, a geometrical motif or a frame in gold, filled with and surrounded by penwork. The most elaborate examples are at the openings of the

Latter Prophets (e.g., fols. 577v, 579r, 583v, 585v, 587v, 588v, 589v and 591r).

The main penwork motifs are spiralling scrolls (e.g., fols. 583r, 583v and 592r), plaits (e.g., fols. 583r, 591r and 592r) and interlaces (e.g., fols. 585r and 589r). Gold bars are sometimes decorated with penwork in black (e.g., fols. 260v, 347v – Fig. 503, 465v and 469v). The arabesque motifs in the margins or between the text columns are mostly shaped as palmettes or interlaces supported by short stands. They are formed by interlacing foliate bands in gold, mostly with coloured fillings, and surrounded by additional motifs in brush or pen drawing (e.g., fols. 215v, 234r, 250r, 281v, 284v, 289v, 347v – Fig. 503, 383r, 500r, 573r and 583r). These are often combined with border decorations or panels, sometimes extending horizontally into the margin from the other decoration (e.g., fols. 260v, 279r, 365v – Fig. 504, 469v, 577v, 583v and 588v). Chronicles (fol. 295v) and Malachi (fol. 598r) have title panels in gold and penwork, the former with a foliage motif extending into the margin, the latter with an interlacing gold frame.

C. Decorated Parashah Signs.

All fifty-two *parashah* signs and their numbers in the margins are decorated with arabesque and other motifs incorporating small frames for the signs. They are mostly shaped as vessels supported by triangular stands and consist of various geometrical and foliage motifs in pen and brush work (e.g., fols. 14v, 17v, 42r, 53v, 103v, 118r, 145r, 148r, 152v and many others). Some are shaped as stars (e.g., fols. 56v and 75v) or other geometrical shapes. Common motifs — besides leaves, spiralling scrolls and flourishes — are the geometrical interlaces (e.g., fols. 36r, 64v, 66v, 69r, 87v, 91v, 93v, 120v, 145r and 151r) and the foliate arabesque interlaces (e.g., fols. 81r, 89v, 96r, 110v and 124r) which sometimes incorporate floral motifs (e.g., fol. 85v).

(2) The second stage of decoration follows a model and some underdrawings of the earlier stage. It is crudely executed with thick outlines and coloured in magenta, green and violet paint and red and violet ink; the reddish burnished gold is heavily outlined in black. There is very little modulation of the painted fields, except for occasional thin brushwork (e.g., fol. 234r). The decorative carpet panels (§F) are painted by another hand in different colours.

D. Full-Page Illustration of Sanctuary Implements.

The Sanctuary implements on fol. 11r (Fig. 507) are in thick gold bands, outlined in violet. In the centre, across the whole length of the page, is a tree-like *Menorah* with seven straight branches, each with three bowls, a knop and a flower. Three more knops are at the branching points. The shaft

has a bowl, a knop and a flower. Two more flowers are supported by a horizontal bar above the base, and a later hand added yet another one on the shaft above the base. On top of each branch is a double-shelved structure. Each lower shelf, inscribed: מחתה, "fire pan", encloses a pair of מלקחים, "tongs". On each top shelf is a bowl-like נר, "candle", the edge closer to the centre being inscribed: פתילה, "wick". The *Menorah* is flanked by two stone steps with three stairs, inscribed: אבן היתה לפני המנורה / שבה שלש מעלות, "A stone was in front of the *Menorah*, which had three steps". On the right of the *Menorah* is a bishop's crozier with four pairs of heart-shapes hanging from it, each terminating in three silver leaves, inscribed: מטה אהרן, "Aaron's rod". To the left is the צנצנת המן, "manna jar", with two handles, filled in with silver dots on a purple ground. For an iconographical discussion, see Introduction to Catalan Bibles (pp. 101–104).

E. *Decorative Computistic Tables, 1428 to 1523.*
The tables on fols. 7r–8v are written in red and brown ink, occasionally forming geometrical patterns.

F. *Carpet Pages and Carpet Panels.*
The carpet pages (fols. 156v, 163r – Fig. 508, 347r – Fig. 510, and 600r – Fig. 505), measuring (218–240) × (170–185) mm, are on leaves left empty at the main divisions. The carpet panels, measuring (147–235) × (90–193) mm, fill the space left on the last page of each of the three parts of the Bible (fols. 156r, 340v – Fig. 509, and 599v – Fig. 506). Although the drawing of the patterns resembles the earlier decorations in the manuscript (e.g., a small panel on fol. 585r), some were overpainted by a different hand, in a very crude manner, in blue, green, red and ochre, with burnished gold pasted on a thick grey ground. The patterns are of two types: (1) running patterns of lozenges, plaits, stars etc., formed by spared ground and interlacing bands with coloured ground fillings, framed by gold or coloured bands with crude foliage motifs at the corners (fols. 156r, 156v, 163r, 340v and 599v – Figs. 509 and 506); (2) a medallion with a star-shaped interlace within a rectangular frame of similar interlacing patterns (fols. 347r and 600r – Figs. 510 and 505). The spandrels of the medallions were filled with stars, crescents, crude lotus buds or brush scrolls by the same hand that painted the panels; on fol. 600r, the star pattern of the medallion was covered with crude brush scrolls on a burnished gold ground; the original design is still visible overleaf. On fol. 156r, the same hand added a star and crescent in gold on the vellum ground and smeared several pages (e.g., fol. 163v) with the paste that was used as a ground for the burnished gold.

G. *Inner-Cover Decoration.*
The decoration in the insides of the covers resembles the carpet pages. They are decorated with large medallions, 158–160 mm in diameter, with cut-out patterns on a copper-gold ground. In each medallion (Fig. 511) various circular shapes interlace with a six-pointed star to form a six-petalled flower in the centre. The direction of the interlacing and the perforation of the shapes on the lower cover are reversed from those of the upper cover. The front inner cover (Fig. 511) has additional borders of spared ground plaits drawn in black ink in the spandrels of the medallion.

Conclusions
While this manuscript has no colophon, its two stages of decoration can be dated by means of its two sets of computistic tables to *c.* 1279 and to 1428 and after. The earlier stage of 1279 to 1515 (fols. 9v–10v) which begins with Quire III, is part of the original manuscript; the later stage of 1428 to 1523 (fols. 7r–8v) is written on Quire II, which was added to the original.

The original decoration of the beginnings of books and *parashah* signs of the Bible is similar in style and motif to the *First Cambridge Castilian Bible* (No. 1).

The later stage of decoration, with its pages of Sanctuary implements and full-page panels at the ends of books, follows the decoration programme and interlacing motifs of the earlier manuscript. Traces of earlier underdrawings at the ends of books indicate that they were overpainted by the cruder hand of the later stage. Even some of the more delicate decorations of the first stage may have been repainted in this manner.

The geometrical interlacings, however, were in common use in both stages. Carpet pages similar to those of the later stage of our manuscript can be found in the *First Kennicott Bible* of 1476 (No. 48, fols. 441r, 443v, 444v, 122r – Figs. 451, 454–456). The vestiges of box-like binding and cut-out inner cover decoration also resemble those in the *First Kennicott Bible* (fols. 352v, front cover verso – Figs. 458, 459). The page with the *Menorah* and other Sanctuary implements (fol. 11r – Fig. 507) is of the stylized type common to the fifteenth century. It is somewhat similar to the *Feinberg Spanish Implements Page*, now in Jerusalem, Israel Museum (MS 180/59).

Despite its similarity to the *First Kennicott Bible* of 1476, the second stage of decoration in our manuscript may possibly be dated closer to the middle of the fifteenth century, but in any case after 1428, the opening date of the later set of computistic tables.

Bibliography
Loewe, *Hand List*, No. 25.

53. DUBLIN CASTILIAN PENTATEUCH

Toledo, Castile (?), 1478

TCLD, MS. 13

Figs. 512–519

Pentateuch and massoretic lists.

General Data

Codicology

Vellum; III + 176 + III leaves; *c*. 235 × 195 mm. Text space (174–184) × (132–134) mm, except for the first and last quires of the massoretic lists (fols. 1–6 and 181–176): each column measures (100–150) × (45–57) mm, and the frames — 180 × 134 mm. Written in square Sephardi script, in dark and light brown ink (some faded parts have been over-written in dark ink at a later date), the biblical text in 24 lines and the lists in 22 lines, both in two columns. The Massorah Magna is in smaller square script, in 2 lines in the top margin and 3 lines in the bottom margin; the Massorah Parva is in a single column in the outer margin and between the text columns. Ruling by stylus, 2 + 24 + 3 horizontal and 2 + 3 + 2 vertical lines, except for the massoretic list pages, which have 24 horizontal and 1 + 2 + 1 vertical lines. Pricking not noticeable. 23 quires of 8 leaves each, except for Quires I^6, one quire missing after Quire XIV (fol. 110v), with Lev. 26:2 to Numb. 4:47, XVI6, XVIII6 and XXXIII6. In both Quires XVI and XVIII the middle conjoint leaves have been torn out, and the missing texts were added after fol. 121r (Numb. 15:29 to 17:4), and after fol. 135r (Numb. 32:11 to 33:56). Taking into account the missing texts in the massoretic lists, at least one folio is missing at the end of Quire I and one folio at the beginning of Quire XXIII. Fol. 1r was originally blank.

Binding

Fifteenth-century brown morocco binding on wooden boards, with blind tooling on each cover consisting of four concentric rectangular frames, two of them decorated with interlacing frets and palmette motifs; five palmettes are in the central panel. The three end papers are, in fact, four conjoint ones, the fourth one being stuck to the inner covers. There are two kinds of watermarks: (1) three circles topped by a Maltese cross, 65 mm in height; (2) a Greek cross on top of a dome resting on two other domes.

Colophon

fol. 170v (Fig. 519) "The Pentateuch was completed on Wednesday, the 2nd of Kislev 5239" (28 October 1478), for a patron whose name has been erased; a new name was inserted instead (see below, History).

History

fol. 170v (Fig. 519) Owner's inscription: "R. Joseph Cohen b. R. Isaac Cohen." Written within the colophon in burnished gold letters, in a fifteenth-century Sephardi script, somewhat different from that of the original

scribe (cf. especially the *qof* and the *lamed*), in a different technique; e.g., the red ground of the gold is mere colour and not gesso. This was done after the name of the original patron had been erased, and after the decorative penwork frame had been executed, since it covers part of it.

fol. 1r Deed of sale on the 27th of Marḥeshvan 5283 (17 November 1523), mentioning the name ha-Cohen.

fol. IIIv "The gift of Major Clanaghan of Gibraltar 1748", who received it from a Jew in North Africa. Former shelf mark: M.2.5.

Decoration

The full-page decoration in the manuscript and most of the *parashah* signs are decorated with penwork in red, violet and brown ink, used as framing or filling elements, on the vellum ground.

Programme

A. Full-page framed massoretic lists.
B. Full-page panels.
C. Penwork frames.
D. Decorated *parashah* signs.
E. Micrographic Massorah in geometrical shapes.
F. Floral decoration of other sections.

Description

A. *Full-Page Framed Massoretic Lists.*

The massoretic lists in the first and last quires (fols. 1v–2v, 3r – Fig. 512, 3v–5r, 5v – Fig. 513, 6r, 6v and 171r–176v) are fully framed with verses from the Psalms, and each column is surrounded by penwork decoration. The penwork title and initial-word panels occupy either part of, or the whole of, the text column's width.

The framing penwork of double or triple lines round both sides of the framing verses, the text columns and the initial-word panels, also divides the different sections in the list. From these lines issue feathery scrolls and bulges of fine tendrils, each surrounding a small floral motif. Sometimes fillets of frets and pearl motifs frame the panels or divide sections.

The titles and initial words are written in burnished gold, outlined in black. The panels are sometimes combined to form one elongated panel beside the text column (e.g., fols. 3r – Fig. 512, 4v and 5r; cf. 2v). The motifs are elongated paisley scrolls surrounding club palmettes, open rosettes and other floral and foliage motifs.

B. *Full-Page Panels.*

The four extant openings of books (fols. 7r – Fig. 514, 51r – Fig. 517, 87v and 138v) and the colophon (fol. 170v – Fig. 519) are full-page panels written in burnished gold letters. The opening panels contain a few words of the first verse of each book, in duplication of the text. Two of the books — Genesis (fol. 7r – Fig. 514) and Deuteronomy (fol. 138v) — measuring 170 × 145 mm, and the colophon (fol. 170v – Fig. 519), measuring 155 × 145 mm, are framed by verses from the Psalms written in violet and surrounded by linear penwork similar to that of the massoretic lists.

The opening words written in the centre of the panel are surrounded by concentric, rectangular frames, the outer frame consisting of interlacing penwork, paisley scrolls and flower motifs similar to the panels in the massoretic lists. All outer frames are studded with gold dots, three at each side. On fols. 7r and 138v, a gold fillet frames the inner panel, which consists of a framing band of running club-palmette motifs and a ground of paisley scrolls on which the words are written.

The panels of the other two books — Exodus (fol. 51r – Fig. 517), measuring (190–150) × (175–140) mm, and Leviticus (fol. 87v), measuring 155 × 135 mm — have a wide frame of densely interlaced multiple frets on a burnished silver ground. The frets are painted in sections, in alternating colours of red, olive green, blue and spare ground. The inner panel (60 × 50 mm) has a double frame of paisley scrolls in gold and violet penwork (fol. 51r) or a single frame in light brown ink (fol. 87v). On fol. 51r, the entire panel is surrounded by red linear tendril motifs, spiralling and bulging out. On fol. 87v, the panel is surrounded by red, linear pearl motifs.

The colophon, written on a penwork ground divided into bands that correspond to lines, is framed by a band of paisley scrolls. Red, linear, bulging tendril and pearl motifs surround it, filling most of the space within the outer frame of verses.

C. *Penwork Frames.*

The two text columns opposite the openings of books are framed by linear penwork, with bulging tendril motifs surrounding each text column (e.g., fols. 88r and 138r). That on fol. 50r (Fig. 516: end of Genesis) is more elaborate because the text ends in the first column. The entire second column is composed as a panel divided into sixteen rectangles by indented fillets enclosing pearl motifs. Each rectangle is divided by two intersecting diagonal lines, with a double circle in the centre.

D. *Decorated Parashah Signs.*

There are two types of *parashah* signs, both within penwork panels:

1. Most are rectangular penwork frames in red and violet (e.g., fol. 84v – Fig. 518), enclosing the contraction פרש׳ (*parash*), and sometimes the name of the *haftarah*. The penwork motifs are mainly paisley scrolls with open rosettes and other flowers. Some club motifs and linear elongations extend from the frames.

2. Shield-like frames in brown ink, with fleurs-de-lis springing from them (e.g., fols. 11v, 23r and 26r – Fig. 515). Fol. 11v has additional red ink.

E. *Micrographic Massorah in Geometrical Shapes.*

The Massorah Magna is written in micrography, two lines in the upper margin and three lines in the lower margin, by two different massorators. The first, up to fol. 46v (end of Quire VI), sometimes forms geometrical zigzags and circular motifs which extend into the side margins and the space between the columns (e.g. fol. 26r – Fig. 515).

F. *Floral Decoration of Other Sections.*

Other notations, such as *sedarot* and mid-book signs, are decorated with foliage motifs in brown ink (e.g., fols. 22r, 28v and 42v).

Conclusions

The manuscript, which the colophon lists as having been completed in 1478, was probably not written for Joseph b. Isaac Cohen. It seems that his name was inserted in the colophon by a different, though contemporary, hand, after the decoration of the colophon had been completed. This can be inferred from the different script and technique used for writing the entire name, which extends into the frame. The 1523 deed of sale mentions the name ha-Cohen, which may refer to the same family.

The small size of the book and its almost square proportions resemble earlier types of biblical manuscripts, mainly those from Toledo of the thirteenth and fourteenth centuries. The division into both *parashot* and *sedarot* also points to a Toledan tradition.

The decoration of the manuscript was obviously planned by the scribe, who left complete empty pages for the openings of books. The decoration of these, as well as the verse within, may possibly have been executed by the massorator. The penwork decoration is of two types: (1) The paisley scroll motifs for the title and initial-word panels are traditional and archaic in nature; the contemporary element in them seems to consist of open flowers and rosettes, which also appear in the *First Kennicott Bible* of 1476 (No. 48). (2) The linear, feathery extensions, which are entirely contemporary, can be found in the *First Kennicott Bible*, as well as in the *Lisbon Bible* of 1482 (No. 42) and in the *Lisbon Maimonides* of 1473 (No. 41). The geometrical massoretic micrography is not indicative of either date or place of origin.

Bibliography
Never published.

Abravanel Pentateuch Group
[Nos. 54–58]

The five manuscripts in this sub-group consist of Biblical texts related to each other through their decoration programme and common micrographic motifs, as exemplified in the *Abravanel Pentateuch* of 1480 (No. 55). The decoration programme of this sub-group includes carpet pages of micrographic interlaces at the beginning and end of each manuscript; frames to the concluding pages of some books of the Bible and some massoretic lists; and decorated massorah, functioning as catchwords, at the beginning and end of quires. The marginal massorah consists of patterns in the upper and lower margins, with occasional lozenge shapes and knots or scalloped foliage motifs in the outer margins. Also common are snake-head terminals to interlacing bands in the marginal decoration.

The *Oxford Hispano-Portuguese Pentateuch* (No. 54), the *Oxford Hispano-Portuguese Psalter* (No. 56) and the *First Hispano-Portuguese Bible* (No. 57) reveal connections with the Portuguese School in their painted carpet pages surrounded by floral scrolls (see Chapter Four, pp. 137–138). Other relations to Portuguese manuscripts can be found in the size and oblong shape of the *Oxford Psalter* and in the formula of the colophon of the *Abravanel Pentateuch*. However, attribution of the whole group to a Lisbon workshop cannot be fully substantiated, since the micrographic decoration and its programme do not correspond to the typical Lisbon manuscripts. Moreover, the micrographic decorations of the *Abravanel Pentateuch* closely resemble those of a Bible in the Jewish Theological Seminary Library in New York (MS. L. 5), which was copied in Cordoba in 1479. The striking similarity in decoration programme and motifs in these two manuscripts tempts one to attribute the entire *Abravanel Pentateuch* group to Cordoba. However, the undeniable affinities to the Portuguese School, and the present state of research, do not permit an unequivocal attribution.

54. OXFORD HISPANO-PORTUGUESE PENTATEUCH

Hispano-Portuguese, last quarter of fifteenth century

Bodl., Poc. 347

Fig. 520

Pentateuch and Former Prophets.

General Data

Codicology

Vellum; 1 + 232 leaves; (260–263) × (217–220) mm. Text space (175–185) × (148–152) mm; height of the text space with Massorah 223–230 mm. Written in square Sephardi script, in brown ink, 30 lines in two columns. Ruling by stylus, 2 + 30 + 3 horizontal and 1 + 2 + 2 vertical lines. Fols. 134–232 (Former Prophets) are foliated קפ–רכד in the outer upper corners, and the titles are written in the upper margins. Fols. 3r–15v contain different massoretic texts, including differences, a list of 613 precepts and a list of *haftarot*. Fols. 2v and 16r are blank. 29 quires of 8 leaves each, except for Quires XVI6 and XXIX3. Oxford, Bodl. Poc. 348 (Neubauer, No. 9) is Vol. II of this Bible, but has no decorations.

Colophon
None.

History

Owners' Inscriptions
fol. 1r (1) In fifteenth-century Sephardi cursive: "Joseph b. Judah di Levy bought the two volumes of the Bible", i.e., our manuscript and Poc. 348 (Neubauer, No. 9). (2) In a later hand: Solomon di Leyvah (also on fols. 4r and 16r).
fol. 15r In fifteenth-century Sephardi cursive: "Isaac Alaton inherited it from Yehudah Alaton." Purchased by the Bodleian Library in 1693, together with the collection of Edward Pococke, Regius Professor of Hebrew (died 1691).

Decoration

Programme

A. Carpet page.
B. Decorated *parashah* signs.
C. Decorative micrography of the Massorah.
D. Blank spaces for decorations.

Description

A. *Carpet Page.*

The carpet page on fol. 2r (Fig. 520), measuring 165 × 140 mm, consists of micrography and penwork in brown ink. The rectangular central compartment (95 × 73 mm) encloses a roundel with a six-petalled rosette in micrography (Psalms 1–2). The rest of the compartment is filled with dense penwork scrolls which enclose small serrated flowers, a few geometrical motifs and flourishes. The wide framing bands are decorated with dense interlaces in micrography (Song of Songs).

B. *Decorated Parashah Signs.*

A few of the *parashah* signs are within a pen-drawn shield surrounded by a flourished line in brown ink, with a panel above. The panels are square (e.g., fols. 27r, 29r, 73r, 85v, 91r and 105r) or stepped (e.g., fols. 19r and 94v), and are filled with spared ground interlaces. Above the panel and beneath the shield frame are small symmetrical motifs, mostly foliage; those at the top are sometimes supported by a small palmette (e.g., fols. 91r, 94v and 105r) or by a bar decorated with a spared ground plait pattern (e.g., fol. 73r).

Other signs in the margin are decorated with similar though smaller and less elaborate motifs (e.g., fols. 22v, 81r and 214r).

C. *Decorative Micrography of the Massorah.*

At the ends of some books the massoretic notes are written as small lozenges (e.g., fols. 148r and 162r). The Massorah occasionally extends into the side margin in irregular geometrical shapes. The text of the last page (fol. 232v) is written as two triangles, apex to apex. The massoretic texts on fols. 3r–15v are framed by inscriptions.

D. *Blank Spaces for Decorations.*

The scribe left blank spaces for decorations round the text on fols. 53v–54v (the First Song of Moses and the preceding text) and 131r–132r (the Last Song of Moses). The blank spaces at the ends of some books (e.g., fols. 45v, 70v, 87v and 133v) were probably intended for panels.

Conclusions

As stated above, our manuscript, which consists of only the Pentateuch and Prophets, has a complementary volume containing the Hagiographa, which is hardly decorated at all. The only carpet page in our Bible, which consists of a heavy frame in micrography enclosing a linear rosette, is similar in type and density to that of the *Abravanel Pentateuch* of *c.* 1480, from either Lisbon or Cordoba (No. 55; e.g., fols. 3v–4r and 238v – Fig. 526, and 239r). The framed rosette is also similar to that in the *Lisbon Bible* of 1482 (No. 42; Vol. III, fol. 185r – Fig. 418). Similar carpet pages can also be found in the *Dublin Castilian Pentateuch* of 1478 (No. 53) and some undated Bibles (e.g., Coimbra, Municipal Library; Paris, Bibliothèque nationale, hébr. 1314). The *parashah* signs in our Bible (e.g., on fol. 73r) are somewhat similar to those in another Bible attributed to the Lisbon group or dependent on it, the *First Hispano-Portuguese Bible* (No. 57; e.g., fol. 45r). The manuscripts can therefore be attributed to the last quarter of the fifteenth century, originating in Spain with Portuguese influence.

Bibliography

Neubauer, No. 8.

55. ABRAVANEL PENTATEUCH

Bodl., Opp. Add. 4° 26

Pentateuch, Haftarot, Five Megillot and Megillat Antiochus.

General Data

Codicology

Fine vellum; 240 leaves; 229 × 170 mm. Text space (135–139) × 108 mm; height of the text space with Massorah 172–175 mm. Fols. 1r–3r and 240r–v are blank. Written in square Sephardi script, in brown ink, 26 lines mostly in 2 columns; a few pages are written in one column and have decorative frames (see below). Ruling by stylus, 2 + 26 + 3 horizontal and 2 + 3 + 2 vertical lines. 31 quires of 8 leaves each, except for Quires I⁴ and XXXI⁴. Each quire is numbered in Hebrew alphabetical order at its beginning and end.

Binding

Dark brown morocco binding on wooden boards, with gold tooled line-frames and small blind-tooled rosettes along them. Remnants of leather straps.

Colophon

fol. 239v (Fig. 521) The text was written by Moses the Scribe b. Jacob the Sephardi b. R. Moses n'Qalif and completed on Tuesday, the 20th of Elul 5240 (1480). This inscription is erroneous, since the 20th of Elul never falls on a Tuesday; it fell on a Saturday in 5240. In the micrographic pattern framing the colophon: The Massorah was written by Samuel the Scribe b. R. Joshua the Sephardi b. R. Joseph.

History

fol. 239v Owners' inscriptions: (1) Above the colophon, in a hand similar to those of both scribes, possibly of the first owner: Don Samuel Abravanel (born Lisbon 1473, moved to Castile 1483 and to Salonica 1492, was the Rabbi of Naples 1496–1541, died Ferrara 1547). (2) Under the colophon: "This pentateuch and another Bible written by the scribe R. Samuel b. Isaac of Medina (Merina or Modena) the Sephardi, which was written on vellum in 5251 (1491) in Lisbon, are what is left in my possession, Elisha Finzi, as a pledge for the sum of …523 scudi, which they owed me… since January 5344 (1584)."

fol. 2r Owner's signature in a seventeenth-century hand: Naphtali ha-Levi. Birth inscription: A son born on Friday, the 10th of Nisan 5364 ("ten days in April" 1604).

Other inscriptions are illegible.

fol. 238r Censor's signature: "Gio. dom. instruissi 1609."

Decoration

All decorations are in micrography, except for the cover decoration (§ E).

Programme

A. Carpet pages.
B. Full-page frames.
C. Decorative Massorah.
D. Indications of book ends.
E. Imprints of cover decoration.

Description

A. *Carpet Pages.*

The four carpet pages (fols. 3v, 4r, 238v – Fig. 526, and 239r), measuring (130–135) × 100 mm, are unframed and decorated with all-over patterns of micrographic bands forming interlacing horizontal and vertical rows of lozenges connected by bars.

B. *Full-Page Frames.*

There are full-page frames, measuring (132–146) × (108–115) mm, for: lists of portions to be read on the various festivals (fols. 4v–5r, 5v – Fig. 522, 6r – Fig. 523); a section of Exodus, including the First Song of Moses (fols. 57v–59v); the last page of the Pentateuch (fol. 165r); the end of the book and the differences (fols. 236r–238r); and the colophon (fol. 239v – Fig. 521) measuring 115 × 95 mm. The text is written in one column, except for fol. 6r where it is written in two columns separated by an additional border. The borders consist of interlacing micrographic bands forming plait patterns of four bands in several variations (fols. 4v–5v and 237r–238r) or of two parallel bands with interlaces and knots at the corners and middles of the borders (fols. 6r – Fig. 523, 57v–59v, 165r, 236r–236v and 239v).

C. *Decorative Massorah.*

The decorative writing of the Massorah in the upper and lower margins — especially rich at the beginnings and ends of quires where it is often accompanied by a large micrographic ornament in the side margin — is normally written in similar patterns on opposite pages. It is possible that it served as catchwords for the quires, as well as for the order of the leaves in each quire. The most elaborate patterns are found in the lower margins at the beginnings and ends of quires. These consist of a large motif in the middle of the Massorah lines, normally a knot or another geometrical shape, often in combination with stylized lobed foliage (e.g., fols. 12v–13r, 20v–21r, 28v, 29r – Fig. 524,

36v–37r, 52v–53r, 68v–69r, 92v–93r, 148v–149r, 180v–181r and 196v–197r), sometimes interlacing with undulating bands which terminate in fluttering, foliate or snake-like ends (e.g., fols. 44v–45r, 108v–109r, 124v–125r and 140v–141r). The Massorah lines themselves — with or without a central motif — often interlace in different plait patterns (e.g., fols. 22v–23r, 28v–29r – Fig. 524, 44v–45r, 74v–75r, 154v–155r and 220v–221r), sometimes interrupted by alternately upright and inverted V-shapes (e.g., fols. 76v, 77r – Fig. 525, 100v–101r, 132v–133r, 172v–173r, 188v–189r and 228v–229r). On other pages, the lines are broken or interlaced in X- and V-shapes, semi-circles, triangles, lozenges and stylized lobed foliage, especially in the middle of lines.

Many of the first or last pages of the quires contain additional micrographic motifs in the outer margins. These include a staff with symmetrical lobed foliage at either end (e.g., fols. 69v and 196v), sometimes with a ring round the staff (e.g., fols. 12v and 45r); two intertwined snakes, one with a lion's head (fol. 77r – Fig. 525); fruit shapes (fol. 141r); short columns of leaves and flowers (fols. 149r, 156v and 180v); and a plait of foliated bands (fol. 148v). On other pages, stylized lobed foliage extends from the ends of the upper or lower Massorah lines into the side margins (e.g., fols. 29r, 61r, 93r and 101r); on fol. 133r a small bunch of grapes is included.

D. *Indications of Book Ends.*

Micrographic motifs at the ends of the books include bands across one text column which consist of plaits of foliate bands (fols. 46v: Genesis; and 81r: Exodus) or of stylized acanthus scrolls (fol. 137r: Deuteronomy). There are also small six-pointed stars (fols. 104r: Leviticus; 219r: Song of Songs; and 233v: Esther). The star on fol. 214r (end of the *haftarot*), which is formed by double lines, is enclosed within a circle (diameter *c.* 28 mm).

E. *Imprints of Cover Decoration.*

The lost original covers were decorated on the inside, as evidenced by the surviving imprints on fols. 1r and 240v (Fig. 527). The technique was probably similar to that of the inner covers of the *First Kennicott Bible* (No. 48). The two inner covers had identical decoration of interlacing squares and other geometrical shapes, forming a rosette incorporating five stars.

Conclusions

In spite of the erroneous day mentioned in the colophon, the year 1480 is supported by the characteristics of the manuscript. The programme of the micrography decoration — full-page panels at the beginning and the end, frames for the concluding pages of books or divisions and decorated Massorah at the beginnings and ends of quires, including small motifs in the outer margins — is similar to that of the *Oxford Hispano-Portuguese Psalter* (No. 56). The lobed foliage and snake-like bands in the upper and lower margins are more elaborate than in the *Psalter*, but are reminiscent of the Massorah decoration of two other manuscripts from the same group, the *First Hispano-Portuguese Bible* (No. 57) and the *Second Hispano-Portuguese Bible* (No. 58), one of which has similar motifs in the outer margins (cf., e.g., fols. 45r, 77r – Fig. 525, and 148v in our manuscript with fols. 212r, 220r – Fig. 539, and 203v, respectively, in the *First Hispano-Portuguese Bible*). The imprints of the cover in our Pentateuch decoration are similar to those of the cover of the *First Kennicott Bible* of 1476 (No. 48). The writing of the micrography in our Pentateuch is finer than in the other manuscripts, although the micrographic scrolls and geometric shapes are wider and less dense.

A Bible copied in Cordoba in 1479 now in the Jewish Theological Seminary in New York (MS. L.5), is very similar to the *Abravanel Pentateuch* in size, decoration programme and motifs. The *Cordoba Bible of 1479* may indicate that the entire Abravanel Pentateuch group was produced in Cordoba. If not by a Cordobese scribe, the *Cordoba Bible* may have been copied and decorated by Portuguese scribes, who carried their tradition to Cordoba.

Moreover, the attribution to Lisbon is strengthened by the fact that the *Oxford Hispano-Portuguese Psalter* (No. 56) includes penwork of the Lisbon type of the last quarter of the fifteenth century. Moreover, the colophon in our manuscript ends with the formula ישע יקרב, "Redemption is near at hand", which is typical of the Lisbon manuscripts, and is accompanied by a reference to Don Samuel Abravanel, who was born in Lisbon. The 1480 date is therefore probably correct, and Lisbon or Cordoba origins are possible.

Bibliography
Neubauer, No. 30.

56. OXFORD HISPANO-PORTUGUESE PSALTER

Hispano-Portuguese, late fifteenth century

Bodl., Opp. Add. 8° 10

Fig s. 528–533

Psalter.

General Data

Codicology

Vellum; 120 leaves; 90 × 130 mm. Text space (41–47) × (70–78) mm; height of the text space with Massorah 62 mm. Written in square Sephardi script, in light brown ink, 11 lines per page. Ruling by stylus, 1 + 11(?) + 2 horizontal and 2 + 3 vertical lines. Pricking not noticeable. The numbers of the Psalms are written in the margins. Fol. 1r is blank. 15 quires of 8 leaves each. No catchwords but the decoration described in § C was probably intended for this purpose.

Binding

Nineteenth-century brown calf binding, rebound in the Bodleian Library.

Colophon

None.

History

None.

Decoration

All decorations are in micrography and penwork.

Programme

A. Micrographic carpet pages.
B. Micrography and penwork frames.
C. Decorative micrography of the Massorah.
D. Penwork panels.

Description

A. *Micrographic Carpet Pages.*

The two carpet pages, one at the beginning of the book (fol. 1v – Fig. 528) and one at its end (fol. 120r – Fig. 533), measuring 43 × 71 and 50 × 78 mm respectively, have patterns of interlacing micrography bands (Psalms 45 and 130, respectively), either winding round diagonal micrography stripes (fol. 1v) or forming recurring knot shapes placed horizontally and vertically (fol. 120v). The panel on fol. 1v is framed by a floral border in violet penwork, with flowers and fruit heightened with red.

B. *Micrography and Penwork Frames.*

Psalm 1 (fol. 2r – Fig. 529) and Psalm 150 (fols. 119v and 120r – Fig. 533) are specially decorated. The micrographic borders form a complete frame on fol. 120r, and a U-shaped frame with an additional border between the text columns on fol. 119v. They are decorated with a plait pattern in micrography. Both these frames, as well as that on fol. 2r, are partly surrounded by penwork floral scrolls similar to those described in § A, but without the red highlights on fol. 119v. On fol. 120r, similar penwork fills the space between the inner frame and the text.

C. *Decorative Micrography of the Massorah.*

The first and last pages of most quires have micrographic decoration, with facing pages normally carrying similar patterns. The lower Massorah lines interlace in the middle in various patterns, mostly knots (e.g., fols. 8v–9r, 16v–17r, 56v–57r, 64v–65r, 80v–81r, 88v–89r, 96v–97r, 104v–105r and 112v–113r). Some are foliated, the foliage motifs often resembling a fleur-de-lis (e.g., fols. 24v–25r, 32v–33r, 40v – Fig. 531, 41r, 72v, 73r – Fig. 532); others have a geometrical criss-cross pattern (e.g., fols. 8v–9r and 48v–49r). The opening page (fol. 2r – Fig. 529, containing Psalm 1) has decorated lower Massorah lines and a micrography staff in the outer margin, with a foliate band wound round it.

D. *Penwork Panels.*

At the main divisions — Psalms 42, 73, 90 and 107 (fols. 31v – Fig. 530, 55v, 73r – Fig. 532, and 87v, respectively) — penwork panels in violet and red extend across the text. Their decorations consist of undulating scrolls with small serrated leaves and flower-like roundels, and their frames are formed by straight and curled lines. Some panels are partly surrounded by floral scrolls (e.g., fols. 31v and 73r), or similar scrolls extend from the side borders of the panel into the side margins (e.g., fols. 55v and 87v). A penwork scroll without a panel also separates the two Psalms on fol. 96r.

Conclusions

In type, size and proportions, this small Psalter resembles two other Psalters, both in the Vatican Library, one from Lisbon dated 1495 (Cod. Ebr. 473; see Sed-Rajna, *Lisbonne*, No. 10), and the other attributed to the same school (Cod. Ebr. 463; *ibid.*, No. 20). The penwork — especially the scrolls with small fruit and flowers shaded with

linework — is also typical of the Lisbon School. It occurs, for instance, in the *Cambridge Portuguese Prayer-Book* (No. 47; cf., e.g., fols. 13v, 16r and 134v with fols. 73r – Fig. 532, and 120r – Fig. 533 in our manuscript). A somewhat different variation appears in the *Lisbon Bible* of 1482 (No. 42; e.g., Vol. I, fol. 99v). However, the programme of the micrographic decoration, which consists of decorated Massorah at the beginnings and ends of quires, including occasional motifs in the outer margins and frames to the concluding pages of some books, is typical of another group of late fifteenth-century manuscripts, including the *Abravanel Pentateuch* (No. 55) and the *First Hispano-Portuguese Bible* (No. 57). The former manuscript, from either Lisbon or Cordoba, has full-page micrographic panels at the beginning and end, as in our Psalter, and the date given in its colophon — though the day is erroneous — is 1480. Within this group, the closest in style to our Psalter is the *First Hispano-Portuguese Bible* (No. 57). The motif in the outer margin of fol. 2r – Fig. 529 in our Psalter should be compared to that on fols. 5v and 164r (Fig. 538) in the *Bible*. The similarities between this Psalter and the Hispano-Portuguese manuscripts point to a date at the end of the fifteenth century, influenced by a Portuguese manuscript.

Bibliography

Neubauer, No. 109.
Sed-Rajna, *Lisbonne*, Nos. 10, 20.
Metzger, T., *Lisbonne*, pp. 79–80, 132–134.

57. FIRST HISPANO-PORTUGUESE BIBLE

Hispano-Portuguese, late fifteenth century

TCLC, F.12.106

Figs. 534–540

Bible.

General Data

Codicology

Vellum; I + 578 + I leaves; 173 × 136 mm. Text space (103–112) × (75–79) mm; height of the text space with the Massorah 124–128 mm. Written in small, square Sephardi script, in light brown ink, mostly 28 lines in two columns. Ruling by stylus and in ink, 2 + 28 + 3 horizontal and 2 + 3 + 1 vertical lines. 76 quires of 8 leaves each, except for Quires I^{6-1}, II6, V^6, VI2, XXXVII4, XLIX6, LIII2, LXXIV2, LXXV6 and LXXVI^{4-1}.

Colophon

None.

History

Owners' Inscriptions

fol. 6r "From Thee is all and from Thy hand it was given to me, Jacob."

fol. 575r Damaged inscription: R. Samuel b. Isaac...

fol. 1r In a nineteenth-century hand: R. Raphael Segre (סגרי; the name is written on top of a different, erased inscription) of Savigliano.

Paper fly-leaf at end Death entry of R. Aaron David Segre, 19 January 1838, by his son, Raphael Segre.

Paper fly-leaf before fol. 1 "William Aldis Wright, Trinity College, Cambridge, 13 December 1906."

Book-plate inside the top cover Given to the College by W.A. Wright, Vice-Master of Trinity College, in 1912.

Decoration

Programme

A. Full-page carpets.
B. Intended frames of decorative micrography.
C. Decorative micrography of the Massorah.
D. Framed inscriptions of massoretic lists.
E. Decorated *parashah* signs.
F. Imprint of cover decoration.

Description

A. *Full-Page Carpets.*

Nine full-page carpets, measuring (99–115) × (78–95) mm, precede the text (fols. 1v–5v). Arranged in pairs of similar pattern on confronting pages, they are pen-drawn in red, violet, brown and green, with some burnished gold. The decoration consists of all-over interlacing patterns (fols. 1v, 2r – Fig. 534, 3v, 4r – Fig. 536, and 5v), or double arcade arrangements sometimes enclosing inscriptions (fols. 2v, 3r – Fig. 535, and 4v–5r), surrounded by beaded lines and framed by inscriptions in bold lettering or mock arabesque

lettering (fols. 1v–2r and 5v). The interlacing patterns of gold or pen-drawn bands, with coloured, penwork or gold ground fillings, consists of: dense, foliate arabesque interlacing (fols. 1v, 2r – Fig. 534); intersecting squares and lozenges forming star shapes, knots and hexagons (fols. 3v, 4r – Fig. 536); or irregular geometrical interlacing forming rosettes (fol. 5v). The double arcade panels (fols. 2v, 3r – Fig. 535, and 4v–6r) are also formed by interlacing bands, and the spaces are filled with penwork interlaces and scrolls.

B. *Intended Frames of Decorative Micrography.*

The only frame executed was the one for the last page of Nehemiah (fol. 569r, measuring 80 × 72 mm), consisting of double plaited bands with additional circlets. Spaces were left for frames round the Last Song of Moses (fol. 153v), the last pages of the Pentateuch (fol. 156v), the Former Prophets (fols. 279r–280r), the Latter Prophets (fols. 407r–407v) and Chronicles (fol. 452r), but there were never executed.

C. *Decorative Micrography of the Massorah.*

The Massorah in the upper and lower margins of the first and last pages of most quires, used as catchwords, is written in decorative forms, richer in the lower margins. A common motif is the interlace or knot in the centre of the Massorah lines, formed by micrography bands which are often foliate (e.g., fols. 6r, 11v–12r, 19v–20r, 27v, 28r – Fig. 537, 33v and many others). In some places there are also foliate terminals to the straight Massorah lines. Another motif, which appears either in combination with the interlace motif or independently, are the bands or snakes coiling round the Massorah lines. This occurs often in the upper margins, but also in the lower ones (e.g., fols. 28r, 115v–116r, 123v–124r, 203v–244r and 321v, 322r – Fig. 540). They are sometimes very rich with foliage motifs, protruding into the side margins (e.g., fols. 147v–148r). The simplest, though very common decoration consists of V-shapes ascending and descending from the straight Massorah lines (e.g., fols. 228r, 337v–338r, 353v–354r and many others). There are also various zigzag combinations, which occur in the outer margin on fol. 180r. The motifs in the outer margins (height 35–45 mm) accompanying some of the micrography patterns described above consist of foliate bands coiling round staffs (fols. 6r and 164r – Fig. 538), a plait of spiky, foliate bands (fol. 203v), or a staff with fruit motifs at both ends (fol. 212r), which is accompanied by a snake on fol. 220r (Fig. 539).

D. *Framed Inscriptions of Massoretic Lists.*

The massoretic lists in fols. 570r–575r are framed by inscriptions in display script.

E. *Decorated Parashah Signs.*

Some of the *parashah* signs are written within small panels of interlacing penwork motifs, topped by candle-like penwork extensions (e.g., fols. 45r and 65r).

F. *Imprint of Cover Decoration.*

The imprint of the lost cut-out inner cover on fol. 578v shows an angular interlace within a roundel, forming a star in the centre, somewhat similar to that in the *Abravanel Pentateuch* (No. 55, Fig. 527).

Conclusions

The programme of the micrography decoration, which includes frames for the concluding pages of books and decorated Massorah at beginnings and ends of quires, is similar to that of the *Abravanel Pentateuch* (No. 55) and of the *Oxford Hispano-Portuguese Psalter* (No. 56). The style of the micrography patterns in the *Abravanel Pentateuch* is particularly close to that of our Bible (cf., e.g., fols. 164r, 220r – Figs. 538, 539 in our manuscript with fol. 77r – Fig. 525 in the *Abravanel Pentateuch*); as is the imprint of the inner cover (Fig. 527). Since the *Oxford Psalter* has some characteristics of Lisbon manuscripts from the last quarter of the fifteenth century, and since the *Abravanel Pentateuch*, from either Lisbon or Cordoba, is dated 1480, a similar date for our Bible is likely. A Lisbon origin is, however, not certain, because the typical micrography programme of our manuscript's group does not appear in the Lisbon School, and may suggest connections with the Cordoba, and other Spanish Schools of the same period.

Bibliography

Loewe, *Trinity*, No. 21.

58. SECOND HISPANO-PORTUGUESE BIBLE

Hispano-Portuguese, late fifteenth century

TCLC, F.12.101

Figs. 541–543

Bible.

General Data

Codicology

Vellum; II + 549 + II leaves; *c.* 200 × 147 mm. Text space (121–123) × (97–100) mm; height of the text space with Massorah 150–153 mm. Written in square Sephardi script, in brown ink, 27 lines in two columns. Ruling by stylus, 1 + 27 + 2 horizontal and 2 + 3 + 2 vertical lines. 70 quires of 8 leaves each, except for Quires XVI[10] (last quire of the Pentateuch), XLVI[4], XLIX[6] and L[6] (last two quires of the Prophets) and LXX[3] (incomplete). The beginning and end are missing. Fols. 130v–131r (end and beginning of quires between the Pentateuch and the Prophets) and 394v–395r (ditto, between the Prophets and the Hagiographa) are blank. Quires XLII–XLIX (fols. 331r–388v) are marked with catchwords.

Colophon

None.

History

Book-plates on inside of upper cover and on first paper fly-leaf Given to Trinity College by W.A. Wright in 1912.

Decoration

Programme

A. Micrographic panels.
B. Decorative micrography of the Massorah.
C. Space for initial-word panels.

Description

A. *Micrographic Panels.*

There are a full-page panel after the Former Prophets (fol. 258r – Fig. 541), measuring 108 × 77 mm, and two smaller panels at the end of Latter Prophets and Chronicles (fols. 394r – Fig. 543, and 440r), measuring 50 × 50 and 45 × 45 mm, respectively. These consist of dense interlaces of micrography bands forming rows of lozenges, plaits and knots.

B. *Decorative Micrography of the Massorah.*

The Massorah in the lower margins was written by two scribes. The scribe of Quires I–XVI and LIV–LXX (fols. 1r–130v and 419r–549v, respectively), who also write the Massorah on a few pages in each of Quires XLVI–L, decorated the Massorah with variations of X-shapes on every alternate pair of confronting pages and with rich

designs in micrography on one pair of confronting pages, usually the last two pages in each quire. He also added another pair of such confronting designs in most of the other quires, where the Massorah scribe did not decorate it at all. The micrographic designs within each quire obviously functioned as catchwords before gathering and binding. The designs consist of interlaces and knots in the middle of the lower Massorah lines, formed by micrographic bands that are often foliate. Similar bands often spread sideways and interlace with the straight Massorah lines (e.g., fols. 47v–48r, 95v–96r, 457v–458r, 481v, 482r – Fig. 542, 505v–506r, 537v–538r, 549v and many others). The only foliage form is the trefoil leaf. Some micrography bands terminate with snake heads (e.g., fols. 79v, 80r).

C. *Space for Initial-Word Panels.*

At the beginning of some books space was left for initial-word panels.

Conclusions

The rich micrography decoration of our manuscript has parallels in other manuscripts. The carpet page on fol. 258r (Fig. 541) is similar to those in the *Abravanel Pentateuch* of 1480 (No. 55, fols. 3v–4r and 238v – Fig. 526, 239r); as are the angular patterns in the lower margins (e.g., fol. 482r – Fig. 542 in our Bible, compared with fol. 77r – Fig. 525 in the *Abravanel Pentateuch*). Those should also be compared with the *First Hispano-Portuguese Bible* (No. 57; cf., e.g., fols. 79v–80r and 537v–538r in our manuscript with fols. 123v–124r and 147v–148r respectively in the *First Hispano-Portuguese Bible*), although in our manuscript they are larger and their style is more angular. However, unlike the *Abravanel Pentateuch* and the *First Hispano-Portuguese Bible*, the decorated Massorah is within the quires and not at their beginnings and ends, and the small micrographic motifs in the outer margins, which are typical to these two manuscripts, are missing here. It is therefore possible that our Bible is of a similar date as these two manuscripts, i.e., the end of the fifteenth century, but nothing specific can be said about its origin.

Bibliography

Loewe, *Trinity*, No. 12, p. 2.

Miscellaneous Manuscripts

[Nos. 59–61]

The only thing that the last three manuscripts seem to have in common is that they all appear to date from the second half of the fifteenth century, and to depend to some extent on the Portuguese School.

The *Berlanga Pentateuch* of 1455 (No. 59) is somewhat archaistic in its type of decoration, though the motifs are related to the *First Kennicott Bible* of 1476 (No. 48). The *Cambridge Surgical Treatise* (No. 60), though it may not have been executed in Spain, was decorated by a Spanish scribe. Although the flourishing scrolls of the *Di Bailo Pentateuch* (No. 61) reveal some similarity to the *First Kennicott Bible* (No. 48), the decoration differs in style.

59. BERLANGA PENTATEUCH

Berlanga, Castile, 1455

Bodl., Can. Or. 77

Fig. 544

Pentateuch, Haftarot and the Five Megillot.

General Data

Codicology

Thick parchment; I + 225 + I leaves; 322 × 247 mm. Text space (218–220) × (162–165) mm. The first pages, containing the text up to Genesis 23:8, are missing. Written in large, square Sephardi script, in light brown ink, mostly 25 lines in two columns. Ruling by stylus, 25 horizontal and 1 + 2 + 1 vertical lines. 29 quires of 8 leaves each, except for Quires II⁶, XI⁶, XVI⁶ and XXIX⁷. The quires are marked with catchwords at their ends.

Binding

Sixteenth–seventeenth-century brown pigskin binding, with blind-tooled foliage border and foliage motifs in the inner corners and the centre.

Colophon

fol. 225r (Fig. 544) Written and punctuated by Eli the Scribe b. Joseph Megi (מיג'י ס"ט), and completed in the month of Sivan 5215 (1455).

History

fol. 225v The copyist of the manuscript sold it to Menaḥem ben Yomṭov Ḥova on the 25th of Ab of the same year (1455).

fol. Iv A note by a later owner on the nature of the book, its scribe and sale, is stuck on to the page.

fol. 47r In the outer margin, owner's inscription, partly cut off: ברוך אני הצעיר מצ, "I, the young blessed."

Decoration

Programme

A. Decorative frames.
B. Shaped writing.

Description

A. Decorative Frames.

There are decorative frames to the beginnings of Exodus (fol. 25v), Leviticus (fol. 62v), Deuteronomy (fol. 121v), the first *haftarah* (fol. 146r), Ruth (fol. 201r), the Song of Songs (fol. 204r), Esther (fol. 217v) and the colophon (fol. 225r – Fig. 544). The beginning of Genesis is missing, and Numbers (fol. 86v) has only a band across the text column.

The frames, of an inverted U-shape, enclose the upper part of the relevant text column. They are formed by bands of spared ground, stylized acanthus scroll (fols. 25v, 62v, 86v, 201r, 204r, 217v and 225r) or vine scroll (fols. 121v and 146r), and a single leaf incorporated into an acanthus scroll (fol. 62v). Both types are drawn in brown ink similar to that of the text, with alternating green and red ground fillings. The spared ground shapes have some touches of ink or colour, and some of the foliage lobes curl to enclose coloured dots. The pen flourishes that surround the decorative bands are larger at the corners, where they consist of lobed foliage with extending flourishes.

B. *Shaped Writing.*

Some of the text on fol. 37v, before the First Song of Moses, is shaped into triangular forms which are crudely bordered by ink lines and a pen-drawn grotesque dog in a spare space. On fol. 142v, several lines are shorter than the rest, with a pen-drawn foliage scroll to their right. The titles of the *haftarot* are written in larger letters, and that on fol. 196r is decorated with a small pen-drawing resembling snails. The indication of the middle of the Pentateuch in the outer margin of fol. 70v is decorated with a small inverted U-frame of pen-drawn geometrical and stylized foliage shapes.

Conclusions

The decoration is of repeated, conventional foliage motifs in ink and colours. The similarity of the ink used in the decoration to that of the text may indicate that the illustrator was the scribe. Though the dense penwork and some motifs can be compared to that of the *First Kennicott Bible* of 1476 (No. 48; e.g., fols. 99r, 119r and 438r – Figs. 466, 438), the style differs because the work of our scribe-artist is cruder.

Bibliography

Neubauer, No. 51.

60. CAMBRIDGE SURGICAL TREATISE

Provence (?), third quarter of fifteenth century

CUL, Add. 1198/3

Figs. 545–546

Surgical treatise (Spanish in Hebrew characters), bound together in one volume with three treatises by Maimonides.

General Data

Codicology

Paper; 8 leaves; 210 × 150 mm. Text space (137–142) × (87–90) mm. Spanish text, written in Hebrew characters in round Sephardi script, in brown ink, 24–25 lines to a page. One quire, catchwords on every verso.

Paper

The paper of this treatise is datable by its watermarks to Provence, 1448(?); Perpignan, 1464; Pignerol, 1464; and Lyons, 1469–1472 (Briquet, *Les Filigranes*, I, No. 3536). Bound together with three other non-decorated treatises, all on paper, Add. 1198 (1, 2 and 4).

Binding

Fifteenth-century binding, of which only the wooden board of the upper cover, partly covered with leather, and the upper parts of two metal clasps, remain.

Colophon

None.
[There is a colophon to treatise 1 of Add. 1198, of 1497. It was copied by Judah N'Abitevet, in Karimsi(?) (קרימה ?), Medina dela Titorra di Viriga(?). The scribe mentions that he was expelled from Spain in 1492.]

History

None.

Decoration

The decorations are in the same ink as the text.

Programme

A. Penwork panels.
B. Marginal decoration.

Description

A. *Penwork Panels.*

There are five panels enclosing initial words (fols. 3r–v and 6v) or mock arabesque lettering (fols. 2r – Fig. 545, and 5r). These are divided into penwork compartments filled by foliage scrolls with flower-like serrated roundels, spirals, golf-club-like motifs and other palmette variations, as well as a human face (fol. 2r – Fig. 545). There are also a plait frame (fol. 3v), striation and other geometrical fillings. Most panels have dotted beads or tree-like shapes attached to their frames and penwork decoration extending into the margins. The extensions consist of multi-linear bars and branches carrying flowers, acanthus leaves, dotted beads and flourishes, some of which frame the page (e.g., fol. 3v).

B. *Marginal Decoration.*

There are also pen decorations in the lower margins of fols. 5v (Fig. 546), 6r and 8v, executed by the same hand of the scribe.

fol. 5v (Fig. 546) On the left are a rabbit and a bird eating fruit from a large, symmetrical foliage motif; on the right is a spread eagle.

fol. 6r An ascender from the last line of the text is decorated similarly to the panel extensions.

fol. 8v A bust of a bearded man.

Conclusions

The scribe and the script of this manuscript point to a Sephardi provenance, though not necessarily to Spain itself. The scribe of the first treatise (Add. MS. 1198/1) states that he was expelled from Spain.

On the basis of the watermarks of the paper it is written on, this manuscript can be dated to the second half of the fifteenth century, from either Provence or Lyons. Since the Jews were expelled from northern and eastern France in the beginning and again at the end of the fourteenth century, but were allowed to stay in Provence, the manuscript could have been written and decorated there. The penwork panels and the crude feathery and floral scrolls are dependent on Spanish motifs of the same period, although the style differs considerably.

Bibliography

Loewe, *Hand List*, No. 604.

Briquet, *Les Filigranes*, I, No. 3536.

61. DI BAILO PENTATEUCH

Ṭa'ushat, 1474

TCLC, F.18.32–33

Figs. 547–549

Bible (Vol. I: Pentateuch; Vol. II: Prophets and beginning of Ruth).

General Data

Codicology

Vellum; two volumes; 112 + II and 206 + I leaves (the end is missing and fol. 1 is blank); 258 × 185 mm. Text space *c.* 165 × 125 mm; height of the text space with Massorah *c.* 202 mm. Written in square Franco-Sephardi script, 31 lines in two columns. Ruling by stylus, 2 + 31 + 3 (?) horizontal and 2 + 3 + 3 vertical lines. 12 and 22 quires of 10 leaves each, except for Quires III[8], IV[8] and XII[6] in Vol. I, and Quires I[5], II[9], XXII[2] in Vol. II. The quires are gathered so that outward hair side faces hair and are numbered with Hebrew letters in the top right-hand corner of the first page; the second quire of Vol. II is also marked at the end. Some of the catchwords survived in the last quires of Vol. II. Foliation with Hebrew letters in the top left-hand corner of rectos by the same hand as that of the Massorah. The names of the books are written in the middle of the upper margin of the rectos; chapter numbering in red in the margins.

Binding

Sixteenth-century leather binding with gold-tooled rectangular frames, triangles with foliage in the corners and a cartouche with foliage in the centre. Blind-tooled foliage scrolls round the edges.

Colophon

I, *fol. 112v* End of the Pentateuch: Written by Joseph Ben Senior (שיניור), called di Bailo (באילו), in Ṭa'ushat טאושת (?), completed on the 5th of Ab 5234 (19 July 1474).

I, *fol. 92r* (Fig. 549) Within the interlacing band, together with the mnemonic sign for Numbers: Completed by Joseph b. Jacob b. Senior, called di Bailo, in Ṭa'ushat, on the 6th of Iyyar 5200 (the number of the year was not completed).

History

Given to Trinity College by W.A. Wright in 1912.

Decoration

Programme

A. Foliage frames.
B. Initial-word panels.
C. Panels at book ends.
D. Decorated *parashah* signs.
E. Decorative micrography of the Massorah.

Description

A. *Foliage Frames.*

There is a full-page frame for the text at the

beginning of Genesis (Vol. I, fol. 1v – Fig. 547), and similar full or partial frames for one text column at the main divisions in Vol. II: Joshua (fol. 1r), Isaiah (fol. 101v) and Ruth (fol. 206v). The full-page frame consists of curly foliage scrolls and gold bars, with foliage ends along the margins and between the text columns. The scrolls are in red and olive green, with small leaves in gold and colour, some dotted. The central bar carries small gold leaves in symmetrical pairs and is topped by a symmetrical foliage motif flanked by two birds. The initial in gold encloses a floral motif in colour. Most shapes are accompanied by flourishes. The decorations at the three main divisions in Vol. II, crudely painted in red, green, violet and burnished gold, consist of gold and coloured stems, mostly along both sides of the first column framing it. They issue from small bases and carry small leaves outlined in colour and enclosing gold dots or curly, coloured leaves (fol. 1r). A crude blossom is normally at the top. A pen-drawn variation of this motif on fol. 15v (Judges) is topped by a pen-drawn bird.

B. *Initial-Word Panels.*

There are penwork initial-word panels for most books, including those with decoration described in §A. The panels are in red, brown, blue and violet. Some extend over one text column (e.g., Vol. I, fols. 29r, 53r and 69v), but most are smaller, measuring (21–36) × (25–32) mm (e.g., Vol. I, fol. 92r – Fig. 549; Vol. II, fols. 1r, 15v, 30r, 65r, 101v, 125v, 157r, 185v and 206v). The initial words are in gold, and the ground is filled with penwork patterns, the most common of which are curly scrolls or series of roundels enclosing golf-club-like motifs, flowers or spirals. There is a horizontal section of plait motif above the initial word in some panels (e.g., Vol. I, fol. 69v; Vol. II, fols. 1r, 30r and 101v). Most panels are surrounded by flourishes, and some have multi-linear penwork bars extending along the sides of the text column (e.g., Vol. I, fols. 69v and 92r – Fig. 549; Vol. II, fols. 30r, 185v and 206v). On fol. 29r of Vol. I, a small bird is in the upper margin above the panel.

C. *Panels at Book Ends.*

There are two types of panels at the ends of books:

1. Small pen-drawn frames to massoretic lists, normally decorated with a spared ground plait pattern (e.g., Vol. I, fols. 28v and 112v; Vol. II, fol. 30r). The last one measures (16–20) × (46–58) mm.
I, fol. 52v (Fig. 548) Pen-drawn foliage with some coloured tinting extends from the corners of the panel and includes large, jagged floral motifs.
I, fol. 69r The frame is U-shaped and decorated with spared ground foliage scrolls. It has foliage extending from the upper corners and a lion and a snake in crude pen-drawing under the lower corners.

II, fol. 101r This panel, framed by inscriptions (87 × 54 mm), encloses geometrical motifs in micrography and pen-drawing.
II, fol. 125v Penwork bars and flourishes extend from the frame, which is partly tinted.

2. Decorative panels in pen-drawing consisting of running patterns of interlacing bands, some with red and violet ground fillings (Vol. I, fols. 28v, 92r – Fig. 549, and 112v), measuring (18–32) × (55–57) mm. On fol. 157r of Vol. II, the word *ḥazaq* at the end of Jeremiah is flanked by two small panels with spared ground interlace decoration.

D. *Decorated Parashah Signs.*

The *parashah* signs and some other notes in the margins are decorated with small pen motifs. The signs, with or without a frame, are topped by spared ground interlaces or elongated plaits within small panels of varying shapes, or by very stylized foliage patterns. These are sometimes surrounded with additional motifs, notably a bird above the main motif (e.g., Vol. I, fols. 11v, 13v, 20v, 38v and 44r). Similar motifs in Vol. II mark the *hafṭarot*, which are sometimes with red tinting (e.g., fols. 121r–122r and 123r–123v).

E. *Decorative Micrography of the Massorah.*

The Massorah is occasionally written in triangular or circular shapes; on fol. 86r of Vol. I, it is shaped as a fleur-de-lis.

Conclusions

The second volume of this Bible is mutilated, lacking the entire Hagiographa (starting with Ruth). The colophon at the end of the first volume (fol. 112v) states that the manuscript was completed in 1474 in Ṭa'ushat, possibly Tauste, between Tudela and Zaragoza. The date mentioned at the end of the book of Numbers (Vol. I, fol. 92r) is probably incomplete, indicating only the thousands and hundreds of years and not the tens and units. The colophon states that the model for this Bible was a מקדשיה (*miqdashyah*) from Barcelona. The angular script is influenced by French Ashkenazi script. The scribe, Joseph b. Jacob, was responsible for decorating the framed mnemonic signs at the ends of books, the *parashah* signs and the decorated Massorah, as well as the penwork initial-word panels.

The pages of the main divisions, decorated with gold and coloured foliage scrolls and bars, are of the same period as the *First Kennicott Bible* of 1476 from La Coruña (No. 48), but even though the scrolls may have similar foliage and floral motifs (e.g., *First Kennicott Bible*, fol. 370r – Fig. 470), the style differs.

Bibliography

Loewe, *Trinity*, No. 13, p. 3.
Ginsburg, *Introduction*, No. 54 (G.3), pp. 747 ff.

GLOSSARY

afiqoman: portion of *mazzah* broken from the middle of the three *mazzot* on the Passover plate and eaten after the meal. It is customary for the leader of the *Seder* to hide it, and for the children to "steal" it and ask for its ransom.

aggadah ("legend"; pl. *aggadot*): those sections of the *midrash* and Talmud containing homiletic expositions of the Bible, stories, legends, folklore, anecdotes, or maxims. In contradistinction to *halakhah*.

amora (Aram. "interpreter"; pl. *amora'im*): title given to the rabbis in Palestine and, especially, Babylonia in the third to sixth centuries who were responsible for the composition of the Talmud.

'aravah ("willow"): one of the *arba'ah minim*.

arba'ah minim ("four species"): the four plants used on *Sukkot*: *etrog, hadas, lulav* and *'aravah*.

Arba'ah Turim: codification of talmudic later halakhic decisions compiled by R. Jacob b. Asher (*c.* 1270–1343).

ascender: top vertical part of the Hebrew letter *lamed* ascending into the written text. See also descender.

Ashkenaz: term applied to Germany from the ninth century. Hence *Ashkenazim*: the Jews of Germany and therefore by extension their descendants living in Eastern Europe and elsewhere. Also used in contradistinction to *Sepharadim*.

Ben Asher and Ben Naphtali: see *massorah magna*.

carpet page: entire page of a manuscript, decorated like a carpet, sometimes with symbolic or narrative representations. Appearing mainly at the beginning and end of Hebrew Bibles.

computistic tables: tables used for calculating leap-years, dates of Festivals, days of the months and weeks, and when within a 19-year cycle, the sun calendar coincides with the moon.

Dayyenu ("it would have sufficed us"): refrain of a hymn in the Passover *Haggadah*, enumerating the deeds of God in Egypt and on the way to the Holy Land.

descender: lower vertical part of the Hebrew final letters *kaf, nun* and *peh* and of the letter *qof* descending into the written text. See also ascender.

din ("law"; pl. *dinim*): halakhic ruling; court ruling.

etrog ("citron"): one of the *arba'ah minim*.

Four Cups: four cups of wine, symbolizing the four promises of redemption, drunk during the Passover *Seder*.

Four Sons: A *midrash* in the Passover *Haggadah* referring to four types of children: the wise, the wicked, the simple, and those who do not know how to ask questions.

Gemara (Aram. "learning"): a popular term for the Talmud, referring mainly to the traditions, discussions, and rulings of the *amora'im*, both commenting on and supplementing the *Mishnah*.

genizah: depository for damaged sacred books and ritual objects. The best known was discovered in the Ben Ezra synagogue of Fustat (Old Cairo).

hadaṣ ("myrtle"): one of the *arbaʿah minim*.

hafṭarah ("concluding"; pl. *hafṭarot*): portion of the prophetical books of the Bible recited in the Synagogue as a concluding paragraph after the reading of the *parashah* from the Pentateuch on Sabbaths and Festivals.

Haggadah ("telling"; pl. *Haggadot*): set order (*ṣeder*) of rites, benedictions, prayers, midrashic comments and Psalms performed and recited at home on Passover eve at the *Ṣeder* table.

Ha laḥma ʿanya (Aram. "this bread of affliction"): opening words of the introductory paragraph of the Passover *Haggadah*, inviting the poor to partake in the Passover meal.

halakhah (pl. *halakhot*): accepted decision in rabbinic law. Also refers to those parts of the Talmud concerned with legal matters, in contradistinction to *aggadah*.

Hallel ("praisegiving"): Psalms 113–118 recited among the prayers for the main Festivals and at the Passover *Ṣeder*.

Hamoẓi ("the One who brings forth"): term used for the main benediction over food, giving praise to God who brings forth bread from the earth.

Ḥanukkah ("dedication"): Feast of Lights; an eight-day celebration commemorating the victory of Judah Maccabee over the Seleucid king Antiochus Epiphanes and the subsequent rededication of the Temple (165 B.C.).

ḥaroṣet: food symbolizing the mortar that the Israelites made in Egypt; a compound of fruit, spices, nuts and wine, eaten at the Passover *Ṣeder*.

havdalah ("distinction"): ritual and benediction for the termination of Sabbaths and Festivals to distinguish between holy days and week-days.

ḥazan ("cantor"): precentor who intones the liturgy and leads the prayers in the synagogue.

initial word panel: decorated panel in manuscript including the opening word of a paragraph, analogous to the Latin initial. Developed in oriental illumination since the Hebrew script, like the Arabic, has no capital letters.

Karaite (Aram. *Qara*, "reader"): name taken by members of a Jewish sect basing their tradition on a strict reading of the Bible, while rejecting the rabbinic mishnaic and talmudic Oral Law. Originated in the eighth century in Babylonia.

karpaṣ (Apium): leafy vegetable (e.g., celery or lettuce), eaten as one of the preliminary appetizers at the Passover *Ṣeder*.

kerikhah ("combination"): custom initiated by R. Hillel on Passover eve of combining *maẓẓah* and *maror* and eating them together.

ketubbah ("written document"): wife's marriage contract specifying the obligations of the husband, as well as the settlement she is entitled to in case of a divorce.

kinah (pl. *kinot*): dirge over the dead. In the Middle Ages the name was applied to a special type of dirge for the Ninth of Av.

lulav ("sprout"): one of the *arbaʿah minim*. Name applied to the palm-branch used on *Ṣukkot*.

magrefah ("rake"): according to the *Mishnah* (*Tamid* 5:5), a musical instrument in the Temple which produced a thousand kinds of songs when thrown between the porch and the altar.

maḥzor: prayer-book, including the prayers and *piyyuṭim* for all the yearly Festivals and special Sabbaths. See also *Ṣiddur*.

maror: bitter herb eaten at the *Ṣeder* on Passover eve, symbol of the sufferings of the Israelites in Egypt.

Marrano(s): Jews (and their descendants) who were forcibly converted to Christianity in Spain and Portugal in the Middle Ages, but continued to observe Jewish rituals in secret.

massorah: body of traditions regarding the correct spelling, writing, and reading of the Hebrew Bible.

massorah magna: concordantial lists of similar and variant readings in the Bible. The list of variants between the Ben Asher and Ben Naphtali traditions is written in parallel columns framed by arcades in Spanish Bibles, resembling canon tables of Gospel-books.

massorah parva: short notes of variant readings and vocalization of the Bible, usually written in the margins of biblical manuscripts and between the columns of the text.

massorator: expert scribe of the *massorah*.

maẓẓah: unleavened bread in the form of a wafer eaten during the Passover Festival.

megillah (pl. *megillot*): "scroll", especially the Scroll of Esther, one of the Five *Megillot*.

Megillot, the Five: comprehensive name for five works of the biblical Hagiographa read on special occasions: The Song of Songs (Passover), Ruth (*Shavuʿot*), Lamentations (Ninth of Av), Ecclesiastes (*Ṣukkot*), Esther (*Purim*).

Megillat Antiochus: apocryphal book on the persecutions of Jews by the Seleucid king Antiochus Epiphanes.

menorah: seven-branched oil candelabrum for ritualistic use in the Tabernacle and the Temple.

micrography: minute script, usually used for writing the *massorah*, sometimes tracing the outline of decorative forms.

midrash: homiletical method of interpreting the text of the Bible by finding new meanings in addition to the literal one by deducing other biblical verses. Also compendia of such rabbinic interpretations.

miqdashiah ("Temple of God"): *Sephardi* designation for an entire Bible Codex of an accurate text.

Mishnah ("learning"): interpretations of basic Oral Law transmitted by generations of *tana'im*, and its codification by R. Judah ha-Nasi (*c.* 200 A.D.), containing statements, descriptions of customs, discussions, and biblical interpretations of halakhic and aggadic nature.

Mishneh Torah: Hebrew compendium of Jewish law compiled by R. Moses b. Maimon (Maimonides, 1135–1204), containing the 613 Precepts, arranged according to subject matter.

Moreh Nevukhim: "Guide of the Perplexed", a philosophical and theological treatise in Arabic by R. Moses b. Maimon (Maimonides, 1135–1204), completed in 1190.

naqdan ("vocalizer"; pl. *naqdanim*): expert scribe who added vowels and accents to the texts of biblical manuscripts, and in many cases also copied the massoretic notes.

netilat yadaim ("washing of hands"): ritual of washing the hands before meals while reciting a special benediction. On Passover Eve *Seder* two washings of hands are performed, one without and one with the benediction.

parashah ("section", "portion"; pl. *parashot*): pericope of the Pentateuch.

Pessah: Passover.

piyyut (from Greek *poietés*; pl. *piyyutim*): form of Hebrew liturgical poetry originating in Palestine, *c.* 300, and flourishing throughout the Middle Ages.

Purim: Festival held on the 14th or 15th day of Adar in commemoration of the delivery of the Jews of Persia through Mordecai and Esther from destruction by Haman.

Qaraite: see *Karaite*.

qiddush ("sanctification"): prayer recited on Sabbaths and Festivals over a cup of wine.

qinah: see *Kinah*.

QoNaKh YeHaNeH MiMaKh (lit. "thy Lord will enjoy you"): mnemonic for Passover eve ritual, common in Spanish *Haggadot*: *Qiddush*; *Netila* – first washing of hands; *Karpas*; *Yevazza'* – breaking of the middle *mazzah* for *afiqoman*; *Ha lahma*; *Netila* – second washing of hands; *Hamozi*; *Mazzah*; *Maror*; *Kerikhah*.

Sanctuary implements: ritual objects used in the Tabernacle in the desert, Solomon's Temple, the Second and Herod's Temples in Jerusalem, usually represented as a mixed array on carpet pages at the beginning of manuscripts of Spanish Bibles.

Seder Pessah ("Order of Passover"): ceremony observed in the Jewish home on the first night (outside Israel on the first two nights) of Passover, when the *Haggadah* is recited.

Sefer Mikhlol: grammatical treatise by R. David Kimhi.

Sepharad: term applied to Spain since the Middle Ages. Hence *Sepharadim*: the Jews of Spain and therefore by extension their descendants living elsewhere. Also used in contradistinction to *Ashkenazim*.

Seleucid calendar (*anno seleucide*): era starting from 312 B.C., introduced to commemorate the victory of Seleucus and Ptolemy over Demetrius Poliorcetes at Gaza. Used by the Jews to date legal documents, *lishtarot* ("documents").

Shavu'ot: Feast of Weeks (Pentecost); second of the three annual pilgrim Festivals, commemorating the receiving of the *Torah* at Mount Sinai.

siddur: daily prayer-book distinct from the *mahzor*, which contains the Festival prayers.

Shefokh hamatkha: "Pour out Thy wrath [upon the nations that have not known Thee]" (Ps. 79:6). The first of several biblical verses recited on Passover eve, following the *Seder* meal.

shofar: horn of animal (usually ram) sounded on New Year and on the Day of Atonement.

special Sabbaths: the four Sabbaths preceding Passover on which special *parashot* are read, the last being *Shabbat ha-Gadol*.

Sukkot: Feast of Tabernacles; the last of the three annual pilgrim Festivals, celebrated by sitting in a *sukkah* (tabernacle).

tallit: four-cornered prayer shawl with fringes (*zizit*) at each corner, worn during the morning prayers by adult males.

Talmud: compendium of oral discussions on the *Mishnah* by generations of *amora'im* in many academies over a period of several centuries, codified *c.* 500 A.D. It became the most important Jewish legal source. The Jerusalem Talmud contains mainly the discussions of the Palestinian sages. The Babylonian Talmud incorporates the parallel discussions in the Babylonian academies.

tanna (Aram. "one who repeats"; pl. *tanna'im*): rabbi quoted in the *Mishnah*. Distinguished from the later *amora*.

Targum: Aramaic translations of the Bible.

tefillin: phylacteries; small case containing passages from the *Torah* to be bound on the forehead and left arm by male Jews during the recital of morning prayers in accordance with Deut. 6:8.

Tish'ah beAv (ninth of the month Av): fast day, commemorating the destruction of both Temples in Jerusalem.

Ṭur Even ha-'Ezer: one of the four parts of the *Arba'ah Ṭurim*, dealing with personal and family matters.

YaQeNHaZ: mnemonic for the order of benedictions for Passover eve when it falls at the end of the Sabbath: *Yayin* – "wine"; *Qiddush*; *Ner* – "candle" light; *Havdalah*; *Zeman* – "time", the benediction for the special event.

yeshiva: Jewish traditional college devoted primarily to the study of the Talmud and rabbinic law.

ẓiẓit: fringes of prayer shawl.

BIBLIOGRAPHY

Beit-Arié, Date

Beit-Arié, M., "An Unusual Method of Rendering the Date from the Creation in Hebrew Manuscripts", *Tarbiz*, XLI:I (1971), pp. 116–124, 343–344, 422 (in Hebrew).

Bohigas, *Cataluña*

Bohigas, P., *La Ilustración y la decoración del libro manuscrito en Cataluña*, I–II, Barcelona 1965.

Briquet, *Les Filigranes*

Briquet, C. M., *Les Filigranes — Dictionnaire historique des marques de papier dès leur apparition vers 1282 jusqu'en 1600*, Geneva 1907.

Byvanck, *Pays-Bas*

Byvanck, A. W., *La Miniature dans les Pays-Bas Septentrionaux*, Paris 1937.

Davidson

Davidson, I., *Thesaurus of Mediaeval Hebrew Poetry*, I–IV, New York, I, 1924; II, 1929; III, 1930; IV, 1933 (in Hebrew).

Delaissé, *Brussels*

Delaissé, L. M. J., *Mittelalterliche Miniaturen von der burgundischen Bibliothek zu den Handschriften der Königlich-belgischen Bibliothek*, Köln 1959.

Domínguez-Bordona, *Catalogo*

Domínguez-Bordona, J., *Catalogo Exposición de Códices Miniados Españoles*, Madrid 1929.

Domínguez-Bordona, *Ars Hispaniae*, XVIII

Domínguez-Bordona, J., "Miniatura", *Ars Hispaniae*, XVIII, Madrid 1962, pp. 17–242.

Domínguez-Bordona, *Manuscritos*

Domínguez-Bordona, J., *Manuscritos con Pinturas*, I–II, Madrid 1933.

Edmonds, Ibn Ḥayyim

Edmonds, S., "A Note on the Art of Joseph Ibn Ḥayyim", *Studies in Bibliography & Booklore*, XI, 1–2 (1975–1976), pp. 25–40.

Frauberger, Buchschmuck

Frauberger, H., "Verzierte hebräische Schrift und jüdischer Buchschmuck", *Mitteilungen der Gesellschaft zur Erforschung jüdischer Kunstdenkmäler, Frankfurt am Main*, V–VI (October 1909).

Ginsburg, *Introduction*

Ginsburg, C. D., *Introduction to the Massoretico-Critical Edition of the Hebrew Bible*, London 1897.

Gutmann, Antiquity

Gutmann, J., "The Illustrated Jewish Manuscripts in Antiquity — The Present State of the Question", *Gesta*, V (1966), pp. 39–44.

Gutmann, Haggadah

Gutmann, J., "The Illuminated Medieval Passover Haggadah — Investigations and Research Problems", *Studies in Bibliography and Booklore*, VII (1965), pp. 3–25.

Gutmann, Kingdom

Gutmann, J., "When Kingdom Comes", *Art Journal*, XXVII (1967–1968), pp. 168–175.

Gutmann, *Manuscript*

Gutmann, J., *Hebrew Manuscript Painting*, New York 1978.

Heawood, *Watermarks*

Heawood, E., *Watermarks (Monumenta Chartae Papyraceae Historiam Illustrantia*, I), Hilversum 1950.

Hillgarth & Narkiss, Contract

Hillgarth, J., & Narkiss, B., "A List of Hebrew Books (1330) and a Contract to Illuminate Manuscripts (1335) from Majorca", *Revue des études juives*, CXX (1961), pp. 297–320.

Italiener, *Darmstadt*

Italiener, B., *Die Darmstädter Pessach-Haggadah Codex Orientalis 8 der Landesbibliothek zu Darmstadt aus dem vierzehnten Jahrhundert*, I–II: Facsimile and Introduction, Leipzig 1927.

Joel, Damascus Keter

Joel, I., "A Bible Manuscript of 1260", *Kirjath Sepher*, XXXVIII (1962), pp. 122–132 (in Hebrew).

Kahle, Cambridge Bible

Kahle, P., "The Reputed Ancient Hebrew Bible at Cambridge", *Journal of Theological Studies*, XXXII (1931), pp. 69–71.

Kahle, *Massoreten*

Kahle, P., *Massoreten des Westens*, Stuttgart 1927–1930. See also review by Williams, A. L., *Journal of Theological Studies*, XXXII (1937), pp. 101–102.

Kennicott, *Dissertatio*

Kennicott, B., *Dissertatio Generalis in Vetus Testamentum Hebraicum cum Variis Lectionibus ex Codicibus Manuscriptis*, Brunocivi 1783.

Leveen

Leveen, J., *Introduction, Indexes, Brief Descriptions of Accessions and Addenda and Corrigenda* (Vol. IV of the *Catalogue of the Hebrew and Samaritan Manuscripts in the British Museum*, by G. Margoliouth), London 1935.

Leveen, *Bible*

Leveen, J., *The Hebrew Bible in Art*, London 1944.

Loewe, *Hand List*

Loewe, H., *Hand List of Hebrew Manuscripts in the University Library at Cambridge* (n.d.).

Loewe, *Trinity*

Loewe, H., *Catalogue of the Manuscripts in the Hebrew Character Collected and Bequeathed to Trinity College Library by the Late William Aldis Wright*, Cambridge 1926.

Luzzatto, *Almanzi*

Luzatto, S. D., *Catalogue de la Bibliothèque de Littérature hébraïque et orientale de feu M. Joseph Almanzi*, Padua 1864.

Manoscritti biblici ebraici

Manoscritti biblici ebraici decorati provenienti da biblioteche italiane publiche e private. Catalogo della mostra ordinata presso la Biblioteca Trivulziana. Castello Sforzesco, Milano 2/28 Marzo 1966. A cura di Valeria Antonioli Martinelli e Luisa Mortara Ottolenghi con prefazioni di Carlo Bernheimer, Roberto Bonfil & Cecil Roth, Milan 1966.

Margoliouth

Margoliouth, G., *Catalogue of the Hebrew and Samaritan Manuscripts in the British Museum*, I–III, London 1899, 1905, 1909–1915. See also Leveen.

Meiss, Catalonia

Meiss, M., "Italian Style in Catalonia and a Fourteenth-century Catalan Workshop", *Journal of the Walters Art Gallery*, IV (1941), pp. 45–87.

Metzger, M., Bologna Haggadah	Metzger, M., "Two Fragments of a Spanish Fourteenth-century *Haggadah*", *Gesta*, VI (1967), pp. 25–34.
Metzger, M., Caractères	Metzger, M., "Quelques caractères iconographiques et ornamentaux de deux manuscrits hébraïques du Xᵉ siècle", *Cahiers de civilisation médiévale*, I (1958), pp. 205–213.
Metzger, M., *Haggada*	Metzger, M., *La Haggada Enluminée*, Leiden 1973.
Metzger, T., *Lisbonne*	Metzger, T., *Les Manuscrits hébreux copiés et décorés à Lisbonne dans les dernières décennies du XVᵉ siècle*, Paris 1977.
Metzger, T., La poule	Metzger, T., "Note sur le motif de 'la poule et des poussins' dans l'iconographie juive", *Cahiers archéologiques*, XIV (1964), pp. 245–248.
Metzger, T., Masora	Metzger, T., "La Masora ornementale et le décor calligraphique dans les manuscrits hébreux espagnols au moyen âge", *La Paléographie hébraïque médiévale (Colloques internationaux du CNRS*, No. 547), Paris 1974, pp. 87–116, Pls XCVII–CXII.
Metzger, T., Objets du culte	Metzger, T., "Les objets du culte, le sanctuaire du Désert et le Temple de Jérusalem, dans les Bibles hebraïques médiévales enluminées en Orient et en Espagne", *Bulletin of the John Rylands Library*, LII (1966), pp. 397–436; LIII (1970–1971), pp. 175–185.
Millar, *Honoré*	Millar, E. G., *The Parisian Miniaturist Honoré*, London 1959.
Monumenta Judaica	*Monumenta Judaica — 2000 Jahre Geschichte und Kultur der Juden am Rhein*. Katalog einer Ausstellung im kölnischen Stadtmuseum, 18 Okt. 1963–15 Feb. 1964.
Müller & Schlosser, *Sarajevo*	Müller, D. H., J. von Schlosser & D. Kaufmann, *Die Haggadah von Sarajevo*, I–II: Facsimile and Introduction, Vienna 1898.
Narkiss, *Golden Haggadah*	Narkiss, B., *The Golden Haggadah*, I–II: Facsimile and Introduction, London 1970.
Narkiss, *HIM*	Narkiss, B., *Hebrew Illuminated Manuscripts*, Jerusalem–New York 1969.
Narkiss, Relation	Narkiss, B., "The Relation between the Author, Scribe, Massorator and Illustrator in Medieval Manuscripts", *La Paléographie hébraïque médiévale (Colloques internationaux du CNRS*, No. 547), Paris 1974, pp. 79–86, Pls LXXVIII–XCVI.
Narkiss, Sanctuary	Narkiss, B., "A Scheme of the Sanctuary from the Time of Herod the Great", *Journal of Jewish Art*, I (1974), pp. 6–15.
Narkiss & Sed-Rajna, *Ibn Gaon*	Narkiss, B. & G. Sed-Rajna, "La première Bible de Josué ben Abraham Ibn Gaon", *Revue des études juives*, CXXX (1974), pp. 4–15.
Narkiss, M., Schocken Haggadah	Narkiss, M., "An Illuminated Ashkenazi Passover Haggadah from the First Quarter of the Fifteenth Century at the S. Z. Schocken Library in Jerusalem", *Ha'arez*, 30 March 1953 (in Hebrew).
Neubauer	Neubauer, A., *Catalogue of Hebrew Manuscripts in the Bodleian Library and the College Libraries of Oxford*, I–II, Oxford 1886, 1906.
Nordström, Bibles	Nordström, C. O., "Some Miniatures in Hebrew Bibles", *Synthronon*, II, Paris 1968, pp. 89–105.
Nordström, Jewish Legends	Nordström, C. O., "Some Jewish Legends in Byzantine Art", *Byzantion*, XXV–XXVII (1955–1957), pp. 487–493.

Nordström, Peter Comestor — Nordström, C. O., "The Temple Miniatures in the Peter Comestor Manuscript at Madrid (Bibl. Nac. Cod. Res. 199)", *Horae Soederblomianae*, VI, Lund 1964, pp. 54–81.

Paecht, Ephraimillustration — Paecht, O., "Ephraimillustration, Haggadah und Wiener Genesis", *Festschrift Karl M. Swoboda*, Wiesbaden 1959, pp. 216–217.

Paecht & Alexander, *Bodleian MSS* — Paecht, O. & J. J. G. Alexander, *Illuminated Manuscripts in the Bodleian Library Oxford*, I–III, Oxford, I, 1966; II, 1970; III, 1973.

Rosenau, Nicolaus de Lyra — Rosenau, H., "The Architecture of Nicolaus de Lyra's Temple Illustrations and the Jewish Tradition", *Journal of Jewish Studies*, XXV:2 (1974), pp. 294–304.

Rosenau, Rylands, 1954 — Rosenau, H., "Notes on the Illuminations of the Spanish Haggadah in the John Rylands Library", *Bulletin of the John Rylands Library Manchester*, XXXVI (1954), pp. 468–483.

Roth, Additional Note, 1961 — Roth, C., "An Additional Note on the Kennicott Bible", *The Bodleian Library Record*, VI (1961), pp. 659–662, Pls XIV, XV.

Roth, Antecedents — Roth, C., "Jewish Antecedents of Christian Art", *Journal of the Warburg and Courtauld Institutes*, XVI (1953), pp. 24–44.

Roth, Kennicott, *Sefarad*, 1952 — Roth, C., "A Masterpiece of Medieval Spanish-Jewish Art — The Kennicott Bible", *Sefarad*, XII (1952), p. 351–368.

Roth, *Kennicott, Bodley*, 1957 — Roth, C., *The Kennicott Bible (Bodleian Picture Book*, No. 11), Oxford 1957.

Roth, Rylands, 1960 — Roth, C., "The John Rylands Haggadah", *Bulletin of the John Rylands Library Manchester*, XLIII (1960), pp. 131–159.

Roth, *Sarajevo* — Roth, C., *The Sarajevo Haggadah*, Belgrade 1963.

Rye, *Mocatta* — Rye, R. A., *Catalogue of the Printed Books and Manuscripts Forming the Library of Frederic David Mocatta*, London 1904.

Rylands Exhibition, 1958 — *John Rylands Library. Exhibition Catalogue of Hebrew Manuscripts*, Manchester 1958.

Salmi, *Miniatures* — Salmi, M., *Italian Miniatures*, London 1957.

Santos, *Portugal* — Santos, R., "Les principaux manuscrits à peintures conservés en Portugal", *Bulletin de la société française de reproductions de manuscrits à peintures*, XIV, Paris 1930 (1932).

Sassoon, *Ohel David* — Sassoon, D. S., *Ohel David — Descriptive Catalogue of the Hebrew and Samaritan Manuscripts in the Sassoon Library, London*, I–II, Oxford University Press 1932.

Scheiber, *Kaufmann* — Scheiber, A., *The Kaufmann Haggadah — Facsimile Edition of MS. 422 of the Kaufmann Collection in the Oriental Library of the Hungarian Academy of Sciences (Publications of the Oriental Library of the Hungarian Academy of Sciences*, I), Text Vol. See also Review by Narkiss, B., *Kirjath Sepher*, XXXIV (1958/59), pp. 71–79.

Schiller-Szinessy — Schiller-Szinessy, S. M., *Catalogue of the Hebrew Manuscripts Preserved in the University Library of Cambridge*, I, *Holy Scriptures*; II, *Commentaries on the Bible*, Cambridge 1876.

Schilling, *Frankfurt* — Schilling, R., *Die illuminierten Handschriften und Einzelminiaturen des Mittelalters und der Renaissance in Frankfurter Besitz*, ed. G. Swarzenski, Frankfurt am Main 1929.

Schirmann, *Hebrew Poetry* Schirmann, H. J., *Hebrew Poetry in Spain and Provence*, I–II, Jerusalem 1956 (in Hebrew).

Schubert, U., Adam Schubert, U., "Die Erschaffung Adams in einer spanischen Haggadah-Handschrift des 14. Jahrhunderts (Br. Mus. Or. 2884) und ihre spätantike jüdische Bildvorlage", *Kairos*, XVIII:3 (1976), pp. 213–217.

Schubert, U., Erschaffung Schubert, U., "Eine jüdische Vorlage für die Darstellung der Erschaffung des Menschen in der sogenannten Cotton-Genesis-Rezension", *Kairos*, XVII (1975), pp. 1–10.

Schwarz, *Austria* Schwarz, A. Z., *Die hebräischen Handschriften in Österreich (ausserhalb der Nationalbibliothek in Wien)*, I: *Bibel–Kabbala*, Leipzig 1931.

Schwarz, *Lisbon* Schwarz, S., *A tomada de Lisboa conforme documento coevo de um códice hebraico da Biblioteca Nacional*, Lisbon 1953.

Sed-Rajna, *Lisbonne* Sed-Rajna, G., *Manuscrits hébreux de Lisbonne*, Paris 1970.

Sed-Rajna, psautier de Bry Sed-Rajna, G., "Le psautier de Bry manuscrit hébreu enluminé (Espagne, XVe siècle–Florence, 1489)", *Revue des études juives*, 4e série, IV (CXXIV) (1965), pp. 375–386.

Sed-Rajna, Toledo Sed-Rajna, G., "Toledo or Burgos?", *Journal of Jewish Art*, II (1975), pp. 6–21.

Sirat & Beit-Arié, *Manuscrits* Sirat, C., & M. Beit-Arié, *Manuscrits médiévaux en caractères hébraïques portants des indications de date jusqu'à 1540*, Jerusalem–Paris, I, 1972; II, 1979.

Sotheby Sale Auction Sale at Sotheby and Co., London (followed by date and lot no.).

Stassof & Gunzburg Stassof, V., & D. Gunzburg, *L'Ornement hébreu*, Berlin 1905.

Synagoga, Cat. Exhib. *Synagoga — Kultgeräte und Kunstwerke von der Zeit der Patriarchen bis zur Gegenwart*, Recklinghausen–Frankfurt 1960–1961.

Tamani, Parma Tamani, G., "Elenco dei manoscritti ebraici miniati e decorati della Palatina di Parma", *La Bibliofilia*, LXX:1–2 (1968), pp. 39–136.

Warner, *British Museum* Warner, G. F., *Illuminated Manuscripts in the British Museum*, London 1903.

Wieder, Sanctuary Wieder, N., "'Sanctuary' as a Metaphor for the Scripture", *The Journal of Jewish Studies*, VIII (1957), pp. 165–175.

Wischnitzer, Haggadahs Wischnitzer, R., "Illuminated Haggadahs", *Jewish Quarterly Review*, NS XIII (1922–1923), pp. 193–218.

Wischnitzer, Maimonides Wischnitzer, R., "Maimonides' Drawing of the Temple", *Journal of Jewish Art*, I (1974), pp. 16–27.

Wormald, Copenhagen Wormald, F., "Afterthoughts on the Stockholm Exhibition", *Konsthistorisk Tidskrift*, XXII (1953), pp. 75 ff.

Zotenberg Zotenberg, H., *Catalogues des manuscrits hébreux et samaritains de la bibliothèque impériale*, Paris 1866.

Zunz, *Geschichte* Zunz, L., *Zur Geschichte und Literatur*, Berlin 1845.

GENERAL INDEX
Page references in bold type refer to main entries

ICONOGRAPHICAL INDEX

LIBRARY INDEX

For manuscripts referred to here by name, see General Index

LIST OF DATED MANUSCRIPTS

1279 Castile	1A	1415 Franco-Spanish	51
1300 Toledo	2	1455 Berlanga	59
1304 Soria	7	1471 Lisbon	41
1306 Soria	3	1474 Ta'ushat	61
1332 Spain	27	1476 La Coruña	48
1384 Solsona	22	1478 Toledo (?)	53
1391 Catalonia	31	1482 Lisbon	42
1396 Castellón d'Ampurias	24		

LIST OF FIGURES IN PART TWO
The numbers in parentheses refer to the pages of Part Two

[200]

[205]

[207]

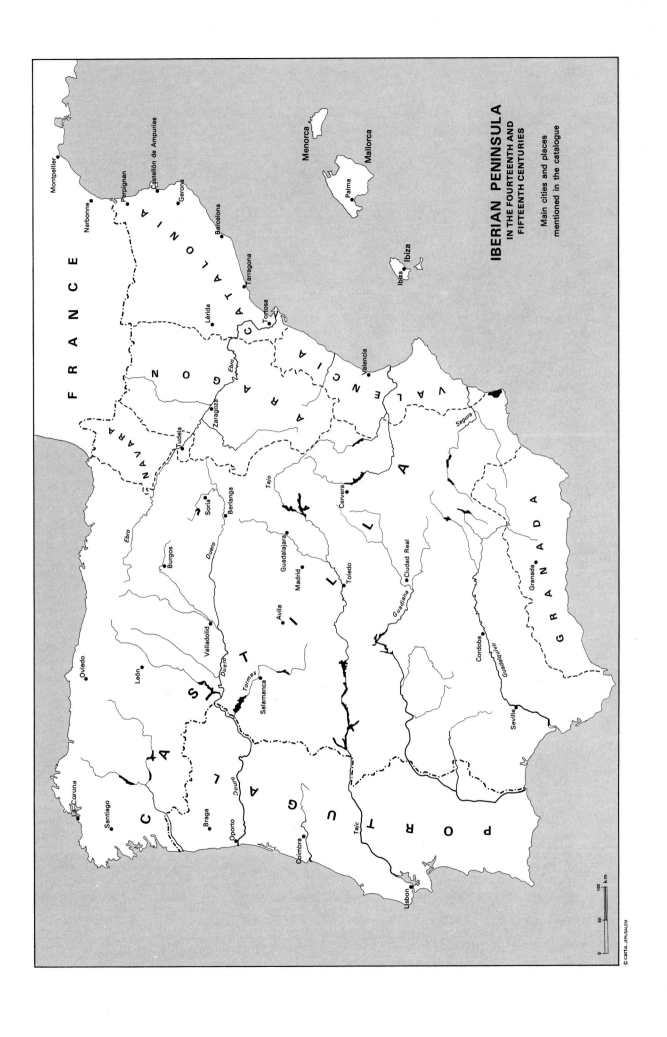

IBERIAN PENINSULA
IN THE FOURTEENTH AND
FIFTEENTH CENTURIES

Main cities and places
mentioned in the catalogue

FRANCE

Montpellier

Narbonne
Perpignan
Castellón de Ampurias
Gerona

C A T A L O N I A

Barcelona

Tarragona

Lérida

Tortosa

A R A G O N

Ebro

Zaragoza

Tudela

N A V A R R A

Ebro

Soria
Berlanga

Burgos

Duero

V A L E N C I A

Valencia

Segura

Cervera

Taio

Guadalajara

Madrid

Toledo

C A S T I L L A

Ciudad Real

Guadiana

Avila

Valladolid

Oviedo

León

Duero

Tormes

Salamanca

Córdoba

Guadalquivir

G R A N A D A

Granada

Seville

Coruña

Santiago

C A S T I L L A

Braga

Douro

Oporto

Coimbra

P O R T U G A L

Tejo

Lisbon

Menorca

Mallorca

Palma

Ibiza

Ibiza

km

100

50

0

© carta, JERUSALEM

ADDENDUM

Initially this volume of our Catalogue was designed to include the David Solomon Sassoon private collection. The collection, however, was moved to Zurich and was not available for study. After the sale by auction of about 200 manuscripts from the Sassoon Collection in 1975, 1978 and 1981, there remained about 50 manuscripts in the British Isles; half of these was acquired by public and private libraries, and half was accepted this year by Her Majesty's Treasury in lieu of estate duty. While this volume was being printed, an exhibition of 20 manuscripts from this collection was held at the British Library (10 August – 31 December 1982), among them five Spanish manuscripts which ought to have been included in this volume of the Catalogue and will be added to the second volume. These are:

21A. Rashba Bible (Sassoon 16, now private collection), Cervera, 1383.

29A. Maimonides' Guide (Sassoon 1047, now B.L. Or. 14061), Barcelona, c. 1350.

49A. Bible (Sassoon 199, now B.L. Or. 14054), Franco-Spanish, fifteenth century.

54A. Vernon Bible (Sassoon 499, now Bodleian Library), Seville, 1454.

54B. Seville Bible (Sassoon 487, now private collection), Seville 1468.